MICHELANGELO, GOD'S ARCHITECT

MICHELANGELO, GOD'S ARCHITECT

THE STORY OF HIS FINAL YEARS AND GREATEST MASTERPIECE

WILLIAM E. WALLACE

PRINCETON UNIVERSITY PRESS
PRINCETON AND OXFORD

press.princeton.edu

Cover design by Chris Ferrante
Cover art: (Left) Portrait of Michelangelo Buonarroti, by Jacopino del Conte (1510–1598).
Casa Buonarroti, Florence, Italy. Photo: Scala / Art Resource, NY. (Right) Dome of St. Peter's Basilica.
Photo: Vyacheslav Lopatin / Alamy Stock Photo

First paperback printing, 2021
Paperback ISBN 978-0-691-21275-3
Cloth ISBN 978-0-691-19549-0
Library of Congress Control Number: 2019941489

British Library Cataloging-in-Publication Data is available

Text design by Leslie Flis

This book has been composed in Adobe Jenson Pro and Trajan Pro

Printed in the United States of America

To Paul Barolsky, who taught me the value of a good story

CONTENTS

PREFACE

Having written a biography of Michelangelo, I thought I was "done" with the artist. But, as Leonardo famously mused, "Tell me if anything is ever done." And as my mentor Howard Hibbard once remarked, "There is no such thing as a definitive book or a final word on great art or artists." Indeed, as I wrote the final pages of my biography, I became increasingly drawn to the poignant narrative of an aging artist confronting the greatest challenge of his creative life: to build New St. Peter's all the while knowing he would never see it to completion.

I think I needed to pass age sixty before I could write a book about Michelangelo in old age, and that means that I have incurred many years of personal and scholarly debts. I would like to thank Nicholas Terpstra, Elizabeth Cropper, and the board members of the Renaissance Society of America for the invitation to deliver the Josephine Waters Bennett Lecture in 2014, which permitted me to sketch the broad ideas for the book and to publish them in *Renaissance Quarterly*. For the rare privilege of visiting the Pauline Chapel on multiple occasions, I am grateful to Antonio Paolucci, Arnold Nesselrath, and Marco Pratelli. I would like to thank Vitale Zanchettin for an afternoon spent in some normally inaccessible parts of St. Peter's; to Richard Goldthwaite, Eve Borsook, Peggy Haines, and Joseph Connors for always asking the most penetrating questions; to Jim Saslow for many questions answered, especially about Michelangelo's poetry; to Paul and Ruth Barolsky, Ralph Lieberman, Maria Ruvoldt, and Deborah

Parker for years of conversation regarding everything Michelangelo and Michelangelesque; to Sarah McHam for first permitting me to write an essay employing a fictionalized voice; to Eric Denker and Meredith Gill, Livio Pestilli and Wendy Imperial, Jack Freiberg and Franco Di Fazio, Michael Rocke, Andrew McCormick, and Nelda Ferace for sharing Michelangelo in Italy and always eating well afterward, and to Judith Martin for my title. Four persons deserve special thanks: Roger Crum for his attentive labor on the entire manuscript, Eric Denker for being my longest-standing friend—art historical and otherwise, Elizabeth Fagan for being my wife, companion, and invaluable editor of forty-five years, and Paul Barolsky, to whom I warmly dedicate this book.

Of particular value was the fall 2014 spent at Villa I Tatti as a visiting senior professor. I am especially grateful to the then director Lino Pertile and to Anna Bensted for extending to me their generous and supremely gracious hospitality. Thanks to them and a wonderful group of fellows that included Lucio Biasiori, Francesco Borghese, Dario Brancato, Gregorio Escobar, the late Cyril Gerbron, Jessica Goethals, Caitlin Henningsen, Joost Keizer, Rebecca Long, Francesco Lucioli, Lia Markey, Laura Moretti, Alessandro Polcri, Sean Roberts, Sarah Ross, Paola Ugolini, and Susan Weiss, I was stimulated to write large portions of the current manuscript. Needless to say—but it is well worth saying nonetheless—members of the staff and the I Tatti "family" were equally instrumental in offering the ideal conditions in which to ruminate about growing old—a luxury Michelangelo never enjoyed. My thanks are extended especially to Allen Grieco, Jonathan Nelson, and Michael Rocke.

Over the years I have been blessed with wonderful friends and colleagues and a few exceptional students who have done much to shape my views of Michelangelo. The following have all contributed in small or larger ways to the present book. My gratitude is *not* adequately expressed in the following impersonal alphabetical listing: James Anno, Simonetta Brandolini d'Adda, Bernadine Barnes, Cammy Brothers, Caroline Bruzelius, Jill Carrington, Silvia Catitti, Joseph Connors, Bill Cook, the late Roy Eriksen, Emily Fenichel, Meredith

Gill, Marcia Hall, Emily Hanson, Eric Hupe, Paul Joannides, Nathaniel Jones, Stephanie Kaplan, Ross King, Margaret Kuntz, Tom Martin, the late Jerry McAdams, Erin Sutherland Minter, Renée Mulcahy, Mike Orlofsky, John Paoletti, Deborah Parker, Gary Radke, Sheryl Reiss, Andrea Rizzi, Charles Robertson, Patricia Rubin, Carl Smith, Tammy Smithers, and last but not least (since I am sensitive to alphabetical discrimination), Shelley Zuraw. I would also like to extend thanks to Sarah Braver, Hannah Wier, Hua Zhao, and Betha Whitlow for their assistance with the book's illustrations.

It is an honor and privilege to publish a book with a former student, now editor and colleague, Michelle Komie.

MICHELANGELO,
GOD'S ARCHITECT

INTRODUCTION

For a half year in Rome, I looked from my window on the dome of St. Peter's, the dome that Michelangelo di Lodovico Buonarroti Simoni (1475–1564) designed but never actually saw. The fact that Michelangelo remained committed to building this crowning feature of St. Peter's Basilica in Vatican City for seventeen years with no hope of finishing the task made writing this book seem simple by comparison.

In the fifteen years between writing a monograph, *Michelangelo at San Lorenzo: The Genius as Entrepreneur* (1994), and a biography, *Michelangelo: The Artist, the Man, and His Times* (2010), I became increasingly aware of how much the story of the artist's heroic rise to fame had deflected attention from his very different but no less enterprising later life. Resisting the attraction of that well-rehearsed narrative, this book examines the final two decades of Michelangelo's career, from the installation of the tomb of Pope Julius II in Rome's San Pietro in Vincoli in 1545 to his death in 1564—that is, from age seventy to a few weeks shy of his eighty-ninth birthday. Notably, while this period represents fully one-fifth of the artist's long life and constitutes nearly a quarter of his approximately seventy-five-year artistic career, it remains the least familiar segment of the artist's biography.

I examine Michelangelo's life and works from the perspective of his ever-advancing age—his seventies and eighties—with a focus on what the artist chose to accomplish in his final years. This study is not as

much an investigation of "late style" (in the manner of Titian, Rembrandt, Goya, or Beethoven) as it is a probing into a late life: how Michelangelo lived and worked in the face of recurring setbacks and personal loss, advancing age, and the constant expectation of his own death. The artist's aspirations to future fame and glory, his concern with family status, and his interventions in shaping his biography and legacy are all informed by this ever-present specter of death. But Michelangelo did not retreat from the world in the medieval tradition of the *ars moriendi*, with its preoccupation with a "good death"; rather, he became more productive than ever. Most importantly, despite the repeated efforts of others to lure him back to Florence, Michelangelo never abandoned his commitment to St. Peter's in Rome. Indeed, the artist firmly believed that he "was put there by God," and he vowed never to abandon the project. Dutifully, he worked at St. Peter's for a succession of five popes, but he toiled above all for God and for his own salvation. He accepted the burden of being God's architect.

The Artist in His Seventies and Eighties

The overarching themes of Michelangelo's late life are significantly different from those of his earlier career, which was characterized by the artist's remarkable productivity and spectacular rise to fame, manifested in a series of astonishing creations: *Bacchus*, the Rome *Pietà*, and *David*, the Medici Chapel and the Laurentian Library in Florence, and the frescoes in the Sistine Chapel. Michelangelo was no less active as he approached the end of his life, but he worked in a substantially different manner. With the elderly Michelangelo, we are no longer dealing with an artist who insisted on doing everything himself or who, as he did at the church of San Lorenzo in Florence, directed assistants with near-obsessive attention to detail.[1]

In another contrast to his earlier career, there is a notable absence in his later work of paintings and sculptures made for the public sphere. After installing the tomb of Pope Julius II, in 1545, and still with nearly two decades to live, Michelangelo completed no more sculptures. He carved the Florentine *Pietà* as his own grave memorial,

but gave it away damaged and unfinished. He worked on the Rondanini *Pietà* until several days before his death, but the sculpture remained radically incomplete. He lived with these unfinished sculptures in his house—as he previously had lived with the *Moses*—for nearly two decades. There, they served as *memento mori*, perpetually reminding the artist of his impending death and, more poignantly, of a life littered with unfinished and abandoned work.

Michelangelo's final years were largely devoted to architecture. Between 1545 and his death, in 1564, he was associated with more than a dozen architectural projects and was principally responsible for half of them, including, all in Rome, the Capitoline Hill (or Campidoglio), the Farnese Palace, Santa Maria degli Angeli e dei Martiri, the Porta Pia, the Sforza Chapel in Santa Maria Maggiore, the never realized plan for a new church of San Giovanni dei Fiorentini, and, most important of all, New St. Peter's. At the time of his death, however, not a single one of these projects was anywhere near completion. Strikingly, Michelangelo's two monumental frescoes in the Vatican's Pauline Chapel, completed in 1550, when he was seventy-five, were the last works the artist ever finished. We are faced with the seeming paradox of an aged artist who, despite a plethora of incomplete undertakings, never wavered in his devotion to work, whose power of expression never waned, and who continued to exercise a tremendous influence on the art and architecture of his time.

How do we assess Michelangelo's final accomplishments, given that they are substantially different from the achievements of his earlier career? How do we account for the artist's stature and prestige given the absence of completed work? Most importantly, how do we understand Michelangelo's art in light of his growing preoccupation with death, sin, and salvation?

Michelangelo's "late life" begins in 1545, when he turned seventy years of age. Although old, the artist had ample reason to be content. With the installation of the tomb of Pope Julius II, Michelangelo had just completed one of his most important commissions and his final work of public sculpture. He was already well beyond the age of normal life expectancy, yet he was about to embark on a wholly new, and

arguably the most significant, phase of his career. For the next seventeen years, Michelangelo devoted himself to God and St. Peter's.

The Materiality of Art

In a review of Herbert von Einem's monograph on Michelangelo, John Pope-Hennessy noted that "never, or scarcely ever, do modern scholars look at Michelangelo's works and ask themselves how they came into being and why."[2] One of the principal emphases of my writing about Michelangelo for more than thirty years has been to address this lacuna. I continue to be fascinated with the difficulty of making art, the arduousness of carving marble, the challenge of transporting and lifting heavy objects, the tedious necessity of erecting scaffolding, and the quotidian preoccupation with the mechanics, detail, and complexity of building. In the face of these difficulties, Renaissance artists, with Michelangelo chief among them, created some of the most sublime works the world has ever seen. There is enough evidence to suppose that Michelangelo mused on the evident incongruity of fashioning sublime works of art from mundane material and toilsome labor. This book is about a final paradox in Michelangelo's long life, when the aged artist desired spiritual salvation yet was mired in the incessant materiality and minutiae of his craft.

Art is first and foremost about stuff, the materials from which it is made and the means by which it is fabricated. Artists know materials, their nature, source, availability, quality, durability, beauty, and cost. Art is about obtaining materials, moving them, working them, and moving them again. In the Renaissance, and still today, lifting a five-ton sculpture is a difficult, costly, and dangerous task. Architecture in particular requires an inordinate amount of labor and time. But Michelangelo had little time, even as a young man and ever less as he advanced into old age. He was seventy-one when he took over as architect of St. Peter's. From the beginning, Michelangelo knew that a building of that scale would take much longer than the number of years he had remaining on this earth. As it turned out, Michelangelo was able to devote only seventeen years to the enormous project, which required 150

years to complete, from its beginning with Donato Bramante in 1505 to its acknowledged completion under Gianlorenzo Bernini in the mid-seventeenth century. While long predating Michelangelo's tenure and still under construction well after his death, St. Peter's is arguably the artist's greatest accomplishment. I wish to tell that story.

The reader might accuse me of resorting occasionally to a fictionalized voice or what the writer Michael Orlofsky has termed "historiografiction."[3] This tendency is something of a current trend (dubbed "narrative truth"), even among serious scholars of history.[4] Michelangelo is the best-documented artist of the entire Renaissance. Leonardo da Vinci may have left a greater number of drawn and written pages, but Michelangelo left much more information about his personal and professional life. Thanks to his extensive familial and professional correspondence, his voluminous business and financial records, and the masses of documentary notices by friends, associates, and contemporaries, not to mention three biographies written in his lifetime—two of which Michelangelo himself read and helped to shape— the artist is unmatched as a biographical subject. Certainly there is little reason to fictionalize when one can garner so much from the documents we have. Yet, one still needs to rationally glean much by reading between the lines and often to reconstruct what is missing. Given the immense quantity of primary and secondary documentation, I would argue that I am filling in some missing gaps rather than fictionalizing my subject. In part, I do this by reading both sides of Michelangelo's correspondence, even if one side is missing. And I read both central and peripheral source materials, since they so richly evoke the world and society of Renaissance Italy. In addition, by observing engineers, masons and carpenters, marble sculptors and quarry workers, the construction of scaffolding, the repair of old structures, and even the laying of paving stones, I have learned about continuities in the building industry from ancient to modern times. Even if there is more mechanization in our modern world, manual labor, tools, and construction sites remain similar, and builders still face challenges comparable to those of Renaissance architects. This is some of the "research" that informs my reading of the extensive documentary rec-

ord left by Michelangelo and his contemporaries. In the words of the historian John Elliott, the writing of good history is "the ability to enter imaginatively into the life of a society remote in time and place, and produce a plausible explanation of why its inhabitants thought and behaved as they did."[5] And further, I am in sympathy with the biographer Richard Holmes, who, faced with "an astonishing lack of solid evidence," concluded his compelling portrait of Samuel Johnson and Richard Savage by writing, "I have given the evidence as I have found it, and allowed the story to create its own emotional and artistic logic."[6]

There is one additional factor that possibly inflects my writing. I was born on July 30, which also is the birthday of Giorgio Vasari, Michelangelo's greatest biographer and one who precedes me in creatively fashioning his subject's life. And just as Michelangelo found much to correct in Vasari's life of the artist, so too, I am certain, would he find much to criticize in my account. I anticipate that a few critics may accuse me of writing a Vasarian-style account of Michelangelo. Given that we increasingly recognize Vasari to be a great literary writer, I will be happy to be so accused and happier still to be as widely read.

Note to the reader:

We benefit from a long and distinguished tradition of translation of Michelangelo's sometimes difficult Italian. In my discussion of the artist's correspondence and poetry, I have utilized whichever translation I felt best captured the sense in that particular communication or cultural expression. Unacknowledged translations of the correspondence and poetry are my own.

MOSES

It was time to move Moses. Michelangelo was seventy. Of course, Moses was much older, but the artist sometimes felt as old as the patriarch; after all, he had become a patriarch of art.

The marble *Moses* (see plate 1) sat in Michelangelo's spacious workshop in Via Macel de' Corvi, a location that also served as his Roman residence (see plate 2). The two-story dwelling stood adjacent to the ancient forum of Trajan and close to the unfinished church of Santa Maria di Loreto. On the ground floor were two large rooms used as work studios. In addition, there was a pantry, below which was a small cellar where Michelangelo stored wine and the special mineral water he drank to break up the painful kidney stones that occasionally plagued him.

Upstairs one reached two large bedrooms, the master's sitting room, and a small servant's room, both sparsely furnished. In Michelangelo's room was a well-constructed metal bed with a straw bed box, three mattresses, and two coverlets of white wool and one of white lambskin. A large credenza stored the master's household linens and clothes, which included a long fur coat of wolf skin, two lined black mantles of fine Florentine wool, a lamb's-wool tunic, also dyed black, a rose-colored undershirt with a rose silk border, two black Persian hats, and more undershirts, stockings, old shirts and new shirts, handkerchiefs,

and a pair of slippers—all made in Florence. The same credenza held hand and face towels, extra sheets, and tablecloths. On a large table sat a walnut coffer filled with letters and drawings and a locked strongbox containing a substantial sum of money. Behind the house, a kitchen with a loggia and a small forge opened onto a vegetable garden and small vineyard with a few fruit trees, where some hens, a "triumphing" rooster, and a "lamenting" cat made their home. Toward the rear of the property stood a ramshackle shed and a small stable that housed Michelangelo's chestnut nag.[1]

The locals referred to the street as the *macel de' corvi* (slaughterhouse of the crows) because of the bustling market where one could purchase such common birds as pigeons and thrushes but also more expensive pheasants and capons. The nearby butchers (*macellai*) sold horsemeat, stringy dried goat, and when times were lean, all manner of dogs, cats, and even rodents. On the same street lived the pork butcher and a greengrocer, whose daughter, Vincenza, Michelangelo employed as a household servant, but only briefly, because one day her unruly brother appeared at the house and dragged her away.[2] Did the foolish youth think that working for an artist was less dignified than chopping fish heads, cleaning offal, or washing cabbages?

The muddy, unpaved streets of the neighborhood teemed with life, noise, and unpleasant smells. Michelangelo once described finding mounds of dung around his door, as if nobody who ate grapes or took laxatives ever found anywhere else to shit. "Dead cats, carrion, filth and slop are my constant companions," he wrote.[3]

Rome's population—still smaller than that of Michelangelo's native Florence—huddled in the bend of the Tiber River, the principal source of drinking water, washing, and waste disposal. Michelangelo lived far from the river, at the ragged edge of Rome's more populous center. His was *not* a dignified address, but it was a spacious, utilitarian property where he had lived and worked for some three decades, ever since the death of Pope Julius II in 1513.

Michelangelo had begun the *Moses* in a different location—in a workshop that stood alongside the medieval church of Santa Caterina, near Old St. Peter's. When Michelangelo moved to the larger property

in Via Macel de' Corvi, he also moved more than fifty uncarved and partially carved blocks of marble to his new home. A few astonished persons stood gaping as *Moses*, peering over the side of a rude cart, slowly rolled through the streets of Rome—from St. Peter's Square to the Castel Sant'Angelo bridge, along the Via del Pellegrino (Via Peregrinorum) to the prophet's new home near Trajan's Forum. And there the *Moses* sat for another three decades.

Michelangelo lived with *Moses*; the two grew old together. Every morning the artist woke up with *Moses*. Every time he returned home, he was confronted by the same imposing figure. To live with *Moses* could be unnerving. The figure's fiercely accusatory stare perpetually reminded Michelangelo that the tomb of Pope Julius II was still unfinished, twenty, thirty, and then nearly forty years after it had been commissioned. Legend has it that the artist—frustrated by the sculpture's stubborn silence—once demanded: "Why don't you speak?" (*Perché non parli?*).[4] Whether he actually barked at the sculpture is uncertain, but there can be little doubt that he occasionally picked up his hammer and chisels to make an alteration. The artist was always revising his ideas and was rarely satisfied. Indeed, there is good evidence that Michelangelo changed the position of the *Moses*'s left leg, and he may have changed as well the direction of the prophet's powerful gaze.[5]

Now it was time to move the *Moses*. For reasons that even Michelangelo could not entirely understand, the final destination for the figure would not be St. Peter's in the Vatican, as originally intended, but St. Peter in Chains (San Pietro in Vincoli), the titular church of Pope Julius. The changed location did not lessen the difficulty of moving the sculpture. On an overcast January day in 1545, Michelangelo wrote: "I believe that on Thursday I will give the order to drag the figure to San Pietro in Vincoli."[6] The verb *tirar*, "to pull," but really "to drag," was well chosen, for the *Moses* was, after the *David*, the largest marble he had ever carved.[7]

Trajan's Column stood less than a hundred steps from Michelangelo's house. Constructed in the second century CE, the column is formed of twenty stacked drums, each behemoth weighing thirty-two tons. To lift a thirty-two-ton marble drum to the top of the almost

finished column was an engineering feat worthy of a Roman emperor, but it was well beyond the capacity of any Renaissance builder. Although Michelangelo had already accomplished astonishing feats—carving the Rome *Pietà* and the *David* and painting the Sistine Chapel—he nonetheless remained in awe of Roman engineering. Of course, the *Moses* weighed much less than a single drum of Trajan's Column, but this did not lessen the challenge of moving the sculpture. There is no avoiding the tyranny of weight.

The gigantic blocks that formed the base of Trajan's Column served as convenient support to a swarm of lean-to dwellings that huddled close to the ancient monument. On one side opened a deep excavation pit left over from a brief enthusiasm to explore Rome's ancient past. In the 1550s, Michelangelo would be responsible for expanding that excavation, thereby revealing magnificent ancient reliefs around the column base (see plate 3). But now Michelangelo was less interested in the site's archaeology than its potential as a loading platform.

The previous week, workmen graded the downward slope of the earthen depression and paved it with marble debris (there was no lack of marble detritus around Trajan's Forum). The flat bed of a cart, once backed down the ramp, was approximately level with the surrounding ground. Michelangelo enlisted a half dozen burly locals to roll the *Moses* on smooth round logs from his studio to the waiting cart. The operation drew the attention of a claque of gawking spectators and elicited plenty of useless advice. After all, how often do butchers of pigs and crows see an eight-foot marble prophet roll through their neighborhood?

Once the cart was loaded and secured, the carter beat and screamed his smelly oxen into lumbering action. With a stomach-churning lurch, the cart was on the move. Michelangelo watched as *Moses* suffered the indignity of being jolted along a rutted track that crossed the cow pasture (*campo vaccino*) in the direction of the Colosseum. An hour later, near the basilica of Santa Maria Nova, the heavy load got mired in soft muck, causing the statue to tilt alarmingly. In danger of having *Moses* indecorously deposited in the Roman Forum, Michelangelo once again conscripted some neighborhood toughs to right the listing cart.

An overgrown track skirted the left side of the Colosseum, turned, and gradually climbed the Esquiline escarpment. Below the imposing ruins that crowned the hill, the carter paused to water and feed his belching oxen. Being dumb but social animals, they pissed and shat in unison. The area was known to be a haven for thieves, but even they would have little interest in robbing a marble statue. The carter hitched an extra pair of oxen to the team for the slow, final climb to the flat piazza that fronted San Pietro in Vincoli. Somehow it seemed fitting that the number of beasts was twelve—the same number as the tribes of Israel that accompanied their prophet to the Holy Land. Such a lofty thought, however, did not occur to the ignorant carter, who cared only about his pay. Never before having transported such an unusual load, he imagined the stories he could tell about how he had carried *Moses* "to the mountain." But first, upon completing the task, he thought it best to repair to a nearby tavern and get thoroughly drunk.

A light rain began to fall. The wet, partly wrapped, and less than majestic *Moses* was deposited in the middle of the piazza. Spectators watched as the sculpture was maneuvered from the cart onto log rollers before being dragged into the church. The curious few were soon joined by a growing crowd of Jews who had come to see "their" prophet. Later described as "flocks of starlings," the Jews acted just like those skittish birds, as they fluttered, murmured, and quailed before *Moses's* ferocious countenance.[8] It was easy for them to ignore the Hebrew prohibition against idol worship, since they evidently did not believe this to be a graven image but the actual flesh-and-blood prophet. Their attempts to approach the statue were violently repulsed by Christian bystanders who feared the Jews' polluting touch. The heathens were allowed to look, but they were not permitted to touch, much less follow *Moses* into the holy sanctuary of the church.

With mixed emotions, Michelangelo relinquished his masterpiece to the public: the curious, the miserable poor, the uncomprehending sinners, even the heretical yet awestruck Jews. Would Pope Julius II— now dead longer than Christ had lived—appreciate the artist's efforts? One could not help but reflect on Moses wandering in the wilderness

for forty years, for that was how long it had taken for Michelangelo's statue to arrive at its final resting place.

Michelangelo and Julius: Grand Ambition

Some forty years earlier, in late February 1505, Michelangelo was first called to Rome. His Florentine friend Giuliano da Sangallo and the banker Alamanno Salviati had recommended the artist to Pope Julius II (1443–1513; r. 1503–13). Although the papal summons induced Michelangelo to abandon his current obligation to carve the *Twelve Apostles* for Santa Maria del Fiore, the Florentine cathedral, and a commission to paint the monumental *Battle of Cascina* fresco for the city government, this was not an opportunity to miss. The election of the energetic Pope Julius in 1503, following the corrupt regime of Alexander VI (r. 1492–1503) and the short-lived pontificate of Pius III (r. 1503), began an era of a resurgent papacy. Julius had ambitions of once again making Rome an imperial city.

In the early months of 1505, Michelangelo was "continuously" at the house of Giuliano da Sangallo (c. 1443–1516), who in addition to being a friend and mentor, was also the papal architect.[9] Sangallo, whom Michelangelo knew from Florence and the household of Lorenzo de' Medici (1449–1492), was thirty years older than his protégé. An accomplished architect and engineer, Sangallo had designed the hoist and rolling cart used to move Michelangelo's *David* from the Florentine cathedral to the Piazza della Signoria in 1504. He was a genial man with broad open features and thin, straggly hair. Sangallo introduced Michelangelo to Rome; they visited ancient ruins, and the younger man watched as the more experienced architect forged a renewed classical language from antiquity's debris. Michelangelo learned to make sense of architectural fragments: the order and sequence of moldings, the infinite variety of decorative details, the crisp beauty of carved marble ornament. Following Sangallo's example, Michelangelo made drawings of ancient buildings, partly on-site but also by copying the drawings of others. And, thanks to Sangallo, he was introduced to the pontiff.

No part of Michelangelo's biography is more fraught with fiction than the artist's relationship with Pope Julius II, in part thanks to the indelible image of Charlton Heston arguing with Rex Harrison in the Hollywood epic *The Agony and the Ecstasy*. Michelangelo was thirty years old and short in stature but giant in ambition. Like many sculptors, he was strong, of compact frame, and revealed the signs of his physically demanding profession, especially in his thick arms, gnarled hands, and wiry muscles. Pope Julius, more than thirty years Michelangelo's senior, was known as the warrior pope because he personally led the papal troops in battle. Raphael portrayed him in the Vatican *stanze* as a rugged and commanding figure; before the altar of God, Julius appears more demanding than supplicating. Julius was headstrong, had a fierce temper, and brooked no opposition. Contemporaries applied the word *terribilità*—frightful, even dreadful—to both of these strong-willed and oftentimes difficult individuals. In whatever manner we envisage their near-mythic encounter and tumultuous relationship, we should acknowledge that the two men fundamentally altered the traditional relations between patron and artist.

They talked and understood one another. Julius wished for a tomb design, and Michelangelo made him a drawing or several. But there was no contract. Money was a matter of trust not terms. It is frankly astonishing to realize that there was no formal agreement. Contracts would come later, after the death of the pope. In contrast, during the Julian years, Michelangelo and the pope came to a verbal understanding without a fixed design, contract, or firm deadline and with no clear budget. Together they imagined not merely an imposing work of art but the eighth wonder of the world.[10]

In July 1505, Michelangelo departed Rome for Carrara to locate marble for the giant tomb. He stayed on through the hot summer months and the cool fall weather. In total, Michelangelo remained in the Carrara mountains for at least six months, searching for marble, wresting blocks from their geologic slumber, increasingly in the grip of a grandiose vision. He envisioned a tomb three stories tall, with forty life-size figures, and also niches, entablatures, grotesque ornament, and

even bronze reliefs. It would take years to complete. Forty years! There, among the sublime peaks of the Apuan Alps, Michelangelo's imagination soared, his ambitions grew. As he looked at the scarred mountain face, he was inspired to carve a colossus, using the entire mountain as his raw material. "And he certainly would have done it," his biographer Ascanio Condivi confidently asserts, "if he had had enough time."[11] Michelangelo later commented that "a madness . . . came over me, but if I could have been sure of living four times longer than I lived, I would have taken it on."[12]

That was how the great monument began. It did indeed take forty years, but the result was significantly different from what Michelangelo and Julius first imagined in those heady days of 1505. Different but still grand.

The artist of 1505, who in his youthful hubris wanted to carve an entire mountain of marble, was very different from the deeply spiritual individual who, in his late sixties, finally completed the tomb. To appreciate fully the artist and the pope he honored with this monument, we should recognize how much Michelangelo and his art had matured in the intervening years.

Over forty years, the artist generated multiple designs for the Julius tomb, agreed to various contracts, and quarried and transported more than a hundred marble blocks, among which were several dozen intended for figures. He began carving many of them, first in Rome and then, after Julius's death, also in Florence. Every single one was a male figure. When he agreed to the final tomb design in 1542, he rejected more than a half dozen partially carved male figures, including the *Dying Slave* and the *Rebellious Slave*, now in the Louvre Museum, and the four bound prisoners now in the Accademia Gallery in Florence. Among the many sculptures he carved for the tomb, *Moses* is the only figure he retained for the final version. Instead of all those male figures, two important female figures joined the ensemble. It was a radically different monument.

The drawn-out history of the Julius tomb can be stated as an axiom: the frequency of contracts is in inverse relation to work actually accomplished. The more the heirs of Pope Julius tried to exercise control,

the less Michelangelo obliged them. Following the unveiling of the *Last Judgment* in the Sistine Chapel in 1541, the heirs again agitated for completion of the tomb.[13] In March 1542, Guidobaldo II della Rovere (1514–1574), the current Julian executor, learned that Pope Paul wished Michelangelo to paint the Pauline Chapel, in the Vatican. Conceding this preemptive obligation, Guidobaldo suggested that he would be content with just three statues from Michelangelo's hand, including the already carved *Moses*.[14] Guidobaldo offered the artist a highly favorable new contract, the fourth and final one, in August 1542.

After multiple contracts and innumerable delays, the tomb was finished in 1545, under the aegis of Guidobaldo della Rovere. In contrast to the previous and less sensitive Della Rovere representatives in the Julius tomb saga, Guidobaldo treated Michelangelo with tact, patience, and generosity. By this point in his career, Michelangelo elected to work only for persons he esteemed. Everyone else was either refused— usually with claims of old age and prior obligation—or had to be satisfied with vague promises. Guidobaldo, therefore, deserves some credit for the tomb's completion, just as his predecessors are partly culpable for its delay.

Michelangelo responded gratefully to Guidobaldo's generosity. In the comparatively short span of two years, Michelangelo not only assembled the entire tomb, but carved two entirely new figures: *Rachel* and *Leah*. The accomplishment is especially impressive given that the artist was then approaching seventy years of age, had fallen deathly ill in 1544, and had suffered a long convalescence that had temporarily prevented him from carving marble. Moreover, he supposedly was still working on the Pauline Chapel frescoes, which he had begun in 1542.

In relating the long, tortuous history of the Julius tomb, Michelangelo's biographer, pupil, and amanuensis, Ascanio Condivi (1525–1574), resorted to calling it a "tragedy." Surely he was characterizing Michelangelo's frustrations, including the artist's complaint that "I lost the whole of my youth, chained to this Tomb."[15] Condivi may have been lamenting, as many persons have since, that the tomb is a much reduced version of the artist's original, more grandiose conception. In

the end, the artist devoted enormous energy to creating one of the grandest and most noble funerary ensembles of the Renaissance. "It is yet the most impressive to be found in Rome and perhaps anywhere else," conceded the otherwise disappointed Condivi.[16] The biographer's claim is confirmed daily by the number of persons who "flock like starlings" to visit San Pietro in Vincoli.

Innovative Architecture

To complete the Julius tomb, Michelangelo once again faced the challenge of redesigning—after numerous previous iterations—its architecture. The lower story had been carved mostly in the early years of the tomb's history, and this shows, both in scale and style. In 1513, Michelangelo had contracted with a skilled craftsman, Antonio da Pontesieve, to carve the tomb's architecture and ornament.[17] Antonio adorned many smallish blocks with dense foliate and grotesque decoration in the prevailing manner of Roman tombs of the late fifteenth century, especially those produced in the prolific workshop of Andrea Bregno. Full of fascinating details, Antonio's decorative carving was certainly out of fashion by the 1540s.

Just as he rejected his own previously carved figures as no longer appropriate for a modified tomb design, so Michelangelo could have rejected the lower-story architecture. Instead, he used the finished elements to advantage. He raised the entire tomb by almost two feet on a plinth constructed of thirteen blocks of "old marble" taken from an ancient ruin on the Capitoline Hill. He transported the repurposed blocks to San Pietro in Vincoli in June 1542 and then faced them with thin slabs of gray-streaked marble.[18] One hardly notices the new plinth, since it is formed of smoothly polished, undecorated marble, but the effect is transformative. Without the new plinth, the *Moses*, *Rachel*, and *Leah* would have stood near floor level and appeared small, rather than grand. What might have been a small-scale, fussy, and overly precious architectural backdrop now serves as an effective foil, or something like a patterned curtain that frames and contrasts with the powerful actors on a shallow stage (see plate 4).

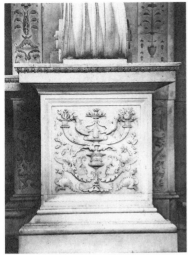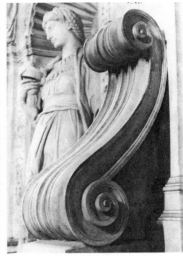

LEFT: Antonio da Pontesieve, Relief ornament, 1545, Tomb of Julius II,
San Pietro in Vincoli, Rome

RIGHT: Volute, 1545, Tomb of Julius II, San Pietro in Vincoli, Rome

In addition, four newly carved herms and four reversed volutes provide visual accents, weight, substance, and vertical emphases that counteract the surrounding and otherwise distracting low-relief carving. As in many previous Michelangelo experiments in architectural decoration (e.g., the San Lorenzo vestibule), the herms and volutes, while not serving as structural elements, create a lively, anthropomorphic architecture. The powerful, uncoiling volutes frame the figures and lure the eye upward.

In the upper story, Michelangelo made no effort to replicate or extend the now old-fashioned, Quattrocentesque decoration of the lower story. Rather, by purposefully designing an antithesis, he created a greatly enhanced, emphatically vertical ensemble. The architecture is Michelangelo's design and it was *not* an expedient means of completing the tomb. The upper story required a lot of new marble. Michelangelo designed it and supervised its carving.[19] As with the inclusion of *Rachel* and *Leah*, these were the artist's choices, made in his full artistic maturity.

In the much taller upper story, in contrast to the lower, one is not distracted by ornament nor does one linger long over any individual element. The tapered, piston-like piers are inventively strange. They belong to a fascinating series of similar architectural experiments, such as the tapering windows that Michelangelo designed for the Medici Chapel in Florence and the Sforza Chapel in Rome. The attenuated, less decorated upper story encourages one's eyes to rise heavenward. In the uppermost regions, architecture begins to dissolve: four rectangular windows puncture the tomb's solidity, and the cornice is severely fractured, with emphatically advancing and retreating entablature segments that create a myriad of sharply protruding and reentrant angles. Four tall candelabra on the cornice and the anthropomorphic coat of arms all contribute to the swift dissolution of architecture into something less substantial: architecture gradually transforming into sculpture before dissolving into air.

Michelangelo placed the entire tomb under an open arch and pierced the upper story with four large openings from which issue the heavenly voices of a choir, heard yet unseen. Precisely as one might expect in the presence of a successful tomb monument, we are transported from the busy detail of the earthly realm to the ethereal abstraction of heaven, from the living to the life hereafter. Francesco Borromini, a sensitive student of Michelangelo's innovative architecture, later accomplished a similar effect at Sant'Ivo della Sapienza in Rome. In Borromini's design, a powerful but mostly conventional architectural language of the lower story sweeps upward into tapering, diminishing, and increasingly less logical and ever-more sculptural forms in a swiftly rising, tall upper story. It is architecture that serves the spiritual by rising from the earthly to the heavenly realm, thanks, in part, to the presence of unseen choir voices.

Moses

The Julius tomb's drawn-out history and multiple design changes tend to mask an obvious but largely inexplicable alteration: *Moses* (see plate 1), once a secondary element in the tomb's composition, has become

the centerpiece of the entire ensemble. Indeed, the figure so dominates our attention that few take cognizance of the recumbent figure of Julius. It is *Moses* that draws thousands of visitors, including the psychoanalyst Sigmund Freud, who stood before it, mesmerized, every day for three weeks in 1913. In the famous essay Freud finally wrote on the *Moses*, he described the angry prophet restraining himself from rising and hurling down the tablets of the Ten Commandments.[20] Not since Donatello's *Zuccone* (1423–25) had a Renaissance artist created a figure so brimming with startling vitality that we imagine it capable of moving and speaking.

Even seated, *Moses* is taller than a standing person; the immensity of the figure is both real and implied. He gazes sideways, as though addressing God. His is a face that, having beheld divinity, is more than human and thus not for mere mortals to look upon. Piercing eyes, rippling facial muscles, tempestuous hair, and stubby horns (standing in for beams of light that radiated from Moses when he descended Mount Sinai) all contribute to the transfiguring power of *Moses*'s expression. Exaggeratedly long fingers of his right hand pull at thick strands of his weighty beard. This is one of those unconscious gestures that one sees repeatedly in Michelangelo's art, subconscious thought animating unconscious, nervous movement. A loose sleeveless tunic, a tour de force of marble carving, simultaneously clothes and decorously reveals the figure's muscular build. Meanwhile, an inexplicable excess of drapery cascades over the knees, exposing the prophet's peculiar, loose-fitting leggings and sandals.

Michelangelo originally conceived *Moses* as one of four seated prophets that would adorn the corners of the second level of a freestanding monument. Taking into account this elevated location, Michelangelo carved the figure with an elongated torso, the disproportionate length of which is evident mainly from side views. Nonetheless, most visitors scarcely notice this anatomical distortion, since it is disguised by the muscular arms and the extravagant, cascading beard. As finally installed in San Pietro in Vincoli, *Moses* is placed on a low plinth and at the center of the entire ensemble. Indeed, so imposing is the sculpture that many visitors pay little heed to the tomb's other attractive

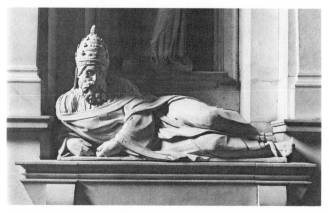

Michelangelo, *Julius II*, 1545, Tomb of Julius II, San Pietro in Vincoli, Rome

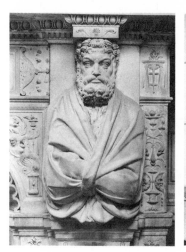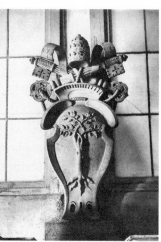

LEFT: Herm, 1545, Tomb of Julius II, San Pietro in Vincoli, Rome
RIGHT: Coat of arms of Pope Julius II, 1545, Tomb of Julius II,
San Pietro in Vincoli, Rome

elements, including the reclining effigy of the pope (seen approximately at the height originally intended for *Moses*), the unusual standing Madonna and child, the four glaring herms, the curiously anthropomorphic coat of arms, and an efflorescence of grotesque decoration. Also deserving our special attention—even if they are frequently criticized—are the female figures of *Rachel* and *Leah*.

Rachel *and* Leah

If one sets aside expectations based on Michelangelo's earlier career, it is easier to appreciate the beauty and quiet dignity of *Rachel* and *Leah* (see plates 5 and 6). In form and expression, these female figures were clearly conceived as a pair—two purposefully diminutive statues to flank and complement the prophet *Moses*. Exemplary figures of the Old Testament, the sisters Rachel and Leah represent Faith and Good Works or, as they were commonly allegorized, the Active Life and the Contemplative Life. In substituting these two figures for the earlier male prisoners or slaves, Michelangelo turned from a language of exaggerated physicality to one of spiritual yearning, from pagan to Christian allegory expressed in appropriately clothed feminine form. Unlike *Moses*, or any of the male prisoners that preceded them, these two figures encourage prayer and reflection.

Although he was to live another eighteen years, the *Rachel* and *Leah* are the last two sculptures that Michelangelo ever fully finished. Michelangelo *elected* to carve *these* two figures, and he placed them prominently on either side of the celebrated *Moses*, on what was then the most important tomb in Christendom.

The modesty of the size and expression of *Rachel* and *Leah*, well confined by the niches that enclose them, is remarkable given our tendency to think of Michelangelo's titanic forms as bursting the boundaries of their blocks. They are not slaves, not captives, not male, and they do not display the quality of *terribilità* expected of Michelangelo but rarely seen in his late life and work. To view *Rachel* and *Leah* as bland, however, is to fail to recognize Michelangelo's current sensibilities and his new corporeal vocabulary, which favored the spiritual over the earthly. The carnal body was of little interest to the seventy-year-old artist; it was, rather, a sinful burden. As in his late drawings and poetry, the artist pared his art to essentials. Whether with chisel, chalk, or verse, Michelangelo increasingly sought to express an inward spirit, Christian truths, and a profound but abstract yearning.

Dressed in robes suggestive of a nun's habit, *Rachel* clasps her hands and appeals to heaven. The drapery modestly clads yet reveals the subtle and multiple turns of her elongated, asymmetrically disposed

body. She rises ethereal and flame-like, in direct contrast to the solid, matronly aspect of earthbound *Leah*. The two females are themselves a subtle contrast in form, spirit, and expression.

Leah's more voluminous drapery and *contrapposto* stance give her the appearance of a classical goddess, and indeed, Michelangelo was inspired by a famous antique sculpture. We know of many works of ancient art that Michelangelo admired, such as the *Laocoön, Torso Belvedere, Apollo Belvedere, Marcus Aurelius*, and the monumental river gods that he moved to the Capitoline Hill—all male. Less known is that he greatly admired a statue of the goddess Juno in the collection of the Cesi family, which he praised as "the most beautiful thing there is in all of Rome."[21] The *Cesi Juno* is a large, imposing figure, yet Michelangelo extracted her feminine aspect in creating *Leah*. Ultimately, the comparison with the *Cesi Juno* reveals just how much and how little Michelangelo owed to the ancient model. The artist transformed the famous antiquity into a modern figure, no longer pagan and monumental but Christian and attractively demure.

The youthful maiden glances wistfully though unspecifically toward the mirror she holds in her right hand, perhaps reminding us that "Leah's eyes were weak" (Genesis 30:17). Her symmetrically parted, bound, and braided hair creates a natural diadem, the effect of which is heightened by the shell niche that enframes and accentuates her radiant pulchritude. One thick tress falls over her right shoulder and trails to her waist, there to be confused with the vertical folds of her drapery.

Leah's long, flowing garment is accentuated by an unusually ornamented bodice and collar, a tightly wrapped horizontal band that underscores her small breasts, and loose folds that loop down below her waist. An unnatural flourish of drapery draws attention to her abdomen, evoking her fertility and the six sons she bore Jacob. According to the Bible, Leah was not as comely as her sister, but she was favored by God. As though to express the beauty of her inner spirit, Michelangelo created one of the loveliest creatures of his entire oeuvre.

Michelangelo's biographer Ascanio Condivi tells us that in creating *Leah*, the artist was following Dante, who, in *Purgatorio*, conflates the

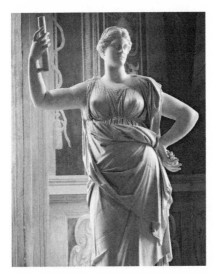

Cesi Juno, Roman copy of Hellenistic statue, Capitoline Museums, Rome

idea of the Active Life and the actual person of Matilda of Canossa, from whom Michelangelo claimed descent. Condivi, who is generally a prosaic biographer, surely reflects what Michelangelo had related to him. The artist, deeply indebted to Dante for his education and world-view, would have appreciated that his most important ancestor was a celebrated character in the *Divine Comedy*, and now was a figure adorning the most important funerary monument in Rome.[22]

The female figures of the Julius monument were not stipulated in any of the contracts Michelangelo signed with the pope's heirs as they sought to compel the artist to finish the project. Rather, the *Rachel* and *Leah* were Michelangelo's highly personal means of completing the tomb, which, after forty years, had become as much his legacy as it was that of Pope Julius II.

Tomb Installed

The Julius tomb was installed in the shallow right transept of San Pietro in Vincoli, without an altar, without candles, and therefore, without much light. Partially illuminated by an east-facing window,

the tomb receives weak morning light, but at most other times of the day, the transept and tomb are cast in gloomy shadow.

When Michelangelo brought *Moses* inside the church, he had to maneuver the figure around the many tomb slabs in the nave. Some were old and worn smooth; others were more recent. In the left aisle was the monument to the humanist theologian Nicholas of Cusa, carved by Andrea Bregno in the 1460s. Despite his early exposure to humanist learning, Michelangelo was less familiar with the cadaver than the carver. Nearby were a number of Della Rovere burials, including a cardinal who died on March 8, 1517—not so long before, except the name was already so worn as to be nearly illegible. Would Julius II, whose new tomb lacked an inscription, be as rapidly forgotten?

Just inside the church entrance, a monument with striking portraits honored two Florentine artists, the brothers Piero and Antonio Pollaiuolo. In 1498, both Antonio Pollaiuolo (c. 1432–1498) and a much younger Michelangelo had completed sculptures for Old St. Peter's. As proud as Michelangelo was of his early marble *Pietà*, most persons in the early sixteenth century would have paid more attention to Antonio Pollaiuolo's expensive bronze monument of Pope Sixtus IV. Now, nearly a half century later, Michelangelo had completed a tomb to memorialize Sixtus's nephew, Pope Julius II. The Julius tomb was magnificent, although it was made of marble, not bronze, and it was in San Pietro *in Vincoli*, not in San Pietro *in Vaticano*. For many years, Pollaiuolo's bronze monument to Sixtus was destined to remain more important—and more visited—than the marble monument to his nephew in the remote church of St. Peter in Chains.

It was now 1545, and the Della Rovere were far from the center of power. In fact, the family would never again produce a pope. The Della Rovere barely retained a presence in Rome, as their unimpressive descendants clung to minor fiefdoms in the remote Marche region. If one sought to pay homage to Julius II by visiting San Pietro in Vincoli, one would need to brave a large, sparsely populated and often dangerous expanse of Rome. The Colosseum hosted an undesirable tranche of humanity, mostly destitute poor, prostitutes, and criminals. The main draw of San Pietro in Vincoli was a relic: the chains that once bound

Antonio Pollaiuolo, Tomb of Pope Sixtus IV, 1493, St. Peter's Basilica, Vatican City, Rome

Peter in prison. But how many ignorant pilgrims praying before those rusting links would glance toward Julius's tomb?[23] How could Michelangelo not reflect on the transience of life and inadequacy of monuments to preserve memory?

Having installed the tomb, Michelangelo stood gazing down the nave of the church. San Pietro in Vincoli has twenty matching marble columns—*imezio* marble from Greece—softly tinted, grayish white, similar to certain Carrara marbles prized by the artist. Not only are the columns a perfectly matched set, but each is a monolith, its shaft a single block of marble about ten *braccia* (almost twenty feet) high. Nearly thirty years earlier, Michelangelo had planned to adorn the facade of San Lorenzo in Florence with twelve such magnificent columns. To this end the artist devoted a herculean effort to locate, quarry, and transport the giant blocks, only to see the commission cancelled in 1520. It was the greatest disappointment of his life.

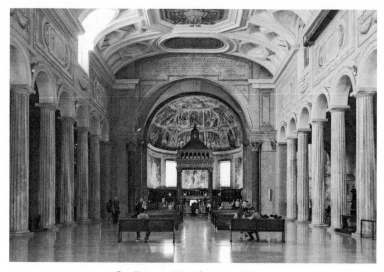
San Pietro in Vincoli, interior, Rome

Here were twenty perfectly matched monoliths, each approximately the size and the equal in beauty of those Michelangelo had imagined for the facade of San Lorenzo. Yes, the ancients had done the hard work of quarrying and transporting these particular columns. And yes, Michelangelo knew that Christian builders had purloined the columns from a nearby Roman temple here on the Esquiline Hill. Someone in the late Middle Ages had desired to build a church here. Someone who recognized the beauty of those columns managed to remove them from a dilapidated pagan temple and erect them here without breaking them. Who was that architect? Engineer or magus? Michelangelo could only marvel, since before him was the very thing that he had hoped to accomplish at San Lorenzo. While contemporaries celebrated Michelangelo's varied accomplishments, *he* was inevitably haunted by his failures.

The window to the left of the tomb was washed. From top to bottom, the tomb was brushed and wiped clean of construction dust and de-

bris. The scaffold was taken down, one level at a time: vertical posts, cross bracing, wood planks, ladders, rope, pulleys, iron rings and nails, a few miscellaneous tools, and plenty of other refuse—all removed. The floor was swept and washed. Thanks were extended to the priest, and a few copper coins given to the perpetually grumpy sacristan. The day laborers were dismissed. The tomb was finally ready.

In the failing light of this last long day, Michelangelo must have wondered whether he would ever return to the church. Together Pope Julius II and Michelangelo had envisioned a grand mausoleum on the scale of something from ancient times. Did it bother the artist that the tomb erected in San Pietro in Vincoli was significantly different from what he had first conceived? After four decades and innumerable delays, Michelangelo finally had created a decorous and moving monument—grand rather than grandiose, inspired more by Christian sentiment than pagan ambition.

Michelangelo was seventy years old. Four years previously he had completed the *Last Judgment* on the altar wall of the Sistine Chapel. His greatest burden—the tomb of Pope Julius II—had just been lifted from his shoulders. Other than completing the frescoes in the Pauline Chapel, Michelangelo, for the first time in his life, had no other work and little expectation for the future.

CHAPTER 2

FRIENDS AT SEVENTY
MATTER MORE

When Michelangelo turned seventy-one in March 1546, he had reason to feel content. The installation of the tomb of Pope Julius II had finally freed him of his most burdensome obligation. Like his literary hero Petrarch, Michelangelo recently had been made an honorary citizen of Rome. He was working for an enlightened patron in Pope Paul III (r. 1534–49); he delighted in a tight-knit circle of close friends; he had money to invest in property, and Lionardo Buonarroti (1522–1599), his nephew and heir, had initiated the search for a suitable bride, thereby promising the continuation of the Buonarroti line. Michelangelo was realizing his lifelong ambition to "raise up" his family.[1] He enjoyed the protection of the pontiff, the patronage of princes, and the admiration of nearly everyone. But the wheel of fortune soon turned.

Affliction began when Michelangelo's horse fell ill in late 1545. The horse, "which he loved," was a visible sign of prestige, since only the wealthiest persons could afford to own one.[2] Over the course of six months, the artist purchased an amazing array of medicines for the poor animal, including sugar tablets, cinnamon and cassia pills, licorice and lupine syrups, chicken broth, and much more.[3] The horse recovered, but much worse soon followed.

Luigi del Riccio

There was not a better, nor a more loyal friend than Luigi del Riccio (d. 1546). A Florentine living in Rome, Del Riccio worked as an agent for the Florentine financial magnate Roberto Strozzi (d. 1566). He resided in the Strozzi Palace on the Via dei Banchi in the Florentine quarter, near Ponte Sant'Angelo (also known as Canale di Ponte). Del Riccio and Michelangelo likely became acquainted, either in Florence or Rome, through their mutual ties to the Strozzi family. Both were much attached by friendship, professional association, and political sympathies to the circle of Florentine exiles who had fled Medici oppression and gathered in Rome in the 1530s, including Niccolò Ridolfi, Giovanni Salviati, Ippolito de' Medici, and the humanist writer Donato Giannotti.[4]

Michelangelo considered Del Riccio "a very great friend of mine." "Not since Bartolommeo Angelini died [in 1540], have I found anyone to look after my affairs who did so better or more devotedly than he."[5] Like Michelangelo's longtime Florentine friend Giovanfrancesco Fattucci and, more recently, Bartolommeo Angelini, Del Riccio handled many of Michelangelo's business, financial, and personal affairs. Once, during a tense negotiation with the heirs of Pope Julius II, Del Riccio defended the artist against accusations of fiscal mismanagement. Del Riccio sorted through a whole stack of documents relating to the Julius tomb and then promised to serve Michelangelo as "the lance of Achilles, that on one hand wounds, and on the other hand heals."[6] This was a reference to Dante's *Inferno* (31:4–6), for which the two friends shared a deep admiration. Del Riccio served as Michelangelo's faithful lance bearer.

Del Riccio's friendship and service extended well beyond supervising Michelangelo's tangled finances. He handled payments to Michelangelo's workers, negotiated some of Michelangelo's property investments, and even wrote letters on the artist's behalf.[7] Addressing him as "friend, or rather, honoured patron," Michelangelo once asked Del Riccio to properly thank Cardinal Federico Cesi for a gift: "I beg you, believing you to be a friend of his lordship's, to thank him in my name, when you conveniently can, with that formality which is as easy to you

as it is difficult to me."[8] Del Riccio even advised Michelangelo's nephew, Lionardo, about marriage prospects and investment opportunities.[9] "I am," he wrote to Lionardo, "all yours, as you know."[10] And when Michelangelo was in the final stages of finishing the tomb of Pope Julius II, the artist appealed to Del Riccio to help resolve a conflict between two overseers who were close to blows. At his wit's end over the escalating conflict, Michelangelo wrote to Luigi: "I beg you to get them to agree as best you can, because this would be an act of charity."[11] Del Riccio talked to both men and efficiently took care of the problem, thereby leaving Michelangelo free to work without the petty distractions of his warring underlings.[12]

During the winter of 1545, a fire damaged the roof of the Pauline Chapel and exposed Michelangelo's partially completed frescoes to the open air and wintry rains.[13] Because of the season, the artist was not working in the chapel, yet he worried about the chapel's neglect and the deleterious effect on his paintings. Again, he appealed to Del Riccio for help: "I have written to the pope about it . . . however, I beg you, perhaps you can speak to him, or to his chief steward Eurialo Silvestri, to whom I beg you to recommend me."[14] Since Michelangelo knew Luigi to be a stalwart supporter, he was always willing to follow his friend's sage advice: "Tomorrow after dinner I will come to your house, and do whatever you command me."[15]

Charity, tact, courtesy, solicitude, diplomacy, loyalty: all are aspects of Luigi del Riccio's warm relationship with the artist. Most importantly, he was a cherished friend and frequent companion. In Luigi's company, Michelangelo, a self-described melancholic, became uncommonly garrulous. When Del Riccio acted with natural but excessive politeness, Michelangelo urged greater familiarity: "Messer Luigi, dear friend—When I come to your house please would you treat me as I treat you when you come to mine. You let me come and be a nuisance to you, without telling me, so that I appear to be a presumptuous buffalo (*un bufolo prosuntuoso*) even in the eyes of the servants."[16] It is a striking glimpse of a self-deprecating and socially awkward Michelangelo dropping in to visit his friend without invitation or particular purpose. Likewise, Del Riccio sometimes would go consid-

erably out of his way to visit Michelangelo at his much more modest dwelling near Trajan's Forum. He did so once because he wanted to introduce the artist to the son of their mutual friend, the Florentine banker Bindo Altoviti (d. 1556).[17] Another time, Del Riccio invited Michelangelo to dine, evidently at the Strozzi Palace near the Ponte Sant'Angelo: "If you want to give everyone pleasure, come to supper this evening at our house."[18] Imagine Michelangelo "giving everyone pleasure," and in such a patrician setting!

Portrayals of Michelangelo that emphasize him as "tragic" and "tormented" obscure the fact that the artist had a quick, acerbic Tuscan wit, loved laughter and ribald humor, and could be a marvelous dinner companion, at least among close friends.[19] Michelangelo referred to his circle of friends as his *brigata*, his brood, a term of endearment used to describe close companions. Away from Florence, his Roman *brigata* was the closest thing that Michelangelo had to a family. He clearly cherished the companionship, although we are afforded only occasional glimpses of these enduring bonds. They appear frequently enough to reveal the importance of Del Riccio's friendship to Michelangelo.

Michelangelo and Luigi del Riccio spent Sundays together—a day to rest, write letters, and share the Trebbiano wine, marzolino cheeses, and fruits that Michelangelo's nephew regularly sent from Florence.[20] When he couldn't meet his friend, Michelangelo fell to silly bantering: "About our spending the day together tomorrow, I make my apologies, because the weather is bad and I have business at home. The day we were going to spend tomorrow, we'll spend later on, this coming Lent, at [the Strozzi villa of] Lunghezza with a fat tench [fish]."[21] It may be challenging to imagine a dour Michelangelo enjoying a holiday idyll, riding out to Lunghezza on the road to Tivoli to spend the day with his dear friend in the Roman Campagna eating grilled fish. With Del Riccio, Michelangelo could indulge in good food and verbal wit.[22] When Del Riccio went to Lyon on banking business, Michelangelo missed his friend so intensely that he contemplated visiting him, suggesting that they make a pilgrimage together to the shrine of Saint James in Santiago de Compostela.[23]

Del Riccio was many things to Michelangelo, including an enthusiastic reader of the artist's poetry and his first editor. Because Michelangelo considered Del Riccio the genuine poet, he often sent his poems accompanied by expressions of modesty, such as "this is truly a scribble." On another occasion, Michelangelo asked that a poem be returned "so that I may revise it . . . as you bid me." He sometimes joked that he was sending a verse in thanks "for the trout" or "for last night's duck," or a "miserable scribble" in gratitude for a delicious meal. In their friendship and exchange of poetry, Michelangelo and Del Riccio formed a triumvirate with their mutual friend, the humanist and writer Donato Giannotti (1492–1573). Michelangelo is, by far, the most important poet of the three, but one would never know it from his deferential attitude toward those friends whose literary gifts (and command of Latin) he held in awe.

"Messer Luigi," Michelangelo once wrote, "You, who have the spirit of poetry—please would you shorten and revise one of these madrigals, whichever seems to you the least lamentable, as I have to give it to a friend of ours."[24] The artist expected his friends to polish his verse, as when he added the following postscript to his appeal to Giannotti for editorial intervention: "To Messer Donato, mender of badly made things, I commend myself."[25] Reverting to an analogy drawn from his family's artisan background in the Florentine cloth trade, Michelangelo wrote to Del Riccio about a Giannotti sonnet: "Donato's sonnet seems to me as fine as anything written in our time. But, having poor taste, I am no more able to judge of cloth newly-spun, although of the Romagna, than of worn brocades, which make even a tailor's dummy appear fine."[26] In hindsight, Michelangelo's deference is entirely unwarranted, although understandable: he was not a "man of letters," he could not write in Latin, and in such company he was painfully conscious of his lack of learning.

A startling case of Michelangelo's intellectual modesty is found in a letter and poem he wished to send to his new acquaintance, the illustrious Vittoria Colonna, although not before it was vetted by his friend Donato Giannotti. We still have the draft written by Michelangelo (probably in the mid-1530s), in which he purposefully left

Michelangelo, Drafts of a letter and poem to Vittoria Colonna, "corrected" by
Donato Giannotti, 1541, Casa Buonarroti, Florence, AB XIII, fol. 114

room on the sheet for Giannotti to "correct" both the letter and the
sonnet. Giannotti's alterations appear absurdly unimportant—some
three dozen minor spelling changes, including, most commonly, the
elimination of Tuscan vocalizations, so that *pechato* becomes *pec-
cato*, *obrigato* becomes *obligato*, and so forth. Giannotti even changed
the spelling of the artist's name, from "Michelagniolo" to "Michel-
agnolo."[27] The interventions strike a modern reader as entirely un-
necessary; however, in his early relationship with a renowned lady of
the aristocratic Colonna family, Michelangelo wished to appear so-
cially proper. She was the genuine poetess, he merely a humble artist
trying his hand at verse. "I can't help seeming to lack talent and art,"
he once wrote.[28]

Vittoria Colonna

Vittoria Colonna (1490–1547) was a woman in possession of numerous virtues. In an unfinished book, *Notable Men and Women of Our Time*, commissioned by Vittoria Colonna herself, Paolo Giovio extensively catalogues many of these virtues, including her noble lineage, chastity, and grace, as well as her devotion to civic and religious responsibilities. In addition, Giovio describes her many attractive physical features and gives a surprisingly long and vivid account of her breasts: milky white orbs that "spring back softly and becomingly from their sternly chastising little bindings in time with the musical beat of her breathing and, like turtledoves sleeping, they swell at sweet intervals."[29] Nineteenth-century Victorians similarly fantasized of her as the sort of beauty an artist such as Edward Burne-Jones might paint.[30] By the time Michelangelo knew her, Vittoria Colonna was a widow in her forties who donned the chaste demeanor and dress of a profoundly religious person. For many reasons Michelangelo was strongly attracted to Vittoria Colonna, but these did not include her swelling breasts.

Her true beauty lay within. She was intelligent, refined, aristocratic—from a noble Roman family. Her arranged marriage in 1509 to Ferrante Francesco d'Avalos, the marchese of Pescara, was happy but brief; he died in 1525, leaving Vittoria a widow at age thirty-five. Although much admired by contemporaries, Vittoria's long face and plain features did not excite the naturally flattering tendencies of artists. There are many purported portraits of Vittoria Colonna, but none succeed in making her into a beauty (see plate 7).

Vittoria was the granddaughter of the great humanist prince and professional soldier of the church (*condottiero*) Federico da Montefeltro, the duke of Urbino. Had she lived earlier, she, rather than her mother-in-law, Elisabetta Gonzaga, might have been the protagonist of Baldassare Castiglione's *Book of the Courtier*, for Colonna possessed all the attributes of the ideal female courtier. As it was, she was a friend of Castiglione, one of the first readers of his manuscript, and a catalyst in his book's publication.

There is no obvious reason Vittoria Colonna should have ever met and befriended Michelangelo, except that they shared many of the same friends as well as a profound commitment to Christian devotion. Having been born to nobility, she moved easily in the patrician class to which Michelangelo claimed a tenuous membership. Any one of a half dozen persons, all of elevated social status, might have brought the two together, including Cardinal Pietro Bembo (1470–1547), a mutual friend and one of the protagonists of Castiglione's *Courtier*, or Tommaso de' Cavalieri (d. 1587), who served as an intermediary in Michelangelo's early friendship with Colonna.[31] Or it might have been Ercole Gonzaga (1505–1563), the cardinal of Mantua, who is the champion of a fetching anecdote related by both of Michelangelo's contemporary biographers, Ascanio Condivi and Giorgio Vasari. According to the story, Pope Paul III visited Michelangelo one day at his Macel de' Corvi studio, ostensibly to see about progress on the tomb of Pope Julius II. The pope was accompanied by eight or ten cardinals, one of whom was Ercole Gonzaga. When the young cardinal saw the *Moses*, he is said to have exclaimed: "This statue alone is enough to honour the tomb of Julius," whereupon it was soon agreed that Michelangelo should sign a new contract and abbreviate his obligation to the nettlesome heirs of the long-dead pope.[32]

The perspicacious Cardinal Gonzaga is thus given credit for helping to cut the Gordian knot that bound the artist to the burdensome tomb project. Ercole Gonzaga was a cultivated patron of the arts, a great admirer and a collector of Michelangelo's work, and a close friend of Vittoria Colonna. He is actually mentioned in the first extant letter from Colonna to Michelangelo (probably from the mid-1530s): "My most cordial Messer Michelangelo, I beg you to send me the crucifix [a drawing he was making for Colonna] for a little while, even if it is unfinished, because I want to show it to some gentlemen of the most reverend cardinal of Mantua."[33] In this way Michelangelo—no cardinal and no learned theologian—became inserted into an ever-expanding circle of socially elevated friends and acquaintances.

Corresponding with a Colonna

Michelangelo's early letters to the august lady are stunning examples of mannered politesse and exceptional modesty, as befits an artist of a lower class and without the languages, learning, and social graces that distinguished persons in the circle of Vittoria Colonna. In a manner similar to that he used to woo Tommaso de' Cavalieri with drawings, Michelangelo made a beautiful drawing of the crucified Christ as a gift for the marchesa (see plate 8), and sent it with an accompanying letter alluding to their mutual friendship with Cavalieri. It is worth quoting the letter, if only to observe Michelangelo falling all over himself in his ingratiating and stilted prose:

> Signora Marchesa—Seeing that I am in Rome, I do not think it was necessary to have left the Crucifix with Messer Tommao [Cavalieri] and to have made him an intermediary between your ladyship and me, your servant, to the end that I might serve you; particularly as I had desired to perform more for you than for anyone on earth I ever knew. But the great task on which I have been and am engaged [the *Last Judgment*] has prevented me from making this known to Your Ladyship. And because I know that you know that love requires no task-master, and that he who loves slumbers not—still less had he need of intermediaries. And although it may have seemed that I had forgotten, I was executing something I had not mentioned, in order to add something that was not expected . . .[34]

The self-conscious, contortionist writing, which is nearly incomprehensible as prose, scans and reads almost like an example of Michelangelo's poetry:

> E perché io so che la sa
> che amore non vuol maestro
> e che chi ama non dorme,
> manco manco achadeva ancora mezzi.

He ended the letter with a fragment of a line from Petrarch, never doubting that such a learned lady would recognize the allusion and

additionally understand its import. In turn, Colonna was no less capable of an equally clever and polite manner, especially when she thanked Michelangelo for the crucifix, "which certainly has crucified every other picture I have ever seen."[35] She implicitly praised the drawing by rhetorically doubting its authorship: "If this is someone else's, patience; if it is yours I applaud you. But in case it isn't yours and you wish to make one that is yours . . . but if it is yours, be patient if I don't return it to you." She ended by informing the artist that she had inspected it in good light, through a magnifying glass, and with a mirror, "and I have never seen a more perfectly finished thing."[36] In courtly fashion, she knew how to simultaneously tease and praise the artist.

Michelangelo was ecstatic about having received such a gracious and appreciative response. Drawings and poems poured forth from the artist. He was the eager admirer, she the grateful but slightly more restrained recipient of the artist's ardent affections. The two began to spend time in each other's company, a blossoming friendship that is vividly captured in Francisco de' Hollanda's (1517–1584) fictionalized *Diálogos em Roma*. Hollanda, a young Portuguese artist and writer, caught the tone if not the precise words of their learned exchanges. The amiable nature of the friendship is further suggested by Colonna's request to Michelangelo: "If you are not working today, would you at your leisure come to talk with me."[37] It is difficult to imagine Michelangelo at leisure, but it speaks of his admiration for Colonna that he shared time with this fascinating woman.

The two friends were actually neighbors, although the Colonna lived in a privileged district of Rome while Michelangelo, we recall, lived on a street known as the "slaughterhouse of the crows." But if Michelangelo turned left on leaving his house, he would quickly depart his insalubrious neighborhood and begin climbing the Quirinale (Quirinal Hill). Colonna properties—and they were extensive—dominated this area. On a prominent spur of the Quirinale stood the church of San Silvestro al Quirinale. Francisco de' Hollanda describes, and myth has greatly embellished, a tradition that San Silvestro was the favored site where the two friends occasionally met, on a lovely little terrace overlooking the city spread below them. For a healthy

artist in his seventies, the walk to San Silvestro would have been ten minutes at most, although up a steep and unpaved slope. Hollanda may have re-created the conversation, but he did not invent these friendly and intellectual trysts. When Colonna wrote to Michelangelo, "would you at your leisure come to talk with me," it was not an invitation he would refuse.

Friends at a Distance

Michelangelo's eager attentions, however, could prove tiresome. Colonna occasionally felt obliged to remind him of their primary duties to the church. Seeking spiritual solace, Colonna retreated to the convent of Santa Caterina in Viterbo, where she felt slightly overwhelmed by letters from a friend she had encouraged and who now, quite evidently, missed her companionship desperately. With aristocratic tact, she wrote: "If you and I continue to write according to my obligation and your courtesy, it will be necessary for me to abandon the chapel of Saint Catherine without devoting the hours to these sisters, and you will abandon the chapel of Saint Paul without devoting the full day to colloquy with your paintings."[38] It took some time before Michelangelo fully assimilated the admonition: Colonna was devoted to the sisters of Santa Caterina; Michelangelo was supposed to be devoting *his* time to finishing the paintings in the Pauline Chapel.

Letters and poetry continued to pour forth from the artist. Vittoria Colonna proved to be a catalyst for Michelangelo's verse, including some of the artist's most sophisticated, deeply spiritual, and penitential poems, as well as a few verses that reveal his self-conscious doubt about being an artist.[39] As with his relationship with Tommaso de' Cavalieri, the initial ardor gradually abated while the friendship deepened and matured.

Inspired by Colonna's poetry and ascetic character, Michelangelo became prolific. Among the early sonnets that he sent to the august lady was the one that his friend Donato Giannotti "corrected" for him. In composition and sentiment, it reveals the labor of its overly self-conscious creation:

To be less unworthy, my exalted lady,
of that gift, your wondrous courtesy when we met,
I tried, with all my heart, to repay the debt
with some token of the little wit God gave me.
But saw no way at all—no, not to save me!—
Couldn't climb that high with the energies I muster.
Pardon me then. I was rash to try. Mere bluster.
I lapsed and learned, so am less a fool already.[40]

Employing a ubiquitous contemporary expression of exaggeration—
one thousand times—he ended the sonnet by depreciating his *l'ingegno*
and *arte* in favor of the heavenly treasure of her poetry:

Talent and art and all remembrance yield;
for treasure from heaven no mortal makes return,
though a thousand times he try. Not anybody.[41]

As their relationship developed, Michelangelo became less obsequi-
ous and more self-revelatory, especially with regard to his art: "For a
reliable guide in my vocation beauty was set before me as a birthright,
a mirror and a lamp for either art."[42] Michelangelo wrote poems that
candidly reveal his ambitions and struggles as an artist. Two quatrains
of an incomplete sonnet address themes similar to those he had con-
fronted in carving the sculptures in the Medici Chapel in Florence:
art's struggle to arrest "grudging time." And further: "the live figure in
the hard mountain stone" which will "last far longer than its maker."[43]
Ironically, the sonnet, like the chapel, remained incomplete.

On one hand, these are Michelangelo's tentative assertions of his
artistic abilities and belief in the immortality of art (measured as a
thousand years). Whether in painting or stone—or, as Michelangelo
writes, "in any medium"—he could make portraits that would cheat
death and triumph over time. On the other hand, he also acknowl-
edges a certain futility, as art is neither infallible nor truly immortal. In
another poem, he confessed the impossibility of representing *her* per-
son, at least in his preferred medium of marble: "I carved the statue,
but she's heaven's own art, not mortal, but divine."[44] The statue he

carved for Vittoria Colonna was not in "colors or stone" but in his poetry. But, while the poetry written for Colonna reveals brief expressions of confidence, more common is an acute awareness of the limitations of art and its transience:

> After many years of seeking and many attempts,
> the wise artist only attains a living image
> faithful to his fine conception,
> in hard and alpine stone, when he's near death;
> for at novel and lofty things
> one arrives late, and then lasts but a short time.[45]

Some of Michelangelo's most authentic feelings regarding art are expressed in his poems to Vittoria Colonna. He was, moreover, never quite so revealing as when he expressed his love and admiration for her: "Lady, if you've such power in celestial things as here on earth, make all of me eye alone, all eye, to delight, the whole of me, in you."[46] Vittoria's friendship unleashed in Michelangelo a font of creativity that found outlet in a torrent of words and a few magnificent drawings. The English Victorians were sensible to this tender dimension of Michelangelo's character, as was the modern German artist Paula Modersohn-Becker, who was especially affected by the artist's love poetry:

> This hard man, strong as a giant, is as gentle as a child in them. He was a vessel which love was nearly able to burst open. How it shook him! He gave himself to love with every nerve and fiber, and was gentle as a lamb. And even then, in each of these fibers, there was more strength and warmth and humanity than there usually is in a whole person.[47]

"Into the memory of beautiful things must come death"

As a token of her regard, Colonna presented Michelangelo with a handwritten "little book" of her poems, which the artist considered among his most treasured possessions (see plate 9).[48] He equally valued a volume of her published poetry (see plate 10) and the "many

letters which she wrote me from Orvieto and from Viterbo," of which, unfortunately, only five have been preserved.[49] Thanks in part to his relationship with Vittoria Colonna, Michelangelo was inspired to publish a volume of his own verse. This was essentially a reciprocal gift and a means of thanking Colonna for her friendship and spiritual counsel. The artist, of course, turned to his friend Luigi del Riccio for assistance. Together, the two companions selected eighty-nine of the artist's poems; they were given final revisions, written out in fair copy, and placed in numbered order.[50] Months were spent on this endeavor. Michelangelo was about to become the first artist in history to publish a volume of verse.

On the verge of publication, Luigi del Riccio suddenly died. A contemporary described Michelangelo as being at wit's end with grief and despair.[51] He was truly desperate, lonely in his advanced age. There was no friend, other than perhaps Vittoria Colonna, with whom he could lament such a loss, yet she was cloistered in a remote convent and not available to share Michelangelo's grief. He was still friendly with Tommaso de' Cavalieri, but they no longer saw each other as frequently as they once had. Tommaso had married Lavinia della Valle and was much occupied with Roman civic affairs.[52] In the past few years, Del Riccio had been Michelangelo's closest friend and companion, even closer than Tommaso de' Cavalieri, although the latter receives far more attention from the artist's biographers. Unfortunately, we have no adequate means of gauging the true depth of Michelangelo's loss, since he avoided recording his feelings and fell into a deafening silence. We merely hear that he was at his wit's end (*disperarsi*). Desperate. Distraught.

It may surprise us, but over the seven decades of Michelangelo's life, he had enjoyed many close friendships. Michele di Piero Pippo (1464–1552?) and Domenico di Giovanni Fancelli (b. 1464), known as Topolino, were stonecutters and boyhood friends from Settignano with whom he naturally felt comfortable; Giuliano Bugiardini (1475–1554) was a clumsy painter but a longtime friend; Sebastiano del Piombo (c. 1485–1547) was an amusing and irreverent crony until he became annoyingly self-important; Francesco Berni (1497/98–1535) was an

uproariously funny poet and good dinner comrade, and there was the ever-diverting Domenico da Terranuova (known as Menighella), who caused Michelangelo "to roar with laughter." All these were the boon companions with whom Michelangelo felt perfectly at ease.

Then there were the more important, deeper friendships, with persons like Giovanfrancesco Fattucci (d. 1559), the canon at Santa Maria del Fiore in Florence, with whom Michelangelo shared a lifelong relationship. Fattucci was never replaced, but when Michelangelo moved permanently to Rome in 1534, he was gradually superseded by the equally important but almost equally faceless Bartolommeo Angelini (d. 1540). These figures remain faceless indeed, except as they are illuminated by their exceptional, longstanding and warm relations with Michelangelo.

For many years, Angelini served as the Roman counterpart to Fattucci—the person who managed many of Michelangelo's professional and personal affairs. Bartolommeo Angelini was as gentle, kind, and angelic as his name. He served Michelangelo as a friend, a fellow poet, and an invaluable business manager until he died in 1540. After Angelini's death, no one grew closer to Michelangelo than Luigi del Riccio. Moreover, the friends when one is seventy matter more than the rowdy companions of youth.

Confronted by his friend's death, one might expect that Michelangelo would find a refuge in poetry, but he turned away even from this comfort. The few poems he did write were left in disarray, perhaps reflecting his mournfully desperate state. Papers were scattered everywhere: many of Michelangelo's most finished poems were at Del Riccio's house, since the latter was to oversee their printing; others had been written on various notes and letters—some more complete than others; a few were still with Donato Giannotti, who had promised to edit them; many more lay among the mess of Michelangelo's own papers. The artist had never been entirely convinced that he was a poet, nor that his highly personal and idiosyncratic verses deserved a public airing. Among other reasons, Michelangelo felt inadequate compared to his learned friends Luigi del Riccio, Donato Giannotti, and Vittoria Colonna.

In the absence of Del Riccio's constant encouragement, he lacked the will to pick up the scattered pieces. Indeed, one of the last poems that Michelangelo sent Luigi was an unedited madrigal replete with imprecise and overlapping pronoun references, hastily written at right angles to the note that joked about the two friends getting together to eat a tench fish at the Strozzi villa.[53] There was no longer any joy in recalling the circumstances or the first scribbled line: "Into the memory of beautiful things must come death . . ." Death had unexpectedly come to Luigi, and although Michelangelo had intended the poem as a general reflection on transience, it suddenly had a specific and poignant resonance: "Into the memory of beautiful things must come death, to take away that man's face from your memory." What would become of the project to publish the artist's poetry? It died with Luigi del Riccio.

Yet Another Death

Michelangelo did not wait long for the next blow to fall. Just three months later, in February 1547, Vittoria Colonna also died unexpectedly. She was fifty-seven. Michelangelo was fifteen years older. Why was he still alive when two of his closest and younger friends were no more? But things got worse. In the same horrendous year, Michelangelo lost two more friends: the humanist writer Pietro Bembo and the poet Jacopo Sadoleto (1477–1547). Michelangelo's circle of literary friends suddenly was decimated. Not only was the publication project now defunct, but he almost entirely abandoned writing poetry altogether. In the last eighteen years of his life, the artist penned at most thirty-five poems and possibly as few as half that number. What is more, most of these later poems are mere fragments, and few had readers, as many of his closest friends and fellow poets were now dead. None were published.[54]

With a deepening melancholy, Michelangelo wrote: "I am an old man and death has robbed me of the dreams of youth—may those who do not know what old age means bear it with what patience they may when they reach it, because it cannot be imagined beforehand."[55]

Michelangelo, Sonnet "Di morte certo . . . ," after 1547, Biblioteca Apostolica, Vatican City, Rome, Cod. Vat. Lat. 3211 fol. 76r

And among the few verses he continued to write, he longed for death: "Di morte certo, ma non già dell'ora"

> Certain of death, though not yet of its hour,
> life is short and little of it is left for me;
> it delights my senses, but is no fit home
> for my soul, which is begging me to die.[56]

The sonnet is a relentless drumbeat of pessimism: in addition to the repeated appearance of death and its cognates (*morte, mora, mortale*), we encounter the blind world (*Il mondo è cieco*), light extinguished (*spent'è la luce*), the triumph of error (*trionfa il falso*), a curtailing of hope (*tronca la speme*), the soul in mortal danger (*l'alma fa mortale*), and life without refuge (*senza alcun refugio*).[57] Almost oppressively, there are more than a half dozen pessimistic expressions in the course

of this single fourteen-line sonnet. Death was now an omnipresent part of Michelangelo's life.

Beneficio di Cristo

Rather than publish his own poetry, Michelangelo found consolation in the "little book" of Vittoria Colonna's poems as well as another volume the two friends valued greatly, the *Beneficio di Cristo*. Written in the vernacular by the largely obscure Benedetto of Mantua, the *Beneficio* proved to be one of the most popular and influential books of its time. Published in 1542/43—yet widely circulated beforehand in manuscript form—the *Beneficio* was a highly accessible tract that emphasized justification by faith and personal salvation through a loving relationship with God and Jesus Christ.[58] Most comforting of all, but also dangerously unorthodox, was the assertion that we are predestined for salvation.[59]

Most often quoting from Saint Paul and Saint Augustine, but also from many other writers such as Origen, Saint Ambrose, and Saint Basil, the *Beneficio* rendered these church theologians accessible to a broad vernacular-reading public. Saint Paul, surely the most important religious inspiration in Michelangelo's late life, speaks indirectly to the reader of the *Beneficio* through such phrases as "san Paulo dice," "come dice san Paulo," "secondo san Paulo," "dimostra san Paulo," "insegna san Paulo," and "come afferma san Paulo." In the words of Benedetto of Mantua, Saint Paul not only teaches and affirms, he exhorts: "san Paulo ci esorta," "ci ordina San Paulo," "commando san Paulo." Saint Paul also offers comfort: "All of us, who believe in Jesus Christ, are children of God, according to what Saint Paul tells us."[60] Instead of the Old Testament's fear of God, the New Testament preaches a loving God and a spiritual happiness that is justified by faith alone (*giustificato per la fede*).[61]

The *Beneficio* offered a soothing and consolatory message in simple and easily understood Italian, even when making extensive use of patristic literature. It was balm for the troubled soul, which is why so many—including the elderly Michelangelo—were attracted to it. But

in the eyes of the Church, the text was heretical. In Michelangelo's day the Inquisition placed the *Beneficio* on the index of prohibited books, and thousands of copies were destroyed.[62] Nonetheless, it was still widely read, shared, and discussed. Religious debate was ubiquitous, "in the squares, in the workshops, in the taverns and even in women's washing places," warned a preacher, who further denounced, "the tailors, the carpenters, the fish-sellers and other dregs of the earth in discussing the mystery of predestination, the article of justification, the prescience of God and the most holy sacrament of the altar, grace and free will, faith and works and other tangled questions and most high dogmas of the faith."[63]

Michelangelo, who never was among "the dregs of the earth," did not need a tavern to hear these ideas; he absorbed them from some of the most learned religious thinkers of his day. Thanks largely to his intimacy with Vittoria Colonna, Michelangelo had been introduced to these ideas and to many of the individuals who espoused personal spirituality, believed in justification by faith, and were committed to religious reform. This loose-knit group came to be known as the Spirituali.[64] Many of its members were strongly influenced by the teachings and writings of Juan de Valdés, Bernardino Ochino, and even some of the northern European reformers, although the more radical ideas of the lattermost were often filtered through Italian intermediaries. A widespread, pan-European call for reform—so evidently necessary given the endemic corruption of the Church—was heeded by many prominent figures, including Peter Martyr Vermigli, Marcantonio Flaminio, Giovanni Morone, Pietro Carnesecchi, Gasparo Contarini, and Bernardino Ochino. Michelangelo was not of the intellectual stature of these individuals, nor was he personally or temperamentally suited to be associated with any of them. Rather, his relations with the Spirituali were mostly indirect, via his friends, most notably, Vittoria Colonna, Ludovico Beccadelli, and, to a lesser extent, Cardinal Reginald Pole (1500–1558), the future archbishop of Canterbury. Thanks to these eminent individuals, Michelangelo was exposed to the broad current of reform thinking that was sweeping across Italy and Europe. At first heady and liberating, reform eventually proved dangerous. When the

church turned its attention to this "heresy," Michelangelo did his best to obscure his relations with the so-called Spirituali.

It is unnerving to witness the persecution and exile of persons with whom one is sympathetic and loosely associated. The institution of the Roman Inquisition in 1542 prompted growing alarm as a once-tolerant Church sought to expunge all heterodoxy.[65] Until then, Michelangelo had had little reason to think that his relationship with Vittoria Colonna and other reform-minded individuals could be dangerous. But, with her many ties to the Spirituali, Vittoria Colonna had been skirting heresy, especially in the eyes of an increasingly suspicious and censorious Church. Most likely she escaped suspicion because she was a woman and a pious widow rather than a political or public figure. Sensitive to the gathering tumult, she elected to live a life of partial seclusion in San Silvestro in Capite in Rome and then of greater seclusion in the convent of Santa Caterina in Viterbo. She died before the worst of the persecutions.

Other acquaintances and intimates of Colonna and Michelangelo were not so fortunate. Cardinal Reginald Pole, who was a promising candidate for the papacy, gave into pressure and returned to England. Bernardino Ochino and Peter Vermigli fled Italy, acts that implied their guilt and tainted all who had contact with them. Ludovico Beccadelli, despite years of faithful service as a bishop, a papal nuncio, and a vicar general of Rome, was marginalized by being sent to Ragusa (modern Dubrovnik, Croatia) on the Istrian coast. Cardinal Giovanni Morone was imprisoned, Pietro Carnesecchi was burned at the stake, and Gasparo Contarini was probably poisoned. Most of these persecutions, self-imposed exiles, and deaths did not directly affect Michelangelo, but each emphasized the danger of associating and sympathizing with these individuals or their teachings. Thus, even if Michelangelo was not directly affected, any affiliation with these individuals could be deeply compromising. To experience the muzzling, exile, and death of persons whom one knew and admired— even from a distance—was enough to drive Michelangelo to his own sort of inquisitorial silence. This was perhaps another reason for the suppression and eventual suspension of his poetic activity. Amid the

ruthless hounding of the Inquisition, Michelangelo faded quietly back into the mainstream Church. Death had claimed his best friends, and soon other unexpected events would dramatically shape the artist's late life.

Crucifixion Drawings

While poetry now seemed a vain and aimless pursuit, Michelangelo may have found some consolation in drawing. Among Michelangelo's extant drawings are approximately a half dozen sheets of the Crucifixion and a number of smaller, related studies. Extremely fine examples are found in the Louvre Museum, the British Museum, and Windsor Castle. The drawings of the series share a similarity of subject matter, style, and facture, and an absence of identifiable purpose.

In one example, Mary and John huddle close to the cross as though seeking the last bit of warmth in the dying flesh of their son and savior. In another (see plate 11), Christ hangs limply on a Y-shaped cross, his face obscured by the shadow of death. His drooping head and straggling, matted hair suggest his expiration, yet in his last living moment he commends his mother to John's care. The figures are ghostlike, hunched by the weight of their grief. A heavily cloaked Mary extends her right arm in a gesture that presents her son and expresses her anguish. At the same time her arms are folded across her chest, a private clutching at sorrow. In the double set of limbs, as in the repeated, shivering contours of the figures, we see not anatomical freaks but figures in motion, successive moments in a tragic drama. The repeated contours bear witness to the artist's hand attempting to touch his Lord. Evidently, these drawings were a form of private prayer and meditation. Conscious of his own mortality, Michelangelo wrote, "no thought is born which does not have death within it."[66]

It is difficult to imagine Michelangelo making many more of these Crucifixion drawings and even more difficult to imagine dating these few sheets over a long span of time. Uncertain of their date, scholars

tend to assign them broad chronological parameters, such as "c. 1550s/ 60s." The Crucifixion drawings sometimes have been asked to stand in for the artist's "late work" and style—a dozen drawings spread across a decade or more. Yet, the drawings are a cohesive group—in their overall character and style and in their insistent repetition of theme.

These are moving and intensely personal creations. One sees the artist repeatedly, almost obsessively, drawing the same subject, as if the caressing marks of chalk on paper permitted him to approach closer to Christ. Michelangelo likely drew all the Crucifixion drawings in a brief period—maybe just a few days—shortly after the death of Vittoria Colonna in 1547. These drawings were a means of exorcising pain, a way to mourn and find small comfort, as was reading Colonna's religious verse in the "little book" she had given him. The Crucifixion drawings share the same subject matter as the magnificent example he had given Colonna at the beginning of their relationship (see plate 8), although now the ravaged body of Christ appears incapable of triumphing over death. These plangent images are less artistic creations than spiritual exercises, drawn only for himself. By drawing and redrawing the body of Christ, Michelangelo drew closer to Christ. He may have expressed doubts about his art, but his faith in Christ never wavered. Christ's body is the one physical image that Michelangelo never relinquished. Christ is the central figure of his later two *Pietà* sculptures, and he is the most important figure in these drawings. Although Michelangelo is supposed to have burned many of his drawings, he did not immolate these poignant sheets.[67] It would have been a sacrilege and a desecration of a friendship.

Following the back-to-back tragic deaths of Luigi del Riccio and Vittoria Colonna, Michelangelo's poetic and graphic production dropped off markedly. The artist largely stopped writing poetry and, equally, lacked motivation to make the sort of exquisite drawings he once gave as gifts to Vittoria Colonna and Tommaso de' Cavalieri. Professionally, he had fewer reasons to draw and personally, much less incentive and desire. In fact, he began to question the validity of making art altogether.

Rummaging in Rubbish

In the span of just a few months in 1546 and 1547, death claimed more than a half dozen persons important to Michelangelo, includ-ing—in addition to Vittoria Colonna, Luigi del Riccio, and Pietro Bembo—his friend and sometime collaborator Sebastiano del Pi-ombo; his patron Ottaviano de' Medici, for whose son Michelangelo acted as godfather; and Francis I, the king of France, an eager patron and the artist's erstwhile final hope for the liberation of Florence from Medici domination.

Even the death of Francis I—a much less personal loss than the others—must have come as a shock to the aging artist. In February 1546, Michelangelo received a letter addressed "Au Seigneur Michel-angelo" and signed, in the king's own hand, "Francoys."[68] The king, who already owned plaster copies of Michelangelo's *Risen Christ* and early *Pietà*, earnestly requested an original work by the artist. Re-sponding that he was an old man (nearly twenty years older than Francis), Michelangelo nonetheless declared his desire, "which, as I have said, I have had for a long time, to execute for Your Majesty a work, that is, in marble, bronze, or paint."[69] Michelangelo concluded by praying to God "to grant Your Majesty a long and happy life." Less than a year later, the king was dead.

Two further poignant and somber notes were soon sounded. First, Michelangelo learned that a male child of his niece, Francesca, had died in childbirth, causing the artist to grieve "as if it had been my own son."[70] Then, just four months later, Michelangelo's twenty-six-year-old nephew and heir, Lionardo Buonarroti, wrote to inform his uncle of the death of Giovansimone Buonarroti, Michelangelo's brother, in January 1548. To this latest news, Michelangelo expressed a rare yet typically restrained note of sorrow: "Lionardo—The news of Giovan-simone's death reached me in your last letter. It has been a very great grief to me, because, old though I am, I had hoped to see him before he died and before I die myself."[71]

This is one of those passages in Michelangelo's correspondence that biographers repeatedly pass over when they describe the artist's mani-

fold problems with his family—understandably. Giovansimone was the same brother to whom Michelangelo had written one of the angriest letters of his life, threatening to cut off his financial support and leave "that ne'er-do-well to nurse his ass." Because the miscreant had threatened their father, a furious Michelangelo was fully prepared to "ride post haste to Florence and show you the error of your ways. . . . If I do come home, I will give you cause to weep scalding tears, and you will learn what grounds you have for your presumption."[72]

As with many angry exchanges among members of Michelangelo's family—or arguments among Italians past and present more generally—the anger quickly dissipated, even in the course of this same letter. Michelangelo had long ago forgiven his brother's execrable behavior. As he expressed it to his nephew, "he was my brother, no matter what he was like."[73] Now, living in Rome and growing old, Michelangelo regretted not having seen his brother once again before his death. As he would repeatedly do in years to come, the artist resigned himself to God's will: "It has pleased God that it should be as it is, and we must be resigned." But Michelangelo did add a touching, personal request in his letter to Lionardo: "I should be glad to hear in detail how he died and whether he died having made confession and having received the Sacrament together with all those things ordained by the Church; because if he received them and I knew of it, I should be less grieved."[74] As a Christian and a deeply religious person, such things mattered to Michelangelo. When he received insufficient information from Lionardo, he detected a degree of insensitivity on the part of his nephew:

As regards the death of Giovansimone about which you write me, you pass it over very lightly, since you do not give me any more detailed information about anything . . . I would remind you that he was my brother, no matter what he was like, and that it cannot but be that I should be grieved and should wish that something should be done for the welfare of his soul, such as I did for the soul of your father.[75]

Michelangelo was equally disappointed not to have heard from his youngest brother, Gismondo (1481–1555), "who hasn't written to me at all."[76] The uncommunicative Gismondo was now the only remaining

member of the artist's immediate family. It was January 1548—cold and dreary in Rome. Michelangelo could not work in the Pauline Chapel during the wet winter months. The artist dwelled on family and mortality, the one darkening thoughts of the other. At nearly seventy-three years, Michelangelo was considerably older than every one of the friends, as well as the brother he had just lost.

Michelangelo had suffered a similarly distressing constellation of deaths a half century earlier. At another critical turning point in his life, in 1492, the artist's first patron, Lorenzo de' Medici, died. Shortly after Lorenzo's death followed the passing of two luminaries from Lorenzo's humanist circle, Angelo Poliziano and Giovanni Pico della Mirandola. That coincidence of deaths drastically upset Michelangelo's world at an early point in his nascent career. Years later, in 1548, he was reminded of that now distant world from letters exchanged with the Florentine writer Benedetto Varchi (1503–1565). Varchi had selected one of Michelangelo's sonnets as the principal text for a learned discourse he had delivered to the members of the fledgling Florentine Academy. The sonnet, which begins with the line, "Non ha l'ottimo artista alcun concetto . . ." is one of Michelangelo's best known, thanks in part to Varchi's published commentary but also because the opening quatrain suggests, to many commentators, the rudiments of Michelangelo's artistic theory: "There is nothing within a marble block that cannot be realized by the superior artist provided his hand obeys the intellect."[77]

Luca Martini, a fellow member of the Florentine Academy, sent a published version of Varchi's discourse to Michelangelo. The artist responded to Martini's gift of the small book (*libretto*) with modest pride, noting that he had shared it with his friend Donato Giannotti. Michelangelo took credit for penning the sonnet, but marveled at Varchi's learned commentary:

> The sonnet does in fact come from me, but the comment from Heaven, and is truly a marvelous thing, which I say not as my opinion but as that of men able to judge, especially of Master Donato Giannotti, who never tires of reading it and who greets you. As to the sonnet, I know

it for what it is, but regardless of that I cannot keep from a little access of vanity, since it has been the cause of such a beautiful and learned comment.[78]

Rather than doing so himself, Michelangelo begged Martini to thank Varchi on his behalf, imploring him to use "such words as are suitable to such love, affection, and courtesy." In characteristic fashion, Michelangelo became self-conscious in the face of what he considered true learning. He resorted to aphorism—"when one has such a good reputation, one shouldn't tempt fortune; it is better to be silent than fall from the heights." He claimed to be "old," and added that "death has robbed me of the thoughts of youth."[79] He was not one to indulge in learned academic discourse, nor was he writing much poetry any more.

Shortly after, however, Michelangelo was lured into responding directly to Varchi, who importuned him on the matter of the *paragone*— a learned discussion regarding the relative merits of painting versus sculpture. With evident reluctance, Michelangelo responded to Varchi's query. In doing so, the artist offered one of his clearest and most succinct statements regarding art:

> I admit that it seems to me that painting may be held to be good in the degree in which it approximates to relief, and relief to be bad in the degree in which it approximates to painting. I used therefore to think that painting derived its light from sculpture and that between the two the difference was that between the sun and the moon.[80]

But, having read Varchi's treatise on the subject, Michelangelo admitted to having changed his mind:

> Painting and sculpture are one and the same, and being held to be so, no painter ought to think less of sculpture than of painting, and similarly no sculptor less of painting than of sculpture. By sculpture I mean that which is fashioned by the effort of cutting away, that which is fashioned by the method of building up being like unto painting.[81]

It is evident, however, that Michelangelo had little patience for such abstruse debates, "because they take up more time than the execution

of the figures themselves." He then, again, invoked his advanced age, as if to bring to an end any further discussion of the subject: "I am not only an old man, but almost numbered among the dead."[82]

The melancholy revealed in Michelangelo's exchange with Benedetto Varchi is surely related to the recent deaths of Luigi del Riccio and Vittoria Colonna. Shades of this are revealed in how he unburdened himself, around the same time, to Giovanfrancesco Fattucci, his longtime friend and a canon of the cathedral of Santa Maria del Fiore in Florence. The artist's current emotional distress is evident in the disjointed, run-on sentence that he unspooled on his friend:

> Having been very unhappy lately, I have been at home, looking through some of my things, there came to hand a great number of these trifles which I used to send you, of which I am sending you four, which I may have already sent you, you will say that I am old and crazy (*vechio e pazo*): and I assure you that only distractions keep one from going crazy with grief; so don't be surprised, and reply to me about something, I beg you.[83]

The letter paints a vivid picture: in the failing light of evening, the old man bends nostalgically over the bedroom chest filled with his personal items. He is rummaging through stacks of loose pages filled with poetry, some of it written out in a clean hand for Vittoria Colonna, some of it shared with his friend Fattucci years ago, many verses incomplete, none printed, as he and Del Riccio had once hoped. Now it all seems terribly insignificant. He, nonetheless, selects four of those old poems, "trifles which I used to send you," and encloses them in a letter of "a few lines to prove to you by this that I'm still alive." In the same letter, Michelangelo enclosed his carefully crafted but slightly irritable reply to Varchi regarding the relative merits of painting and sculpture and implored Fattucci "to give it to him and thank him on my behalf better than I am doing or can do myself."[84] Thus did Michelangelo discharge a tedious duty. An earlier draft of the letter to Varchi still sits among his papers. It breaks off after just a few lines—his philosophic posturing interrupted by moody poetic reflections,

... within this mortal carcass now frail and tired.
What else can I do so as not to live this way?
Without you, Lord, I'm deprived of every blessing,
and the power to change fate is God's alone.[85]

Elsewhere on the same sheet he wrote of the melancholic reflections of a "tired old man" with few "bittersweet tears" left to shed.[86] He filled the page with further poetic fragments, turned it over, and penned this madrigal:

Once again a woman's beauty
cuts me loose, and spurs and lashes me;
not only has Terce gone by,
but None and Vespers too, and evening is near.
Between my birth and fortune,
the one dallies with death,
and the other can't give me real peace down here.
I, who had come to terms
with both my white head and my many years,
already held in my hand the pledge of the next life
for which a truly penitent heart hopes.[87]

He did not send this or any of the poetry scribbled on the sheet. All was left incomplete. We call the most finished set of verses on the sheet a "madrigal," but in fact it never arrived at such a complete state. Certainly Michelangelo never considered it finished. Nor did he send it. Instead, he begged the indulgence of his friend, beseeching Fattucci to "reply to me about something." It scarcely mattered what, for Michelangelo was awaiting death, "with both my white head and my many years." He would have to wait seventeen more years. Meanwhile, little did he know that he was far from done with life or art. In fact, he was at a key turning point in his life and about to become busier than ever.

A LONG-LIVED POPE

Throughout the period of sorrow Michelangelo endured in the mid-1540s, there remained the firm presence of Pope Paul III (Alessandro Farnese, 1468–1549, r. 1534–49). Paul and Michelangelo shared many things, beginning with advanced age. At Paul's elevation to the papacy in 1534, the artist was fifty-nine and the pope was sixty-six. A trust and mutual respect were founded on the fact that they were near contemporaries who shared the experience of having been forged in the crucible of Lorenzo de' Medici's Florence. Now, more than a half century later, they were both profoundly religious individuals dedicated to the Church and to its internal reform. They also shared the melancholic fact that they had outlived most of their contemporaries.

Having received a polished humanist education in Florence and Rome, Alessandro Farnese proved to be a shrewd operator in the worldly politics of the Church and the Vatican bureaucracy. In painted portraits by Sebastiano del Piombo and Titian (see plate 12), we see Paul as a man of keen intelligence and steely determination. His penetrating eyes peer from the shadow of a creased, overarching brow; his prominent straight nose affirms an ancient Roman ancestry. What is less evident is the perspicacious individual who was a friend to Michelangelo and the artist's greatest patron. More than anyone, Paul appreciated and fully capitalized on Michelangelo's genius.

Michelangelo's biographer Giorgio Vasari relates that shortly after his election, Paul summoned Michelangelo. After paying the artist compliments and making him various offers, the pope

> tried to persuade him to enter his service and remain near him. Michelangelo refused, saying that he was bound under contract to the Duke of Urbino until the tomb of Julius was finished. Then the pope grew angry and said: "I have nursed this ambition for thirty years, and now that I'm Pope am I not to have it satisfied? I shall tear the contract up. I'm determined to have you in my service, no matter what."[1]

Of course, the angry pope did not tear up the Julius tomb contract. Instead, one day, in the company of a group of cardinals, the impatient pope crossed Rome and visited Michelangelo at his house in the Via Macel de' Corvi. What a sight for the sellers of dead crow and pig offal to witness a scarlet entourage making its way through their muddy neighborhood! Although the Swiss Guards kept them at bay, the curious neighbors crowded around the front entrance of Michelangelo's dwelling. Perhaps even the man who some years previously had dragged his sister Vincenza from Michelangelo's house now regretted his rash action.

For the pope and his entourage to appear at Michelangelo's home was a singular honor. We might dismiss the event as a version of the famous story of Alexander the Great visiting the studio of the greatest ancient painter, Apelles; however, the pope's visit to Michelangelo's studio is well attested. It was during this visitation that Cardinal Ercole Gonzaga proclaimed that the *Moses* alone would do honor to the tomb of Pope Julius. Thus, Michelangelo was given a way to expeditiously complete the tomb while also being told, in no uncertain terms, that henceforth he would work for Pope Paul.

Michelangelo soon was working full-time for the pope. Paul first employed the artist to paint the *Last Judgment* (1536–41) and subsequently to fresco the eponymous Pauline Chapel (c. 1542–50). In addition, Michelangelo was assigned to numerous architectural projects, beginning with a design for the Capitoline Hill (or Campidoglio, begun c. 1538), subsequently the Farnese Palace (begun 1546), and

ultimately New St. Peter's (also 1546). Michelangelo never had a more ambitious patron nor a more staunch supporter.

Early in Paul's pontificate, Michelangelo received a friendly note from the architect and papal functionary Jacopo Meleghino, who wrote at the behest of the pope: "Because His Holiness is here alone and has no one to entertain him, he desires, if it is not too much of a bother, to speak with you and visit the Sistine Chapel in your company."[2] It offers an unusual glimpse of the artist's casual intimacy with the pope. Thus, Vasari might have exaggerated when he wrote that "Pope Paul felt for Michelangelo such reverence and love that he always went out of his way to please him."[3] But Vasari observed their relationship firsthand, and Michelangelo's own words and behavior lend support to his surprising characterization. Paul's long pontificate, from 1534 to 1549, proved an astonishingly productive period for Michelangelo, especially considering that the artist was in his late sixties and early seventies. Looking back, Michelangelo acknowledged having received many benefits from the pope. He greatly valued the friendship and support of this remarkable patron.

Friends with a Pope?

Despite their respective roles, responsibilities, and positions in the world, Paul and Michelangelo enjoyed a well-attested friendship. As different as were their career paths, both were launched in similar circumstances, in the humanist circle around Lorenzo de' Medici. Given their differences of age, social station, and education, it is unlikely they crossed paths in the early 1490s. Thus, while they did not come of age together in Florence, they became kindred spirits fifty years later in Rome. There is something special about a relationship that is built upon the fruits of common origin. Both had vivid memories of Lorenzo "il Magnifico" and other members of his learned entourage. This shared experience alone was enough to unite them, especially in the face of the viperous environment of contemporary Rome.

Stunning confirmation of their friendship is found in the *motu proprio* in which Paul named Michelangelo supreme architect of St.

Peter's. The document characterizes the artist as "our beloved son, Michel Angelo Buonarroti, a Florentine citizen, a member of our household, and our regular dining companion."[4] The unique relationship between pope and artist is vividly illustrated by the food, wine, and meals they shared. Consider the day in mid-June 1547, when Michelangelo sent the pope ten of the forty-four flasks of new Trebbiano wine he had just received from his nephew in Florence (of the original shipment, three had broken en route and three had been impounded by customs officials, undoubtedly for their own enjoyment).[5]

Michelangelo's nephew, Lionardo, who managed the Buonarroti estates, regularly sent Tuscan specialties not available in a surprisingly provincial Rome: every June, between three and four dozen flasks of Trebbiano wine, and in the winter, a dozen or more marzolino cheeses (and sometimes cacio). Lionardo also sent ravioli, Tuscan beans and sausages, red and white *ceci* beans, and green peas, as well as apples, plums, and sweet yellow pears. When these staples and delicacies arrived, Michelangelo took great pleasure in sharing them with his close friends, such as Tommaso de' Cavalieri, Sebastiano del Piombo, and Bartolommeo Angelini. With the latter two friends now dead, Michelangelo was pleased that Pope Paul appreciated the produce of the Buonarroti farms.

Once, Michelangelo peevishly complained to his nephew that a batch of ravioli had been ruined in transit (sometimes it took more than a week to transport goods from Florence to Rome). Michelangelo's young nephew had made an effort to send something special: Florentine ravioli that would be the talk of Rome! Of course, it made little sense to send fresh ravioli. But when the wine, pears, or even the unruined ravioli were especially good, the curmudgeonly uncle expressed genuine thanks—in part by letting Lionardo know that many of the delectable food items had been shared with the pope. It is easy to imagine why Michelangelo's nephew, hearing that a portion of his gifts had been given to the ruler of the Christian world, would go out of his way to send the very best of Tuscany. And one can be certain that friends and a few envious neighbors heard that the pope in Rome was savoring Buonarroti delicacies and regularly eating with Michelangelo.

Fruits in general, and especially pears, were a type of aristocratic gift that was exchanged only with persons of similar social standing and considerable familiarity.[6] Of the thirty-three pears that Michelangelo sent Paul in May 1548, the pope, "thought them excellent and was very grateful for them."[7] Good fruit required an equally good wine, as is suggested by the contemporary proverb, *Pesche, pere, e pomi vogliano vini buoni* (Peaches, pears, and apples want good wine).[8] Pope Paul was especially particular about his wines, largely for reasons of health. Given that thirty-three Buonarroti pears arrived in the pope's kitchen in May 1548, we are permitted to imagine the conversation among the Vatican cooks as to how best to pair the fruit with a good wine or, perhaps, how to prepare the fruit *in* an excellent wine. Unfortunately, we are missing the thanks the pope extended to Michelangelo for this delicious delicacy.

Like most of their contemporaries, Paul and Michelangelo subscribed to the theory of bodily humors, founded on the principles of balancing hot/cold and wet/dry according to an individual's predominant temperament, whether choleric, melancholic, sanguine, or phlegmatic. Elderly men, such as Paul and Michelangelo, were considered cold and dry; therefore medical wisdom recommended they eat warm foods and drink wines that would compensate (*bere compensatorio*) for the natural coldness of aged bones.[9] Although he tended to favor wine from Montepulciano during the hot summer months, Paul was nonetheless grateful for the periodic gifts of Tuscan Trebbiano that he received from Michelangelo.

The best Trebbiano came from the area of the Valdarno (towns such as Bucine, Montevarchi, and San Giovanni) and was acknowledged to be the finest and most expensive wine produced in Tuscany.[10] Both Paul and Michelangelo drank in moderation, since they gave due consideration to their dry, old bones. But, old as they were, they enjoyed their wine. Just as Michelangelo was inclined to dress like an aristocrat—always favoring superior Florentine goods and manufacture—so did he favor the best Tuscan wine. Thus, despite his occasional complaints to his nephew, Michelangelo was clearly appreciative of Lionardo's efforts to furnish him with excellent Tuscan delicacies.

Michelangelo's relationship with Paul brought him into the inner circle of the powerful Farnese family. The pope's highly cultivated grandson, Cardinal Alessandro Farnese (1520–1589), known as "il Gran Cardinale," assisted Michelangelo in negotiations with the Julius heirs and subsequently in securing lucrative benefices. The artist, moreover, became close with a number of persons in the large Farnese household, such as the pope's chamberlain, Ascanio Sforza, for whom Michelangelo would design a chapel in Santa Maria Maggiore. Cardinal Alessandro's secretary, Annibale Caro (1507–1566), may have helped Ascanio Condivi write his *Life of Michelangelo* (published in 1553), and Ludovico Beccadelli proved to be one of the artist's dearest friends. This extended network provided advantages comparable to what Michelangelo had enjoyed years earlier as a member of the Medici entourage. Indeed, life among Paul and the Farnese allowed Michelangelo to recover something of his Medici past a half century later, in the warm embrace of an enlightened circle of friends and patrons.

Can One Defend Rome?

In August 1546, Pope Paul's favored architect, Antonio da Sangallo the Younger, died. While Michelangelo had revered Antonio's uncle, Giuliano da Sangallo, he thought much less of the officious and self-important nephew. This sentiment doubtless was exacerbated by the fact that in the past few years the younger Sangallo had had several run-ins with Michelangelo, including a public disagreement over the fortifications of Rome. With its twelve-mile circuit of walls, Rome was nearly indefensible. The brilliant military commander Belisarius had faced the same problem in the sixth century CE when he sought to defend the city against "barbarian" hordes. A thousand years later, the defense of Rome still proved impossible. No contemporary army was large enough to defend such an extensive fortified circuit. In addition, the walls of Rome were ancient in origin, and however impressive, they were completely inadequate in the current era of gunpowder warfare. Concentrated firepower from a small number of cannon could reduce

high walls to rubble in a surprisingly short time. The problem, therefore, was twofold: What parts of Rome should one defend, and how? Michelangelo, who considered himself an expert on fortifications, was still bitter about the debate, which had taken place early in Paul's pontificate.

The Sangalli were a large family of experienced builders. In fact, Antonio da Sangallo was one of the few Renaissance architects to have been trained as such. Many so-called Renaissance architects came from other professions. Giotto, for example, was trained as a painter, Filippo Brunelleschi as a goldsmith, Leon Battista Alberti as a scholar, and Michelangelo as a sculptor. In contrast, Antonio da Sangallo had a proper and impeccable pedigree as a bona fide architect, not to mention extensive experience; therefore, he had every right to claim a certain authority—which he did, in a most irritating manner.

Well before Michelangelo appeared on the scene, the Sangallo clan had been involved in numerous architectural projects, including several commissions from the current Farnese pope. In addition, the Sangallo family, and Antonio in particular, were experienced designers and builders of modern fortifications. An impressive item on Antonio da Sangallo's long résumé was the small town of Castro—a darling project of Pope Paul III.[11] Castro was the seat of an independent duchy in northern Lazio that Paul had conferred upon his oily son Pier Luigi Farnese. Although the ancient town was little more than a group of small structures (a cluster of "gypsy huts" as one contemporary described it), Castro was given a complete architectural makeover by Sangallo, who also designed the town's fortifications as a model of modern defensive design.

When the defense of Rome became an issue early in Paul's papacy, Sangallo and Michelangelo were poised for their first public confrontation.[12] Michelangelo's authority in the area of military architecture and engineering rested primarily on his role as governor-general of Florentine fortifications during the siege of his native city in 1529–30 (see plate 13). That experience earned him an advisory role regarding the defense of Rome as early as 1537.[13] However, by the 1540s Michelangelo no longer had in his possession any of the designs drawn for the

Florentine Signoria, and worse still, Florence had lost the war—even if it could be argued, and legitimately, that the city had surrendered because of starvation, exhaustion, and betrayal rather than any failure due to Michelangelo's defenses. Ultimately the city had been forced to capitulate, an irrefutable fact that the unctuous Antonio did not hesitate to exploit. Meanwhile, Antonio could produce sheaf after sheaf of sketches to remind the pontiff of his many designs for Castro, as well as numerous drawings for a brilliant plan to significantly shorten Rome's defensive circuit.[14]

One imagines something of the exchange before the pontiff, and the inevitable result. Which argument was going to carry more force? "I was in charge of the fortifications for Florence, but my designs were not actually constructed as I intended . . ." Or, from the opposing party: "I am the architect of the new duchy of Castro with the most up-to-date defenses in the world . . . which Your Holiness is welcome to visit at any time."

To buttress his claims, Sangallo employed a squadron of assistants, including the highly experienced military engineer and mapmaker Leonardo Bufalini.[15] This supremely well-staffed workshop was able to produce drawings and a clay model in just a few days. Before Michelangelo had sketched a single idea, Sangallo and his entourage showed the pope a small but impressive three-dimensional model of a modern angle bastion with a lowered and battered profile (that is, with a receding upward slope) concealing cannon ports within reentrant angles. The slanted wall and rounded crown were designed to deflect cannon balls, and most importantly, the bastion provided for maximum cross fire from well-protected defenders. Instead of old-fashioned merlons and loopholes for crossbows and harquebuses, the construction presented a formidable monolithic appearance. Each star-shaped bastion would replace more than a half dozen square and ineffectual medieval towers that would prove easy victims of modern ordnance. Michelangelo might have countered that Sangallo's designs were similar to his own, but he did not have a comparable model or drawings to prove it. As much as the pope believed in Michelangelo, Antonio da Sangallo was better prepared. Michelangelo lost the argument.

Sangallo's Roman bastion (see plate 14) is an intimidating structure at the city's southern boundary that anticipates fortifications of a later vintage—from America's Fort Ticonderoga to the French Maginot Line.[16] Looking from outside the walls—that is, from the perspective of an attacking army—it is impossible to grasp the overall design (as one might from an aerial perspective) and, therefore, difficult to know where to attack. At every point of possible approach, one is confronted by an imposing battered wall nearly fifty feet in height, of some three hundred brick courses. But height is the least important aspect of its strength. Only when one approaches does it become apparent that every part of the wall is defended by a decimating cross fire from large- and small-bore weapons. This was not the "conventional" warfare most contemporary soldiers would have encountered. Siege towers, scaling ladders, grappling hooks, battering rams, trebuchets, and overwhelming numbers of pike-, sword-, and bowmen would prove totally ineffectual against such modern defenses. The number of cannon one could deploy was infinitely more important than the size of one's army. Anyone inside Sangallo's new bastion would feel complete confidence; anyone outside would elect to attack elsewhere.

Sangallo built only one section of his mammoth enceinte. It took an exceptionally long time to construct, and its cost was astronomical; his brilliant conception was far in advance of available resources. What is more, the decision to build the bastion alongside the Porta Ardeatina, defending the southern approaches to Rome, proved strategically unsound. Far removed from St. Peter's and at considerable distance from the greatest concentration of Rome's population, the new bastion did little to protect the all-important city center and Vatican Borgo. And so, the perennial problem recurred: What parts of Rome should one defend, and how? But then came the additional, pressing question: At what cost?

Ever the pragmatist, Pope Paul diverted Sangallo to a defense of the Borgo—the area *trans pontina* most important to the papacy. Intelligent and amenable, Sangallo turned his attention to the natural topography of the steep Vatican hill facing Trastevere. Here, he designed a ravelin-like bastion to protect the approach to the Saxon gate, now

known as Porta Santo Spirito, which faces south and is the culmination of the long straight street, parallel to the Tiber, now known as the Via Lungara. Sangallo dressed his gate in the decorative language of classical antiquity: giant engaged columns of white travertine on tall plinths declared this to be a monumental entryway to the Vatican Borgo. Given the attractive classicizing architecture, an enemy would be little aware of being lured into a narrow corridor of destructive cross fire. Brilliantly, Sangallo perfectly fulfilled the needs of the pope: to defend but also to adorn Rome.

More than half of the travertine blocks needed to complete the monumental gate were delivered and put into place. The engaged columns rose two-thirds their full height against a brick backdrop. Then, suddenly, in the late summer 1546, Antonio da Sangallo died, and all work halted. Unfortunately, the gate stands incomplete (see plate 15); the brick core and weather-stained travertine blocks inspire neither fear nor admiration. But worse than merely unfinished, the gate appears weirdly amputated.

One might rightly ask: Why was Antonio da Sangallo's Saxon gate never finished, even though it was more than half complete? What is the explanation for the sudden interruption? Was the architect really so critical to its ultimate realization? These questions are particularly relevant because they highlight one of the central themes of Michelangelo's late life: projects by his contemporaries were allowed to languish while nearly every one of Michelangelo's architectural projects eventually was brought to fruition, even if left incomplete at his death.

A Giant Mess

At Sangallo's death, in August 1546, work halted not only on the Saxon gate but on all of his current architectural projects, including the Farnese Palace and New St. Peter's. Michelangelo was not unhappy to be rid of the annoying younger man, but he hardly imagined that he soon would inherit all of Sangallo's unfinished work. At first the pope tried to enlist Giulio Romano as architect of St. Peter's, but the Gonzaga court artist died in Mantua less than three months after

Sangallo. Of course, there were other architects—especially from Sangallo's entourage—who were capable of carrying on the master's projects. Among these, Nanni di Baccio Bigio was an obvious choice. Nanni had long been associated with the Sangallo family and St. Peter's, or Jacopo Meleghino, another long-term employee, whom Pope Paul III actually appointed as architect on November 1, 1546.[17] It therefore came as a genuine surprise—even a shock—when the pope told Michelangelo that he was to take over the enormous task of completing the largest church in Christendom. One can glean from Michelangelo's correspondence and other records what may have been pondered and discussed between the artist and his pontiff, and the imagination fills in the rest, beginning with Michelangelo's initial thoughts.

No.

Not a good idea.

What of Nanni di Baccio Bigio? Or Meleghino?

Michelangelo had many ready objections, beginning with the sorry condition of the "new" church. He had just suffered a constellation of intense personal losses, and his advanced age surely rendered him unqualified for the job. Indeed, he fully expected his own imminent death. He was, after all, older than the recently deceased Antonio da Sangallo—and his own failing health would place the whole project once again in jeopardy. Sangallo had died at age sixty-one, and Michelangelo was already ten years older! These were all good reasons to justify his reluctance. Moreover, he added, "I am not an architect."

One imagines how that went over.

There is a pause.

Paul is pope.

Michelangelo is an artist and servant to the pope.

They have already worked together a dozen years, and both are in their seventies.

Paul is silent.

Michelangelo then added that he still had not completed the frescoes in the Pauline Chapel—that is, Paul's eponymous chapel—which was true.

Silence.

Michelangelo then claimed to have so many obligations that he didn't even have time to write to his family—as his niece had recently reminded him.[18]

"Architecture is not my profession," he protested once again, which also was true, if a bit disingenuous. He claimed to have only limited experience as a builder, an occupation, he rightly recognized, that demanded more diverse skills than any of the arts. One does not build a building from mere ideas and models, which is why there were so many problems with paper architects such as Antonio Filarete, Leon Battista Alberti, and Leonardo da Vinci. Even Donato Bramante (1444–1514) had been much better at making beautiful drawings than anticipating engineering solutions.

The fortifications of Florence were Michelangelo's major claim to being a builder of large architectural projects, and yet Pope Paul had favored Sangallo as the designer of Rome's fortifications. A discomfiting, rankling moment followed, which, of course, rankled the artist more than the pope.

The pope remained silent.

Michelangelo's greatest architectural accomplishment to date *would* have been the facade of San Lorenzo in Florence, but to the artist's enduring shame and sorrow that project had been cancelled more than two decades earlier. His other two architectural projects—the Medici Chapel and the Laurentian Library—languished incomplete. In any case, the scale and complexity of New St. Peter's dwarfed these comparatively modest structures.

The pope had never seen a single building by the artist.[19] In fact, no complete building existed. What sort of evidence did the pope have to justify such an appointment?

Michelangelo was nearly seventy-two; he was simply too old to take on such a burdensome responsibility. He would never live to see St. Peter's completed or even advanced in any significant fashion. He doubted he would even live long enough to complete the frescoes in the Pauline Chapel. It would be foolish and irresponsible for him to accept such a monumental task. During the twelve years he had lived

in Rome, since settling there in 1534, Michelangelo had witnessed almost no progress at St. Peter's. How could he possibly rectify this sad state of affairs?

More silence.

Everything about St. Peter's was a mess. Every architect who followed Bramante had departed from his original, centralized design. In forty years there had been a succession of a half dozen architects, and every single one had tried to impose his own, incompatible ideas. Equally problematic were the deputies of the building works (the Reverenda Fabbrica di San Pietro, usually referred to by Michelangelo as the *fabbrica*). The deputies were a constantly changing body of officious, interfering bureaucrats—penurious by nature and obstructionist by inclination. The overseers were all Church-appointed officials, many of whom had worked closely with Antonio da Sangallo during the twenty years he had served as chief architect of St. Peter's. They would be skeptical of Michelangelo, legitimately so, as he was not Sangallo's natural successor nor the best qualified to step into Sangallo's experienced shoes. One could hardly fault them for thinking Michelangelo's appointment a colossal error.

From top to bottom, the *fabbrica* was rife with inefficiencies and favoritism that courted corruption. Bribery and graft were rampant. A huge amount of waste resulted from incompetent officials unknowingly purchasing shoddy materials at exorbitant prices. Hardly a person, from the lowly carter to a red-hatted cardinal, remained untainted by the loose money resulting from poor organization and the shady business practices of the *fabbrica*.

Nonetheless, parts of the building *had* been constructed. That too presented problems. With every architect, St. Peter's had "advanced," but ever further from Bramante's original and clear conception. This was no longer a building Michelangelo could believe in, nor could he do much to correct its multiple faults—of conception, design, and construction. In Michelangelo's mind, Sangallo was the worst culprit, and yet he had enjoyed the longest tenure in the long succession of architects. Did Pope Paul really expect Michelangelo to take over and continue Sangallo's design?

Sangallo had built a significant portion of the south transept, thereby implementing his own ideas for "improving" Bramante's original design. He had greatly increased the size of the building by adding an ambulatory, that is, an exterior aisle that was to extend around the entire perimeter of the church. But even this folly only signaled the beginning of multiple problems.

And still the pope was silent.

Another major sticking point was the model. Anyone foolish enough to take over from Sangallo would be constrained by his gigantic wooden model (see plate 16). And what a stupendous model it was! It sat on sawhorse supports, which permitted a person to walk under and inside it, to gaze up into the miniature dome and to marvel at its painted detail, to imagine a church that was to be twenty times this size. Built with hinges, it opened to reveal the church in cross section. The architectural extravaganza measured twenty-four feet long and twenty feet wide. It had required eight woodworkers seven years to build, at a staggering cost of some four thousand ducats.[20]

It was impossible *not* to be impressed by Sangallo's model. Even Michelangelo, who had constructed an impressive model for the San Lorenzo facade, had to admit that Sangallo's model was a masterpiece beyond compare. Nonetheless, it was an outrageous extravagance and a brazen public-relations ploy. Due to its size, expense, and the effort required to construct it, the model practically guaranteed that Sangallo's design would be built. It gave one hope that the venerable Constantinian church would be replaced with a more magnificent building. Never mind that, at least in Michelangelo's opinion, it would be more horrific than magnificent.

Michelangelo surely knew the *fabbrica* would never countenance his appointment, especially if he immediately suggested changing Sangallo's design. Most church officials embraced the status quo. The status quo was now Sangallo's model. Moreover, these same officials were the very persons who approved the model's financing in the first place. Why would they reverse course now? What guarantee would Michelangelo *ever* have of the *fabbrica*'s support? And, quite honestly, why *should* they give him their support?

Heavy silence.

The model was, as we say now, in modern parlance, "a fact on the ground." Yet, Michelangelo maintained that he could never build a church according to such a design. Fascinating in miniature, he saw only disaster when it was imagined at full scale. To his mind, it was an architectural monstrosity. But many held a vested interest in Sangello's model, and they inevitably argued the obvious: Why depart now, at this advanced stage, from a design that had been approved and enshrined in this fabulous (and expensive) model? Most favored Sangallo: the deputies of the *fabbrica* who had approved the funds, the group of senior assistants who understood Sangallo's plans and were ready to carry them out, and a large cadre of workers who labored at the building site every day and whose employment depended on maintaining the status quo. What counterargument did Michelangelo have?

Then Paul spoke. Disregarding the conflicting arguments and emotions, Paul made his decision. Paul was determined. He was the pope.

Undeterred by his artist's "intense dismay," Pope Paul appointed Michelangelo supreme architect of St. Peter's.[21] The appointment officially began on January 1, 1547. Michelangelo had been negotiating with Paul since November. Perhaps reconciled, he started working on an alternative design as early as December 1546.[22] But suddenly he was no longer merely an adviser; he was now the architect in charge.

Just as the artist feared, he inherited a bevy of thickheaded deputies, a bunch of obstructionist overseers, and a recalcitrant workforce—all as loyal to Sangallo as they were skeptical of the new and comparatively inexperienced architect. Facing countless obstacles, and supposedly still responsible for completing the frescoes in the Pauline Chapel, Michelangelo took on the new obligation with understandable reluctance. It was a dubious honor. His first task was to meet with the deputies who oversaw the building's financing and construction. And then he must persuade the workers: the stonecutters, the bricklayers . . . and so many others.

A Pasture for Silly Sheep

As Michelangelo expected, the model immediately became an issue. Many of the overseers, as exasperated as the pope by the lack of progress in building the new church, could not understand why Michelangelo refused to embrace Sangallo's model. Michelangelo failed to hold his tongue. When one of the model's supporters praised Sangallo's design as "a meadow where there would never be any lack of pasture," Michelangelo dryly responded: "That's only too true," by which he meant that it "provided pasture for dumb oxen and silly sheep who knew nothing about art."[23] One might suspect Vasari of cleverly inventing this pungent exchange, if not for the fact that, in a calmer moment, Michelangelo had actually written a lengthy critique of Sangallo's project in a letter to one of the few sympathetic members of the *fabbrica*, Bartolommeo Ferratino:

> For with his outside ambulatory, Sangallo immediately took away all and every light from Bramante's plan; and moreover it does so when it has no light itself whatsoever. And there are so many hiding-places above and below, all dark, that they provide great opportunities for no end of vile misdemeanors: such as the concealment of outlaws, the counterfeiting of money, getting nuns pregnant, and other sordid misbehaviour; and so in the evening after the church closes, you would need twenty-five men to seek out those who are hidden there.[24]

Michelangelo further noted that Sangallo's plan required the destruction of several significant structures, including the nearby Pauline Chapel. "Nor, I believe," Michelangelo continues, in his letter to Ferratino, "would even the Sistine Chapel survive intact."[25] Had the spiteful Sangallo been purposefully perverse in designing a structure so enormous that it would wipe out Michelangelo's greatest work of painting? If not for death's saving grace, Michelangelo's entire oeuvre in fresco might have been lost. After signing the letter, Michelangelo could not restrain himself from adding a poignant, personal note: "Looking at Sangallo's model, it would mean that everything that has been done in my time would be destroyed, and that would be a great loss." Indeed.

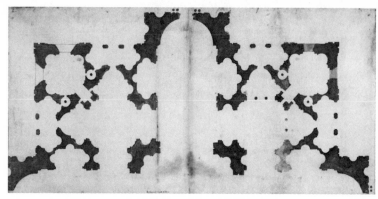

Donato Bramante, Plan of St. Peter's, 1505, Gabinetto Disegni e
Stampe degli Uffizi 1A, Florence

But Michelangelo believed he could rectify Sangallo's mess. The real
intention behind his long letter to Ferratino becomes clear when Mi-
chelangelo makes a plea to abandon Sangallo's model in favor of re-
turning to Bramante's original conception. This is notable, for in mak-
ing this appeal, Michelangelo set aside his personal dislike of Bramante,
his onetime rival.

> It cannot be denied that Bramante was as skilled in architecture as
> anyone else from the time of the ancients until now. It was he who drew
> up the first plan for St. Peter's, not full of confusion, but clear and
> uncluttered, luminous and free on all sides so that it did not detract at
> all from the palace. It was regarded as a beautiful achievement, as is still
> manifest; and thus anyone who has distanced himself from Bramante's
> arrangements, as did Sangallo, has distanced himself from the truth.[26]

Michelangelo addressed Ferratino as a dear friend—*amico caro*—
and signed the letter "Vostro Michelagniolo." Ferratino was one of the
few inside members of the supervisory *fabbrica* who proved helpful to
the artist. While not a figure of great historical consequence, he lent a
sympathetic ear and helped Michelangelo navigate the obstructionist
bureaucracy of the *fabbrica*. With the backing of a person of Ferratino's
stature and the unqualified support of the pope, Michelangelo hoped
to accomplish something at St. Peter's. His first and most important

victory was winning the battle against Sangallo's model. But though he won the battle, he had not yet won the war, for problems with the *fabbrica* and with Sangallo's loyal supporters continued for many years.

Next, Michelangelo surveyed the work site.

After more than forty years of demolition and new construction, St. Peter's was a depressing sight. Vaults linked the four massive piers, yet the central crossing remained open to the sky. While a temporary structure protected the grave of Saint Peter from the elements, pilgrims had difficulty negotiating the chaotic work site or feeling any sense of veneration.[27] Broken pieces of the nave columns and entablature of Old St. Peter's lay where they had been pulled down in ruinous haste. The new construction was encased in scaffolding, festooned with ropes, cranes, and hoists, and littered with disordered piles of building stone and equipment: clamps of old and new bricks, sand and *pozzolana* (volcanic ash) for mortar, carts, nails, rope, pulleys, wood, and mud everywhere. The foul stench of animals and refuse and the cacophony of work pervaded St. Peter's. The largest construction site in the world looked more like a Roman ruin than a new church (see plates 17 and 18).

Bramante was a brilliant designer but a sloppy engineer. Charged by Pope Julius II with redesigning the most important church in Christendom, Bramante had proposed a bold solution. Constantine the Great, the first Roman emperor converted to Christianity, sponsored the building of a monumental basilica over the supposed site of Saint Peter's grave in the early fourth century CE. When Julius commissioned Bramante to rebuild the church, the early Christian basilica was more than one thousand years old; the walls listed and the roof leaked. Bramante proposed replacing the early Christian basilica with a centralized church crowned by a monumental dome. The audacious design meant the destruction of the venerable but decaying older structure. Piece by piece, the early Christian basilica disappeared as the new church came into being.

In the urgency to erect the new church, Bramante proved ruthless in destroying the old. Pulled down one by one, the monolithic marble columns of the Constantinian basilica disappeared into fragments.

The loss of those beautiful antique columns prompted Roman wags to dub Bramante *Il Ruinante*, an assessment shared by Michelangelo, who pointed out that "it was an easy thing to place one brick upon another but to make such a column was most difficult."[28] Moreover, in constructing the four massive piers that were to support the central dome, Bramante had significantly underestimated the weight and thrust they would be asked to sustain. Michelangelo's immediate challenge was to revive Bramante's conception and correct its many engineering deficiencies. But this required removing much recent construction—in a sense, reversing nearly forty years of building history. It demanded courage and vision from both patron and artist. Fortunately, the pope trusted his artist.

Pope Paul's charge to rebuild St. Peter's gave new purpose and focus to Michelangelo's life, becoming his greatest, lifelong responsibility and inducing him to put aside his private concerns and sorrows. St. Peter's offered a final mission and the best reason for the artist not to yield to old age, despair, or death. Michelangelo had already accomplished much and had every right to wonder whether this was the best way to devote his few remaining years. He was old and recently had lost many of his dearest friends. He never before had faced such a daunting challenge. Yet his salvation, he eventually came to realize, depended on resurrecting St. Peter's. In the remaining years of Michelangelo's life, St. Peter's was the artist's principal and ever-present concern. The church is the central narrative of his late life.

ARCHITECT OF ST. PETER'S

Pope Paul had convinced a reluctant Michelangelo to take over St. Peter's. Maybe it was because he was pope, or maybe it was because the two shared more than just wine and pears. The church gave life and purpose to the pope and his artist—both conspicuously aware of the brief time remaining to them and their overriding responsibility to God.

Reorganizing the Work Site

Michelangelo's most urgent task was to strengthen the four crossing piers that would support St. Peter's dome. At least this work was not controversial. It was fairly easy to demonstrate Bramante's engineering inadequacies and much safer to blame the long-dead Bramante than the recently deceased Sangallo. Already the piers were visibly deflecting, and cracks had appeared in the crossing vaults. Michelangelo immediately set about encasing and greatly enlarging the girth of the four central piers. However, when he turned his attention to the exterior wall of the building, he quickly ran into determined resistance from the *setta sangallesca* (Sangallo sect), the group of workers and overseers loyal to their former master. Given that many had worked for Sangallo

for a decade or more, they felt justified in questioning whether the newly appointed architect knew how to build such a complex structure. Was he even an architect?

Michelangelo wanted to remove Sangallo's exterior ambulatory. This was no minor matter, for it meant undoing some twenty years of construction.[1] Michelangelo explained that the ambulatory significantly reduced the amount of interior light and, from a structural perspective, was inadequate to counteract the enormous thrust of the dome. Rather than recognizing this engineering problem, most members of the *setta sangallesca* merely understood this as criticism of their work. Convincing these insistent loyalists would not be easy; therefore, for the moment, Michelangelo turned his attention to the north side of the building. There, at least, he could build a reinforced perimeter wall substantial enough to convince skeptics of the south transept's inherent design faults and structural weaknesses.

Work proceeded simultaneously on the four central, crossing piers, as well as on the four equally important monumental piers on the building's exterior. Because the latter are incorporated into the building's exterior wall, and appear from the outside as engaged pilasters, they are not immediately recognizable as structural elements in the same manner as the freestanding crossing piers. Nonetheless, the perimeter piers are critical in absorbing the weight and thrust of the dome. In order to persuade the many skeptical workers, Michelangelo launched what today we would call a marketing campaign—with donkeys and mules.

Michelangelo designed each of the four external piers with internal helical ramps. The gradual incline of the ramps permitted sure-footed donkeys and mules to transport building materials to the uppermost reaches of the construction: thousands of bricks, sand and lime for mortar, rope, wooden poles and planks for scaffolding, and water in large jugs (*orcioli*). Only an experienced project engineer would appreciate the amount of water needed in construction as well as by workers, who did not have time to descend a scaffold to get a drink or to wash mortar from a trowel. And the animals—because they plodded along a gently sloping and entirely enclosed helical ramp—had no sense of

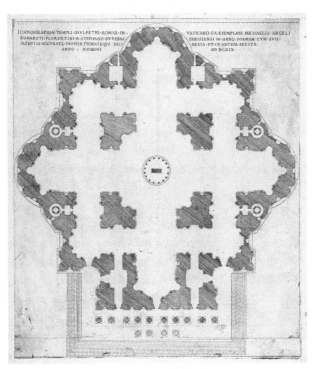

Etienne DuPérac, *Michelangelo Plan for New St. Peter's*, 1569,
engraving, Metropolitan Museum of Art, New York

the extreme height to which they were climbing and therefore carried
their heavy loads without fear. The muleteers easily controlled their
dumb and trusting charges. Even the midday meal was brought up by
donkey. Michelangelo had learned this practice from the legendary
Filippo Brunelleschi. As architect of the Florentine cupola, Brunel-
leschi had greatly increased efficiency by feeding and watering his
workers on the high construction site of the cathedral of Florence.

Michelangelo organized the laborers into small groups and gave
them explicit daily instructions. Eventually, even some of the most
resistant workers realized that Michelangelo understood how to or-
ganize a building site. Few were aware that the new architect had
managed more than three hundred laborers and artisans at San Lo-
renzo in Florence and even greater numbers in constructing that city's

fortifications. The entrenched supervisors soon recognized that the new architect grasped the complexity of the work and understood how the manifold tasks must be carried out in a well-determined sequence. Michelangelo astonished them with his grasp of detail and his ability to maintain oversight of the complete project. This displayed not the useless book learning of a well-educated humanist but a craftsman's hands-on knowledge. Although he claimed a noble lineage, Michelangelo knew as well as any day laborer how to construct a scaffold. He equally knew the value of good-quality rope, the cost of materials, and the necessity of providing a regular supply of water. He understood stone, and he had a special appreciation for the marbles being removed from Old St. Peter's. And he knew the tragic cost in human lives often associated with such dangerous work. Michelangelo had been appointed as the new architect of St. Peter's, but he also shouldered the many responsibilities of general project manager.

Shortly after he began work at St. Peter's, Michelangelo called an immediate halt to the wanton destruction of the old basilica. If material could be reused, and much could—marble revetment, entablature blocks, and especially the original columns—then it was to be preserved and repurposed. Perhaps Bramante had decided that the columns of the old basilica were too small for the new building. There were, however, more creative solutions than breaking them into useless pieces. Michelangelo found homes for some of the smaller columns by using them as frames for altar tabernacles in the transepts. Granted, they no longer served as structural elements, but who would deny their multihued beauty; moreover, these columns were, in effect, architectural relics of the Constantinian church. When he ran short of material, Michelangelo obtained additional columns from other sites. For example, in April 1547, he contracted to have two white granite columns transferred from Santa Maria Nova, a venerable early Christian church in the Roman Forum, and one red granite column from the remote Baths of Caracalla.[2] Along with many other medieval and Renaissance builders, Michelangelo could be accused of despoiling ancient and medieval Rome. But those purloined columns found new life in St. Peter's.

More Stone, Less Waste, and a Brass Ruler

Although Michelangelo professed to be a marble sculptor, he also had a feel and an appreciation for travertine (*lapis tiburtinus*), the local stone that Emperor Augustus exploited in his transformation of Rome from a city of brick into a city of "marble." The Romans used the chalky white calcareous stone, found in large quantities in nearby Tivoli and in shallow beds along the Aniene River (a Tiber tributary), to build Rome. Travertine is a porous limestone composed of compacted crustaceous organisms that has a rich texture and a pitted surface that absorbs and colors the bright Roman sunshine.

From the travertine quarries at Tivoli to St. Peter's is about nineteen miles. A two- or four-wheel cart loaded with stone generally made the trip in two days, stopping overnight near Settecamini on the Via Tiburtina. Fees were negotiated; the price for a cartload of travertine depended on the size of the blocks and the number of oxen needed to haul the load. When the road turned to mud—which was often— carts were delayed, and fees escalated as additional oxen and time were required. Mud posed one of many opportunities for petty corruption: complaining of the travel conditions, the carters could charge almost anything. But suddenly, the new head architect at St. Peter's was questioning those inflated costs. He and his equally hard-nosed representatives refused to accept lame excuses for inflated prices and desultory work. When stone arrived, Michelangelo or his trusted overseers inspected it and approved that of acceptable quality; inferior material was rejected, and the carter sent packing. Within just a few weeks, stone began arriving at the work site on a regular, predictable schedule. Hods of well-mixed, viscous mortar no longer turned uselessly hard while masons awaited tardy deliveries of stone. Suddenly, with less wasted labor and material, waste and costs declined.

The work crew overseers (*soprastanti* and *capomaestri*) grudgingly recognized that the new architect was experienced in multiple facets of the work. Michelangelo demonstrated his knowledge on a daily basis. He designed, for example, ingenious and more efficient hoisting mechanisms, which meant that he understood block and tackle,

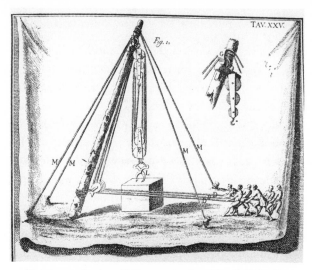

Hoisting mechanism, 1743, engraving from Niccola Zabaglia,
Castelli e ponti, Washington University, St. Louis

pulleys, capstans, and bollards—all of which became increasingly im-
portant as the building rose higher. Michelangelo also knew rope: the
bane and basic necessity of the builder, quarryman, and carter; the
shipwright, sailor, and cattle thief; the meat-packer, hauler, and hang-
man. There was a constant need to replace worn ropes and to locate
additional rope. Often rope was poorly manufactured; good rope was
expensive and difficult to obtain in sufficient quantities. And vexingly,
because of negligence, rope was too often left outdoors, where it weak-
ened from prolonged damp. Or it was simply stolen.

As shipbuilders, the Venetians were expert rope makers. But their
rope could not be purchased; indeed, its manufacture was a state mo-
nopoly and a closely guarded secret. One day, Michelangelo found
himself repeating something he had heard years ago from his overseer
at San Lorenzo in Florence, Michele di Piero Pippo: "You will succeed
if you have a good rope."[3] The workers at St. Peter's began taking better
care of the ropes, especially when they realized their lives depended on
the cords that lashed their scaffold, that raised the loads under which
they worked, and that secured their precarious position when they laid

bricks at two hundred feet elevation. In a short amount of time, the new architect was proving to be useful on the building site. And he had other good ideas.

A bell was purchased to sound the hours, so workers knew when it was time for the midday meal and when it was time to quit. Michelangelo fixed the workweek at six days and regularized working hours. Generally, laborers toiled from sunup to whenever the light failed, around vespers in the winter but as late as compline during summer months. Stone carvers brought their own tools, but Michelangelo installed a smithy on-site to hone chisels and repair equipment. With so many stone carvers at work, a constant supply of anthracite (*carboni per assottigliare*) was required to keep chisels sharp. At strategic locations on the sprawling work site, Michelangelo built simple roofed sheds for the most important carvers—to keep the workers out of the elements and their equipment dry and safe from theft.

The *segatori*, those responsible for cutting the travertine blocks received from Tivoli, required the largest spaces—which were also the messiest. They also required an enormous quantity of sand and water—so much water!—for the abrasive slurry used in sawing blocks. There was some water to be had from an ancient aqueduct that fed a horse trough near the Porta Cavalleggeri, but its volume was inadequate for the needs of the giant construction site. The next closest source was the Tiber River, some twelve hundred paces distant. Michelangelo organized a regular delivery by donkeys, each of which could carry two heavy barrels of water, trekking from the Tiber to St. Peter's and back again. These were the drudge animals, not the elite donkeys and mules that carried food and water—as well as bricks, sand, and wood planking—up Michelangelo's helical ramps.

The carvers of marble—the *scarpellini* (in Tuscany, *scalpellini*)— were scattered in diverse locations around the building site. One heard a constant, irregular rhythm of hammers and chisels—melodic to the stonemasons, irritating to the officious priests. The most highly skilled carvers, the *intagliatori*, were also the best paid. *Intagliatori* carved column capitals and bases as well as the many complicated moldings Michelangelo designed. For example, the records show, Michelangelo

tasked Ciola, a Florentine *intagliatore*, to carve two column capitals, while he hired *maestri* Pietra Santa and Pavolo da Borgo to carve one each.[4] They were given eight months to complete their respective tasks, which indicates the large size of the blocks and the difficulty of carving an intricate Corinthian capital. It also suggests Ciola's superior skill and speed; he could carve two capitals in eight months, whereas the other two *intagliatori* were expected to produce only one each. Such specialized carvers were handsomely paid, and they required the finest tools—rulers, calipers, fine-point chisels and drills, and precisely cut tin templates to guide their detailed work.

Michelangelo made many drawings of building details and templates (profile drawings used as patterns). A skilled assistant would double or quadruple the proportions of the drawn design in order to produce a full-size pattern. Templates then would be cut from tin sheets and duplicated for distribution to the carvers at several locations across the large work site. If a particular feature was unusual or complicated, a woodworker might construct a three-dimensional model, which all the carvers could consult. The templates and models guided carvers at the various workstations, thereby ensuring that the *scarpellini* and *intagliatori* all carved precisely what the master had designed. Michelangelo needed to draw only one Corinthian capital, or make just one profile drawing, since each drawing served to make multiple templates. Thus, not many drawings were required to keep the highly skilled carvers busy for months. And, of course, either Michelangelo or one of his trusted supervisors periodically checked the work, thereby ensuring quality control.

As with rope, standard measures at a building site were critical. Without standardization, neither vault nor dome could be properly constructed. But standard measures did not yet exist. A *braccio* (an arm's length)—the most frequently used unit of length—was measured differently in Milan (0.599 meters), Florence (0.584 meters), and Rome (0.670 meters). Indeed, everywhere in Italy, "standard" was a local matter. Although rulers and knotted ropes had mostly replaced the length of a builder's forearm, there was still confusion as to what constituted standard measures. Yet, even the slightest deviation might

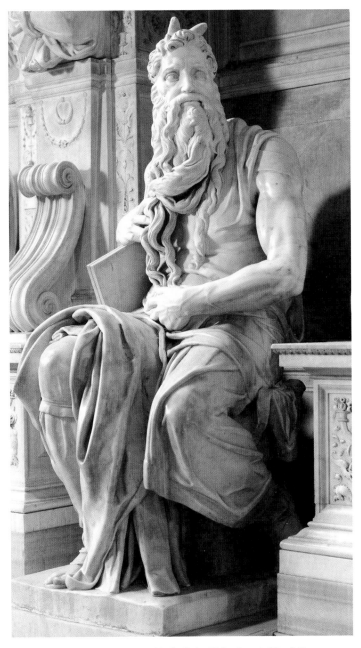

PLATE 1. Michelangelo, Moses, Tomb of Julius II, San Pietro in Vincoli, Rome

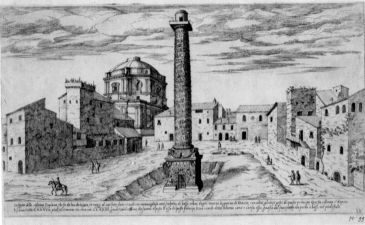

PLATE 2. (top) Facade of Michelangelo's house, moved from Via Macel de' Corvi to Passeggiata del Gianicolo, Rome

PLATE 3. (above) Etienne DuPérac, Trajan's Column, in Michelangelo's neighborhood, c. late sixteenth century, engraving. Private collection, St. Louis

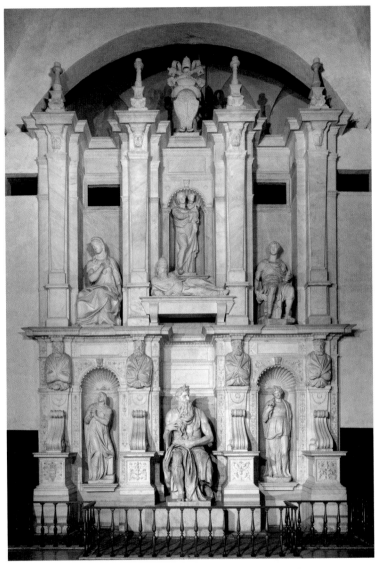

PLATE 4. Michelangelo, Tomb of Julius II, 1545, San Pietro in Vincoli, Rome

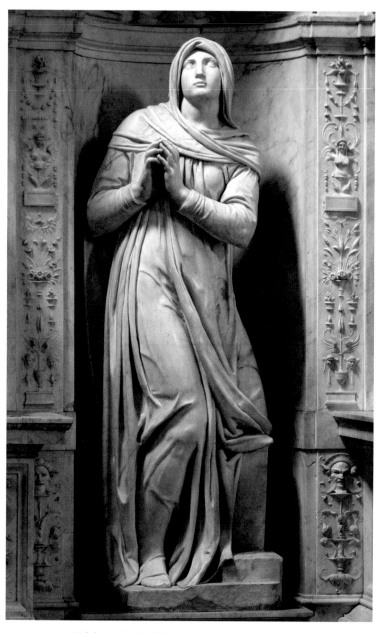

PLATE 5. Michelangelo, Rachel, 1545, Tomb of Julius II, San Pietro in Vincoli, Rome

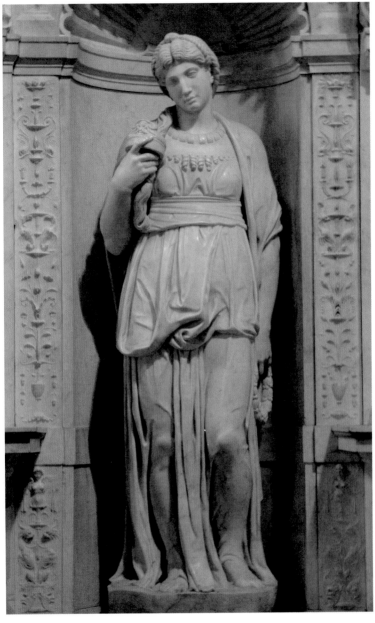

PLATE 6. Michelangelo, Leah, 1545, Tomb of Julius II, San Pietro in Vincoli, Rome

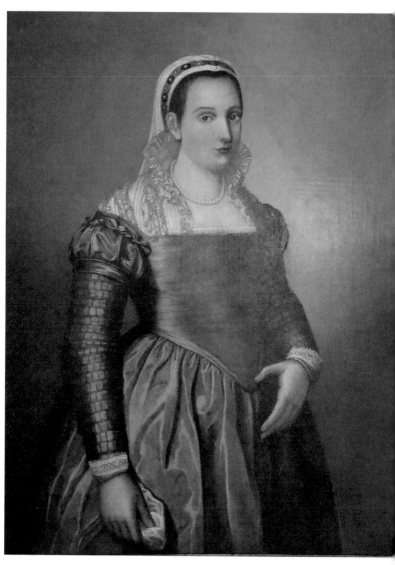

PLATE 7. Unknown artist, Portrait of Vittoria Colonna. Palazzo Colonna, Rome

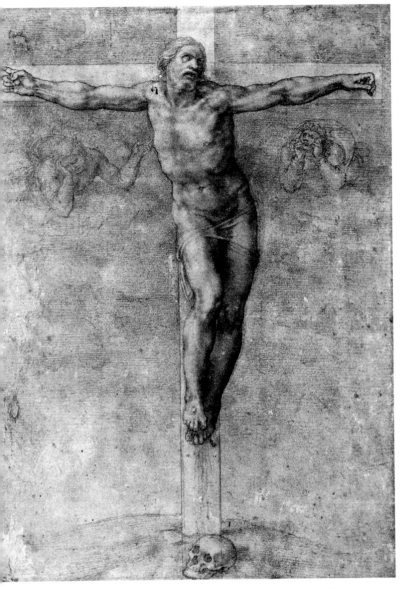

PLATE 8. Michelangelo, Crucifixion, black chalk drawing, given as a gift to Vittoria Colonna. British Museum, London, inv. 1895-9-15-504r

I

Poi chel mio casto amor gran tempo tenne
L'alma di fama accesa; ed ella un angue
In sen nudrio; per cui dolente hor langue
Volta al Signor, ond'el rimedio venne.
I santi chiodi homai sian le mie penne,
Et puro inchiostro il pretioso sangue,
Vergata carta il sacro corpo exangue,
Si, ch'io scriva ad altrui quel ch'ei sostenne.
Chiamar qui non convien Parnaso o Delo:
Ch'ad altra acqua s'aspira, ad altro monte
Si poggia, il piede human per se non sale.
Quel sol, che alluma gli elementi el cielo;
Prego, ch'aprendo il suo lucido fonte;
Mi porga humor a la gran sete eguale.

II

Con la croce a gran passi ir vorrei dietro
Al Signor per anguste erte sentiero
Si ch'io in parte scorgessi il lume vero
Ch'altro chel senso aperse al fidel Pietro.
Et se tanta mercede hor non impetro;
Non e ch'ei non si mostri almo et sincero
Ma comprender non so con l'occhio intero
Ogni humana speranza esser di vetro
Che sio lo cor humil puro et mendico
Apresentassi a la divina mensa;
Oue con dolci il partipate tempre
L'agnel di Dio nostro tsato amico
Se stesso in cibo per amor dispensa
Ne sarei forse un di satia per sempre.

PLATE 9. (above) Vittoria Colonna, "Little book" of sonnets, given to Michelangelo. Biblioteca Apostolica, Vatican City, Rome, Cod. Vat. Lat. 11539, fols. 1v-2r

PLATE 10. (right) Book of Vittoria Colonna's published poetry owned and signed by Michelangelo, as "Michelagniolo schultore." British Library, London, C.28.a.10

392
Ma quanto fece allor pungente strale
Più larga piaga, tanto oggi mi uanto
Di noua gioia, e doue pianfi, or canto,
E l'alma spoglio d'ogni antico male.
Vostra merce, Madonna, che rompeste
Il corso al pianto, e d'aspra indegnitade
Sgombraste il cor con note alte, e modeste.
L'alme, ch'or san del ciel tutte le strade,
Crebbero al gioir lor ben mille feste
Piene di casto amore, e di pietade.

IL FINE.

Michelagniolo schultore

PLATE 11. Michelangelo, Crucifixion, black chalk drawing. British Museum, London, inv. 1895-9-15-509r

PLATE 12. (right)
Titian, Portrait of Pope
Paul III, 1545–46, oil on
canvas. Museo di Capodi-
monte, Naples

PLATE 13. (above) Michelangelo, Drawn design for a fortified bastion. Casa Buonarroti, Florence, no. 22A

PLATE 14. (top)
Antonio da Sangallo
the Younger, Fortified
bastion, 1540s, Rome

PLATE 15. (left)
Antonio da Sangallo
the Younger, Saxon
gate, 1543–46, Rome

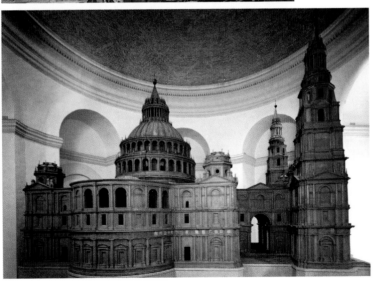

PLATE 16. (above) Antonio da Sangallo the Younger, Wooden model of St. Peter's Basilica, 1539–46, Vatican City, Rome

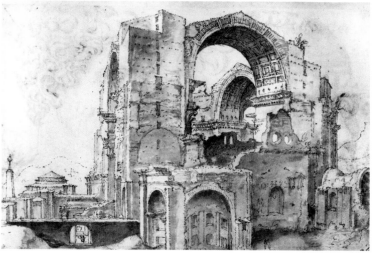

PLATE 17. (top) Maarten van Heemskerck, Drawing of New St. Peter's, 1530s. Berlin-Dahlem Museum, Berlin, Kupferstichkabinett 79D2a 52r

PLATE 18. (above) Maarten van Heemskerck, Drawing of New St. Peter's, 1530s. Berlin-Dahlem Museum, Berlin, Kupferstichkabinett 79D2 13r

PLATE 19. (top) Antonio da Sangallo the Younger, Farnese Palace, 1534–68, Rome

PLATE 20. (above middle) Farnese Palace, detail of cornice designed by Michelangelo, 1547, Rome

PLATE 21. (left) Farnese Palace, detail of third-story courtyard windows designed by Michelangelo, 1547, Rome

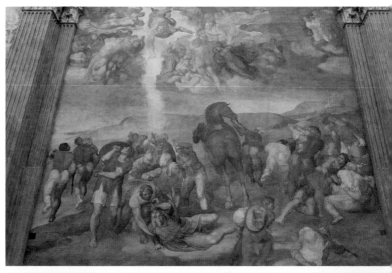

PLATE 22. (top) Michelangelo, Conversion of Saul, c.1542–50, fresco, Pauline Chapel, Vatican City, Rome

PLATE 23. (above) Michelangelo, Crucifixion of Peter, c.1542–50, fresco, Pauline Chapel, Vatican City, Rome

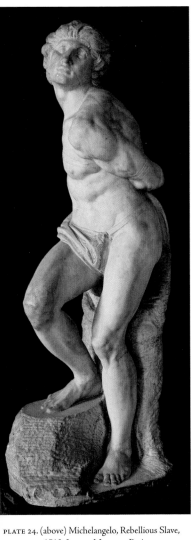

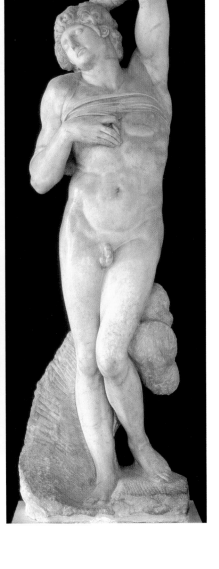

PLATE 24. (above) Michelangelo, Rebellious Slave, c. 1513. Louvre Museum, Paris

PLATE 25. (right) Michelangelo, Dying Slave, c. 1513. Louvre Museum, Paris

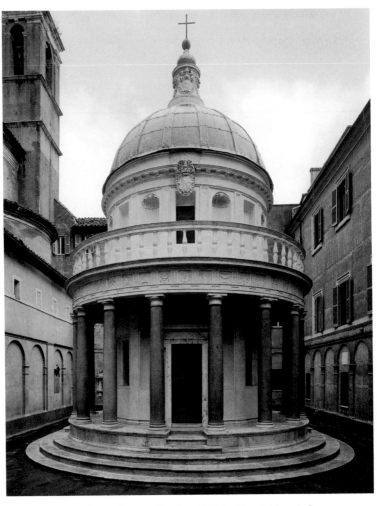

PLATE 26. Donato Bramante, Tempietto, 1502, San Pietro in Montorio, Rome

be responsible for a serious building error. Michelangelo had concerned himself with this problem when he worked at San Lorenzo, since the *braccio* used in Florence was not the same *braccio* used in the quarries of Pietrasanta, even though Pietrasanta was within the Florentine territorial state. To address the problem, Michelangelo sent a *braccio* measure to the quarries to ensure that every one of his underlings followed a standard measure. He was equally adamant about such details at St. Peter's. A slight difference in measurement could spell disaster.

In September 1547, Michelangelo's nephew sent him a brass ruler. Having heard that Michelangelo had taken over the largest architectural project in the world, Lionardo thought this would be an appropriate gift. The most important building in Rome *should* be built using superior Florentine equipment. Moreover, a ruler made of brass was very expensive—even more costly than Lionardo's most recent shipment of pears. Poor Lionardo. He was trying his best to ingratiate himself with his ornery uncle, who found a myriad of colorful ways to express his peevishness: the wine wasn't as good as last year; the ravioli was ruined en route; even a peasant wouldn't wear the new shirts Lionardo had sent; the property the nephew was considering buying belonged to a bunch of cheating knaves.

This latest gift also piqued Michelangelo's ire: "You have sent me a brass ruler, as if I were a mason or a woodworker who has to have such a thing with them. It shames me to have it in the house, and so I got rid of it."[5] So much for *that* gift. It took years for Lionardo to fully grasp that his uncle—the famous sculptor, painter, and architect— was, like so many of his Florentine contemporaries, much concerned about appearances. While Michelangelo was the greatest artist of his time, he nonetheless considered himself an aristocrat of noble birth. He aspired to be treated as a gentleman, that is, someone who does *not* work with his hands and someone who does *not* carry a ruler, even one of expensive brass. Ultimately, Michelangelo proved remarkably successful in sustaining both roles: artisan and aristocrat. As a Florentine

aristocrat of noble birth, he would never keep a brass ruler in his house; yet, at the same time, he convinced the artisans at St. Peter's of the importance of standard measurement—probably by giving one of them the brass ruler.

Gaining Their Trust

One day, Michelangelo intervened when two experienced carvers disagreed over the proper means of carving a molding for the cupola drum (tambour). To resolve the disagreement, Michelangelo made a still-extant profile drawing and then took up hammer and chisel to show them precisely what he intended.[6] The carvers were impressed: the chief architect could still carve fast and with precision—and he was over seventy years old! Of course, most carvers at St. Peter's were unaware—or cared little—about Michelangelo's previous experience as a builder and carver of stone. They were simply happy to be receiving wages on a regular basis.

While the workers at the building site appreciated a number of improvements, the overseeing deputies of the *fabbrica* were not as swift in acknowledging Michelangelo's superintendence. They little appreciated helical ramps for donkeys or precisely drawn template drawings. Rather, they saw the cost, especially of destruction. Thus, Michelangelo was called before the deputies to justify his many radical decisions. Anticipating their complaints, the architect wrote to his friend, the sympathetic Bartolommeo Ferratino. This is the letter already discussed in which Michelangelo criticized Sangallo's model and recommended a return to Bramante's original design. Knowing that the deputies were concerned that a large sum had already been expended on Sangallo's exterior ambulatory, Michelangelo wrote:

> As regards the part of the outer ambulatory that has been built, which they [the deputies] say cost a hundred thousand *scudi*, this is not true, because it could be done for sixteen thousand, and little would be lost if it were dismantled, because the dressed stones and foundations could well be reused and the *fabbrica* would save two hundred thousand *scudi* and three hundred years building time.[7]

In other words, though criticizing Sangallo's work in general, Michelangelo also acknowledged that some of his work could be salvaged. The expended monies would not be wasted. Rather than constructing the ambulatory envisioned by Sangallo, Michelangelo proposed to incorporate the construction, and its foundations, into a greatly thickened perimeter wall—one that would serve to counteract the thrust of the dome. It proved a reasonable and efficient means of proceeding, even if it implicitly criticized the very deputies who were then questioning him and who earlier had authorized the money to build Sangallo's misguided design.

Darkening Clouds of Dissension

Two of the *fabbrica* deputies, Giovanni Arberino and Antonio de' Massimi, voiced particular dissatisfaction with Michelangelo's management of the building project. These two felt their authority was being undermined, especially when an employee rudely informed them that he intended to follow only Michelangelo's orders. This prompted Arberino and de' Massimi to write an indignant letter to the pope, who in turn attempted to smooth their ruffled feathers by assuring them that Michelangelo was merely the architect in charge and had not been given authority over administrative affairs. Unpersuaded, the two deputies insisted on knowing Michelangelo's plans, especially since it appeared that he had no intention of following Sangallo's wooden model. The pope acquiesced to a meeting between the disgruntled deputies and his chief architect, although Paul, attuned to his architect's sensibilities, warned them that Michelangelo had to be treated with kid gloves (*con qualche morbidezza*).[8]

The meeting took place but quickly devolved into an ugly confrontation. An incensed Michelangelo accused the deputies of exploiting their position for financial gain. Despite much outraged expostulation, little was resolved. A subsequent meeting with the pope left the two deputies even less satisfied, since Paul declared his faith in Michelangelo's "rare virtue not only in painting and sculpture but also in architecture."[9] In retort, the deputies repeated a rumor that Michelangelo

intended to reduce the size of the building, thus creating a "little bitty St. Peter's" (*piccolo tempio di San Pietrino*).[10] The deputies further complained that they could not possibly be responsible for overseeing the building when Michelangelo's plans were unknown to them. The pope dismissed their protests, and then he dismissed them. Michelangelo explained his plans to a satisfied pope; the deputies were told to stick to administrative affairs.

Michelangelo's immediate problem with meddlesome deputies appeared to be momentarily resolved, but he soon learned how persistently obstructionist they could be. Even though Michelangelo had secured the unqualified support of Pope Paul, he repeatedly had to battle them. Things became especially problematic when Paul increased Michelangelo's duties by appointing him to take charge of all of Antonio da Sangallo's unfinished projects. These included the fortifications of Rome and the Farnese Palace, which the pope was particularly keen on seeing completed. It was the Farnese Palace project that inspired an especially nasty attack from an unexpected quarter.

Nanni di Baccio Bigio

Nanni di Baccio Bigio (d. 1568) was the son of Baccio Bigio, a Florentine builder who had worked with Michelangelo at San Lorenzo in the 1520s, first on the never-realized facade for the church and subsequently on the Laurentian Library.[11] Repeatedly, over a period of some ten years, Baccio Bigio had proven his worth as an overseer (*capomaestro*), directing work crews and offering Michelangelo invaluable advice on the construction of foundations.

Part of Michelangelo's managerial brilliance was his ability to identify persons with technical skills on whom he could rely. In Florence, he had benefited from a long succession of skilled persons, drawn from an interconnected network of "parenti, amici, e vicini"—relatives, friends, and neighbors. In addition to Baccio Bigio, there were Michele di Piero Pippo, Donato Benti, Stefano di Tommaso Lunetti, Andrea Ferrucci, Meo delle Chorte, Scipione da Settignano, and numerous

members of the Fancelli clan, including the laughable but completely dependable Domenico di Giovanni Fancelli, known as Topolino (the little mouse). These individuals were mostly older than Michelangelo, they were highly skilled, and they all had extensive experience in various facets of the building trades. All proved deeply loyal to the artist, working with him for ten, twenty, or more years. They were the core members of the vast San Lorenzo workforce, and Michelangelo truly appreciated what they could do for him.

In Rome, Michelangelo set about reconstituting a similarly reliable group of experienced foremen (*capomaestri* and *soprastanti*). Fortunately, a number of Florentines had been attracted to work opportunities in Rome, and they soon were followed by a younger generation eager for steady employment. But by the 1540s, many of Michelangelo's most trusted former overseers were dead, including Donato Benti and Andrea Ferrucci. Two others, Michele di Piero Pippo and Topolino were a decade older than Michelangelo and now in their mid-eighties. The artist knew they would not move to Rome. Baccio Bigio was also dead, but at least his son, Nanni, was working at St. Peter's. However, Michelangelo soon discovered that the son was not like his father. Instead of the reliable and loyal overseer that Michelangelo so desperately needed, Nanni proved to be constant trouble.[12]

Like Antonio da Sangallo, Nanni di Baccio Bigio came from a family of builders with much experience. Along with others, Nanni doubted that Michelangelo was equipped to take over St. Peter's. After all, it had been his father who years earlier had advised an inexperienced Michelangelo at San Lorenzo. Nanni knew that Michelangelo neither understood Vitruvius's theory of architecture nor followed its precepts (indeed, it was widely rumored that Michelangelo did not even read Latin!). Nanni refused to suffer any more slights, nor any more changes to Sangallo's plans for St. Peter's or for the Farnese Palace. The idea of Michelangelo appropriating the latter project appears to have especially peeved Nanni, who considered himself the more experienced architect. At the very least, he should inherit the Farnese Palace project because Michelangelo was preoccupied with St. Peter's.

Nanni di Baccio Bigio's jealousy and irritation are understandable. Not only had Michelangelo been appointed architect of St. Peter's—in preference to other, more experienced individuals—but now he was consulting as well on the unfinished Farnese Palace (see plate 19). While the palace was mostly complete, the large edifice still lacked a crowning cornice, the design of which called for a knowledgeable, experienced architect. Nanni believed he was that person, not Michelangelo.

Even more irksome were Michelangelo's radical ideas about how to "correct" Sangallo's design. In order to demonstrate the ill proportions of the unfinished edifice, Michelangelo had a wooden model made for a section of the cornice. Nanni was furious. Wasn't this the man who had criticized Antonio da Sangallo for wasting time and money building models? Michelangelo's cornice model, moreover, was "so enormous, that although it was made only of wood, masons had been obliged to shore up the walls" when it was hoisted into place high above street level.[13] According to Nanni and his confederates, Michelangelo's cornice design contravened the rules of classical architecture and proportion—that is, the precepts described in Vitruvius's treatise on architecture. Precisely.

The cornice that Michelangelo ultimately built *is* massive, but it successfully closes and contains the monumental palace block (see plates 19 and 20). It is visually rather than theoretically correct. For Michelangelo, the classical past did not prescribe a set of rules to be slavishly followed but instead offered a rich inheritance that fertilized his own fecund imagination. Equally, he did not feel constrained to adhere to recent architectural precedent, especially when he perceived errors of design and proportion. In order to make sound judgments, the artist once remarked, "one must have compasses in the eyes."[14]

As usual, Michelangelo did not disclose his intentions to those he considered lesser individuals. Therefore, Nanni went on the attack, and his venom spread. A friend, writing to Michelangelo from Florence, reported that a jealous Nanni was going about boasting that he would make his own model that would clearly demonstrate that "you

are doing mad and childish things." Nanni further claimed that the pope favored him, and that Michelangelo was throwing away infinite amounts of money. "Not only does he say all this," Michelangelo's informant continued, "but many other things against your honour and good fame. . . . Thus he utters a thousand follies [*mille pazzie*] about you, which vex your friends, for your honour is somewhat touched. Although he is not generally believed, still he goes about slandering to such an extent, that it is said, he has found some to believe him."[15]

Michelangelo was highly sensitive with regard to his honor, yet he refrained from responding to Nanni's insinuations (or to those of Nanni's associate), for, as he once remarked, "Anyone who fights with a good-for-nothing gains nothing."[16] Rather than deign to defend himself, Michelangelo merely forwarded the slanderous letter to Bartolommeo Ferratino, his principal defender at the building *fabbrica*. He added a brief postscript: "Messer Bartolommeo, please read this letter, and take thought who the two rascals are who, lying thus about what I did at the Palazzo Farnese, are now lying in the matter of the information they are laying before the deputies of St. Peter's. It comes upon me in return for the kindness I have shown them. But what else can one expect from a couple of the basest scoundrelly villains?"[17]

Mindful of Nanni's father, to whom he remained indebted, Michelangelo sought to avoid an open confrontation with the younger man. But Nanni proved to be a small-minded, ambitious scoundrel. He was the very sort of person with whom Michelangelo repeatedly had problems, one who did not subscribe to the unspoken laws of reciprocal favor and patronage that bound and guided Italian society then and now. Nanni continued to make trouble, and when Michelangelo died in 1564, Nanni had the temerity to immediately put himself forward as the next architect of St. Peter's.[18] His long-festering malice, however, gained him little.

Fortunately, with the pope's support, Michelangelo's designs for the Farnese Palace were implemented. In addition to the cornice, Michelangelo also designed the third story of the courtyard facade (see plate 21). The windows, in particular, reveal Michelangelo's inventive architectural vocabulary, although at first glance they appear little different

from those designed by his predecessor. This is one of many examples of Michelangelo's ability, despite his reputation for radical innovation, to integrate his work with a previous architect's design. He accomplished much the same decades earlier in creating a design for the tambour of the Florentine cathedral. Similarly, the reliquary tribune he designed for San Lorenzo fits comfortably within the church designed by Brunelleschi, just as his New Sacristy (the Medici Chapel) perfectly complements, without replicating, the Old Sacristy in the same church.

While mindful of his predecessors, Michelangelo had his own, original ideas about architecture, especially when it came to details and ornament. In the Farnese Palace windows, for example, we note many original features, such as the layered pediments supported by triglyph-like brackets adorned with guttae and lion heads. One imagines the stonemasons interpreting these innovative designs either from Michelangelo's verbal instructions or from drawings, templates, and possibly a full-scale wooden model. Indeed, the vocabulary of Michelangelo's stone architecture sometimes recalls complex carpentry.

Even though Michelangelo maintained a hands-on approach to architecture, the truth is his presence rarely was required at the Farnese work site. Thus, he could entrust Benedetto Schela, a skilled stone carver and longtime building supervisor to direct the day-by-day operations. As had been true at San Lorenzo, the work required a highly experienced overseer and a select number of persons privy to Michelangelo's intentions. These professionals successfully translated brilliant designs into beautiful carving, and the finished work is by Michelangelo, not Benedetto Schela, even if the latter was the on-site, day-to-day supervisor of the work.

Further demands did require Michelangelo's direct attention. Eager to make use of Michelangelo's talent, Pope Paul could hardly restrain himself. Together, patron and artist generated multiple ideas to enhance the otherwise banal design of the Farnese Palace: a long, broad interior corridor with an unusual flat arch of beautiful proportions; a bridge to span the Tiber and connect the Farnese Palace with its suburban villa, the Farnesina; and a plan to move two impressive antiqui-

ties, the *Farnese Hercules* and the newly discovered *Farnese Bull*, to the palace and incorporate them as part of a unified garden design. Of course, each of these projects took time away from St. Peter's, but they were immensely satisfying because, unlike the new church, they actually could be realized in the lifetimes of the artist and patron. The longer Paul lived—and he was an extremely long-lived pope—the more the projects multiplied: first there was the *Last Judgment*, then St. Peter's, the Farnese Palace, and the still unfinished Campidoglio and Pauline Chapel. Yet, without a doubt, the most demanding of Michelango's many concurrent obligations was New St. Peter's—and it would remain so for the rest of his life.

Indispensable Overseers

In a short time, Michelangelo had changed the course of St. Peter's. The building works were better organized, construction proceeded apace, and the workers felt a sense of purpose. Gradually Michelangelo replaced certain entrenched members of the *fabbrica* with his own chosen staff, and he even won over a few of Sangallo's loyalists, including the omnipresent project manager Jacopo Meleghino.

Born into a noble family, Meleghino (c. 1480–1549) was from Ferrara, where he had studied humanist letters and jurisprudence. In the 1520s he entered the service of the Farnese family and rose to become architectural adviser and confidant to Cardinal Alessandro Farnese. After Alessandro became Pope Paul III, in 1534, Meleghino worked on a number of Farnese building projects in Rome, including the Palazzo San Marco, Santa Maria in Aracoeli, the Pauline Chapel and the adjacent Sala Regia, and New St. Peter's.[19] As an experienced builder working under Antonio da Sangallo at St. Peter's, Meleghino favored his superior in the debate with Michelangelo regarding the fortifications of Rome. However, after Sangallo's death, Meleghino switched his loyalties to the new architect and, as a dutiful *servitore*, addressed Michelangelo as "Magnifico honorando."[20] He served Michelangelo faithfully as a senior project manager (*soprastante*) at St. Peter's until his own death in November 1549. Meleghino also proved valuable in

training the next generation of builders, including Giacomo Vignola, who would become a ubiquitous presence on many of Michelangelo's Roman architectural projects.

Serving alongside Meleghino was Salvestro, "alias nostro soprastante," about whom we know little, except that Michelangelo appointed him. When Salvestro died, Michelangelo replaced him in 1551 with Francesco Gatto, "Frank the Cat"—another of those little-known but indispensable assistants.[21] As project managers who organized men and materials, the *soprastanti* worked alongside Michelangelo, carrying out his plans and directions. Just as often, they worked independently, as the master's on-site representatives and with his full authority. After fifteen years of experience at San Lorenzo in Florence, Michelangelo had become a good judge of talent. Even if history gives them little credit, Michelangelo knew the sorts of persons he needed, which is why he promoted another little known figure: Bastiano da San Gimignano.

Shortly after his appointment as architect of St. Peter's, Michelangelo petitioned the deputies of the *fabbrica* to hire Bastiano da San Gimignano as a *soprastante*.[22] Michelangelo quickly discovered, however, that he had to justify every new appointment. After some resistance, the *fabbrica* finally agreed, thereby allowing Michelangelo to proceed with a triumvirate of capable overseers: Meleghino, Salvestro, and Bastiano da San Gimignano. They served as Michelangelo's core team.

Of course, there were others—many others: Sebastiano Malenotti, Cesare Bettini, Pier Luigi Gaeta, Jeronimo de la Gagiata, and Giovanni Battista Bizzi. Bizzi was even summoned from Settignano, the small town outside Florence and home to many of Michelangelo's trusted assistants.[23] A project as large as St. Peter's required many overseers. A number came, and a few left, including that first hire, Bastiano da San Gimignano, as well as Antonio Labacco, Giovanni Battista de Alfonsis, and Sebastiano Malenotti. A few others, including Nanni di Baccio Bigio, refused to go away and proved to be a constant headache. Some, like Meleghino and Salvestro, died before Michelangelo. One overseer, Cesare Bettini, was murdered. The deaths of Michelangelo's assistants, whether natural or otherwise, weighed heavily on him. They

were all younger and thus inevitably reminded him of the short time he had to devote to St. Peter's.

A surprising number of Florentines worked at St. Peter's. While bankers, merchants, and sycophants flocked to Rome with each newly elected pope, laborers of wood, stone, and brick tended to remain close to home. Thus St. Peter's offered a notable exception, at least under Michelangelo's direction. Many Florentine workers settled permanently in Rome, and one finds descendants of the Cioli, Fancelli, and Ferrucci families becoming "Roman" while often living in Florentine enclaves.

Michelangelo was not responsible for the immense ocean of paperwork at St. Peter's, as he had been at San Lorenzo. Vatican functionaries handled purchasing, accounting, wages, and record-keeping. Michelangelo also worried much less about the day-to-day workforce. With a central staff in place, he could leave the logistics of hiring and work organization, as well as attendance and payroll, to his capable overseers. And he had a right-hand man who proved to be the most valued assistant of all. Neither Florentine nor famous, Urbino was Michelangelo's rock of constancy.

Francesco di Bernardino Amadori, "Urbino"

Francesco di Bernardino Amadori (d. 1556) was from the small town of Casteldurante (modern Urbania), in the Marche near Urbino, hence his nickname. Urbino was the longest lived and best loved of the many household assistants who shared domestic life with Michelangelo over the course of his seventy-five-year career. These persons included the shadowy Silvio Falcone and the better-known but inveterately lazy and vain Pietro Urbano, who eventually ran off to Naples in his red velvet shoes. Urbano was followed by the kindly, if charmingly inept, Antonio Mini, who served Michelangelo as a personal assistant from 1523 to 1531. When Mini left for France, Michelangelo was fortunate to find a replacement in Urbino, whose nickname may be similar to the surname of the earlier Pietro Urbano, but who was a diametrically opposite character. Ostensibly pupils, these persons were primarily

housemates and secondarily professional assistants who helped in a variety of ways—running errands, keeping accounts, and assisting Michelangelo both at home and on the work site. None was more important than Urbino.

Urbino worked with Michelangelo as a general assistant on all his Roman projects, including the *Last Judgment*, the tomb of Cecchino Bracci in the church of Santa Maria in Aracoeli, and most recently in assembling the tomb of Pope Julius II.[24] But it was not just Urbino's skills as a stone carver and project manager that endeared him to Michelangelo. Like other long-term housemates with limited artistic abilities, Urbino offered companionship and complete devotion. In social class, intelligence, and servitude somewhere between Lear's fool and Hamlet's Horatio, Urbino was like those boon companions in displaying deep attachment and unwavering loyalty to his master.

When the septuagenarian Michelangelo occasionally felt unable to make it to the work site or was called to another duty, Urbino effectively represented his master.[25] Moreover, Urbino was entrusted with the keys to the *fabbrica* of St. Peter's, which meant that he generally was the first to arrive and last to leave.[26] Acting on Michelangelo's behalf, however, was not always easy. Once, when the self-important Jacopo Meleghino contradicted Michelangelo's wishes, Urbino employed both verbal and physical abuse in an effort to convince the wayward *soprastante* to fall in line. Meleghino was clearly less comfortable taking directions from Urbino than from Michelangelo himself.[27] Michelangelo continually had to manage such little blowups, mostly by informing certain stiff-necked members of the *fabbrica* that Urbino acted as his representative and with his full authority.

With a trusted team of overseers, as well as the improved management of men and materials at the work site, Michelangelo could claim genuine progress at St. Peter's. But Pope Paul was impatient, and the number of outstanding projects multiplied. With the warm weather and long hours of summer in 1548, Michelangelo felt torn between supervising the encouraging progress being made at St. Peter's and facing the more solitary task of finishing the frescoes in the pope's chapel.

Pauline Chapel

Even before Michelangelo had completed the *Last Judgment* in 1541, and well before his appointment as architect of St. Peter's in 1547, Pope Paul expressed his desire for the artist to paint his newly constructed, and eponymous, Pauline Chapel. The painting of the two large frescoes would occupy Michelangelo on and off for nearly eight years (c. 1542–1550). His work on the chapel decoration suffered frequent interruptions, sometimes due to freak accidents—a leak in the roof and then a fire—but mainly because the artist was simultaneously engaged, first in completing the Julius tomb and then in Paul's multiplying projects: St. Peter's, the Farnese Palace, and the Campidoglio. How much could the pope and his artist reasonably expect to accomplish before one or both died?

Designed and built for Paul by Antonio da Sangallo, the Pauline Chapel was intended to replace the old *parva* (small) chapel, now too confined to accommodate the business of the greatly expanded Curia. Sangallo created a perfectly proportioned architectural jewel, smaller than the Sistine Chapel but still an ample space. The Pauline Chapel served the dual functions of chapel of the sacrament and chapel of the conclave. Here, successive popes would be elected and begin their missions as Peter's successor. This lesser known chapel (in comparison to the Sistine Chapel) is one of the innermost sanctuaries of the Christian religion and the location of two of Michelangelo's greatest, albeit less familiar, paintings.[28]

Paul made a memorable visit to his new chapel in July 1545, just after Michelangelo had completed the first of two facing frescoes, the *Conversion of Saul* (see plate 22).[29] The pope was immensely satisfied. The chapel promised to be a *capolavoro*—a masterpiece of architecture and painted decoration. It was time to fresco the opposite wall. The artist and the pope conferred on the appropriate decoration.

Michelangelo directed the Vatican laborers to build a scaffold along the second wall. The preparatory work always took longer than anticipated. In the Pauline, two day laborers supported vertical wooden posts while a skilled rope handler lashed them to a horizontal cross

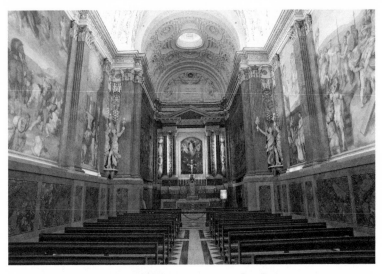

Pauline Chapel, interior, Vatican City, Rome

piece. A second set of vertical posts created a wobbly rectangle, stabilized by adding diagonal braces. Measure, cut, and secure horizontal boards and braces; move up to begin constructing the next level. The higher it goes, the wider the construction must be and the more cross bracing it needs—that is, more materials, more rope, more labor. It all takes time. Once the scaffold was in place, the waller (*muratore*) chiseled hundreds of short gashes into the roughly constructed wall to prepare it for a thick layer of plaster (*arriccio*), which, once dry, would be ready for the thinner layer of *intonaco*—slaked lime and fine volcanic ash (*pozzolana*)—applied section by section, day by day. On this carefully prepared surface, the artist would paint. Inspired by Paul's visit, Michelangelo began designing the second fresco.

Fresco requires a full, uninterrupted, ten-hour day. The first two hours are spent grinding and mixing colors, trimming brushes, and pricking the large drawings (cartoons) for transfer, all the while waiting for the *intonaco* to dry to proper consistency—as the artist Cennino Cennini recommends: fat, damp, and tacky. When the plaster nears readiness, one or two assistants hold the pricked cartoon flush

against the wall as the artist or an assistant pats the contour lines with a porous bag of charcoal dust, thereby leaving a series of tracing dots (a process known as "pouncing"). The cartoon is then removed, and the artist begins to paint, with reference to both the dotted outlines on the wall and the cartoon drawing tacked alongside. Now begins the "golden period"—*periodo d'oro*—four hours of concentrated work when the paint flows from the brush onto the slightly damp plaster surface. As it dries, the shimmering color gradually fades from its saturated sheen to a flat matte. An assistant lays on an adjacent patch of *intonaco*, and, after a brief interruption, the artist moves on to complete a head, a cloak, or a hand gesture. This is the perfect union of plaster, paint, and painter: a rough brick and rubble wall transformed to smooth, luminous color.

The artist continues hour after hour, until the day's plaster dries— transitioning from a tacky dampness to a resistant, unaccepting hardness—or until he is interrupted by some self-important cardinal who deems his business to be more important than this wall. Even as the plaster sets, Michelangelo will work on the ever-drier surface (*secco*), making corrections or adding a bit more pigment. When the wall is fully dry, the artist will start working with the special, expensive pigments, such as ultramarine blue, which can be applied only after the *intonaco* has dried to a hard crust. The assistants begin to clean up the day's mess, but Michelangelo continues to paint. There is so much still to be done. Before the helpers are released for the day, they will roll the cartoons, wash and trim the brushes, clean out the paint pots; cover and store the powdered, unmixed colors, taking special care of the valuable lapis lazuli and precious ultramarine powders.

A skilled assistant wielding a sharpened trowel removes excess plaster and cuts a clean diagonal edge to the day's work—the *giornata*—so that tomorrow's fresh plaster patch can be laid along a seamless join. Michelangelo worked more slowly and deliberately in the Pauline Chapel than he had when he painted the Sistine Chapel: the *Crucifixion of Peter* (see plate 23), the second fresco, alone consists of eighty-nine *giornate*, and the *Conversion of Saul* (see plate 22) required eighty-five.[30] It was slow, deliberate work.

Perhaps tomorrow the assistants will remove the upper level of scaffold boards and prepare for work at the next lower level. And still Maestro Michelangelo paints. He will expect that certain colors—especially the earth colors such as ochre, umber, and burnt sienna—will be ground to fine powder tonight, so that no time is wasted tomorrow morning. Despite all the tasks, the master will dismiss the assistants long before *he* goes home. There are corrections and drawings to be made, a letter to write

Winter cold came early, halting work in the chapel. It would be almost four years before Michelangelo once again turned his attention to finishing the chapel. So many disruptions, so many new assignments from the pope. St. Peter's quickly overshadowed the Pauline.

On the Way to the Vatican

Michelangelo went to the Vatican as often as his health would permit—first to paint the *Last Judgment* and subsequently to paint the Pauline Chapel and oversee St. Peter's. When he was younger, it took him approximately forty minutes to walk, briskly, from his house near Trajan's Forum to St. Peter's, and half as long if he rode his horse. He rarely walked now. Michelangelo, who "loved to own horses," now preferred to ride his small chestnut nag, which he kept in the stall behind his house.[31] Michelangelo was old; he was slow getting out of bed and slow getting dressed. Everything took more time. His horse was as old and tired as he was. His servant, Bastiano, who cared for the nag, wiping and saddling him, was slow also, not because Bastiano was lazy, but because the horse, like the artist, was reluctant to be rushed to work.

In the past, on his way to St. Peter's or on his way home, Michelangelo often stopped at the Strozzi Palace, a prominent landmark on the Via dei Banchi in the predominantly Florentine neighborhood near the Ponte Sant'Angelo, the bridge formerly named the Pons Aelius. There, before Luigi del Riccio's death, he could be assured of a welcome from his friend, and even from Messer Roberto Strozzi, if the important Florentine banker was in residence. Strozzi spent much of his time in Lyon, conducting business with the Florentine merchant com-

munity or following the itinerant court of the French king. Michelangelo enjoyed a warm relationship with Strozzi, a prominent man of affairs and a fellow Florentine. Michelangelo and his family had been variously associated with the Strozzi for nearly fifty years, and he would remain forever grateful for the many benefits the Buonarroti family had received from them.[32]

During the pestilent summer of 1544, Michelangelo had fallen dangerously ill with a debilitating fever. Luigi del Riccio insisted that Michelangelo be moved to the Strozzi Palace, where the family physician could closely attend to the artist during a monthlong convalescence. Roberto Strozzi was then on business in France, but thanks to regular reports from Rome, he attentively followed Michelangelo's slow return to health.[33] When Michelangelo finally escaped from danger, the artist expressed his heartfelt thanks to Luigi del Riccio by writing a sonnet and, in the accompanying note, swore his "service" to Roberto Strozzi.[34] But he also did much more.

Michelangelo presented Roberto Strozzi with two unfinished marble figures, the so-called *Rebellious Slave* and *Dying Slave*, now in the Louvre Museum (see plates 24 and 25). This was an astonishing gift, and not one that Strozzi could easily handle, since the larger-than-life-size marble figures weighed several tons and were not easily moved. Were the two figures meant as a pair, and what did they signify? Were they, as some maintained, slaves or captives? (And if so, of what?) Technically, the sculptures belonged to the Della Rovere family, since the marbles originally were destined for the tomb of Pope Julius II. Michelangelo had no business giving these sculptures to Roberto Strozzi, which partly explains his subsequent dissimulation. Even his contemporary biographers knew little about these works.

The act of giving these two sculptures to Roberto Strozzi caused Michelangelo some anxiety, as the gift was both politically charged and extremely dangerous.[35] Not long afterward, in November 1547, the Medicean government in Florence passed a ban against all persons consorting with or even speaking with exiles—first and foremost, the Strozzi. When Michelangelo's nephew, Lionardo, wrote to inform the artist of the ban, he also warned his uncle that there was gossip in

Florence about his relationship with the Strozzi. Michelangelo danced nimbly around the truth when he responded:

> I'm glad that you have informed me about the decree, because I'll be much more on my guard in the future. As regards my being ill in the Strozzi's house, I do not consider that I stayed in their house, but in the apartment of Messer Luigi del Riccio. . . . I no longer frequent the said house; all Rome can bear witness to the kind of life I lead: I am always alone; I go about very little and talk to no-one, least of all to Florentines.[36]

By insisting on the precise place of his convalescence, Michelangelo was indulging in an amazing splitting of hairs. Understandably, he had good reason to be concerned about gossip in Florence, and even better reason for dissembling when it came to the Strozzi. Like most Florentines who still had family and property in their native city, Michelangelo took the ban seriously, since its enforcement could threaten the status and financial security of his family. If he were accused of having consorted with rebels, then the Buonarroti might suffer exile and the confiscation of their properties. Thus, Michelangelo's claims of being "always alone" and "talking to no-one" were gross but carefully calculated exaggerations that reflect his habitually cautious and determinedly nonpolitical stance. There was no mention of two marble statues.

Michelangelo's general recommendation to his family, "don't get yourselves involved in any way, either by word or deed; act as in the plague—be the first to flee," guided his actions throughout his life.[37] We may call it timidity, but it was also prudent. A contemporary proverb observed that "wise persons are timid because they know all the dangers."[38] Michelangelo's brother once advised: "One must blow with the wind and attempt to remain sane."[39] Even in settled times, the family always advised one another "to accommodate yourselves to the times as best you can," and "don't involve yourselves in affairs other than your own."[40]

In being wary of political entanglements, Michelangelo was not different from many of his contemporaries who, of necessity, readily

shifted political allegiances in unsettled and rapidly changing circumstances. As the Florentine patrician Giovanni Morelli advised his sons: "Always keep on good terms with those in power: obey and follow their will and their commands, never speak ill of them and their activities, even if they are evil, keep silent and do not speak unless in commendation."[41] "Attend to your own affairs and speak to no one"—to which the Buonarroti subscribed—was a sentiment so widespread that it was expressed proverbially: "mouth shut, eye open" (*bocca chiusa, occhio aperto*).

Forever being on one's guard was prudent. Given the dangerously disruptive politics of the times, and the increasingly poisonous religious climate, Michelangelo opted for self-preservation, especially after he repeatedly witnessed friends and acquaintances suffering retribution and exile. No wonder he was wary of being associated with the Strozzi or any of the declared enemies of the current Medici regime.

In any case, that portion of his life was now over; his strongest tie to the Strozzi family, Luigi del Riccio, was dead. Michelangelo would have nothing more to do with the family on the Via dei Banchi. Yet, crossing the Tiber at the Ponte Sant'Angelo was the only convenient means of walking or riding to St. Peter's. Therefore, he frequently passed through the Florentine neighborhood, which meant that he sometimes was recognized and greeted by the Strozzi majordomo or one of the family's servants. The exchange of greetings was genuine, albeit sad, for it was an increasingly hollow vestige of a once happier but rapidly receding past.

On the bridge, Michelangelo caught the unmistakable stench of the low river with its garbage-strewn banks. Along the muddy embankment below the Santo Spirito hospital, washerwomen beat laundry and sang in a cacophonous mix of local and foreign dialects. The sluggish green swill served simultaneously as the city's principal water supply, its washing machine, and its only waste repository. Once across the river, Michelangelo entered the teeming and squalid neighborhood that had grown up around St. Peter's. He remembered his first impressions of Rome when he arrived as a twenty-one-year-old in 1496.

The Borgo was crowded, but the widening and straightening of streets carried out under Alexander VI—as corrupt a pope as any since Boniface VIII—had greatly improved the life and health of the city. Michelangelo recalled walking along the enlarged and much improved Via del Pellegrino, leading from the Tiber bridge to the new palace of Cardinal Raffaelle Riario. The street had impressed the young artist, as had his first encounter with ecclesiastic power in the person of the worldly cardinal.[42]

Even more impressive was Alexander's broad Via Alessandrina, which led directly to St. Peter's by cutting through the dilapidated medieval Borgo. However, the street—new in the 1490s—now exhibited the effects of a half century of ramshackle construction and general neglect. One's progress was constantly impeded by street vendors aggressively hawking their wares: used clothing, pilgrim's staffs and badges, straw for bedding and horses, religious trinkets and spurious relics, medicines, tonics, love potions, and all sorts of things to eat: nuts and sweetmeats, pig's feet, tripe, and less identifiable animal parts, whole chickens whose wrung necks were still bleeding, skewers of savory pigeon and other uncertain, fatty meats cooked in bubbling grease on the street. For those interested—and there were many—one could fulfill any desire. Women in low-cut dresses with overly rouged cheeks brazenly displayed their breasts, while others shamelessly lifted their skirts as enticement. Down any side street, one could find what was most in demand: hairless, nubile boys who looked and dressed like virgin girls.

Rome under Paul III was still the world capital of sin. It was a festering nest of immorality, corruption, and rampant promiscuity. The pope, despite his efforts to institute reforms, was regularly pilloried for his past moral transgressions and his overt nepotism. Scandalous gossips claimed that the pope formerly had a mistress and had fathered several illegitimate children. This, of course, was the pope for whom Michelangelo was working, for whom he was painting religious frescoes in the Pauline Chapel. Michelangelo, like others, may have asked: Was the current pope any less corrupt than Pope Alexander VI, of the Borgia family?

Michelangelo had lived and worked under both pontiffs. He first arrived in Rome during the final years of Alexander's pontificate, and now he was Paul's principal artist. Of course, he never knew Alexander, except as the object of endless malicious gossip. Paul he knew much better; this was a pope committed equally to church reform and to his family's advancement. Although bent and frail, Paul still displayed a firm will and acute intelligence. And despite his political ruthlessness, he was remarkably considerate and friendly to Michelangelo.

Given Michelangelo's excellent relationship with the pope, there was no reason for the artist to judge him. Popes—from Boniface to Alexander to Paul—were the subject of constant rumor. But with regard to gossip—especially about *i grandi*—Michelangelo long ago had imbibed current wisdom: "attend to your own affairs . . ."

Moreover, whatever Paul's personal life and worldly interests, Michelangelo mainly knew him in his other guise, as a man of rectitude, a pope dedicated to faith and to the greater glory of the Church. Having witnessed the convoluted politics of great families—Medici versus Strozzi, Colonna versus Orsini, Della Rovere versus Farnese—the elderly Michelangelo was cautious enough not to become entangled. Except for the Orsini, the artist had successfully worked for every one of those rival families. Michelangelo thrived when employed by enlightened patrons. At this stage in his career, he worked only for persons whom he admired and who, in turn, treated the artist with deference and genuine respect. All others were given the irrefutable excuse of his advanced age and the burdensome reality of prior obligations.

Whatever his worldly failings, Paul was the pope who employed and valued Michelangelo. And Michelangelo was the artist who—with such constancy of support—gave visible expression to the very ideals that were dearest to both men. To the artist, riding to the Vatican, this was all that mattered.

Michelangelo dismounted at the Porto del Bronzo and greeted the guard, although neither could quite recall the name of the other. Michelangelo mounted the back steps to the Sala Regia, and paused in the vast, undecorated chamber. Given the importance of this new room as a papal audience hall, adjacent to both the Sistine and Pauline

Chapels, the walls cried out for fresco decoration. What subjects should be painted there? By whom? Might this be the next project Paul would ask of Michelangelo? The artist could only imagine how the frescoes he was painting in the Pauline Chapel would complement decorations in this adjacent hall. But did he really wish to paint any more frescoes? He was already in his seventies, and he was certain he would not live long. The Pauline was only half done, and it was winter. It was far too damp to contemplate painting. However, the real reason he had ridden to the Vatican in the bitter winter cold was to meet with the pope.

Another, Very Painful Loss

Every year on January 25, Pope Paul observed the feast day of his patron saint by saying Mass at the basilica of St. Paul Outside the Walls (San Paolo fuori le Mura).[43] In 1549, Paul fervently hoped that he might be able to celebrate his name day by saying Mass in the Pauline Chapel. Unfortunately, with St. Peter's demanding so much of Michelangelo's time and effort, there was little chance the artist would finish the painting this year. The unfinished chapel lay neglected for months at a time, sometimes for unexpected reasons. Some years earlier, Michelangelo had stormed out of the Vatican in a great rage (con gran furia) because his "beautiful figures" were being damaged by rain infiltrating the chapel.[44] The wet Roman winters disrupted every fresco campaign: the fine plaster never properly set, the continuous damp prevented a wall from properly drying, and mold was a constant threat. Then, when the weather turned warm, Michelangelo spent most of his time at the St. Peter's work site.

Perhaps aware that his time was limited, Paul visited the unfinished Pauline Chapel in October 1549.[45] The chapel was cluttered with scaffolding and equipment: wood planking, rope, sawhorses, stools, tarps, and buckets of every sort, some full of water, others empty except for congealed lime. In the center of the chapel was a large table littered with cartoons, discarded paper, dirty smocks, and heaps of trash. The eighty-two-year-old pontiff made his way through the mess and la-

bored mightily climbing the scaffold. He inspected what Michelangelo had completed and inquired what the artist intended to paint next. They talked about suitable subjects and Paul's wishes. It was mid-autumn and growing chilly. Indeed, shortly after the pope's visit, the weather turned bitterly cold; Michelangelo foresaw a suspension of work until warmer weather.

Disregarding the intense wintry weather, the pope repaired to his villa on the Quirinal Hill, where he was attacked by a violent fever and quickly began to decline. Anticipating the social disruptions following the death of a pope, Paul's grandson, Cardinal Alessandro Farnese, ordered the papal guard to close the gates and occupy Castel Sant'Angelo. By November 9, it was clear that the pope's condition was hopeless, although he remained mentally sharp. He called the cardinals to his bedside and confessed.[46] He died the following day.

Michelangelo was devastated. We get a sense of this from the letter that he eventually wrote to his nephew—more than five weeks later—describing his tremendous loss.

> I have felt the greatest sorrow (*grandissimo dispiacere*), and not less a sense of loss in the death of the Pope. I received benefits from his Holiness, and hoped for more and better. God willed it so, and we must have patience. His death was beautiful, and he was conscious to the very end—to the final word he pronounced, God have mercy on his soul.[47]

While recommending his usual forbearance to his nephew—"we must have patience"—Michelangelo added the intimate observation that suggests the artist actually witnessed the pope's last moments: "His death was beautiful, and he was conscious to the very end—to the final word he pronounced" (*La morte sua è stata bella, con buon conoscimento insino a l'ultima parola*). Michelangelo had just lost his greatest patron and protector, as well as his friend and occasional dinner companion. As he later wrote, he wondered why his nephew continued to send shipments of wine since he no longer had friends with whom to share it.[48] Luigi del Riccio, Vittoria Colonna, and now Pope Paul—all gone. Three important pillars of his life had been removed. Who was left?

Finishing the Pauline

One day, some years earlier, when he was finishing the *Last Judgment*, Michelangelo tripped over the uneven scaffold boards, fell, and injured his leg.[49] Fortunately, he was nearly finished with the fresco, and the scaffold was not very high. Now, once again, he was climbing up and down rickety ladders in the Pauline Chapel. He really had no business clambering on such a perilous construction, much less painting for six or more hours at a stretch, hunched close to the wall, in meager light. As he later complained to Vasari, this work "caused a great deal of effort, because painting, especially in fresco, is no work for men who have passed a certain age."[50] At seventy-five, he was well past that "certain age." The arduous work turned into a final penance after Paul's death.

Since the west wall of the Pauline Chapel never receives direct sunlight, Michelangelo had first painted the well-lit east wall, and with a subject that is all about light, sight, and insight: the *Conversion of Saul* (see plate 22). After a nearly four-year hiatus, he started on the chapel's opposite (west) wall. As he worked, he huddled in almost as much darkness as the figures he was painting in the *Crucifixion of Peter* (see plate 23). How should the artist conceive such a grim scene?

In the failing light of a declining day, the Roman soldiers go about their business of crucifying yet another blasphemer. So many others had been put to death that it might have been yet another round of banal executions, except for the fact that this criminal requested to be crucified upside down. A strange request but nonetheless granted. Death did not come any swifter; indeed, just the opposite occurred. One did not suffocate in the usual manner of crucifixion; rather, the flesh of the hands and feet tore in a grotesque fashion and one slowly bled to death.

Given the number of executions recently carried out under the Emperor Nero, it seemed curious that so many spectators came to this particular one, including women! What did they hope to profit from a man so poor that even his ragged garments were unsalable? As the day's wan light begins to decline behind the Janiculum Hill, more and

more spectators gather at the gruesome scene. Some arrive from the direction of the Circus of Nero; others mount the stairs from the squalid Trastevere quarter. They come clothed in all manner of foreign dress, and most are poor.

Downslope from the crucifixion, a crone and three younger women huddle close together, gesturing strangely. They are the gossipy ones who, in anxious undertones and with furtive glances, eagerly relate to newcomers what is happening. As viewers in the chapel, we are the newcomers, and those witchy women are the first persons we encounter, whispering at us and directing our attention to the horrific scene we can hardly bear watching.

To ensure against potential unrest, the Roman commander has ordered an additional contingent of mounted legionnaires from the military encampment outside Porta Aurelia. They are just now arriving over the brow of the hill from the south. Rather than the usual lonely execution, this one is suddenly attracting a surprisingly large crowd. Some look with wonder, some with sympathy, but most seem lost in their own thoughts—as is Michelangelo in painting them.

Months ago, when the pope made his last visit, the two conferred about the appropriate subject to complete the chapel's decoration. The pairing of Peter and Paul is found everywhere in Rome, as they are central to the iconography of the Roman Catholic Church. The two figures flank the entrance to the Tiber bridge that leads to St. Peter's. At St. Peter's, the two saints are paired on the great bronze doors by Antonio Filarete (1445), on the Stefaneschi Altarpiece, painted by Giotto (c. 1320), on the marble ciborium over the high altar, and in the tapestries designed by Raphael for the Sistine Chapel (1515–16). Their pairing is a well-established tradition: the two saints are shown either at the beginning of their ministries or suffering their grisly martyrdoms.

So what had Paul and Michelangelo decided would be the appropriate subject for the second wall of the Pauline Chapel? Even more importantly (given that Paul was now dead), what did Michelangelo actually paint and why? As with the tomb of Pope Julius II, Michelangelo

once again found himself in the extraordinary position of carrying out a commission for a patron whose death left the artist as the only person privy to "original intent."

A scene of Christ calling Peter would have been an appropriate complement to the conversion scene and particularly suitable for a conclave chapel where the cardinals gathered to elect Peter's successor. Ultimately, however, Michelangelo painted the *Crucifixion of Peter*, an unexpected counterpart to the conversion scene opposite. It is revealing that Giorgio Vasari, in his first edition of the *Lives of the Most Excellent Painters, Sculptors and Architects* (published in 1550, just as Michelangelo was painting the second Pauline fresco), completely misidentified the subject as the "conferring of the keys by Christ to Peter."[51] Vasari may be forgiven his mistake, for it reveals the power of expectation, especially when the iconography is familiar and well established. What Vasari was not prepared to see or remember accurately was the unconventional pairing of Peter's death opposite Paul's conversion. Nowhere previously in Rome, from the earliest Christian basilicas to the most recent decorative cycles—which include hundreds of renderings of Peter and Paul—does one find Paul's conversion coupled with Peter's martyrdom.[52]

Paul was dead; this was his chapel, his legacy, his memorial. A scene of holy martyrdom opposite Paul's conversion was unexpected but perhaps not difficult to justify. Early in his pontificate Paul had restored and embellished Bramante's Tempietto on the Janiculum Hill (see plate 26), the very site of Peter's martyrdom.[53] Since Pope Paul, as successor to Saint Peter, had a vested interest, it would be entirely natural for Michelangelo to associate Paul with that venerated locale. To paint the *Crucifixion of Peter* in Paul's chapel was a means of linking the two men and the two sites. Thanks to Pope Paul's refurbishment of the Tempietto, modern pilgrims could visit the actual site of martyrdom, reach into the hole dug for Peter's cross, and take away some of the golden sand that gave the place its name, Mont'orio.[54] The connection between the holy site and its frescoed depiction was made explicit when Michelangelo painted a figure kneeling, reaching into the pit at the foot of Peter's cross.

Moreover, as painted by Michelangelo, Peter's martyrdom is not primarily about death. Rather, the apostle is still very much alive; he is a powerful, muscular fisherman—a fisher of men. Peter's unremitting gaze pierces us to our core. His is a declaration of unwavering faith and an admonition to do our Christian duty. Peter, the first pope, reminds every new pope of his mission, of what it means to be Peter's successor, Christ's representative on earth, God's anointed one. Peter demands of the pontiff: *Do you have the courage and determination to follow me?* His fearsome countenance demands that we live, to do Christ's work on earth.

Michelangelo painted a large crowd in the *Conversion of Saul*. Every figure in that fresco reacts in a different manner to the unexpected apparition of Christ. In the ensuing chaos, each is left questioning his purpose and future. Will the loyal Roman legionnaires continue Saul's campaign of persecution, or will they follow their leader in his mission as a convert to Christ? Whatever decision they make ultimately does not concern us, for not one of them looks at or implicates us. We witness what transpires, but we are not part of the event.

How different the opposite wall. Before Peter's crucifixion, we are no longer anonymous witnesses nor can we avoid implication and responsibility. At least a dozen figures at Peter's crucifixion look toward us, either directly or obliquely—the oblique glances as unnerving as the unwavering ones. Figures in the fresco are no longer mere actors in a past history but living figures in our present lives. There is no avoiding them. Soldiers at the left climb up the hill to Montorio while other figures descend on the opposite side, walking directly into our space. To art historians, the cutoff figures appear odd; to the faithful, they look and speak to us, they look *like* us, and they walk into our space. We are about to be engulfed. This is not just decoration in a chapel; it is a demand for participation.

Michelangelo painted his frescoes on surfaces recessed several feet behind the lateral walls. Thus they appear as large shadow boxes or dioramas, and, as a consequence, visibly gain in three-dimensionality. If one stands ten to fifteen feet from either wall, one perceives the figures along the bottom and side edges not as truncated bodies but as

partially seen figures in a scenographic setting. They are entering from expanded but unseen spaces, as if from offstage. It is a theatrical effect that unfortunately cannot be captured in engraved or photographic reproduction; it can be confirmed only by viewing the frescoes *in situ*, which, of course, is exactly as Michelangelo intended.

The deceased pope may have taken the name Paul, but he had proven himself to be a worthy successor to Peter. This was his chapel, and it was now Michelangelo's memorial to his pope, his friend, and his greatest patron—the man and vicar of Christ who had commanded him to build God's greatest church.

Paul's funerary monument was designed by Giacomo della Porta and erected in the choir of New St. Peter's. Despite its prominent location, its extravagant employment of marble and bronze, and its many obvious references to Michelangelo's art, Della Porta's tomb is arguably a less eloquent memorial than the Pauline Chapel. The chapel is certainly the more personal of the two monuments and was unquestionably a work deeply meaningful to Michelangelo and inescapably autobiographical. It is little wonder that at least three self-portraits have been proposed in the *Crucifixion* scene alone.

December 1550. It was bitterly cold. The chapel was finished. So, Michelangelo asked himself: Why had he left home, ventured into the frigid outdoors, and made his way once again to the Vatican? It was too embarrassing to admit. He wanted to be paid. Was it too much to expect—to be paid for the tasks required of a papal artist? Under Paul, those duties were many, but generally satisfying, including even those he inherited from Antonio da Sangallo. But sometimes it was hard to believe what was expected of him. As the pontifical artist, he was responsible for oversight of all artistic activity that took place under the aegis of the Camera Apostolica.

He convinced himself that he had come to examine his newly completed frescoes in the Pauline Chapel—and this would give him the opportunity to imagine the next great decoration that would naturally

follow: frescoes in the adjacent Sala Regia. But the truth was that the new Pope, Julius III, had asked the artist to gild the post-knobs of his new bed.[55] Naturally, Michelangelo did not undertake this menial task himself, but he was responsible—as the pope's artist—to make certain it was carried out, correctly and efficiently. Because the pope was a sympathetic and genial character, Michelangelo could not complain; this is what a court artist does.

Having to deal constantly with lower functionaries was another fact of life at the Vatican. Long ago, Michelangelo had learned that his claim to be a descendent of the counts of Canossa mattered little to church bureaucrats. Advancement in the Vatican hierarchy depended on a special set of utterly opaque rules and etiquette. Michelangelo was just an artist. Like dozens of other petitioners, he presented himself before Pier Giovanni Aleotti, the papal secretary. Tedious, unctuous, and arrogant, Aleotti, the bishop of Forli, was officially the *maestro della camera* for Pope Julius. Having previously served as chamberlain to Pope Paul, Aleotti considered himself indispensable. On the sly, Michelangelo dubbed him *Il Tantecose*, "Mister Busybody," because the man seemed to do little except issue endless instructions to underlings—and he considered everyone an underling. Thus Aleotti, himself once a lowly disburser of papal funds, self-importantly directed Michelangelo to an even lowlier papal functionary. And *that* little cockalorum with his shriveled view of the world asked Michelangelo how to spell his name. Then he wrote into a ledger almost as large as himself a payment to "Michelangelo pittore."[56] Before him was the sculptor, painter, architect, and poet, Michelangelo Buonarroti, famous throughout Christendom and beyond, but to this small-minded Vatican official he was just another employee on the papal payroll. Michelangelo signed the receipt. He descended the staircase and, buffeted by the icy winter wind, wrapped himself in his heavy woolen cloak and rode slowly home.

A NEW POPE: JULIUS III

The conclave following the death of Paul III was one of the longest in history, and the first to take place in the Pauline Chapel. A scaffold still covered one wall, since Michelangelo was just completing the painted decoration but, of course, he was not permitted access to the chapel during the conclave. The enforced disruption was not unwelcome. Like many persons in Rome following the death of a pope, Michelangelo was deeply uncertain of his future. The city was in turmoil. Exploiting the interregnum, roving bands of lawless youths despoiled property and wreaked general mayhem. Until a new pope was elected, it was best to remain at home.

The conclave lasted nearly three months, until finally a compromise candidate proved acceptable to all contending factions: Cardinal Giovanni Maria Ciocchi del Monte (1487–1555) was elected in February 1550 and took the name Julius III (r. 1550–55; see plate 27). Michelangelo wrote with evident satisfaction to a friend in Florence: "You are aware that we have a new Pope and who he is; the whole of Rome is rejoiced about it, thank God, and nothing but the greatest good is expected of him, particularly for the poor, owing to his liberality."[1] Given that he was now seventy-five, Michelangelo doubted that the new pope, "would need me owing to my age."[2] But he was wrong.

Soon Julius III confirmed Michelangelo as papal architect and shortly after began employing him in a number of additional tasks.

A Life of the Artist

In 1550, Michelangelo's life became a matter of public interest when Giorgio Vasari published his *Lives of the Most Excellent Painters, Sculptors and Architects* (see plate 28). Vasari began his biography of Michelangelo—the only living artist included in the book's first edition— with a sentence of biblical proportions, a masterpiece of hagiographical hyperbole: "Meanwhile, the benign ruler of heaven graciously looked down to earth, saw the worthlessness of what was being done, the intense but utterly fruitless studies, and the presumption of men who were farther from true art than night is from day, and resolved to save us from our errors . . . ," and on and on.[3]

In our time, the life stories of celebrities and political figures appear with alarming rapidity. Prior to the modern age, however, biographies generally were written after a subject's death. The publication of Vasari's life of Michelangelo in 1550 gave rise to the curious and unusual situation of the biographical subject reading his own biography. Indeed, Michelangelo may have been the first person in history to read and edit his own biography. Except for Petrarch, who likely read Giovanni Boccaccio's *De vita et moribus domini Francisci Petracchi* (1340s), there are few precedents.[4] Kings may sometimes have heard their deeds proclaimed in public, or read aloud to them, as for example, we see in the Sistine Chapel pendentive that shows Ahasuerus listening in bed to the chronicles of his kingdom. But the famous subjects in Plutarch and Suetonius did not read their own biographies, nor did Charlemagne read Einhard's *Vita Caroli Magni*, nor did Samuel Johnson read James Boswell. Michelangelo not only read his own biography, but he had more than merely a polite reaction to Vasari's flattering portrait.

Michelangelo's current state of mind could hardly have contrasted more with the triumphant and laudatory picture presented in Vasari's encomium. The artist had just lost Paul III, a friend and his greatest

patron. He was uncertain of his current position and profoundly concerned for the future of St. Peter's and every one of his unfinished projects. At the same time, he was preoccupied with the future of the Buonarroti family, which was still without an heir. And he increasingly worried about the salvation of his soul, despite the fact that Vasari wrote as if he were God's personal instrument. But beyond the hyperbolic first sentence, the very idea of reading about one's many accomplishments was troublesome, especially when most belonged to a distant, youthful past. And, perhaps most difficult of all was to be reminded of the many false starts, the half measures, the failures . . .

The publication of Vasari's book forced Michelangelo to take stock of his achievements and his advanced years. What's more, reading his own life—as if it were now completed—prompted the artist to take a more active role in shaping his life and legacy, motivating him to become an editor and author of his own biography.[5] Partly to correct Vasari, but mainly to tell his own story, Michelangelo prevailed upon his pupil Ascanio Condivi to write a life, which appeared three years later, in 1553 (see plate 29).[6] The most important differences between Vasari's and Condivi's lives must be attributed to Michelangelo himself, for many of these differences concern family history, which was of intense concern to the septuagenarian artist.

Only one of the five Buonarroti brothers ever married; therefore, the continuation of the family was wholly dependent on Lionardo, the sole surviving male child of the artist's deceased brother Buonarroto. Michelangelo fully recognized his nephew's critical role, exhorting him "to remake and perpetuate the house . . . so that our existence may not come to an end."[7] In 1549, Michelangelo invited his twenty-seven-year-old nephew to Rome to discuss property investments, improvements to the family house in Florence, and the young man's marriage prospects. The aged artist clearly expected to die soon and, therefore, as he wrote, "I want to put my spiritual and temporal affairs in order."[8]

Michelangelo felt a deep obligation to his family lineage because, as he frequently reiterated, "we are citizens descended from one of the noblest families," and further, "it is well known that we are old Florentine citizens and as noble as any other family."[9] This proud claim was

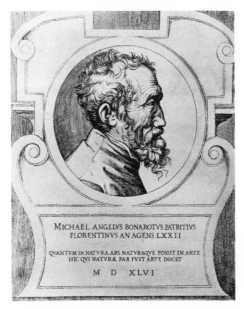

Giulio Bonasone, engraved portrait of Michelangelo, 1546,
Washington University, St. Louis

founded on his family's descent from the illustrious counts of Canossa. This family history had been confirmed for the artist in 1520, when the current Count Alessandro of Canossa had addressed the artist, "To my much loved and honored relative Messer Michelangelo Buonarroto of Canossa" (*Al mio molto amato et parente honorando messer Michelle Angelo Bonaroto de [Cano]ssa*). The count reported that a search among his family papers had established the connection between their families, and he invited Michelangelo to visit the ancestral family seat (*la casa vostra*).[10] Nothing was more important to Michelangelo's current self-perception and sense of self-importance. His belief in his noble ancestry governed the manner in which he conducted himself, and it fully manifested itself in his effort to rewrite Vasari's life.

In contrast to Vasari's lofty claim regarding God's divine plan, Condivi, writing at Michelangelo's behest, began his account in a significantly different fashion: "Michelangelo Buonarroti, that outstanding sculptor and painter, traced his origin from the Counts of Canossa,

noble and illustrious family of the territory of Reggio through their own quality and antiquity as well as their relationship with the imperial blood."[11] No artist had ever claimed to have imperial blood—and, moreover, believed it! This incredible assertion was followed by a lengthy description of the family's origins, surname, and coat of arms—all aristocratic attributes possessed by few artists. Condivi clearly was emphasizing what mattered most to Michelangelo: his noble birth, family history, and elevated social status. An engraving by Giulio Bonasone, which served as the frontispiece and only illustration in Condivi's book, may legitimately be regarded as the artist's officially sanctioned portrait.[12] The Latin inscription declares him to be a Florentine patrician, PATRITUS FLORENTINVS.

Another Consequence of Biography

Having two biographies published in one's lifetime was entirely unprecedented, and certainly contributed to Michelangelo's contemporary fame. His life and work became matters of public interest and fostered expectation. For example, toward the end of his narrative, Vasari briefly mentioned Michelangelo's current works in progress, including the Campidoglio, St. Peter's, and the unfinished Florentine *Pietà*, a sculpture that the author anticipated "will surpass every other work of his."[13] After observing that, "it is enough to say that whatever he touches with his divine hand is given eternal life," Vasari concluded with a rhetorical flourish: "When he departs this life, his immortal works will yet remain, the fame of which, known throughout the world, will live gloriously forever in men's praise and the pens of writers."[14] Such fulsome praise and promise of future glory must have jarred uncomfortably with the current state of affairs, since Michelangelo was acutely aware of his many incomplete endeavors. These included not only the the Campidoglio, St. Peter's, and the Florentine *Pietà*, all mentioned by Vasari, but also the abandoned marble facade for San Lorenzo in Florence, the still incomplete Medici Chapel and Laurentian Library, and a host of unfinished sculptures: *Saint Matthew*, four prisoners (Accademia Gallery, Florence), *Victory*, *David/*

Apollo, and *Medici Madonna*—most languishing in his abandoned Florentine workshop.[15]

Perhaps to counter Vasari's implied expectation that Michelangelo would complete many of these projects, Condivi wrote that the current pope, Julius III, "recognizes and relishes his greatness, but he refrains from burdening him with more than he wishes to do. And this respect, in my judgement, enhances Michelangelo's reputation more than any of the work all the other pontiffs employed him to do."[16] In other words, Condivi suggests that Michelangelo's reputation and future glory would *not* depend solely on his actual works. Indeed, Condivi does not even mention the Campidoglio. He eloquently describes the Florentine *Pietà*, as if Michelangelo were still carving it, little aware that the artist would soon abandon it. And Condivi's brief discussion of St. Peter's largely absolves Michelangelo of much responsibility for that commission, since "he never wished to follow the profession of architect." Condivi continues:

> Indeed . . . when Pope Paul wished to appoint Michelangelo [as archi-tect of St. Peter's] . . . he refused this employment, alleging that it was not his craft; and he refused in such a way that the Pope had to order him to do so and issue a most ample *motu proprio* which was subse-quently confirmed for him by Pope Julius III.[17]

Surprisingly, neither Vasari in 1550 nor Condivi in 1553 wrote much about St. Peter's; neither author wasted words or lavished praise on Michelangelo's most important undertaking. When Vasari revised his biography in 1568, he eliminated the rhetorical exaggeration about Michelangelo's "immortal works" living "gloriously forever in men's praise." Instead, he remarked on the paucity of finished work, noting that most of the artist's completed works were done when he was young.[18] And still there is little about St. Peter's.

Michelangelo and Julius III

The *motu proprio* issued by Pope Paul authorizing Michelangelo's posi-tion as papal architect proved its worth, since every successive pope

reconfirmed its terms.[19] Throughout his remaining years, Michelangelo's position and authority over St. Peter's was guaranteed, though not without resistance from certain quarters. In the face of some determined opposition from the St. Peter's deputies, Julius III defended Michelangelo, "not only by confirming the *motu proprio* but with many noble words of praise, and he refused to lend ear to the complaints either of the overseers or any others." In turn, according to Condivi, Michelangelo "appreciated the love and benevolence of His Beatitude and the respect he entertained for him."[20]

Julius proved to be an appreciative and sympathetic patron whom Michelangelo willingly served. Ascanio Condivi had recently joined Michelangelo's household and therefore saw firsthand the relationship between the artist and the pope. In his *Life of Michelangelo*, Condivi effusively describes the special regard with which Michelangelo was held by Julius. Moreover, given that Condivi's life is the closest thing we have to an autobiography, his words and sentiments are also, in some measure Michelangelo's own:

> In no less esteem . . . is Michelangelo held now as ever by the present pontiff Julius III, a prince of perfect judgement, and a lover and sustainer of all the talents universally, but in particular inclined most of all to painting, sculpture and architecture. This can clearly be recognized from the works he has commissioned for the palace and the Belvedere, and is now having made for his Villa Giulia.[21]

Writing from firsthand observation, Condivi paints a picture of a respectful and friendly relationship between Michelangelo and the new pope. On the other hand, the artist never felt as close to Julius as he had been to Paul. Julius was a very different person, and his papacy lasted only a third as long as Paul's. In many ways Julius was a throwback to an earlier era of self-indulgent Renaissance popes, although he lacked their learning and refinement of taste. Given that Julius had the appearance and coarse manners of a peasant, there are few sympathetic portrayals of him—either painted or written. A large man with a trencherman's appetite, he observed few social graces. Michelangelo, however, expressed his optimism at Julius's election, and shortly afterward

he shared with the new pontiff some of the fine Trebbiano wine that Lionardo sent from Florence.[22] He refrained from sharing other delicacies, since it was well known that Julius preferred onions, immense quantities of which were consumed at the pope's table.[23] While Julius took to his bed with frequent attacks of gout, the situation in Europe deteriorated.

The new pope lived in dangerous times, and he was ill-equipped to deal with a growing Turkish menace and the contending Spanish and French factions, whose political maneuverings threatened the tenuous peace of Europe. Julius was irresolute and vacillating; moreover, the parlous state of papal finances undermined his options and authority.

Just two years into Julius's papacy, the tension between the Holy Roman emperor, Charles V, and Henry II, the king of France—both of whom had legitimate claims in Italy—threatened to degenerate into outright conflict. Once again, Italy became the battlefield of Europe's contending superpowers. The conflict played out in a small but brutish war in which Siena suffered a humiliating defeat at the hands of Florence and Cosimo de' Medici. In December 1552, Rome's populace—some of which had lived through the sack of 1527—trembled with fear as Spanish troops marched through the Papal States.[24] Yet, one would never know about the widespread panic from Michelangelo's correspondence. Seemingly oblivious to international politics, Michelangelo wrote to his nephew on December 17, 1552, expressing concern that the property Lionardo was considering buying in Florence was *onorevole* and "sound"—that is, with a clear, unencumbered title. "Don't worry about the price," he added, as though real estate was the artist's most pressing concern.[25] There is no mention of politics or the terrified Roman citizenry.

While Michelangelo's correspondence is an incomparable resource, it often fails us at moments when we most desire insight into the artist's life and the state of the world at large. After this single letter of mid-December, all correspondence stops for more than three months—a period of increasing tension and political crisis. Given that Michelangelo and Lionardo tended to write to one another on a weekly basis,

this yawning gap is itself revealing. It is a type of "negative evidence" that, while failing in particularity, is nonetheless telling. The political situation was so uncertain that a general panic gripped Rome. Some four years later a similar situation would lead Michelangelo to heed the danger signals and actually flee the city.

Julius III Adds to Michelangelo's Obligations

Incapable of controlling the current turmoil in Italy or abroad, Julius III turned his attention to Rome and a few preferred projects. He instituted a number of reform measures intended to improve the lot of Rome's citizens, especially the poor. Despite his uncouth manners and lack of refinement, the pope conscientiously fulfilled his religious duties and proved to be a pious steward of the Church.[26] Furthermore, Julius treated Michelangelo as a gentleman-artist who added luster to the papacy. The pope showed great respect for his artist, purportedly even insisting that Michelangelo sit by him in the presence of cardinals and other dignitaries.[27] The number of new projects ascribed to Michelangelo during Julius's brief, five-year papacy is astonishing. The pope was full of ambitious initiatives, and Michelangelo soon was busier than ever. One does not refuse a pope.

In addition to his primary obligation to St. Peter's, Michelangelo redesigned Bramante's staircase in the Belvedere Courtyard and supposedly designed a fountain for the same space. He also furnished a drawing for a new palace of the Rota (the Apostolic Court), to be built alongside the church of San Rocco near the Ripetta (the Tiber River port), and he served as a consultant for the Del Monte Chapel decorations in San Pietro in Montorio. He similarly served as an adviser on Julius's pet project: the design and construction of a suburban villa, the Villa Giulia, on the slopes of the Pincian Hill, close to the Porta del Popolo and the Via Flaminia. There is little agreement about Michelangelo's role and the extent of his contributions to these various projects or to Julius's other initiatives, which included a design for the church of the Gesù and a redesign for the Ponte Rotto, the "broken bridge," which was damaged—or collapsed—every time the Tiber

flooded. Michelangelo's name is also linked to projects beyond Rome, such as a design for the choir of the Padua cathedral.[28]

How much could the seventy-five-year-old artist accomplish? How did he actually contribute to these various projects at the same time he was overseeing the large-scale constructions at the Capitoline and St. Peter's? Condivi suggests that Julius was restrained in what he asked of Michelangelo; nonetheless, it is significant that the artist's name is associated with so many Julian commissions. The pope wanted Michelangelo involved. As Condivi stated: "As regards the works of painting and architecture that His Holiness commissions, he almost always seeks Michelangelo's opinion and judgment, very often sending the masters of those crafts to find him in his own home."[29] As Pope Paul once made a visit to Michelangelo's house in Via Macel de' Corvi, so did Pope Julius III regularly send a representative to the artist's studio to consult with his preferred expert. The deference shown to the aged artist would not have been lost on contemporaries. But this is not merely a biographical topos celebrating a rise in the stature of the artist/architect, it also marked a shift in architectural practice.

The Beginning of a Friendship

One of Pope Julius's consulting artists was thirty-nine-year-old Giorgio Vasari (1511–1574). Shortly after the election of Julius III in February 1550, Vasari hastened from Florence to Rome hoping, like many others, to exploit opportunities offered by the election of the new pontiff. In Rome, Vasari lodged with the Altoviti family, and thanks to the recommendation of Bindo Altoviti, he received the commission to paint the altarpiece for the memorial chapel in San Pietro in Montorio where the pope's Del Monte relatives were buried.[30] Vasari was also consulted on another project dear to the pope, the suburban villa on the Pincian Hill north of the Porta del Popolo. For both projects, Michelangelo served as the pope's trusted adviser. Michelangelo and Vasari became well acquainted during the approximately six months that the younger artist worked in Rome, thus marking the beginning of a long but fitful friendship.

Sometime before Vasari returned to Florence in the summer of 1550, he and Michelangelo arranged to spend a day in one another's company as Christian pilgrims. It was a jubilee year, and significant indulgences could be gained from visiting Rome's pilgrimage churches. Moreover, the occasion presented a unique opportunity for Vasari to spend time with his hero, as he proudly recounted years later in the second edition of his *Lives of the Most Excellent Painters, Sculptors and Architects* (1568):

> Now at that time [1550], Vasari used to visit Michelangelo every day; and one morning (it being Holy Year) the Pope graciously gave them a dispensation to visit the seven churches on horseback [given that Michelangelo was seventy-five years old and not as hale as many younger pilgrims visiting Rome during this jubilee year] and gain the indulgence together.[31]

Vasari greatly exaggerated the time the two artists spent together. Writing about events more than fifteen years after the fact, Vasari claims that he would "visit Michelangelo every day." Given how busy Michelangelo was with New St. Peter's and his many other Roman projects, this was certainly an exaggeration. Perhaps innocent, it also served to boost the writer's claim to intimacy. Vasari further states that when he returned to Florence, "both Michelangelo and Vasari were grieved at their separation and they wrote to each other every day," which is another preposterous claim, readily disproven by the documentary record.[32] From the first letter that Michelangelo penned to Vasari, in 1550, until his death, in 1564, we have just twenty-three extant letters exchanged by the two correspondents. There is internal evidence of an additional seven letters, all sent by Vasari but not preserved by Michelangelo. Some thirty letters over the course of thirteen years scarcely supports Vasari's claim of a daily correspondence.[33] The busy elder artist barely found time to write once a week to his most important and frequent correspondent of these years—his own nephew, Lionardo Buonarroti. The exchange of letters between Vasari and Michelangelo was intermittent; moreover, it was often the case that Michelangelo would receive two or

three letters from his admirer before responding, oftentimes weeks after he received a missive.[34]

As for the pilgrimage day in 1550, it was clearly more important to Vasari than to his hero. Writing in retrospect, and with the aim of lending credence to his account, Vasari relates two instances from their day together. In the first, Vasari claims, "While they were going from one church to another they discussed the arts very eagerly and fruitfully, and from their stimulating conversation Vasari composed a dialogue which will be published (with other material on art) at a favourable opportunity."[35] And in the second instance, Vasari recounts that as the two were riding across the Tiber River on the infamous Ponte Rotto, Michelangelo exclaimed, "Giorgio, this bridge is shaking. Let's ride faster in case it crashes down while we're on it."[36]

During the course of this long day, there surely was one additional topic of conversation that Vasari elects not to mention. Following the publication of his *Lives* in March 1550, Vasari presented a copy to Michelangelo. On the ride around Rome in which Michelangelo and Vasari discussed "the arts very eagerly and fruitfully," it is difficult to imagine that the two would *not* have spoken about Vasari's recently published book. Had Michelangelo been at all complimentary, Vasari surely would have repeated whatever the artist might have offered. Rather, the silence is deafening.

When Vasari returned to Florence, he initiated a correspondence, but it was not until Michelangelo had received three letters from his eager admirer that he was finally prompted to respond.[37] Even then, Michelangelo sent the letter via his friend Giovanfrancesco Fattucci, who often acted as the artist's professional and social intermediary.[38] And when Michelangelo finally wrote, it was not to thank Vasari for his *Lives of the Most Excellent Painters, Sculptors and Architects*, but rather to discuss Pope Julius III's commission to decorate the Del Monte family chapel in San Pietro in Montorio. Indeed, Vasari's book is never specifically mentioned in any of Michelangelo's correspondence.

At the end of his first letter to Vasari, Michelangelo makes reference to the younger man's "high praises" and facetiously applauds him for "reviving the dead" and "prolonging the life of the living."[39] Since

Michelangelo was now writing five months after he had received Vasari's *Lives*, it is unlikely that he is referring to the book, much less thanking him (unless ironically). We are not privy to the nature of Vasari's "high praises," because Michelangelo did not bother to keep those effusive missives. However, based on Michelangelo's belated response as well as his droll tone, one recognizes either Michelangelo's typical discomfort in discharging social obligations or a determined silence regarding Vasari's publication. While Michelangelo was perturbed by Vasari's literary hyperbole, he nonetheless appreciated the younger man's flattering attentions, and the two worked without friction as artist-consultants to Pope Julius III.

Villa Giulia

Take the Villa Giulia as an example (see plate 30). Julius had this large-scale suburban architectural and garden complex built *ex novo* in less than five years. It consists of a palace block, curving loggias, long wings enclosing courtyards and gardens on multiple levels, a nymphaeum, and acres of fresco and stucco decoration. In addition, an access road joins the villa to a small harbor on the Tiber, and the redirection of a spur of the Acqua Vergine aqueduct provides an abundant water source for the thirty-six thousand new plantings that decorated the complex. The "villa" was no rustic getaway but an architectural and engineering marvel on a grand scale, all created in the brief period of Julius's pontificate.

Who should be credited as the architect and master designer of this multifaceted endeavor? Contemporary documents record the names of Giacomo Vignola, Bartolomeo Ammannati, Giorgio Vasari, Taddeo Zuccaro, Prospero Fontana, Baronino da Casale Monferrato, and Michelangelo. Vignola (1507–1573), who was forged in the crucible of St. Peter's, was Julius's preferred architect, but Michelangelo had the larger reputation. Although he may have done the least, Michelangelo was the most important artist associated with the project. He may have sketched a few designs, critiqued the drawings and designs of others, and looked over their shoulders. Most importantly, he had the

ear and trust of the patron. As Condivi writes and probably witnessed, the pope "almost always seeks Michelangelo's opinion and judgment."[40] Conversation and advice thus became architectural contributions. Julius listened and gave due consideration to whatever Michelangelo was willing to offer.

Giacomo Vignola was key to the project's execution, while Michelangelo gave it occasional attention. Who is best remembered: the architect in charge, the builder who supervised construction, the on-site foremen who organized the work, the day laborers who actually carried out the work, or Michelangelo, the designer/consultant who, even though he gave less of his time, gave his imprimatur?

Michelangelo's position during Julius's papacy is partly explained by the rise in the stature of artists. Changes in architectural practice followed from changes in the role and status of the architect. Increasingly, authority and authorship depended on invention (*invenzione*) rather than the work of one's hand (*di sua mano*). Michelangelo himself was in no small measure responsible for these evolving attitudes. From the moment he took over St. Peter's, Michelangelo moved beyond the role of hands-on craftsman and project manager to become the principal architect/designer and overall supreme authority. He had risen through the ranks of the artisan class to become an Architect, with a capital *A*. Popes favored him. Except for a recalcitrant few, everyone respected and listened to him. He was clearly the most experienced, and he was the patron's favorite adviser. His authority derived from the knowledge gained from more than a half century of making and doing—in virtually all media: drawing, fresco, wood, marble, bronze, and all aspects of the building trade. He was intimately familiar with every facet of stone and marble work—finding, quarrying, transporting, cutting, carving, polishing, raising, and setting—not to mention every imaginable engineering problem associated with these various operations. No one came close to matching the breadth of his knowledge and experience. Through his accomplishments in so many diverse fields, Michelangelo had achieved more than any previous artist in gaining the respect of his contemporaries and raising the stature of his profession.

Del Monte Chapel

In addition to his villa, Pope Julius was keen on the expeditious completion of another favored project: the family burial chapel in the important church of San Pietro in Montorio in Rome. Michelangelo appears to have been involved with this project—in some manner—from the very beginning. Why and how, given his many other responsibilities?

Michelangelo actually had multiple reasons to show interest in San Pietro in Montorio: it was a Franciscan church on an extremely holy site—the supposed location of Peter's martyrdom. Despite an earlier antipathy toward Bramante and Raphael, Michelangelo admired Bramante's Tempietto, erected alongside the church, and Raphael's *Transfiguration*, which adorned the high altar. But beyond admiration for the work of others, Michelangelo had long been involved at San Pietro in Montorio. One of his earliest commissions was for a painting of the stigmatization of Saint Francis meant as the altarpiece for the first chapel to the left (never painted or lost?), and some years later, Michelangelo provided designs to Sebastiano del Piombo for his *Flagellation of Christ*, in the Borgherini Chapel, directly opposite. At the very moment that Pope Julius III wished to adorn his family chapel in the church, Michelangelo was completing the large *Crucifixion of Peter* fresco in the Pauline Chapel—a work that is visually, geographically, and iconographically linked to this most sacred spot on the Janiculum Hill.

For the Del Monte Chapel, as with every Julian project, Michelangelo was consulted. The artist had no time—or inclination—to work on the project himself, but Julius valued his advice. In the early stages of the commission, Julius favored the sculptor Raffaele da Montelupo to carve the grave monuments of his ancestors. Montelupo was a skilled and experienced marble carver. Partly because he had worked for Michelangelo on two different projects—the Medici Chapel in Florence and the tomb of Pope Julius II in Rome—Montelupo was respected and in demand. He was a natural choice for a commission as important as the current pope's family chapel. However, Michelangelo had reservations. Some years earlier, Michelangelo had commis-

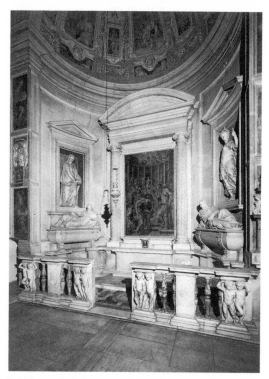

Del Monte Chapel, 1550–53, San Pietro in Montorio, Rome

sioned Montelupo to carve a prophet and a sibyl for the tomb of Julius II. The ungainly and mediocre figures are certainly the weakest elements of an otherwise grand and imposing tomb. When Condivi refers to the tomb as a "tragedy," he may have been reflecting Michelangelo's disappointment in certain figures—such as the two by Montelupo—that were not what Julius or Michelangelo deserved.

Given Michelangelo's experience with Montelupo on the Julius tomb, it is not surprising that he guided the new pope to a better artist. Montelupo may have been an early favorite, but once Michelangelo was consulted the commission passed to Bartolomeo Ammannati. The Del Monte Chapel is a masterpiece not because Michelangelo provided a design or carved the marble but because he saved it from Montelupo's mediocrity. Ammannati certainly proved the better choice.

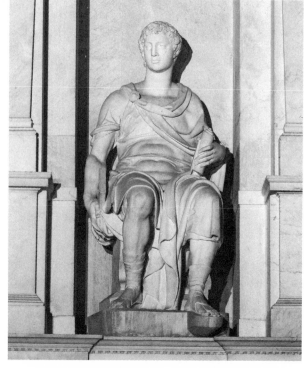

Raffaele da Montelupo, *Prophet*, 1545, Tomb of Julius II,
San Pietro in Vincoli, Rome

Learning to Delegate

During the pontificate of Julius III, Michelangelo made significant
changes in his working procedures as an artist and architect. In order
to fulfill his multiple, simultaneous obligations, he increasingly turned
to collaborators and conferred on them ever greater responsibility.
Michelangelo's late art and architecture depended on these personal
relationships—from supportive patrons to trusted site supervisors and
dedicated work managers. He learned to delegate. In the past, accept-
ing a new commission often provided Michelangelo with a ready ex-
cuse to shed or procrastinate previous obligations, such as when he left
unfinished the *Battle of Cascina* mural, commissioned for the Palazzo

della Signoria in Florence, to work for Pope Julius II, or when he left multiple other Florentine projects to work for Pope Paul III. Under Paul and then under Julius III, Michelangelo learned to accept new duties without also micromanaging them. He still gave the ready excuses of his old age and multiple responsibilities, but now, rather than refusing new initiatives, he became more adept at effectively managing them—mostly from a distance and with fewer encumbrances. And while he was no less the governing authority, he mostly exercised influence—when and where needed—through others.

In addition, and inconveniently, the papal treasury was nearly exhausted. While full of initiatives, Julius III had little money. Thus, Michelangelo is associated with a long string of projects that never advanced much beyond a conversation or a sketch, much less required the artist's full attention. Ultimately, most were carried out well beyond Michelangelo's lifetime. However, even a tenuous connection of a project with the great artist's name ensured it would be associated with and then attributed to him. Here, the concept of single authorship inadequately describes a more complex historical reality. For example, even though Pirro Ligorio completed the exedra and staircase in the Vatican's Belvedere Courtyard in the early 1560s, it is often associated with a Michelangelo design. Moreover, Michelangelo's name and burgeoning reputation lent prestige to the project and to its builder. Ligorio, like many others, claimed to be a pupil and collaborator of Michelangelo, thereby shining on himself the light of reflected authority and glory. It became a common phenomenon: fame by association.

Thus, by act and reputation, Michelangelo became the central figure in the building of late Renaissance Rome. For any given project, he might act as artist, designer, project manager, entrepreneur, and/or consultant. He provided designs, advice, and guidance for the workers under him, and he offered the same for the pope who employed him. One hundred years later Gianlorenzo Bernini (1598–1680), fashioning himself as the new Michelangelo, would assume a similar, multivalent role. If Michelangelo was not central to a project, he was consulted; if he did not build it, he designed it; if he did not design it, he made a sketch; if he was not involved, he offered an opinion; if he did

not see a project to fruition, he was integral to its ideation or gestation. As Condivi emphasizes, patrons oftentimes merely wished for Michelangelo's "opinion and judgment." Michelangelo had not always operated in such a fashion; indeed, this was a relatively new role that emerged less by choice than from his current circumstances and the many demands of his patrons.

Through drawings, trusted assistants, and verbal opinions, Michelangelo expressed and realized his views. Position, experience, and old age lent authority to his voice, as did the backing of the popes. Thus, Michelangelo extended and multiplied himself. Like the *deus ex machina* God he painted on the Sistine ceiling, Michelangelo was here, there, and everywhere—not always physically—because old age prevented him—but variously, through manifestations of his will and directions implemented by his associates and minions. And Michelangelo's word was backed by the full weight of papal authority and an increasingly efficient papal bureaucracy.

Yet, there were unintended consequences. Michelangelo was left with little time to work for himself. He was no longer, as he had been earlier in his career, a carver of single marble figures that astonished the world. The Rome *Pietà* had been carved fifty years earlier, *Moses* almost forty, and thirty years had passed since the *Risen Christ* had been installed in Santa Maria sopra Minerva. *Rachel* and *Leah*, of the tomb of Julius II, were the last sculptures he had carved and finished for the public realm, more than five years ago. Michelangelo was now an architect—the first modern "Starchitect."

Michelangelo was in his late seventies; nonetheless, on certain days he still reached for his hammer and chisels. He was drawn to marble. An exceptionally large block beckoned; he fashioned a paper hat with candles so that he could carve well into the night.

A Work to Surpass All Others

One evening in 1553, Giorgio Vasari stopped by Michelangelo's house in Via Macel de' Corvi to pick up a drawing for Pope Julius III—probably a design for his new villa outside the Porta del Popolo. Michel-

angelo answered the door holding a lamp. Vasari explained his errand, and while the two men conversed, Michelangelo's servant, Urbino, went upstairs to fetch the drawing. In the poor light of the hour, Vasari peered into Michelangelo's work space and noticed a large marble sculpture. As Vasari attempted to get a closer look, Michelangelo let the lamp fall from his hand, and the room was plunged into an inky darkness. Pretending to clumsiness, Michelangelo turned to his friend and said, in a plaintive tone, "One day my body will fall just like that lamp, and my light will be put out." The artist then added, "I am so old that death often tugs at my cloak for me to go with him."[41] As he did so often in his advanced years, Michelangelo was thinking about death. Death certainly clouded his thoughts when he was carving the sculpture he was reluctant for Vasari to see.

In retrospect, Vasari understood that Michelangelo did not want an observer—even a fellow artist—to examine his unfinished work. This was probably with good reason, for Michelangelo was experiencing manifold problems with the sculpture. But more than just another work of art with technical problems, this sculpture was fraught with deeply personal significance. Michelangelo was carving a *Pietà* to be his grave marker, his last will and testament, and probably his final creation. He was reluctant to share it with the world.

Michelangelo had begun the so-called Florentine *Pietà* shortly after he was appointed architect of St. Peter's, not long after suffering the loss of some of his closest friends in 1546 and 1547.[42] Like the Crucifixion drawings he had done in that period, the *Pietà* was likely begun as another means for him to ameliorate loss and to confront his own expected end. From the outset, however, he faced multiple physical and psychological challenges in carving the sculpture. Some of his difficulty can be attributed to the fact that the artist had not quarried the block himself. Indeed, it was *spolia*—a remnant, albeit a giant remnant, from a Roman monument. To be sure, Michelangelo was saved from the difficulties of quarrying and transporting the extremely large block. But on the other hand, marble is best carved when freshly quarried. With time, it hardens and becomes ever more intractable. Fresh marble yields to the hammer; old marble declares its resistance by deflecting

the chisel in a shower of sparks and splintery sherds. Yet, the weathered block attracted Michelangelo. He could begin work immediately, and its enormous size inflamed his ambition.

After the *David*, the Florentine *Pietà* is the largest marble Michelangelo ever carved (see plate 31). It is a giant among his sculptures. Not only did the artist confront a monumental block of marble, he undertook a supremely difficult task: to carve four figures from the single block. Even the most famous antique sculpture group, the *Laocoön*, was composed of just three figures.

The Roman encyclopedist Pliny the Elder had praised the *Laocoön* as a three-figure ensemble carved from a single block of marble—*ex uno lapide*. The sculpture, upon its discovery, in Rome in 1506, immediately set the highest standard for Renaissance sculptors. But when Michelangelo and his friend Giuliano da Sangallo, called to the site, began piecing together the fragmented antiquity, they discovered that it was *not* carved *ex uno lapide*! In fact, it had been carved from at least six blocks of marble that had been cleverly joined together. Pliny's account proved to be erroneous—but this revelation merely intensified the challenge: Could a modern artist succeed where the most famous antique sculpture had not?

The problems of carving a three-figure group are enormous; those attendant to carving four figures from a single block grow exponentially more complex. A four-figure group was a feat rarely attempted even by Gianlorenzo Bernini and the great marble technicians of the seventeenth and eighteenth centuries. To date, Michelangelo himself had carved multifigure sculptures just three times in his career: the *Bacchus*, the Rome *Pietà*, and the *Bruges Madonna*—all two-figure compositions. He had begun two others: the *Medici Madonna* and the *Victory*, but these remained unfinished. He imagined an extremely ambitious two-figure sculpture of Hercules and Cacus, but this project never advanced beyond drawn designs and a small clay model. He had never attempted three figures, much less four.

Michelangelo built a career by creating marvels: the Rome *Pietà*, *Bacchus*, *David*, *Moses*. In his youth, Michelangelo could carve anything he imagined, transforming the cold, resistant marble into supple

folds of drapery or translucent flesh. But like any skill, carving requires constant exercise. In the last twenty years, Michelangelo had carved the *Rachel*, *Leah*, and *Brutus*, but nothing as ambitious as this *Pietà*. Even given the inspiration and precedent set by classical antiquity, the audacity of such an undertaking is astonishing. Michelangelo had long maintained that the modern artist was every bit the equal of his ancient counterpart; however, with the Florentine *Pietà*, he sought not just to equal but to surpass the ancients. And he was well into his seventies.

Carving Marble at Age Seventy-Four

The French cryptographer and alchemist Blaise de Vigenère arrived in Rome in 1549 on a diplomatic mission. He wrote a vivid description of Michelangelo carving, which recounted the early stages of what eventually would be known as the Florentine *Pietà*.

> I have seen Michelangelo, although more than sixty years old and no longer among the most robust, knock off more chips of a very hard marble in a quarter of an hour than three young stone carvers could have done in three or four, an almost incredible thing to one who has not seen it; and I thought the whole work would fall to pieces because he moved with such impetuosity and fury, knocking to the floor large chunks three and four fingers thick.[43]

Leaving aside Blaise de Vigenère's miscalculation of Michelangelo's age—the sculptor was by then seventy-four—the artist's strength, speed, and dexterity clearly impressed the Frenchman. What he failed to describe was any recognizable figures or the subject of the sculpture. And what Vigenère could not possibly know was that Michelangelo's fury and impetuosity caused problems.

Vasari implicitly recognized the exceptional undertaking by describing Michelangelo's Florentine *Pietà* as "an exhausting work, rare in stone."[44] Like Vigenère, Vasari had seen the work in progress, and in his first edition of his *Lives*, he wrote that "it will surpass every other work of his."[45] By the second edition, Vasari knew the sad fate

of the work—never finished, damaged by the artist himself and abandoned. Thus, Vasari changed from anticipating that it would be Michelangelo's greatest masterpiece to faintly praising it as a unique (*rara*) object that was difficult and exhausting (*faticosa*).[46] That is, the sculpture had not met Vasari's earlier high expectations. Nor Michelangelo's.

Despite Michelangelo's celebrated ability to judge the quality of marble, he could never be entirely certain that a block did not contain hidden flaws. One need only recall problems the artist encountered with several of his earlier statues: the first version of the *Risen Christ* had a black vein running through the face; a disfiguring crack traversed the face and neck of the *Rebellious Slave*; the Medici Chapel's *Night* came from a flawed block that left Michelangelo with too little marble to carve the left arm. Unlike the additive practices of painting and much clay modeling, the reductive process of marble carving continually removes material, thereby reducing options for making corrections.

Michelangelo constantly made alterations in the course of carving. He had learned to quarry extra-large blocks not only to cope with undetected flaws but to give himself flexibility in making inevitable adjustments. But in attempting the four-figure sculpture, Michelangelo discovered that the block—as large as it was—offered him little room to maneuver. The Virgin is already too small in comparison to the Christ and the standing figure of Nicodemus. In fact, there is not enough stone to complete the Virgin's face without compromising Christ's head. Similarly, Michelangelo did not leave sufficient material to finish carving the Virgin's left hand, which helps support her son's body. Completing that hand would disfigure the already finished and polished torso on which it rests. Any changes the artist made would affect the other figures and necessitate a reconsideration of the entire group.

Michelangelo encountered an even more difficult problem in carving Christ's left leg. Perhaps there was not enough marble to realize the complicated pose, or the artist may have been disturbed by the sexual implications of having Christ's leg slung over his mother's lap.[47]

Such problems were not mutually exclusive and more than likely compounded one another.

In extreme frustration, Michelangelo took a hammer to the work. We will never know whether the marble accidentally broke or the leg was deliberately removed. What we see is a trimmed stump ready to receive an attachment, perhaps by Michelangelo but more likely by his assistant, Tiberio Calcagni, who rescued the sculpture from even worse desecration. We perhaps are reluctant to imagine the mature master encountering intractable problems, but with this *Pietà* (now referred to as the Florentine *Pietà*) we are witness to a combination of personal and technical impediments that plagued and ultimately doomed the sculpture.

Michelangelo's First Pietà: *From Grave to Altar*

We call Michelangelo's four-figure composition a *Pietà*, although commonly that subject is just a two-figure group, as was the first *Pietà* Michelangelo carved, at age twenty-three. That early sculpture originally adorned the grave of a powerful French cardinal located in a circular structure, attached to the left transept of Old St. Peter's, that was one of the most important burial sites in Rome. Variously known as Santa Petronilla or the Chapel of the Kings of France, this late-antique rotunda had been a preferred resting place for French dignitaries, supposedly since the time of Charlemagne. Michelangelo's beautifully carved and polished marble group more than satisfied a promise he had made to create the "most beautiful sculpture in all Rome."[48]

That was 1498. Fifty years had passed, and much had transpired in the meantime. In Pope Julius II's haste to rebuild St. Peter's, the Constantinian basilica had been torn down, as had the attached rotunda of Santa Petronilla—sacrificed for the greater glory of the new church. If a side benefit was the removal of the French from the heart of Christendom, then so much the better (at least in Pope Julius's opinion). Thus began the wanderings of Michelangelo's first *Pietà*.

By the 1550s, the early *Pietà* had been moved twice, but since the new church remained incomplete, it had yet to find a final resting place.

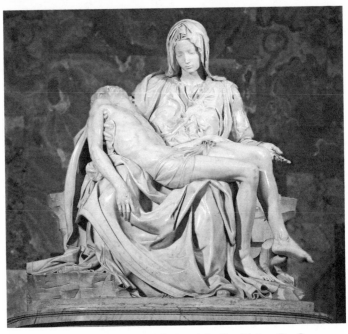

Michelangelo, *Pietà*, 1498–99, St. Peter's Basilica, Vatican City, Rome

The once powerful French cardinal had been disinterred and separated from his grave marker. The *Pietà* now sat above an altar in a remnant of Old St. Peter's. What did Michelangelo think of these peregrinations—or of the change in function and meaning of the sculpture, now adorning an altar rather than a grave? Upon reflection, Michelangelo could only have concluded that two of his earliest sculptures—the *Bacchus* and the *Pietà*—had somehow failed. Neither one served the person or purpose for which it had been made, nor were they in suitable locations. While the larger-than-life marble *Bacchus* had earned Michelangelo the commission to carve the *Pietà*, it had been rejected by Cardinal Raffaelle Riario, who had ordered it, and to Michelangelo's mind, therefore, was always considered something of a failure.

The *Pietà*, originally a source of youthful pride, now stimulated melancholic thoughts. A half century earlier, in an astonishing act of hubris, the twenty-three-year-old Michelangelo had inscribed his name

onto the strap that crosses the Virgin's breast. He never again signed a work of art.

Why Nicodemus and Mary Magdalene?

Now, once again Michelangelo was carving a sculpture with a similar subject: pity, sorrow, lament, lamentation, loss—another *Pietà* (see plate 31). Mary and Christ, of course, were central to his new composition, but what of the other figures?

A large male figure bends over and helps sustain Mary as she embraces her dead son. He would have been the first form Michelangelo blocked out, thereby fixing the upper limit of the pyramidal composition. A heavy cloak drapes across the broad, muscular shoulders and around the down-tilted head wrapped in folds of a cowl-like hood. Although it is cast in partial shadow, we discern an introspective face with deeply sunk eyes, a stubby nose, and an unkempt beard. Not polished but finished, the rough marble keeps us at a distance, wrapped in our own meditative thoughts, seeing "through a glass, darkly."

Is it Joseph or Nicodemus? Michelangelo readily identified with both. Joseph of Arimathea was the "honourable counsellor" (Mark 15:43), member of the Jewish Sanhedrin, and the wealthy man who donated his own tomb for Christ's burial. Nicodemus, while also a member of the Jewish ruling council, was a Pharisee and a secret follower of Christ. Both Joseph and Nicodemus would be appropriate figures, since both were present at Christ's deposition. Like Joseph, Michelangelo was a wealthy aristocrat who nonetheless desired more from life than worldly riches and fame. The artist identified as well with Nicodemus, not only because he had been, according to tradition, a sculptor, but also because in Christ's eleventh hour, Nicodemus had declared himself a devoted follower. So too Michelangelo, believing he was in the eleventh hour of his own life, fervently wished to declare his faith to his redeemer.

Joseph or Nicodemus? Throughout the carving—over the course of a half dozen years or more—Michelangelo likely thought of Joseph and Nicodemus both and, in the end, allowed the ambiguity to stand.

Although most persons favor Nicodemus, viewers are left to think what they wish. Michelangelo kept his thoughts to himself.

Deeper in the center of the block are the figures of Christ and Mary. To their right, Michelangelo carved a fourth figure, Mary Magdalene, in the privileged position at Christ's right side.

Mary Magdalene is not an essential figure in either a *Pietà* or a Deposition. Moreover, the Magdalene scarcely figures in Michelangelo's oeuvre, except in two cases—both painted. She was a youthful, kneeling figure in the master's early *Entombment* (National Gallery of London). And she is a central figure in a painting of the *Noli me Tangere*—designed by Michelangelo and painted by Jacopo da Pontormo (1494–1557).[49] Condivi, who was a witness to Michelangelo's carving of the Florentine *Pietà*, was cognizant of the group's novelty. He introduced his laudatory description of the work by writing that Michelangelo was "full of ideas and so has to give birth to something every day."[50] But given the comparative rarity of prominent female figures other than the Virgin Mary in Michelangelo's art, the question remains: Why Magdalene—and why now?

For a period around the time he began the Florentine *Pietà*, Michelangelo created a number of pious female figures: *Rachel* and *Leah*, Mary in the Crucifixion drawings, and the sorrowing female figures in his fresco of the *Crucifixion of Peter* in the Pauline Chapel. He still mourned the death of Vittoria Colonna, whose faith and piety profoundly moved him. In creating a *Pietà*, perhaps it is not surprising that his thoughts turned to another exemplary female: Mary Magdalene—a sinner who found salvation through Christ. Her inclusion in the composition was itself a significant decision. The choice makes sense when we consider her special place in Christ's life and the role she enacts in the *Pietà*.

Mary Magdalene

The Magdalene kneels on the privileged right hand of her Lord and savior. She helps to sustain his dead body; his right arm and hand fall across her shoulder, and his fingers lightly brush her back. Mary, the

mother of Christ, is lost in grief and is partly obscured by the slumping head of her crucified son; therefore, it is the Magdalene who addresses the viewer and presents Christ to us. The Magdalene's steady gaze is framed by her symmetrically arranged hair and seraphic diadem. Her posture and mute appeal call to mind the words pronounced as a body is lowered into a tomb: "I am the resurrection, and the life: he that believeth in me, though he were dead, yet shall he live" (John 11:25). And these words in turn echo those that Christ spoke to Nicodemus, "that whosoever believeth in him should not perish, but have eternal life" (John 3:15). Indeed, the Magdalene is central to Christ's life after death, as she was the first witness and herald of his resurrection.

In contrast to most images of the Magdalene, such as those by his Venetian contemporary Titian (1488/90–1576), Michelangelo conceived this figure as a diminutive, nubile girl. Her small breasts nearly brush Christ's naked flesh, but contact is obviated by a thick fold of the winding sheet and the chaste inclination of the Magdalene's upper torso. As in his design for the *Noli me Tangere*, Michelangelo heightens the tension of physical proximity, which reminds us of both her former life as a sinner and her new life devoted to Christ. Her unseen left hand embraces Nicodemus, to whom she is a counterpart, a relationship additionally suggested by the counterpoised inclinations of their heads. Like Michelangelo himself, the Magdalene and Nicodemus are penitent figures who yearn for salvation through Christ. Thus the linked figures of the Magdalene and Nicodemus lend a special poignancy to a sculpture that Michelangelo intended for his grave.

The Magdalene's small size is more apparent than real, for she grows and diminishes in stature and relative importance depending on the angle from which one views the sculpture. She is physically and iconographically a supporting figure, as are the *Rachel* and *Leah* to the *Moses* on the tomb of Pope Julius II (see plate 4). The scale of these latter female figures, especially in relation to *Moses*, inspires frequent, negative comment. Michelangelo could have created *Rachel* and *Leah* at any scale; he had plenty of available marble, and their niches could accommodate larger figures. The modesty of their size and expression, and the lesser degree of surface polish, were Michelangelo's decisions.

Rachel and *Leah* do not compete with *Moses*; rather, like a chorus, they are foil and counterpart. They frame, extend, and direct our attention—guiding us in contemplation and prayer. They are a gentle but audible whisper joined to the thunderous voice of the prophet. In these figures, Michelangelo observes what may be called a decorum of proportion, position, and finish.

In her role in a multifigure ensemble, the Magdalene of the Florentine *Pietà* is a close counterpart and worthy successor of the nearly contemporaneous figures of *Rachel* and *Leah*. Of course, the greater challenge presented by the Magdalene was to integrate her into a four-figure group and still create a satisfactory composition.

By the time the artist relinquished the sculpture to Tiberio Calcagni, the Magdalene figure was already well advanced. Bridges of stone that connect the Magdalene's head to the right arm of Christ reveal that the relation between the two figures and their relative sizes were not significantly altered by Calcagni. Again, these were Michelangelo's decisions, not Calcagni's. Being the unassuming and sensitive young man that he was, Calcagni perceived the beauty of the Magdalene and did his best to fulfill the figure's promise by finishing and polishing her form but not altering her size or position. He decided against intervening in the problematic figures of Christ and Mary, and he modestly abstained from touching the roughly chiseled Nicodemus—a figure he likely recognized to be a likeness of Michelangelo.

In carving Nicodemus, Michelangelo carved himself; it is the only generally accepted self-portrait of the artist, and the only one mentioned by contemporaries. Like Nicodemus, Michelangelo was devoted to his savior as a "pilgrim soul," seeking salvation, hoping for forgiveness of his sins. The image of the artist as an aged penitent journeying to God was subsequently enshrined in a portrait medal made by his friend and admirer Leone Leoni (1509–1590). Michelangelo, who may have had a hand in designing the medal, greatly appreciated the finished silver and bronze strikes; he sent two copies to his nephew in Florence and

kept two for himself.[51] The inscription on the reverse of the medal was taken from Psalm 51: "I will teach the unjust thy ways . . ." As has been suggested, the entire psalm can be read as a poem of Michelangelo's, and something of a portrait of the artist as a penitent pilgrim:

Have mercy on me, O God,
according to thy steadfast love;
according to thy abundant mercy.
Wash me thoroughly from my iniquity,
and cleanse me from my sin![52]

The Florentine *Pietà* is an eloquent expression of Michelangelo's faith, intended to mark his grave. But therein lay a dilemma. To finish the sculpture was to bring the marble to life but also to resign oneself to death. He expressed the paradox in poetry: ". . . with false conceptions and great peril to my soul, to be here sculpting divine things."[53] For any number of technical and psychological reasons, the sculpture was destined to remain unfinished.

Abandoned by Michelangelo; Rescued by Calcagni

The artist gave up on the sculpture. But when? Historians tend to favor secure dates: the beginning of events (*terminus a quo*) or their termination (*terminus ad quem*). It is often possible to date the beginning of Michelangelo's projects, but it is much more difficult to determine when he completed or abandoned them. With the *Pietà*, however, even the beginning date is uncertain, although consensus places it around 1547, the year Vittoria Colonna died. Michelangelo was still working on it in 1553, when he unintentionally revealed to Vasari his dissatisfaction with the sculpture by refusing to allow the admiring young man to see it. By then he had worked on the block for nearly six years, although, of course, he had other obligations. Still, six years?!

Michelangelo carved the early St. Peter's *Pietà* in a little more than a year; he finished the *David* in just three years; and he painted the entirety of the Sistine Chapel ceiling in four. Like the *Moses*, this later

Pietà sat in Michelangelo's workshop year after year. How many persons design their own tomb, and then live with it for six or more years? At some uncertain point—was it 1553, 1554, or 1555?—he abandoned the sculpture. Yet, he did not immediately move it. It was larger than the *Moses*, and we recall the herculean effort required to move *that* sculpture. The *Pietà* was not only unfinished and unpolished, but several major appendages had been broken. It was a mutilated work.

For whatever reasons, Michelangelo abandoned the work, but he did not, as is sometimes implied, discard it. He gave it to his banker and close friend Francesco Bandini (c. 1496–1562), who in turn requested that Michelangelo's young assistant Tiberio Calcagni repair the sculpture.[54] Despite his infelicitous last name, which means "heels," Tiberio was born into a Florentine family of some means and rising social station. In the 1530s or 1540s, the family transferred to Rome, where Calcagni's father owned a house with two shops close to the church of San Celso, in the Florentine quarter near Ponte Sant'Angelo. Well bred and well educated, Tiberio was still in his twenties when he was introduced in the early 1550s to Michelangelo by Francesco Bandini and another Florentine friend, the writer and ardent republican Donato Giannotti. Calcagni quickly became one of Michelangelo's closest assistants/companions, in some ways helping to fill the void left by the death of the faithful Urbino in 1556.

Vasari reports that "because he loved Calcagni, Michelangelo gave him to finish the marble *Pietà* that he had broken," adding that the group was "put together by Tiberio from I don't know how many pieces."[55] Frustrated in his effort to carve the most difficult sculpture of his life, Michelangelo relinquished the mutilated statue to his sympathetic assistant. The young man, whom Michelangelo much admired, did his best to repair the damage and salvage the group. Although Calcagni has received little credit for his efforts, the measure of his success is to be found in the number of visitors who admire the sculpture in Florence's Museo dell'Opera del Duomo. Few of those visitors are bothered by the unfinished portions of the work, and many are blithely unaware of Christ's missing leg. Rather, most are moved and humbled by the work's pathos.

It would be years before the *Pietà* was removed from Michelangelo's house. He lived with the sculpture for much of the remainder of his life.[56] On some days it reminded Michelangelo of Christ's sacrifice and Mary's sorrow, the fragility and transitoriness of life itself; on other days it admonished the artist for his hubris and convinced him of the utter futility of art—"laden with error," as he would write. It also served as a perpetual reminder of his many incomplete undertakings—all those unfinished projects, a squandered, imperfect life. After the *Pietà*, Michelangelo began only one other marble sculpture. It was also a *Pietà*. And it too would remain unfinished.

"Giunto è già'l corso della vita mia"

About the time he began experiencing difficulty with the *Pietà*, Michelangelo drafted a sonnet, "Giunto è già'l corso della vita mia," that appears to be directly related to—and perhaps motivated by—his frustrating experience in carving the sculpture. He sent a finished version of the sonnet to Giorgio Vasari in September 1554, and because the latter included it in the second edition of his *Lives* (1568), it was destined to become one of Michelangelo's best-known poems. This "publication" history occludes the fact that the sonnet's birth was as problematic as the carving of the *Pietà*, and both works caused Michelangelo to reflect not only on the difficulty of making art but on its very worth. It is impossible to escape the sense of Michelangelo's increasing pessimism, even with regard to the medium of sculpture, in which he reigned supreme. As he ruefully observed, "No one has full mastery before reaching the end of his art and his life."[57] In a poetic fragment— or perhaps it was just a spontaneous reflection—he lamented his misguided efforts and the "ultimate futility" of art, which he had come to realize was a "false conception."[58] With evident despair, he wrote, "art and death do not go well together."[59] These pessimistic observations were written on the same sheet and just below an incomplete draft of the sonnet that was ultimately sent to Vasari and "published" in the second edition of the *Lives*.[60] What Michelangelo did not reveal to Vasari was his agonizing struggle with the poem's creation—just as he

had refused to allow the younger man to look upon the imperfections of the unfinished *Pietà*.

The sheet on which Michelangelo began the sonnet (see plate 32) reveals many of the characteristics of his unfinished work in stone: a good beginning followed by unanticipated problems and increasing frustration. We see him attacking problems with various degrees of success, and often leaving passages unresolved. The extant sheet offers insight into the artist's agitated state of mind, and it reveals his creative process, which was growing ever more discursive, fragmentary, nonlinear, and frequently incomplete—whether the medium was words or stone.

Michelangelo drafted the first quatrain of the sonnet, and then at line three of the second quatrain he began searching for words, writing three different versions of a couplet that expressed his realization that his life had been "laden with error" (*error carca*). The nearly untranslatable Italian phrase *error carca* carries a heavy and dual implication of artistic failure tainted by sin and futility.[61] Without having resolved the compositional impasse, Michelangelo gave vent to an overwhelming pessimism when he wrote: "In such servility! and all so boring! mistaken notions! and in deadly peril to my own soul, here chiseling things divine."[62] At this point, the composition of the sonnet, which began as a voyage, "Giunto è già'l corso della vita mia," was interrupted and momentarily abandoned.

In composing a poem whose subject was the voyage of life, Michelangelo may have had in mind Petrarch's sonnet "Passa la mia nave colma d'oblio . . ." ("My ship, laden with oblivion, sails on a bitter sea . . ."), and, in a larger sense, he certainly was recalling Dante's journey of self-discovery, penitence, and redemption as described in the *Divine Comedy*.[63] While Dante loses his way in a dark wood, Michelangelo travels a tumultuous sea in a fragile vessel—both pilgrims having lost their direction in the midst of life. Michelangelo's sense that he has erred echoes Dante going astray, "la diritta via era smarrita" ("the straight path had been lost"). Dante had the advantage and sympathy of his guides, the sage Virgil and beloved Beatrice. Michelangelo, who was now more than twice the age of Dante, had only his Lord as guide.

Unfortunately, Michelangelo's Lord is a less helpful and sympathetic companion than were Virgil and Beatrice for Dante. Indeed, Michelangelo's Lord remains unknown, an expectant being to whom the artist cries out in plaintive appeal. In six more lines, written in a cramped, messier hand toward the bottom of the page, Michelangelo poignantly expresses his sense of the uselessness of art in the face of impending death and a silent God.

> The springtime, fresh and green, can never guess
> how, at life's end, my dearest Lord, we change
> our taste, desire, love, longing—years' debris.
> The soul means more, the more the world means less;
> art and impending death don't go together,
> so what are You still expecting, Lord, from me?[64]

Unlike Dante, Michelangelo was *not* in the middle of his life's journey but conspicuously at its end, and still the artist had not found his way, his "diritta via." Finally, he turned the sheet ninety degrees and scribbled a fourth version of the line ending in "error carca," thus reiterating his lament of a life "laden with error."[65] The disrupted composition of the sonnet and the writer's descent into increasingly negative ruminations on art and life are not evident if we read only the finished and less depressing version of the sonnet that Michelangelo sent to Giorgio Vasari (especially as rendered in a lively translation by the poet Frederick Nims):

> So now it's over, my day's long voyage, through
> tumultuous ocean, in a hull unsteady;
> I've come to the world's last anchorage, and make ready
> life's log with its every reckoning, foul and fair.
> The daft illusion once so cuddled there
> that art was a sovereign lord to idolize,
> I've come to know—how well!—was a pack of lies,
> such as, to their grief, men treasure yet as true.
> Fond, foolish, the lovesick longings felt before,
> what becomes of them, my double death approaching?

One certain-sure, one muttering harsh alarms.
Painting and sculpture soothe the soul no more,
its focus fixed on the love divine, outstretching
on the cross, to enfold us closer, open arms.[66]

Vasari did more than simply publish Michelangelo's poem in the second edition of his *Lives*; he actually "polished" it, introducing more than a dozen spelling and word modifications.[67] In contrast to its edited form, the autograph draft reveals a disjointed, even distressed compositional history and a highly dispirited artist. For example, the final verse of the sonnet in Vasari's edited version, "Painting and sculpture soothe the soul no more, its focus fixed on the love divine," is less pessimistic than the same line in the artist's first draft: "The soul means more, the more the world means less; art and impending death don't go together." Similarly, the last line of Vasari's version has Christ offering succor, "love divine, outstretching on the cross, to enfold us closer, open arms," which is more uplifting than the plangent lament of the draft: "so what are You still expecting, Lord, from me?" (*che convien più che di me dunche speri?*).[68] Between draft and edited version, Michelangelo's sentiment is transformed from his despairing cry—"what are You still expecting, Lord, from me?"—into a hope for salvation, with Christ on the cross reaching out to embrace the penitent artist.

In the same way that we examine Michelangelo's drawings and unfinished sculptures for what they supposedly reveal of the artist, we should pay attention to the fragmentary and inchoate form of much of his poetry. Michelangelo's drawings, sculptures, and writing all reveal the artist immersed in the laborious—and not always successful—creative process.[69] While we rightly admire Michelangelo's prodigious artistic accomplishments, it is well to recall that toward the end of his life, he looked upon art as false and futile, even a "deadly peril to my own soul" (*gran periglio dell'alma*).[70] Art, once his "sovereign lord," was now, late in life, "laden with error."[71]

Creating art had become increasingly difficult for the seventy-nine-year-old artist, whether it was a sonnet, a marble sculpture, or the church of St. Peter's. Calcagni and Vasari each helped in different ways

to finish and preserve a work that Michelangelo might never have released into the world. Thus is Michelangelo credited with authorship beyond what he actually created: ideas and inventions (*invenzioni*) were as much admired as work by his hand (*di sua mano*). Such a shift of emphasis was important in the making of Michelangelo.

In Michelangelo's Household

One day in 1551, the Florentine artist Benvenuto Cellini appeared at Michelangelo's door in the Via Macel de' Corvi. Like Osric, the vain and affected messenger in Shakespeare's *Hamlet*, Cellini lavished laudatory greetings on Michelangelo while barely acknowledging the master's servant, Urbino. Cellini had been sent by Cosimo de' Medici (1519–1574), the duke of Florence, who greatly desired to bring Michelangelo "home." Cellini launched into a carefully prepared speech, but Michelangelo, as Cellini expected, interrupted him, claiming that St. Peter's prevented him from leaving Rome. Undeterred, Cellini "retorted that he would do better to return to his homeland, which was governed by a very just prince, who was more fond of talent than any other prince ever born." Urbino was present throughout this exchange, as Cellini later recalled:

> He had with him a lad from Urbino who had served him for a good few years, more as a general helpmate than anything else: it was clear that he had learnt nothing about art. I had harassed Michelangelo with so many sound arguments that he was at a loss what to reply, and suddenly he turned to his Urbino as though to ask his opinion. This Urbino of his, in his uncouth way, suddenly shouted out loud: "I shall never part from my Michelangelo till either he or I is under the ground." I couldn't help laughing at these silly words.[72]

We should be wary of believing anything that the bombastic, self-aggrandizing Cellini set down in his autobiography, but in this case, he unwittingly sketched a true likeness: Michelangelo turned to ask the opinion of "this Urbino of his," who bursts out with an effusive declaration of loyalty to "my Michelangelo," and Cellini can't help but

laugh at the man's absurdity. But his prophesy came true: Urbino, the unlettered helpmate, was faithful to Michelangelo till death. Cellini was the greater artist, Urbino the much greater friend.

Although it is a widely propagated myth that Michelangelo lived alone, he rarely did so and certainly never did once he was beyond middle age and living in Rome. In addition to a sequence of live-in male assistants, Michelangelo usually had a domestic "family," which consisted of one and sometimes two or more female housekeepers, who did the marketing, cooked, cleaned house, and did the laundry. They ran the household. As a young man in Florence, Michelangelo and his four brothers had been raised by a certain Mona Margherita, who similarly was the domestic center of the all-male Buonarroti household. When Michelangelo left Florence in 1534, he ensured that Mona Margherita would be cared for in perpetuity: "I'll never abandon her," he assured his brother, in fulfillment of a promise to his dying father. Michelangelo was as good as his word, and when Mona Margherita died in 1540, Michelangelo expressed his great grief, "as if she had been my sister."[73]

Given that Michelangelo had enjoyed the lifelong service of the faithful Mona Margherita, it is little wonder that he felt all other domestic help paled in comparison. In the artist's harsh estimation, it was difficult to find any maidservant who was clean and respectable, given that "they are all pigs and prostitutes." Nonetheless, he could not live without female servants, and only once was he entirely "without women."[74] It is perhaps surprising, then, that we hear little more about them than their salaries, which Michelangelo recorded every week, and his occasional comments about the trouble they caused, such as when he fired Mona Caterina "because she was too proud" (*per la sua superbia*). No matter Caterina's arrogance—Michelangelo required her assistance and he rehired her a month later.[75]

Michelangelo's domestic "family" expanded when his companion Urbino married in September 1551, and the couple set up house with the artist. Michelangelo furnished a room in his house (adding oilcloth window coverings) for Urbino, his new bride, Cornelia Colonelli, and their female servant.[76] The household now consisted of more than a

half dozen persons, including not only the newlyweds and their servant but also an additional female servant and her daughter, a male assistant named Jacopo, and a man named Bastiano who took care of the animals: that once-sick horse, now grown into an old nag (*ronzinetto*), a few hens, and a "triumphing" rooster. The cat once described as "lamenting" Michelangelo's absence had long since disappeared.

When Cornelia gave birth to a son in 1554 and then another boy in 1555, the eighty-year-old artist found himself surrounded by a large and noisy entourage. He stood as godfather for the elder son, whose parents named him Michelangelo. The evidently proud artist presented Cornelia with a dress made from a dark violet rash (*rascia*), the most expensive woolen cloth manufactured in Florence. Michelangelo, who was knowledgeable about fabrics and sensitive to quality, ordered "the finest to be found," and when it arrived from Florence he pronounced it "molto bella."[77] It sounds like the subject of a nineteenth-century anecdotal salon picture: "The Great Michelangelo Buonarroti Presents Cornelia Colonelli, the Wife of His Favorite Servant, Francesco, known as Urbino, with a Violet *Rascia* Dress Made in Florence, on the Occasion of the Birth of Their First Child, Baptized with the Name Michelangelo."

This was a moment of rare contentment in Michelangelo's life, although sorrow was not long in arriving. When Michelangelo's nephew, Lionardo, reveled in the birth of a male heir in 1554, Michelangelo responded like a damp rag. Maybe Lionardo should demonstrate more restraint, Michelangelo wrote, since "one ought not to laugh when the whole world weeps."[78] This is a particularly unexpected reaction, given that Lionardo and his wife, Cassandra, had just produced the long-awaited male heir of the Buonarroti family. Sadly, in almost perverse fulfillment of Michelangelo's perennial pessimism, a second grand-nephew, another child named Michelangelo, was born a year later but survived barely a week: "Lionardo—In your last letter I had the news of the death of Michelangelo. It has been as great a grief to me as it had been a joy—indeed more so. We must bear it patiently."[79]

But his patience was again tested just six months later, when death claimed Michelangelo's brother Gismondo, his last surviving sibling.

The artist faced this loss with composure, fortified by Christian resignation and a profound belief in divine will: "I had the news of the death of Gismondo, my brother, but not without great sorrow. We must be resigned; and since he died fully conscious and with all the sacraments ordained by the Church, we must thank God for it."[80] Patience and resignation were Michelangelo's frequently invoked antidotes to sorrow. However, nothing could assuage the grief he was about to suffer.

Saddest of All Deaths

In the letter of 1555 to Lionardo that stoically accepted his brother Gismondo's death, Michelangelo revealed what truly preoccupied him: his beloved servant Urbino was seriously ill.

> Here I'm beset by many anxieties. Urbino is still in bed and in a very poor condition. I do not know what will ensue. I'm as upset about it as if he were my own son, because he has served me faithfully for twenty-five years and as I'm an old man I haven't time to train anyone else to suit me. I'm therefore very grieved. So if you have some devout soul there, I beg you to get him to pray to God for his recovery.[81]

Urbino fell ill in June and remained bedridden for five months. Michelangelo grew weary from the strain. He purchased a dizzying array of medicines that included confections, syrups, purgatives, and gilded lozenges, since gold, being valuable, was considered especially efficacious. By early September, Urbino was taking something every day. Two different pharmacists prescribed medicines concocted from hyssop (a pungent European mint), oxymel (a mixture of honey and acetic acid), cassia, cinnamon, cloves, julep, licorice, coltsfoot, oil of violets, rose water, alcohol (*aqua vitae*), and sugar. A few of these concoctions called for some unusual ingredients, such as fox oil, powdered antler, fine Venetian sugar, and pubic hair (whether male or female is not specified). There was no bloodletting, but after months of these various remedies, Urbino understandably needed something "for the stomach." Then decoctions for the heart and liver.[82] Nothing worked.

At the end of November, Urbino made his will, and he died quietly on January 3, 1556.[83] Michelangelo, who loved him "as if he were my own son," was so emotionally distraught that he recorded the wrong month when he wrote to inform Lionardo:

> I must tell you that last night, the third day of December at 9 o'clock, Francesco, called Urbino, passed from this life to my intense grief, leaving me so stricken and troubled that it would have been more easeful to die with him, because of the love I bore him, which he merited no less; for he was a fine man, full of loyalty and devotion; so that owing to his death I now seem to be lifeless myself and can find no peace.[84]

Michelangelo reveals something of the depth of his sorrow, as well as his esteem for his longtime companion, by referring to him by his Christian name. In his grief, Michelangelo hoped that Lionardo might find time to come to Rome. On the same day, the artist's newest personal assistant, Sebastiano Malenotti, also wrote to Lionardo. "I have never written to you before," began Malenotti, but he had taken up the pen after seeing Michelangelo "crazy with grief." He urged Lionardo to visit in order to "prolong your uncle's life."[85] After Urbino's death, Malenotti settled accounts with the apothecaries, took care of the funeral expenses, and gave alms in memory of the deceased to the *frati* of Santa Maria in Aracoeli, Santa Maria sopra Minerva, and Santissimi Apostoli.[86] That Saturday, Michelangelo again wrote to Lionardo:

> Lionardo—Last week I wrote and told you of Urbino's death and that I was left in a state of great confusion and was very unhappy and that I would be glad if you could come here. I'm writing you again to say that when you can arrange your affairs, without loss or risk for a month, you should get ready to come. . . . Come, because I am an old man and should be glad to talk to you before I die.[87]

Enclosed with this letter was another from Malenotti urging Lionardo to come, since it would "give comfort to the poor old man," who was "beside himself with grief."[88] Nearly two months after Urbino's death, Michelangelo's anguish continued to enervate him. Finally, on February 23, 1556, he managed to write to Giorgio Vasari:

My dear Messer Giorgio—I am hardly able to write, but at least I'll make some attempt to answer your letter. You know that Urbino is dead; through whom God has granted me his greatest favour, but to my grievous loss and infinite sorrow. The favour lay in this—that while living he kept me alive, and in dying he taught me to die, not with regret, but with a desire for death.

I have had him twenty-six years and found him entirely loyal and devoted; and now that I had made him rich and that I had expected him to be a support and stay to me in my old age, he has vanished from me, and nothing is left to me but the hope of seeing him again in Paradise. And of this God has given me a sign in the happy death he died; for he was far less grieved at dying than at leaving me here in this treacherous world with so many burdens; though the greater part of me has gone with him, and nothing but unending wretchedness remains to me.

I commend me to you and beg you, if it is not a trouble, to make my apologies to Messer Benvenuto [Cellini] for not replying to his letter, because in thoughts such as these I am so overwhelmed with emotion that I cannot write.[89]

And yet he *did* write—a long and affecting letter in reply to the letter of comfort Vasari sent to him. Michelangelo's letter is a more revealing expression of his emotions than he permitted himself with his nephew. There could hardly be a better gauge of their friendship: Vasari, older and more mature than Lionardo, unencumbered by the complications of family relations, was a person of sympathy and discretion to whom Michelangelo could unburden himself. Notably, Michelangelo could not bring himself to write to the sycophantic Cellini, but trusted Vasari to serve as his discreet intermediary.

A persistent melancholy now accompanied Michelangelo. Later that same year, Michelangelo learned of the death of yet another of Lionardo's children, the baby girl Francesca, who had lived just nine days. Francesca's death caused Michelangelo "much regret." But, he added, "I'm not surprised about it, because it is not the lot of our family to multiply in Florence. So pray God that the one you have may live [Buonarroto, then two and a half], and see that you keep alive your-

self."[90] This fatalism was compounded when Lionardo and Cassandra's next child, Bartolomea, also died before she was two weeks old: "Lionardo—I have learnt of the death of the baby girl; this does not surprise me, because in our family there was never more than one at a time."[91] He was pleased, therefore, to learn of the birth of Alessandra in early 1560: "I was delighted that you've had a daughter, because as we alone remain it will surely be a good thing to make some good alliance."[92] But just four months later, the depressingly recurrent history was repeated, as was Michelangelo's nearly identical, morbid sentiment:

> Lionardo—I had a letter of yours a few days ago with the news of the death of your daughter, Lessandra. I was very sorry about it, but I should have been surprised if she had survived, because in our family there is never more than one at a time. We must resign ourselves and take all the more care of the one that remains to us.[93]

In just five years, between 1556 and 1560, Michelangelo's nephew had lost an infant boy and three girls. These multiple sorrows elicited Michelangelo's tenderness and generosity, qualities that contemporaries sometimes experienced but biographers have largely overlooked. Michelangelo found solace in providing for Urbino's widow and her young family, who occupied an increasingly important place in the artist's heart and mind in his final years. Likewise, he grew ever more solicitous of Lionardo's family and affairs. Understandably, little prevented him from dwelling on thoughts of death. And yet he had to stay alive in order to give birth to St. Peter's.

ROME 1555

On March 6, 1555, Michelangelo turned eighty. Two weeks later, on March 23, Pope Julius III died. As usual, Rome was thrown into tumult. Besides the usual Vatican Guards, an extra two thousand soldiers were enlisted to protect the Sacred College of Cardinals during the ensuing conclave.[1] The thirty (of a total thirty-seven) cardinals resident in Rome met and deliberated in the Pauline Chapel—the first conclave to take place in the space unencumbered by scaffolding and painting equipment. The faces of a blinded Saul and glaring Peter lent weight and urgency to the cardinals' deliberations. The artist remained safely at home throughout the critical period.

The candidate elected, Cardinal Marcello Cervini, was a modest and well-respected intellectual, a former prefect of the Vatican Library, and a protonotary apostolic who had served as a close adviser to Pope Paul III. He and Michelangelo knew one another well, particularly since the two had experienced a sharp disagreement in the past.

Some years earlier, Cardinal Cervini had criticized Michelangelo's handling of St. Peter's. Cervini had supported the two deputies who complained that Michelangelo was undermining their authority and that "everything is kept secret from them."[2] In the ensuing meeting

with the deputies and the cardinal, Pope Paul had reaffirmed his faith in Michelangelo and squelched the critics, including Cervini.

Given this past history, when Cervini became Pope Marcellus II in April 1555, Michelangelo anticipated difficulties regarding his position at St. Peter's. However, before the problem arose, Marcellus precipitously died, just three weeks after his election. Known for precious little else, the pope lived just long enough for Giovanni Palestrina, the genius of polyphonic choral music, to compose his "Missa Papae Marcelli." Michelangelo undoubtedly heard this choral masterpiece sung in the Sistine Chapel, even if the artist, despite being a poet, seemed to have little appreciation for music. Some years earlier, his friend Luigi del Riccio had commissioned the much-respected Franco-Flemish composer Jacques Arcadelt to set two of Michelangelo's madrigals to music (subsequently published in 1543). The artist, at a loss as to how to thank the composer properly or in person, turned to Del Riccio, asking him to send Arcadelt "either cloth or money."[3] How many services Del Riccio rendered the artist; how badly he was missed.

The long illness and death of Michelangelo's beloved companion Urbino, and the sudden death of Pope Marcellus—the third pope to have died since Michelangelo's appointment as architect of St. Peter's—greatly disturbed the artist's already fragile tranquility. Uncertain about his position and the future of St. Peter's, Michelangelo asked his nephew in Florence to send the *breve* (papal brief) of Pope Paul III that gave the artist full authority as papal architect.[4] That document was of such value that Michelangelo first sent it to Florence for safekeeping and now paid handsomely to have it returned to Rome, with the evident intention of showing it to a newly elected pope.

However uncertain Michelangelo's position at St. Peter's, at least the construction was currently in steady hands. Sebastiano Malenotti, one of the more reliable overseers, not only was supervising work at St. Peter's but had joined the extended household that lived under Michelangelo's roof. Malenotti was never as important or as close to Michelangelo as Urbino, but he did much to fill the tremendous void left by that painful loss.

Sebastiano Malenotti

Sebastiano Malenotti, from San Gimignano, worked with Michelangelo at St. Peter's for approximately seven years (c. 1550–57). He was an overseer much like those Michelangelo had employed many years previously at San Lorenzo—skilled and versatile craftsmen who managed men and materials and capably supervised the day-to-day work. It may seem surprising that such persons, so instrumental to the success of any building project, have remained obscure figures, always overshadowed by patrons and architects. There are a few exceptions, such as the indispensable Fray Antonio de Villacastín at the Escorial in Spain, and Il Cronaca, whose comprehensive duties at the Strozzi Palace in Florence earned him a place in the history of Renaissance architecture. For the most part, history remembers architects/designers, not building foremen. And such is the case with Sebastiano Malenotti and his successors at St. Peter's.

Malenotti's competence combined with his blunt manner made him an extremely effective site manager. He kept track of details and was confident in making the hundreds of daily decisions that otherwise would fall on Michelangelo's shoulders. Michelangelo could effectively direct the work at St. Peter's by drafting sketches and giving oral instructions to Malenotti on a daily basis. After being on-site all day, Malenotti would sit with Michelangelo, review the work's progress and problems, and he and Michelangelo would make plans for the following day. Unless there was a special design issue—a column base or capital that required a template drawing—or an issue to be resolved with the meddling deputies, Michelangelo's presence might not be required. The arrangement was extremely effective, but it gave rise to Nanni di Baccio Bigio's slanderous accusation that Michelangelo worked "at night so as not to be observed." This was probably true; with Malenotti at his side, Michelangelo could work day *and* night, and away from the prying eyes of "rascals" like Nanni.

Particularly when age or illness prevented his regular attendance at St. Peter's, Michelangelo received progress updates every evening from his supervisor. After all, things took the elderly artist a bit longer in the morning, and he was slow riding across the city. Once on-site, one

could hardly expect Michelangelo to climb to the current construction level. How often did the twenty-year-old bricklayers see the eighty-year-old architect up at the springing of the transept vault?

In addition to his duties at St. Peter's, Malenotti served as friend, secretary, and manager of Michelangelo's affairs, thus partly filling Urbino's shoes. But, in contrast to Urbino, who was more a personal servant and companion, Malenotti devoted his time to the construction site. Thus, he was invaluable to Michelangelo and to the smooth operation of the building works.

Suffering from "the Stone"

Michelangelo generally was in good health for a man in his eighties, but then suddenly he developed kidney stones. Unable to urinate without excruciating pain, he complained to his nephew that he was "groaning day and night, unable to sleep or to get any rest whatever."[5] For more than a year, Michelangelo suffered from "the stone," which he decried as "the cruelest thing."[6] Michelangelo was grateful to be in the care of "a good doctor," the renowned anatomist Realdo Colombo, but, he conceded, "I believe more in prayers than in medicine."[7] That probably was wise, considering the nature of Renaissance medicine, which employed a frightening array of pills, poultices, confections, and strange concoctions. Hoping to relieve the artist's suffering, one quack doctor recommended an unappealing brew made from anise, mallow root, and a fistful of mallow leaves mixed and boiled in water. Michelangelo was to drink some, at a tepid temperature, every hour.[8] Relief came only when the artist imported a supply of mineral water from a spring near Viterbo, which he drank instead of wine and used exclusively in cooking for two months. He then sent his nephew hopeful reports when he discharged fragments of stone.[9] Painful though it was, Michelangelo found humor in his ailment: "I myself have gotten to know urine and the little tube it comes out of."[10]

Although Michelangelo never specified the Viterbo water's precise source, more than one modern supplier of mineral water claims, on its label, to bottle the very water that relieved the artist of his agony.

During the nineteenth century, society ladies in Rome took high tea at the renowned English Tea Room at the bottom of the Spanish Steps, which advertised its product as diuretically superior to all others. The tea supposedly was brewed exclusively with the water preferred by Michelangelo.

If not kidney stones, then old age. Nearly every Saturday, Malenotti wrote to Michelangelo's nephew, Lionardo, often enclosing shorter missives from the artist. In one of these letters, of March 1556, Lionardo read that even though Michelangelo's sorrow over the loss of Urbino was gradually abating, he was still subject to dark moods, as when some cloth that he ordered as a gift for Urbino's widow failed to arrive from Florence:

> Lionardo—A fine rascal you hit upon to entrust with that cloth. I've been awaiting it here for a month and have kept others waiting, to my great displeasure. Please will you find out what that rascal of a muleteer has done with it, and if it's found send it to me as quickly as you can. . . . As if I hadn't burdens enough! I've had and have so many vexations and troubles that they cannot be numbered.[11]

As Malenotti explained sympathetically to Lionardo: "He is old and every little thing bothers him greatly."[12] Michelangelo's mood improved when the cloth finally arrived; nonetheless, he admitted to a general state of enfeeblement: "I'm very much weakened [molto diminuito] since Urbino died, and every hour might be my last."[13] Gradually, the artist resumed his regular correspondence with Lionardo and took up his usual topics—farms to purchase, food and clothing sent from Florence, and the artist's age. For his part, Lionardo continued his regular shipments of wine and Tuscan delicacies. In July 1556, Michelangelo noted that the wine was "the best you've ever sent me," but, he added sadly, "I've no longer anyone to give it to, since all my friends are dead."[14] Malenotti, who was "with him continuously," provided Lionardo with regular reports on Michelangelo's moods and health: "One must have patience with him and consider his old age," reads one typical communication.[15] Little by little Michelangelo overcame his despondency and, with Malenotti's practical and moral support, returned to work

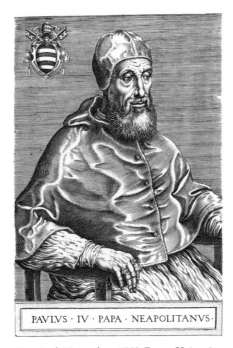

PAVLVS · IV · PAPA · NEAPOLITANVS ·

Pope Paul IV, woodcut, 1568, Emory University,
Pitts Theology Library, Atlanta

at St. Peter's, but only "with a spirit that endures the greatest exertions."[16] St. Peter's required the "greatest exertions," but it also had become the center of Michelangelo's life.

Pope Paul IV

Following the death of Pope Marcellus II in May 1555, Cardinal Giampietro Carafa (1476–1559) was elected pope, taking the name Paul IV (r. 1555–59). Carafa was more respected than liked. As a man of deep faith and high principle, he was widely perceived to be a much-needed antidote to a weakened papacy. In taking Paul as his name, he tacitly declared his adherence to a conservative and doctrinaire church. As pope, he pursued a rigorous and bleak agenda, acting as God's powerful instrument. He was zealous in addressing abuses and in strengthening the office of the Roman Inquisition.[17]

There was no room in Paul's doctrinal conservatism for progressive reformers nor any sympathy for the notion of justification by faith alone (*sola fide*)—the central tenet of the Protestant threat to the Church's universal authority. Several years earlier, Michelangelo had been exposed to reformist ideas via his friendship with Vittoria Colonna and the so-called Spirituali. These included Colonna, Reginald Pole, Gasparo Contarini, Giovanni Morone, and the charismatic Bernardino Ochino. Most of these figures were now dead or dispersed, some hounded from Italy. Like others, Michelangelo treaded softly during the four years of Paul IV's papacy. Never one to be compromised by personal or political entanglements, Michelangelo managed to remain in the pope's good graces. As with his distortions of truth regarding his relations with the Strozzi and the Florentine exiles, Michelangelo was equally adept when dissembling about his ties to the Spirituali. Besides, his only remaining link to this group was his warm friendship with Ludovico Beccadelli.

Ludovico Beccadelli

Although death had deprived Michelangelo of so many dear friends and close associates, he never lacked for company. It would be a grave mistake, therefore, to imagine the elder Michelangelo alone, as Frank Jewett Mather did in his once-popular *A History of Italian Painting*: "From a Roman studio as unkempt and filthy as its owner, he snarled at the world and himself like a dog from a kennel."[18] This image, while compelling, does a disservice to Michelangelo, discounting his patrician character, his constant concern for his family, his bustling household, and the sustaining happiness he derived from his closest friends. It is the depth and importance of those friendships that makes their repeated losses such a poignant leitmotif of Michelangelo's late life.

Ludovico Beccadelli (1501–1572) was a refined, well-educated prelate and poet from a prominent Bolognese family. He was a friend of Vittoria Colonna, Cardinal Reginald Pole, and the humanist writers Pietro Bembo and Giovanni della Casa.[19] The friendship between Michelangelo and Beccadelli undoubtedly was nurtured within this

same circle of cultured individuals and mutual acquaintances. In fact, Beccadelli was precisely the sort of refined younger man (by twenty-five years) to whom Michelangelo was repeatedly drawn. The poems that Michelangelo and Beccadelli wrote to one another reveal the depth of their friendship and their openness in sharing religious and personal sentiments. The two discovered a different dimension to their friendship when Beccadelli served as a deputy for the *fabbrica* of St. Peter's in the 1540s. Michelangelo's tenure at St. Peter's may have proceeded differently had Beccadelli remained at the *fabbrica*, but Pope Julius III appointed him papal nuncio to Venice and subsequently vicar general of Emilia. A more serious and painful separation occurred when Beccadelli became archbishop of Ragusa (modern Dubrovnik) in 1555. He moved across the Adriatic to Dalmatia and never returned to Rome. It was yet another loss Michelangelo suffered.

Only after Beccadelli departed did the two friends have reason to correspond; therefore, the only way to recover the earlier history of their friendship is to recognize the depth of feeling once they separated. Beccadelli was one of those rare friends who shared completely Michelangelo's contradictory feelings of carnal desire and spiritual yearning, simultaneously pining for relief from earthly concerns while fully accepting his obligations as a servant of God. Earlier, while Beccadelli was a papal nuncio in Venice, Titian had painted his portrait, beautifully capturing the intelligent, thoughtful, and sensitive man that shines forth in his correspondence with Michelangelo (see plate 33).[20] It is one of Titian's greatest portraits, partly for being so alive, understated, and gently sensitive.

Shortly after Beccadelli left Rome for Ragusa, Michelangelo sent him a sonnet, to which Beccadelli replied with a sonnet cleverly written in matching rhymes.[21] A few months later, Michelangelo sent another sonnet, in which he lamented both his friend's absence and the recent death of Urbino (with whom Beccadelli evidently had been well acquainted):

Thanks to the cross, and grace, and our various sufferings,
I'm sure, Monsignor, that we'll meet in heaven;

but before our final breath, I would still like

for us to enjoy each other here on earth.

Though a rough road, with mountains and sea, may keep us

far from each other, yet the spirit and feelings

pay no heed to obstacles, either of snow or frost,

nor the wings of thought to snares or impediments.

Thus I am with you always in my thoughts

and I weep, and speak about my dead Urbino

who, were he alive, might have been there with me,

as I once had in mind. But now his death

urges and draws me down another path,

to where he waits for me to lodge with him.[22]

The tension between the secular and spiritual is expressed as a powerful longing: "we'll meet in heaven; but before our final breath, I would still like for us to enjoy each other here on earth." It is clear that Michelangelo missed his friend greatly: "Thus I am with you always in my thoughts." In turn, Beccadelli commiserated with Michelangelo and thanked him for this "beautiful sonnet which pleases me greatly." Michelangelo had largely given up writing poetry following the deaths of Luigi del Riccio and Vittoria Colonna. His friendship with Beccadelli temporarily reawakened this dormant dimension of the artist's creativity.

Beccadelli encouraged Michelangelo to visit Dalmatia, with its "mountains of rugged stone dressed with spruce, cypresses, and orange trees"—a landscape unlike anything in Italy or, he claimed, the New World. Beccadelli grew wistful, for he knew it was impossible, given that Michelangelo was devoted to "that magnificent temple of St. Peter's, the immortal creation of your divine *virtù*."[23] How difficult it must have been for the artist to read these lines while looking over the pitiful, unfinished state of St. Peter's. While Michelangelo longed for the time to enjoy his friend "here on earth," Beccadelli was reminding him—as Vittoria Colonna had done previously—of his primary obligation to a higher purpose. That higher purpose, as they both knew, was St. Peter's, but it was, as yet, no "magnificent temple," no "immortal

creation." Michelangelo did consider visiting Dalmatia; however, the two friends never saw each other again.

Monteluco 1556

Michelangelo mostly succeeded in avoiding religious controversy and political intrigue, but there were times when the outside world intruded upon his life. One of the most serious of these disruptions occurred in the year following Paul IV's election.

The year 1556 began as one of the worst of Michelangelo's life. He was eighty-one and had been in charge of St. Peter's for nearly ten years. He devoted most of that time to reinforcing Bramante's crossing piers and eliminating the ill-conceived exterior ambulatory constructed by Antonio da Sangallo. Vasari praised Michelangelo for having "liberated St. Peter's from the hands of thieves and assassins, and transformed that which was imperfect to perfection."[24] But nothing was "perfect" about St. Peter's. This was merely Vasari's extravagant means of describing Michelangelo's limited success in ridding himself of the most problematic members of the Sangallo clique and for having asserted a degree of control over a meddlesome bureaucracy. In reality, even after ten years the building offered little evidence of Michelangelo's Sisyphean efforts, and few contemporaries, other than Vasari, recognized much progress. Moreover, Michelangelo soon would abandon the unfinished building.

A war was brewing between Pope Paul IV, allied with France, and King Philip II of Spain.[25] Paul, determined to throw the Spanish "barbarians" from the Italian peninsula, found himself woefully ill-equipped to accomplish such a grand objective. In the meantime, Spanish diplomacy and military might proved greater than the pope's hollow posturing and weak alliances. In September 1556, Fernando Alvarez of Toledo, the duke of Alba, invaded the Papal States, captured Ostia, and invested Tivoli. In Rome, confusion turned to panic; the ill-prepared city feared another sack, as citizens still recalled the nightmare of 1527. A contemporary diarist wrote, "one can scarcely describe in words how the Romans are trembling, they think only of flight."[26]

An early indication of how the political situation affected St. Peter's is found in a letter of September 5 from Sebastiano Malenotti to Michelangelo's nephew, Lionardo. Malenotti reported that the *fabbrica* was closing down for lack of funds; fifty stone carvers already had been released, and more would soon follow. Rather than reporting to St. Peter's, workers were being conscripted to repair the city walls and to fortify the Borgo.[27] "And God help us, for here one sees cruel things," was Malenotti's laconic allusion to the disruptive times.[28] The following Saturday, Malenotti was a little more expansive and no less pessimistic: "Here we are in great peril; you can imagine that I am unable to leave Michelangelo much alone because I see him in the greatest vexation."[29] Fearing a sack of the city, the populace began to flee Rome. Before the contending forces reached an eleventh-hour agreement, Michelangelo too decided to leave.

On an early autumn day, Michelangelo and Malenotti departed Rome, uncertain they would ever return. The two passed through the Porta del Popolo and rode north on the ancient and well-traveled Via Flaminia. Their destination was Loreto. Michelangelo had longed to make a pilgrimage to the Basilica della Santa Casa, which enshrined the Holy House of the Virgin, in Loreto, and his friend Antonio Barberini promised "good and beautiful" lodgings in nearby Ancona, far from the "tribulations of Rome."[30] In setting out on the road to Ancona, Michelangelo may have entertained the idea of crossing the Adriatic Sea to Ragusa, where his friend Ludovico Beccadelli also offered refuge. In the current crisis, a number of persons offered sanctuary, including Cosimo de' Medici, who hoped to lure the artist back to Florence.

Michelangelo and Malenotti covered between eighteen and twenty-five miles a day. They rested frequently, because the octogenarian artist suffered if he spent long hours in the saddle. Just north of Terni, the two entered the lush, mountainous terrain of southern Umbria. The road steadily climbed and narrowed, following a twisting mountain valley shrouded in mist and cold drizzle. The weary travelers had been on the road for four days, staying in hostelries with primitive accommodations and worse food. Rather than face the prospect of another

five or six days on the road through increasingly rugged mountains, Michelangelo elected to stop at Spoleto. The rest was not only welcome and restorative but proved to be one of the most peaceful interludes in the artist's life.

Michelangelo accepted the hospitality of the Franciscan hermits who lived in the Monastery of Monteluco on a mountainside overlooking Spoleto (see plate 34). In the spartan accommodations of the nearby hermitage, among the pine and laurel trees of a sacred wood, enjoying fresh, spring-fed waters and the isolation provided by the mountain retreat, Michelangelo experienced a rare tranquility. Monteluco is still a place of natural beauty, a landscape and retreat that might have reminded Michelangelo of the sanctuary of La Verna and the wilds of the Casentino region where he was born. Monteluco, moreover, had been favored by Saints Francis and Anthony, and more recently by Michelangelo's now-deceased friend and patron, Pope Paul III.

Michelangelo spent nearly five weeks in the hermitage of Monteluco. His contentment and peace of mind were evident when, on his return to Rome, he wrote to Giorgio Vasari: "Recently, at great inconvenience and expense, I have had the great pleasure of a visit to the hermits in the mountains of Spoleto, so that less than half of me has returned to Rome." Although physically back in Rome, something of his spirit still dwelled with the Franciscan brothers. He then added an unexpected observation: "Peace is not really to be found save in the woods" (*veramente e' non si trova pace se non ne' boschi*).[31]

This sentiment may seem incongruous, if only because of a widespread assumption that Michelangelo had little interest in landscape and because of his well-known disparaging remarks regarding Flemish painting, with its obvious predilection for landscape.[32] Monteluco offered a peaceful respite, far from the disruptions of Rome. Anyone who visits that special place will better understand how it may have offered the troubled artist some serenity. However, it is less clear how this episode might have contributed to Michelangelo as artist. Although he believed that his life was nearing its end, he was, in fact, about to enter the final and most significant phase of his artistic career.

What Is Five Weeks?

Five weeks does not seem long, considering the full span of the artist's lifetime of nearly eighty-nine years. Do such brief episodes matter in the lives of creative individuals? What, for example, was the effect of the few weeks Johannes Brahms spent walking down the Rhine from Mainz to Bonn?[33] What about the six weeks Percy Bysshe Shelley was in France and Switzerland with Mary Wollstonecraft, or the nine days that Samuel Coleridge passed walking in the fells of the Lake District of England? Such moments, in fact, proved to be creative catalysts. And five weeks is actually an appreciable amount of time, especially for an elderly artist. Moreover, the beneficial effects proved long-lasting.

In departing Rome in September 1556, Michelangelo sought to avoid an advancing Spanish army and a city in turmoil. Work at St. Peter's had been suspended; Michelangelo had dismissed his household servants, and his dearest companion, of twenty-six years, was dead. He was directing his thoughts to Loreto and Ancona, possibly Dalmatia or Florence, but no longer Rome. What would become of his many unfinished projects? What sort of future could he reasonably expect?

Earlier in his life, Michelangelo had fled Florence twice—in 1494, after the exile of the Medici, and again in 1529, during the turbulent Last Florentine Republic (1527–30). He experienced three other significant disruptions to his artistic career: the reinstatement of the Medici in 1512, the collapse of the Last Florentine Republic in 1530, and his self-exile to Rome in 1534. The flight from Rome in 1556, therefore, was the sixth time in his life that political turmoil completely disrupted Michelangelo's artistic endeavors, forcing him to confront an extremely uncertain future. These repeated ruptures drove home the painful fact that he was not master of his own fate and that art was of little consequence in the face of war, politics, uncertain financing, and fickle patrons. As ancient wisdom expressed it: *In arma silent artes*—"During war, the arts fall silent." At eighty-one, Michelangelo had good reason to assume that his artistic career was finished.

Meanwhile, what was the artist doing in the remote hermitage near the Franciscan Monastery of Monteluco? Other than a few letters exchanged with his "exiled" friends, there is little evidence of any activity other than fulfilling his desire—as he stated—to make his devotions.[34] Michelangelo lived more as a hermit than as the world's most famous artist. It is difficult to imagine Michelangelo with nothing to do and with no reasonable prospect of renewing his artistic career. However, a visit to Monteluco permits one to understand how Michelangelo could find "peace in the woods."

It is a walk of approximately thirty minutes—perhaps longer and slower for the octogenarian artist—from the hermitage at Monteluco (now fronted by a very modest Piazzale Michelangelo), where he likely lodged, to the mountain summit where the Franciscan brothers lived in their spartan cells and observed their daily routines. He surely walked in the *sacro bosco* where Saints Francis and Anthony found peace and solitude, and where the latter retreated to a tiny rock-cut cell with a view over the valley. Carved into a rocky promontory, the cell overlooks the lowlands from which the distant sounds of farm life drift upward on the clear mountain air. Even without pursuing the ascetic life of a saint, one feels at peace, in harmony with nature, a tranquility of the soul. The memory far outlives the brevity of time spent here.

At times during his stay, Michelangelo surely rode or walked down the steep mountain path into Spoleto to visit the Romanesque duomo or to observe an important religious holiday, such as the feast day of Saint Francis, which was celebrated on October 4, shortly after he arrived. Impressive frescoes by Filippo Lippi decorate the apse of the duomo, and in the transept one finds Lippi's tomb, paid for by Michelangelo's earliest patron, Lorenzo de' Medici. Who would pay for Michelangelo's tomb, and how would it be marked now that he had violently attacked and abandoned the *Pietà* sculpture meant to adorn his grave? Who was still alive to finance Michelangelo's burial and commemoration? As when he had contemplated the memorial to the Pollaiuolo brothers in San Pietro in Vincoli, Michelangelo could scarcely escape wondering—looking at Filippo Lippi's tomb in this

remote town—how he, Michelangelo Buonarroti, architect of St. Peter's, would be buried.[35] And where?

Michelangelo intended to continue his journey to Loreto and possibly Dalmatia, but, as he subsequently reported to his nephew, "I was unable to carry out my intention, because someone was sent expressly to say that *I must return to Rome*."[36] While he may have found it flattering to be summoned back to Rome, the call reminded Michelangelo that he was still a papal servant. He tacitly admitted as much when he wrote to Vasari, "in order not to disobey, I set out for Rome." But, thinking wistfully of his recent peaceful sojourn in the woods, he added the further melancholy reflection that "less than half of me has returned."[37]

Return to Rome

The return trip to Rome was somber, the weather depressing. The artist had no idea what to expect. It was one thing to escape dangerous circumstances; it was quite another to face the unknown consequences of returning. Rome appeared grim when Michelangelo and Malenotti arrived back in the city in November 1556. Although it escaped a sack, Rome now suffered the privations of war. Requisitioning and outright theft by the armies meant that food remained scarce, and the roads were dangerous. Groups of unpaid mercenary soldiers quickly transformed themselves into roving bands of lawless thieves. Want and fear pervaded the timorous city.

Returning to Rome did little to settle Michelangelo's disrupted life. The leaden November sky soon turned cold and nasty; it was highly unlikely that any sort of work at St. Peter's would resume before spring. The political situation remained volatile, largely because Pope Paul could not bring himself to negotiate with the Spaniards. As late as July of the following year, the imperial ambassador reported that "Rome is in danger."[38] The populace and even the pope still feared a possible sack. Altogether, it would be more than a year before Michelangelo again turned his full attention to St. Peter's. In the meantime, he remained anxious and largely inactive.

Because of "rumors we hear every hour," Michelangelo and Malenotti considered fleeing Rome almost immediately after their return.[39] Greatly concerned about the artist's agitated state, Malenotti wrote to Michelangelo's nephew: "He is so troubled that I scarcely know how to tell you nor possess the means to help him: and I am at his side every hour to comfort him, since he does not have the duties of the *fabbrica* to distract him."[40] Later in the same letter, Malenotti returned to Michelangelo's distraught state. "He, in effect, is not well," he wrote, and "now he is more bothered than ever by things, so that I am unable to help him: and every hour I am at his side trying to comfort him. . . . It saddens me to see him this way."[41] Given the suspension of work at St. Peter's, Malenotti thought this might be a good time to broach the subject of the artist's return to Florence, "because I do not want to see Michelangelo leave Rome another time except for his own reasons."[42] Michelangelo intimated that, should he leave Rome again, he still desired to visit Loreto.[43]

Not only was Rome in turmoil, but Michelangelo's domestic life was equally in disarray. Having dismissed his female servants before leaving for Spoleto, Michelangelo had just two young men (*ragazzi*), Antonio del Francese and Antonio "Durante," to take care of the house and animals. Both had been recruited several years previously by Urbino and his wife, Cornelia, from their hometown of Casteldurante in the Marche. Michelangelo considered them "two good lads," but Malenotti thought somewhat less of the "ruffians" (*ragazzacci*).[44] At Malenotti's urging, Lionardo offered to send from Florence "either maidservants or anyone else" to look after his uncle, but the artist testily responded, "I assure you that at present I don't need anyone else. . . . For an old man I'm pretty well and not discouraged."[45] Although he had the two young men living with him, the household lacked female help. Indeed, the former busy household was now much reduced, since Cornelia had returned to Casteldurante with her children and maidservant.

The fact that Malenotti was writing many letters on the artist's behalf indicates Michelangelo's agitated state. While Michelangelo wrote brief missives to his nephew, primarily concerned with family matters

and property investments, Malenotti wrote longer letters every week, reporting on affairs in Rome and on the master's health. Without a doubt, Malenotti and Lionardo were working in tandem to lure Michelangelo from the Roman miasma to the promise of safety and honor in his native Florence.

Cosimo de' Medici also was keenly interested in bringing Michelangelo back to Florence. He launched his campaign as early as 1554, and maintained a kindly assault on the artist's emotions for the next ten years. At one point, Michelangelo received a missive from the duke's personal chamberlain suggesting that the artist might wish to see his "sweetest homeland" again: "Therefore, dear messer Michelangelo, now is the time for you to comfort our prince, help your family, and honor Florence with your presence."[46]

Vasari proved the most persistent of Cosimo's several ambassadors. In 1554, he wrote to Michelangelo proclaiming the artist's labors were insufficiently appreciated: "Escape that avaricious Babylon, like Petrarch, your fellow citizen, oppressed by similar ingratitude, who elected the peace of Padua; so I promise that you will find peace in Florence."[47] Partly to excuse himself and partly as a bid for more time to complete his work in Rome, Michelangelo responded to Vasari by sending the famous sonnet discussed above, "Giunto è già 'l corso della vita mia": "So now it's over, my day's long voyage, through tumultuous ocean, in a hull unsteady . . ." (plate 32).[48] Michelangelo had every reason to believe that his life's voyage was ending. Yet, he found some consolation in Vasari's kindly overtures; the exchange even permitted him to indulge in a bit of self-mockery. Below the poem, Michelangelo appended the following note:

> Master Giorgio, dear friend: You will surely say I am old and crazy [vechio e pazzo] to want to produce sonnets, but since many say I am in my second childhood [son rinbanbito], I wanted to act the part. From yours I see the love you bear me; know that without doubt I would be very glad to lay down my fragile bones beside my father's, as you entreat me, but if I left here now, I would be the cause of a great disaster in the construction of St. Peter's, of great shame and of great sin.[49]

Harmless banter (*vechio, pazzo, rinbanbito*)—humor as armor—but a missive also tender and genuinely appreciative, is appended to a poem that is profoundly moving, reflective, melancholic, devout. All done in an effort to fend off the temptation of abandoning Rome for the peace of his native Florence. In subsequent years, especially after his flight from Rome in 1556, Michelangelo repeatedly was tempted by the idea of reuniting with his home and family—a desire that was expressed in colorful ways, including, to return to his "second childhood" and to discover "a nest just for myself and my brood." The sad reality was that Michelangelo's extended family and friends—his *brigata*, both in Rome and Florence—was greatly diminished.

Altogether, Michelangelo's return to Rome in November 1556 was extremely trying. Most challenging for the octogenarian artist was the effort to once again take charge of his many incomplete endeavors, which he surely now realized he would never live to see completed. The realization might easily have inspired despair. Rather, after his retreat to Monteluco, Michelangelo experienced a renewed sense of purpose and commitment to his and to God's work.

After a lengthy suspension, work gradually picked up at St. Peter's. Like a giant flywheel, the engine required time and energy to overcome inertia and return to full capacity.

A Week in the Life of Michelangelo

From February to April 1557, the bare vaults of St. Peter's emerged from the drear of overcast skies into spring sunshine. The building, majestic in scale, still had the appearance of an ancient ruin. Winter rains and general neglect had wreaked havoc on the work site. Gradually, the workforce returned to full strength. With individual work crews reconstituted, various segments of the building once again made incremental advances.

In 1557, Michelangelo was eighty-two years old. He was managing a large labor force, a huge work site, and a complicated business and construction operation. He was both artist and building foreman,

craftsman and businessman, genius and entrepreneur. The following is the story of one week in his busy life.

Friday, April 16, 1557

It had been six months since Michelangelo and Sebastiano Malenotti had returned from Monteluco. The memory of the wind whispering in the sacred woods still offered Michelangelo a bit of solace. Thanks to that experience, he found it easier to follow the Franciscan model: concentrate one's thoughts on the places and sufferings of Christ's life. By such a mental exercise, one could identify with Christ; all else mattered less. However, the peace Michelangelo had experienced at Monteluco was difficult to achieve in Rome, where the incessant demands of everyday life constantly intruded upon contemplation. In the woods of Monteluco, Michelangelo found resolve and clear purpose: he was to build New St. Peter's, the New Jerusalem, the new center of the Christian world. He was God's architect. But such thoughts helped little in constructing a complicated vault.

Less than two weeks previously, Rome had celebrated an early Easter. As usual, Michelangelo participated in the annual rite of confessing one's sins and taking Communion. Because he had spent his entire life among the Franciscans, from his boyhood church of Santa Croce in Florence to his recent retreat with the brothers at Monteluco, Michelangelo attended services at his neighborhood Franciscan church, Santissimi Apostoli. After prayers, he walked to Santa Maria sopra Minerva, the Dominican church where the Florentine community gathered. He sat near a small side chapel, as it seemed sacrilegious to pray before his own statue of the *Risen Christ*. Installed some thirty years earlier, the sculpture was frequently a center of attention and sermonizing during the Easter season. He recognized few people in attendance. If by chance he conversed with his fellow parishioners, he knew to speak cautiously, since Cosimo de' Medici had prying eyes everywhere.

The one thing he wanted to accomplish today was to ride to the Antoniana (Baths of Caracalla), which Pope Paul had authorized

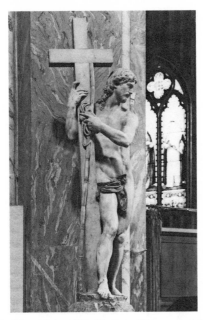

Michelangelo, *Risen Christ*, 1519–21, Santa Maria sopra Minerva, Rome

Michelangelo to mine for materials. A few multicolored marble columns remained in the despoiled structure. Michelangelo wished to bring them to St. Peter's. Given renewed life and purpose, the columns would look splendid in the new basilica. Although Malenotti was needed at St. Peter's, Michelangelo asked the younger man to accompany him. It would not be wise for the octogenarian artist to wander alone among Roman ruins in the remote *disabitato* (uninhabited area) where thieves were known to lurk. While he carried no money with him, those destitute types might slit his throat just for fun and then feed on his horse!

Saturday, April 17, 1557

St. Peter's was still a giant mess. Neglected for months during the crisis of 1556, the work site was more disorganized than usual. Many of the exposed travertine blocks looked weathered and discolored; a pile of

lime powder had dissolved in the rain; bricks had been pilfered; everywhere there were mud and animal droppings. Fortunately, the tools, as well as most of the rope and tackle had been secured, locked away in a dry shed.

Saturday, of course, was a workday and also payday. Laborers worked from sunrise to sundown six days a week, which meant twelve- to fourteen-hour days during the labor-intensive spring and summer months. Sunday was the only day of rest, although there were also numerous church and civic holidays—about fifty a year.

Today, Michelangelo intended to meet with his foremen, the *capomaestri*, and authorize them to hire the skilled and unskilled laborers needed for the various work teams. It was time to complete the south transept vault. For that large task, he would need to increase the number of brick masons and stone carvers. In addition, woodworkers were required to construct the centering scaffold—an operation that demanded skill and courage, given the tremendous height at which the carpenters would labor. And since marble was burned for lime, and bricks were made on-site, more kilns were needed.

Pay for skilled labor, such as stone carving and masonry, was generally *a cottimo*, that is, one was paid for the amount of work accomplished in a day, judged by a *misuratore* (measurer). The *fabbrica* paid manual workers a flat day rate, and although they were generally a less reliable labor force, their lot improved when Michelangelo raised their wages. Materials were purchased by contract; carters were paid by individual delivery, brick and lime makers by the quantity of material provided. Digging foundations or erecting and dismantling scaffolding often continued after darkness fell, for which torches were required, and of course, more than one watchman remained on-site throughout the night to protect against theft.

Late that day, and with some reluctance, Michelangelo crossed the muddy work site and climbed the stairs to the *fabbrica* office to inform the deputies of the next phase of work and how many additional workers were required. He also wanted to make certain that Maestro Ciola, the *intagliatore*, Pietra Santa, and Pavolo da Borgo were paid for the capitals they had carved.[50] And he would inquire about arranging a

small celebration, a *benfinito*, with food and wine, when the vault was successfully completed.[51] In the hedonistic days of Pope Julius III, the workers had even enjoyed an occasional bullfight in the piazza.[52] However, Michelangelo anticipated the usual obstinacy from the *fabbrica* officials, especially when it came to spending the Church's money. With his friend Ludovico Beccadelli in faraway Ragusa, Michelangelo no longer had a staunch ally among the deputies, and the current pope did not appear keen on bullfights or celebrations.

Sunday, April 18, 1557

Sunday was a day for rest, prayer, and writing to his nephew, Lionardo. In the quiet of his bedroom and before the rest of his household awakened, Michelangelo read some passages from his well-worn copy of the *Beneficio di Cristo*. Although the *Beneficio* had been placed on the index of prohibited books, Michelangelo still received solace from the work's wise counsel, expressed in simple vernacular prose. He took comfort from its many beautiful passages: "This immense goodness of God" (*Questa immensa benignità di Dio*), "he forgives all" (*ha perdonato a tutti*), "faith purifies our hearts of all our sins" (*la fede purifica li nostri cuori da tutti peccati*), "we are the faithful and brothers of Christ" (*siamo stati fideli e fratelli di Cristo*), "Faith alone will send me to Paradise" (*Basta la fede a mandarmi in paradiso*).

The repressive atmosphere of Pope Paul's pontificate often reminded Michelangelo of Girolamo Savonarola, whose shrill voice he still recalled more than a half century after the despotic preacher's death, particularly when he encountered a zealous friar haranguing a crowd in the streets. But as he grew older, Michelangelo felt that salvation was less likely to be found in punishment and renunciation than in quiet prayer. Often, as on this morning, when his kidney stones were bothering him, instead of listening to a sermon, he remained at home and read Scripture. He took stock of his supply of spring water from Viterbo. Lately, he also had begun riding his horse on Sundays, which his doctor had recommended as a remedy against "the stone."

After a simple repast of thin fennel soup and a single herring, Michelangelo sat at his desk to write letters. He first wrote a brief missive to Lionardo, thanking him for the latest shipment of Trebbiano wine. Then he penned a longer letter to Cornelia, the widow of his beloved servant Urbino. Every time he wrote, he was pained by memory, yet he enjoyed his correspondence with Cornelia. She was an intelligent woman, and Michelangelo respected her. Following Urbino's death, in 1556, Michelangelo had deposited a huge sum, 660 *scudi*, with his friend and banker Francesco Bandini, who had invested in shares of the public fund (*Monte di Fede*) on behalf of Urbino's heirs.[53] After Cornelia and her two boys had returned to her hometown of Casteldurante, she wrote faithfully, addressing Michelangelo as "a most beloved father." Hers were long letters, coming approximately every month, although somewhat less frequently after she remarried in 1559. But also, as she once wrote, they were not more frequent "because I don't want to bother you."[54]

Since Michelangelo had provided for the children's future, Cornelia was conscientious in providing news of the little ones. She wrote that her son Michelangelo "with the help of God is growing rapidly," and that young Francesco had said, "he wanted to be called Michelangelo too so as to be loved equally by you."[55] Less than two months earlier, Cornelia had asked Michelangelo to visit. Little Michelangelo, in particular, "begs you to come to Casteldurante: or, would you like it if he came to Rome?"[56] The artist had replied:

> As regards my coming to Castel Durante to see the little ones, or your sending Michelangelo here, I must tell you how I am placed. It would not be possible to send Michelangelo here, because I have no women in the house [all dismissed when he had departed for Spoleto] and no-one to look after things and the little one is still too young and something might befall which I should very much regret. . . .
>
> Having arranged my affairs, and yours as regards the Public Funds [the *Monte* shares he had invested for her], I shall leave for Florence this winter for good, since I am an old man and time will not remain for me to return to Rome any more. I'll pass through Castel Durante

and if you are willing to entrust Michelangelo to me, I'll cherish him in Florence with more affection than the children of my nephew, Lionardo, teaching him what I know his father wished him to learn.[57]

It is a compelling and touching image: the eighty-two-year-old artist promising to lavish attention on his three-year-old godson. Cornelia fully agreed to the plan, and expected to see Michelangelo in Casteldurante in September, writing, "with this I beg you, for the love of God, that you write me more often and advise me of how you are, because I can never rest if I don't have letters from you." She closed by reiterating her desire that he write more often (*spesso spesso*).[58] Unfortunately, Michelangelo was unable to visit Casteldurante that September, because he encountered a major problem with the vaulting of St. Peter's.

Michelangelo never again saw Cornelia, but he did receive a visit from his godson. In 1562, when little Michelangelo was eight years old, he came to Rome to visit his eighty-seven-year-old godfather and namesake.[59] It is difficult to picture the visit, mainly because no one described it for us, and also because it counters a popular image of Michelangelo as a disagreeable, lonely old man. As children were often apprenticed at age eight, it is likely that Michelangelo took his godson to the building site and introduced him to some of the more experienced workers. The visit of his godson clearly pleased Michelangelo and appears to have animated in the aged artist a strong desire to return to Florence to meet his own grandnephew, Buonarroto, Lionardo's son. Unfortunately, death arrived first.

Lastly and with the greatest satisfaction, Michelangelo answered a letter he had received from his dear friend Ludovico Beccadelli—a letter that had been sitting on his desk since yesterday, after it mistakenly had been sent to Spoleto.[60] As is evident from their warm correspondence, the two friends longed to see one another. While the octogenarian Michelangelo had managed to make the trip to Spoleto, he could not imagine making the even longer and more rigorous journey to Ragusa. Thus, unless Beccadelli was recalled to Rome by the pope, Michelangelo sadly realized they would never see each other again.

Doodling on the back of the letter, Michelangelo noted his recent meals: one consisted of a herring, two bread rolls, and a jug of wine. Another was more substantial: salad greens, four rolls, a plate of spinach, four anchovies, some tortelli pasta, and wine. And then today's frugal repast: fennel soup, a herring, bread, and wine.

Monday, April 19, 1557

A brilliant spring morning. As the bells of Rome rang matins, Michelangelo crossed the Tiber along with several carts that were making their way to St. Peter's. Travertine blocks from the quarries at Tivoli and Fiano arrived in a steady stream. A carter delivered a load to St. Peter's and then returned to the river port for another. Quarried some nineteen miles west of Rome, the blocks were sent by barge down the Tiber and Aniene Rivers and unloaded at Castel Sant'Angelo. As work at St. Peter's once again picked up, more of the material was hauled the entire distance by oxcart, especially when the oxen were not needed for plowing or when there was too little water in the rivers to float the heavily laden barges.

Michelangelo rode to St. Peter's alongside an uncouth carter who complained that he did not like working for Florentines and his oxen did not like pulling such heavy loads of stone—cartload after cartload of travertine, and then there was the long return trip to the quarries. It was tedious work, but at least it was steady employment. When Michelangelo inquired about the problematic Florentines, the carter spat and named the overseer at the Fiano quarry, Matteo di Chimenti.[61] Michelangelo instantly recognized the name. The Chimenti—a family he had worked with for many years at San Lorenzo—originated from Settignano. They were among the most dependable of his employees, in part because they were skilled carvers but also because they were Florentines. Michelangelo felt pleased to have a good number of his countrymen working at St. Peter's. They knew stone, were trustworthy, and would deliver only high-quality materials. As he and the carter progressed slowly through the crowded streets of the Borgo, the latter continued to make disparaging remarks about foreigners,

PLATE 27. Girolamo Sicciolante, Portrait of Pope Julius III, c. 1550–55. Rijksmuseum, Amsterdam, no. SK-A3413

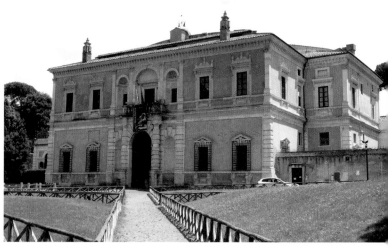

PLATE 28. (top left) Giorgio Vasari, Title page of the first edition of Le Vite de' più eccellenti architetti, pittori, et scultori italiani, 1550

PLATE 29. (top right) Ascanio Condivi, Title page of Vita di Michelagnolo Buonarroti, 1553. Collection of the author

PLATE 30. (above) Villa Giulia, 1551–53, Rome

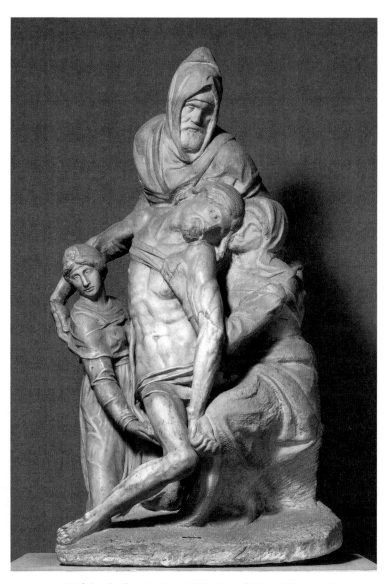

PLATE 31. Michelangelo, Florentine Pietà, c. 1547–. Museo del Opera del Duomo, Florence

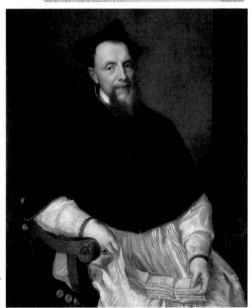

Giunto g ral Corso della vita mia
e tempesto mar cō fragl barca
al Ccomun porto o ua meder si aurca
cō fo eraguo dogmio pria falsa cria
q nde la ffeEtuo sa fantasia
che larte mi fece idolo emonarca
or m tor nar si uana edevror carca
or ueggio bē q o omera devror carca
e a uamormai suo gra do luo dosia
or ueggio bē come eauanttrar carca

Contanza sor uiou cō ttatto te dio
e cō fassi tō cotti agra pe viglo
dellabma aseulpir eui sesrdum
non puo signor mie care lafresca e uonda
o tai sentir q uanta lutrimo passo
Si Cagua gusto amor uoglie e pō sieri
pie la bma acquistr one puisino de por do
laver e lamorto nō ua bene in seamue
che cō mie pui che dime du cho speri

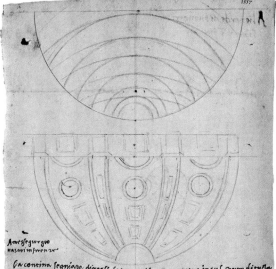

PLATE 34. (top) Franciscan Monastery at Monteluco (Spoleto), Italy

PLATE 35. (left) Michelangelo, Letter to Giorgio Vasari describing the problems with the vault of St. Peter's Basilica, July 1, 1557. Casa Vasari, Arezzo, Cod. 12, Cap. 22

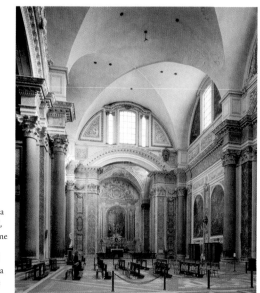

PLATE 36. (right)
Michelangelo, Santa
Maria degli Angeli,
interior, 1561–, Rome

PLATE 37. (below)
Michelangelo, Porta
Pia, 1561–, Rome

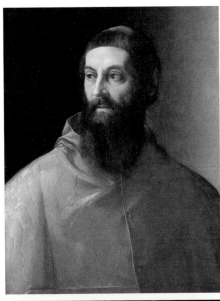

PLATE 38. (left)
Francesco Salviati,
Portrait of Rodolfo
Pio da Carpi, c. 1550.
Kunsthistorisches
Museum, Vienna

PLATE 39. (below)
Michelangelo, Model
of the dome of St. Pe-
ter's Basilica, 1559–61,
Vatican City, Rome

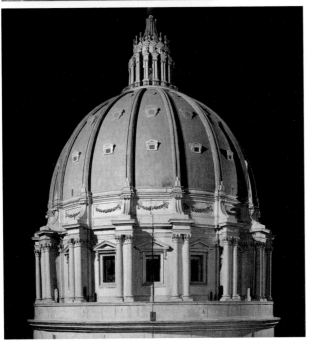

PLATE 40. (right) Santa Maria di Loreto, Rome

PLATE 41. (below left) Michelangelo, Pietà drawing presented to Vittoria Colonna, before 1547. Isabella Stewart Gardner Museum, Boston

PLATE 42. (below right) Marcello Venusti, painted version of Michelangelo's Pietà drawing. Private collection, Turin

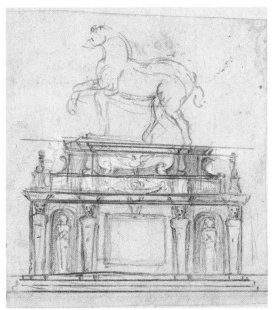

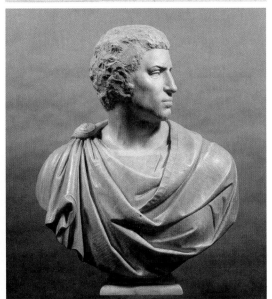

PLATE 43. (top) Michelangelo,
Drawn design for an equestrian
monument of Henry II of
France, c. 1559. Rijksmuseum,
Amsterdam,
Rijksprentenkabinett
Inv. 53:140r

PLATE 44. (left) Michelangelo,
Brutus. Bargello Museum,
Florence

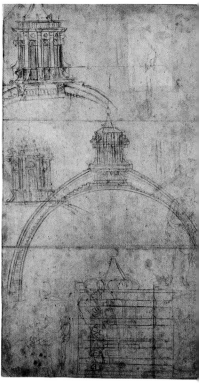

PLATE 45: (top) Michelangelo, Drawn design for the church of San Giovanni dei Fiorentini (never built), c. 1559. Casa Buonarroti, Florence, no. 124A

PLATE 46. (above) Michelangelo, Drawn design for the dome of St. Peter's Basilica, c. 1559–61. Musée d'Art et d'Histoire, Lille, inv. 93–94

PLATE 47. (right) Michelangelo, Drawn design for the dome of St. Peter's Basilica, c. 1559–61. Teylers Museum, Haarlem, inv. A29

PLATE 48. Dome of St. Peter's Basilica, Vatican City, Rome

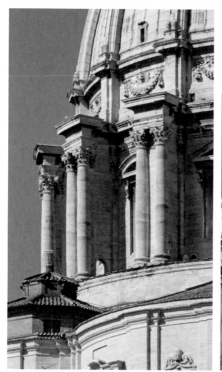

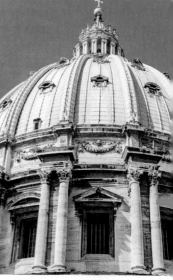

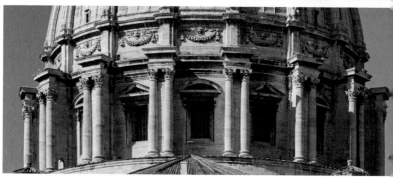

PLATE 49. (top left) Buttresses with paired columns, detail, St. Peter's Basilica, Vatican City, Rome

PLATE 50. (top right) Buttresses and dome, St. Peter's Basilica, Vatican City, Rome

PLATE 51. (above) Drum and attic, detail, St. Peter's Basilica, Vatican City, Rome

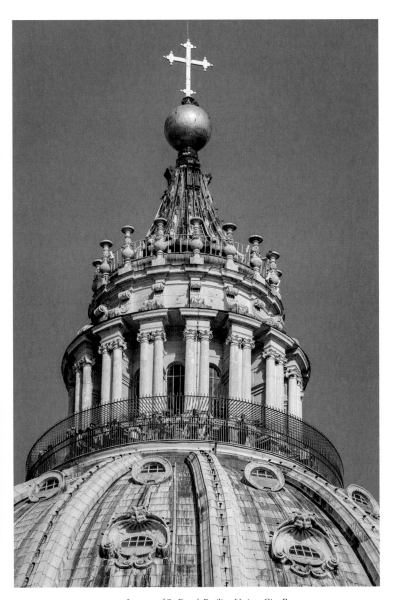

PLATE 52. Lantern of St. Peter's Basilica, Vatican City, Rome

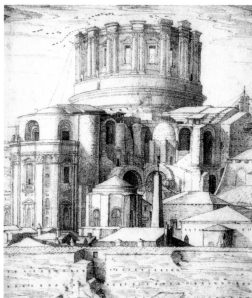

PLATE 53. (top) Unknown
artist, Drawing of the un-
finished state of St. Peter's,
c. 1564–65, pen and ink.
Kunsthalle, Hamburg, Kup-
ferstichkabinett 21311

PLATE 54. (right) Unknown
artist, Drawing of St.
Peter's, c. 1580, pen and ink.
Städelsches Kunstinstitut,
Frankfurt, no. 814

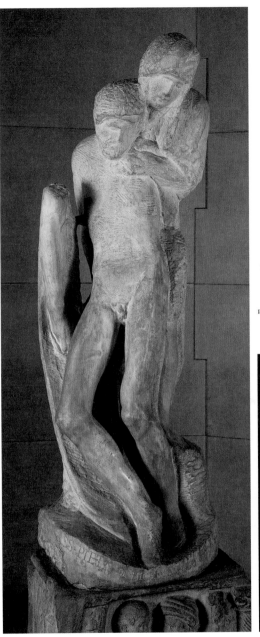

PLATE 55. (left) Michelangelo, Rondanini Pietà, 1556–. Castello Sforzesco, Milan

PLATE 56. (below) Michelangelo, Rondanini Pietà, side view. Castello Sforzesco, Milan

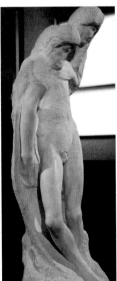

PLATE 57. (top) Campidoglio, Rome, designed by Michelangelo

PLATE 58. (above) Maarten van Heemskerck, The state of the Campidoglio during most of Michelangelo's life, 1530s. Berlin-Dahlem Museum, Berlin, Kupferstichkabinett 79D2a 72r

but Michelangelo held his tongue. He too was a foreigner—a Florentine no less—although he had not seen his native city in more than twenty years.

Michelangelo thought about the number of Florentines who had followed him to Rome, largely because of the employment opportunities. There was another Chimenti, Francesco, known as the "stone hugger" (*abbraciatore di sassi*). An experienced overseer who years earlier had worked on the foundations for the facade of San Lorenzo, he now was helping to shore up the exterior foundations of St. Peter's.[62] Then the ubiquitous Cioli clan had arrived. Michelangelo had employed more than a half dozen Cioli at San Lorenzo, and now the next generation—another half dozen members—was working at St. Peter's.[63] Breaking from his reverie and into the carter's harangue, Michelangelo asked how many loads he had delivered that month, but the illiterate carter spoke such a grotesque form of Romanaccio, the local dialect, that Michelangelo gave up trying to understand him.

At St. Peter's, Michelangelo checked in with Sebastiano Malenotti, who had arrived at least three hours earlier. Malenotti and Michelangelo met with a recently hired *capomaestro*, Cesare Bettini, who supervised work at the highest construction level. In discussion with his overseer, Michelangelo asked whether there were enough carvers to dress the large quantities of stone now arriving at the work site. At the beginning of the year, there had been fifteen stone carvers (*scarpellini*) and thirty other workers on-site.[64] After Michelangelo's return to Rome in November 1556, work had steadily picked up. Every day, he and Malenotti assessed how many manual laborers were needed to move the dressed blocks from the stone sheds to the staging areas and then to hoist the stone to the ever-higher levels of construction. While the number of stone carvers held fairly steady, manual labor was irregular and depended on the task to be accomplished.

Thanks to the helical ramps in the piers, the sure-footed donkeys delivered wood, water, and mortar, but stone was lifted by pulleys and hoist. Young Bettini requested that Michelangelo come up to the tambour level in order to approve a new hoist specially constructed for lifting heavy stone blocks. The hoist's antenna-like vertical post with

angled beam rested on a temporary platform (*barbacane*) that projected over the void of the church crossing. By a system of pulleys and a great quantity of rope individual blocks of dressed stone were raised and placed close to their final position, as the guy ropes (*vetoni*) permitted the lift beam to swing left and right.

It all required rope of exceptional quality, but also an immense quantity, as the lines had to reach from the tambour to the ground. Rope!—the banal requirement of every building project. From antiquity to Michelangelo's day, the greatest engineering challenge was moving and lifting heavy objects. As had been true since the Egyptians built the pyramids, so much depended on rope. *Corde, canape, fune, gomena, capestro*—if you worked the hoist, you knew the name of every type of rope, as well as the winches, pulleys, iron rings, chains, hoisting hooks, and pins on which a lift and life depended. One learned the weaknesses of ropes, which diminish in strength with increased length, and one learned the importance of all the associated equipment. Michelangelo recalled that once he had been nearly killed, not because of the rope's weakness but by the imperfect forging of a weak iron ring.

It was a glorious sight to look down into the crossing of St. Peter's from the height of the tambour. The men who were working around him knew what they were doing, and this quietly pleased Michelangelo. He respected and even felt a fatherly affection for these artisans (all one-third or one-quarter his age), who worked fearlessly above the vast void. With Cesare Bettini in charge, Michelangelo was comfortable approving the operation of the new hoist. Before descending, Michelangelo imagined the dome that would one day enclose this great open space. He then slowly made his way down the ramp in company with an unburdened donkey.

Tuesday, April 20, 1557

With the St. Peter's workforce once again at full strength, Michelangelo elected to remain home, where he could quietly work on a vexing problem: how to make the transept barrel vaults merge with the

semicircular vault of the apses. Yesterday, when he was visiting the construction site, he recognized an unfolding disaster. The newly hired overseer, Giovanni Battista Bizzi, probably failed to give detailed instructions to the masons. Bizzi had been recruited from Florence, partly because Malenotti was about to leave Michelangelo's employ. His most trusted overseer, who had lived in Michelangelo's household and faithfully served him for seven years, Malenotti wished to return home. Michelangelo could hardly fault the man; after all, he constantly thought about returning home himself. Still, he would miss Malenotti's companionship and his expertise.

Michelangelo had explained the vault construction to Malenotti, but miscommunication crept in somewhere between the architect and the builders. He feared that it might be too late to rectify the problem. Did the drawings fail to adequately convey his intentions? Were the foremen and masons incapable of properly interpreting his drawings? Should a model have been built? Maybe so, but a model, even on a large scale, rarely communicates the issues and problems of brick and stone construction. Can wood show a mason where the stresses will appear? Would any number of drawings and models have served the masons working two hundred feet above the ground? Had Sebastiano Malenotti been negligent in overseeing the persons under him? All these problems were compounded by the fact that Michelangelo knew next to nothing about Giovanni Battista Bizzi. Yes, he was a Florentine from Settignano, but how much experience did the man have? In a departure from his past practice, Michelangelo had not personally hired Bizzi, but rather he had delegated that responsibility to his overseers. Michelangelo was learning to work more efficiently than he had at San Lorenzo, but this did present difficulties. Moreover, the construction of St. Peter's was significantly more complicated than anything that had been built in Florence—or anywhere in Italy. What did Giovanni Battista Bizzi know about *vaults*? What did anyone on the work site of St. Peter's know about vaults, especially on this scale? Was Michelangelo required to be on-site every day to solve this and every problem?

Michelangelo worried late into the night.

He was correct. There were problems. Serious problems.

He spent the day on the building site. He spoke with select individuals and chose his words judiciously. He knew better than to speak with the pope and certainly not with the deputies.

The vault had been built incorrectly, or rather it was begun incorrectly and must now be dismantled and started anew. The *capomaestro* Giovanni Battista Bizzi had misunderstood Michelangelo's intentions. Yet, Michelangelo felt at fault because his advanced age prevented him from being on-site every day.

He was eighty-two years old and felt every ache of those years.

How many workdays would be lost, how much money wasted, how much prestige and authority squandered? How would he explain this mess to the pope or to the deputies? He worried even more about explaining it to the workmen who had risked their lives laying travertine blocks and bricks over a void, only to be told their work must be dismantled. Suddenly, the authoritative, knowledgeable architect looked to be what he was: a shrunken, elderly man who had made a serious error. And, of course, he would be blamed, because he was the official architect of St. Peter's.

Since there was little that could be done immediately, the workers were dismissed. It proved to be a short day—that is, for everyone except Michelangelo.

Thursday, April 22, 1557

Actually, little happened on Thursday, Friday, Saturday, or Sunday, as Michelangelo considered what needed to be done, and how, at the dangerous height of the improperly constructed vault.

We learn about this difficult episode—one of the greatest setbacks of Michelangelo's entire career—when he finally sat down to unburden himself to Giorgio Vasari and Lionardo. He discovered the problem in April but did not write to Vasari until July.[65] Of course, in the meantime, he had been dismantling the vault, which set back the overall construction schedule by many months. As was typical of Michel-

angelo, he did not want to talk about the issue until he had it under control. Yet, despite the magnitude of the problem and his evident distress, he persevered, corrected the problem, and ultimately had the vaults properly constructed.

Michelangelo sent two letters to Vasari (with appended drawings; see plate 35) describing what had gone wrong. In addition to detailing the technical issues, he expressed his anguished feelings and sense of personal responsibility for the affair:

> This mistake happened through my not being able to go there often enough, owing to old age, and whereas I believed that the said vault would now be finished, it will not be finished until the end of this winter, and if one could die of shame and grief I should not be alive.[66]

In a follow-up letter to Vasari, Michelangelo again offered a detailed explanation of what had gone wrong. He concluded by asking Vasari to make his apologies to Cosimo de' Medici, as this latest mishap would keep the artist tied to St. Peter's for many more months: "I thank the Duke for his kindness with all my heart, and may God grant that I may be able to serve him with this poor body, for there is nothing else. My brain and my memory have gone to await me elsewhere."[67]

Year after year, and especially during trying times such as these, Cosimo, Giorgio Vasari, and Michelangelo's nephew renewed their efforts to bring Michelangelo home to Florence. He was promised peace and tranquility without any of the obligations that burdened him in Rome. It is something of a miracle that Michelangelo managed to fend off these inducements. It speaks to the depth of his commitment to St. Peter's.

His current feelings, however, were anything but coherent. On a stray piece of paper, he wrote: "Fevers, flanks, aches, diseases, eyes, teeth."[68] He found some consolation in deciding to make improvements to his house in Rome, doing accounts, giving alms, and sending money to the children of his deceased servant Urbino.[69] On another sheet, we discover another scribbled fragment: "... God devotedly" (... *Dio devotamente*).[70] Despite everything, he remained devoted to God and to St. Peter's.

CHAPTER 7

ARCHITECT OF ROME

Once again, death visited. Pope Paul IV died in the summer heat of August 1559. The death of this much despised, zealous inquisitor prompted unusually long and violent riots. It was, therefore, a great relief when Giovanni Angelo Medici (1499–1565)—not related to but a close ally of Cosimo de' Medici, the duke of Florence—was finally elected pope, as Pius IV (r. 1559–65), in December. As with his predecessors, Pius confirmed Michelangelo's position as supreme architect of St. Peter's, the fifth pope in succession to do so. But how long would this temporary security last? After all, Michelangelo was wholly aware that he had now outlived a dozen popes.

Michelangelo did not make an appearance at St. Peter's that December, in view of the fact that celebrations for the new pope and the Epiphany season interrupted all work; moreover, the wet weather was particularly hard on his old bones. What exactly could he accomplish on such a sprawling site, especially now that he was in his mid-eighties?

With the election of Pius, Michelangelo made the same mistake he had with Pope Julius III in assuming the new pontiff would expect little from him. But Pius had ambitious plans for urban renewal of Rome and the development of its vast and largely unsettled area (*disabitato*).[1] Soon Michelangelo was drawing up designs to transform the

Pope Pius IV, woodcut, 1568, Emory University,
Pitts Theology Library, Atlanta

Baths of Diocletian into the church of Santa Maria degli Angeli (see plate 36), and he was refashioning the nearby city gate, the Porta Pia (see plate 37), into a novel architectural fantasy.[2] Pius was not the only patron who sought Michelangelo's services. For Ascanio Sforza, a long-time acquaintance, Michelangelo provided a fascinating design for the Sforza family chapel in the patriarchal basilica of Santa Maria Maggiore.[3] Then, because he considered it a propitious moment, Cosimo de' Medici commissioned Michelangelo to design a new church for the Florentine community in Rome, San Giovanni dei Fiorentini. Meanwhile, pressure mounted for Michelangelo to ensure the future of St. Peter's by having a model of the dome built from his design.

A Model for the Dome (1559–61)

Michelangelo liked Cardinal Rodolfo Pio da Carpi (1500–1564), whose intense but sympathetic character shines forth in a portrait

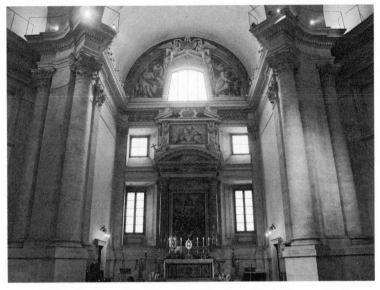

Michelangelo, Sforza Chapel, interior, 1560–, Santa Maria Maggiore, Rome

attributed to Francesco Salviati (see plate 38).[4] A generation younger than Michelangelo—Pio da Carpi was an eminent and cultured man, antiquarian collector, effective diplomat, and influential deputy of the St. Peter's *fabbrica*.[5] Thus, once again, the papal architect had a strong advocate among the Vatican bureaucracy. Michelangelo addressed the cardinal as "my most worshipful patron" (*padron mio colendissimo*), and Vasari, who knew Pio da Carpi well, lists him among the artist's friends.[6] It was Cardinal Carpi who urged Michelangelo to make a model for the dome of St. Peter's. What's more, it was in a letter to Carpi that the artist articulated what has been understood as a laconic "theory" of architecture: "It is certain that the parts of architecture are derived from the parts of man. No one who has not mastered the human figure, and especially anatomy, can hope to understand this."[7]

As much as Michelangelo liked Cardinal Carpi, he did not like the idea of building a model. Understandably, given his position as a deputy, the cardinal was concerned about the incomplete church, which now had been under construction for more than fifty years. But Carpi

was also thinking of Michelangelo. He was fully conscious of Michelangelo's advanced age; the cardinal himself was nearing sixty, and Michelangelo was twenty-five years his senior. They both knew—even if it was left unsaid—that Michelangelo could not possibly live long enough to see the dome completed. A model was the guaranteed means of ensuring the realization of his design, even if death intervened. Or was it?

Michelangelo had a bad history with models. He was not convinced that a model ensured the implementation of a design or explained architectural problems to builders. Years earlier, his friend Giuliano da Sangallo had made a model for the Strozzi Palace in Florence. While large and impressive, Sangallo's model had been little more than a toy for the patron. The model did nothing to solve the structural problems of building in stone. It had little value on-site or to the stonemasons cutting blocks and erecting walls.

Many years previously, Michelangelo had furnished a design and a wooden model for the unfinished tambour, the facing between the drum and base, of Brunelleschi's dome for the Florentine cathedral, Santa Maria del Fiore. Twice, Michelangelo gave some attention to the project: in 1507 and again between 1516 and 1520.[8] Michelangelo's design was never used, nor were those of a half dozen other architects, all of whom submitted wooden models. It was abundant effort to no avail, and the tambour remains incomplete to this day.

Michelangelo experienced his greatest dissatisfaction regarding models during his tenure as architect of San Lorenzo in Florence (1515–34). At the insistence of Pope Leo X, Michelangelo had produced an impressive wooden model of the church facade. The still-extant model, held in the Casa Buonarroti, accomplished what models do best: it convinced the patron to expend an astronomical sum of money on the most extravagant building project in Renaissance Florence. The model more than adequately backed up Michelangelo's bold promise to create "the most beautiful work in all Italy."[9] Even Michelangelo's sometimes indifferent family grasped the enormity of the commission, repeatedly wishing him "good luck" and success in the great endeavor.[10]

The cancellation of the facade project was one of Michelangelo's greatest personal disappointments. He and a skilled woodworker had created the large and expensive model, yet it had failed to guarantee the project's completion. It remained a bitter memory. After more than forty years, Michelangelo resigned himself to the fact that the San Lorenzo facade would never be built.

Now, once again, Michelangelo was being asked to create a model. And yet, his first act as the new architect of St. Peter's so many years earlier had been to reject Antonio da Sangallo's extravagant wooden model (see plate 16). Sangallo's model had been the most insistent effort by any Renaissance architect to guarantee a "final" design. Sangallo must have assumed—as did his followers—that the model ensured that the new church would be carried out in accordance with his design. Michelangelo, however, had no intention of being constrained by Sangallo's extravaganza. He despised the model, which, nonetheless, still squawked like a giant albatross in a nearby *fabbrica* storeroom.

Given his numerous experiences with ignored, irrelevant, and moribund models, Michelangelo understandably felt reluctant to concede the necessity of constructing one for St. Peter's. Moreover, creating a definitive design had never been Michelangelo's *modus operandi*. Rather, in the tradition of most medieval and Renaissance builders, Michelangelo worked from moment to moment, solving design and structural problems as they arose. From his first engagement with architecture, he recognized that design and construction were inextricably linked, simultaneous rather than successive moments. This tradition, or procedure, little changed in use from medieval Europe to colonial America, parallels Michelangelo's approach to sculpture. He worked into a block, made decisions and alterations in midcourse, and kept enough material in reserve to effect changes. The procedure is symptomatic of what James Ackerman described as the "peculiarly biological character" of Italian Renaissance buildings that "evolved like a living organism in their growth."[11]

Models and finished drawings were public-relations efforts to convince patrons to spend money; they were largely worthless at the work site. The Strozzi Palace offered an example of fairly standard proce-

dure. Despite Giuliano da Sangallo's model, most design and all structural decisions were made once construction began. Even an exceptionally well-organized project such as the Escorial in Spain proceeded similarly: designs and working drawings for any given section were made just prior to construction and adjusted according to exigencies. All evidence of working procedure at St. Peter's demonstrates that Michelangelo operated in similar fashion.[12] Architecture was not a science, and no amount of planning could anticipate the problems encountered or the changes that needed to be made, especially if one were building on the unprecedented scale of St. Peter's.

Michelangelo certainly appreciated having Cardinal Pio da Carpi as a friend at the *fabbrica*, particularly since the artist had struggled against the entrenched bureaucracy for years. It may have been contrary to Michelangelo's nature to reveal his intentions or commit himself to a fixed design, but it was also in his character to cultivate and show appreciation for influential friends. Because Carpi supported Michelangelo in his dealings with the *fabbrica*, so Michelangelo returned the favor, albeit reluctantly, by finally acquiescing to making a model. Resigned, Michelangelo first reported the situation to his nephew in February 1557:

> I am obliged to make a large model in wood, including the cupola and lantern, in order to leave it completed as it is to be, finished in every detail. This I have been begged to do by the whole of Rome, and particularly by the Most Reverend Cardinal di Carpi; so that I think it will be necessary for me to stay here for at least a year in order to do this.[13]

Michelangelo cooperated but then procrastinated. The model to which he grudgingly agreed was not begun until two years later. Its construction occupied the efforts of eight specialized woodworkers, took more than two years to build (1559–61), and cost more than 750 *scudi*. Michelangelo was eighty-six when the woodworkers finally completed the impressive object (see plate 39). The model supposedly established his "definitive" design, but, in the meantime, construction proceeded apace. Did the model still represent his intentions, given that, over the course of those years, Michelangelo continued to think

about the problem of constructing the dome and was constantly experimenting with various ideas? Yet, he was old, and he acceded to Cardinal Pio da Carpi with hopes that he might guide Michelangelo's vision after the artist's death. Of course, Michelangelo could not know that the much younger cardinal would die less than three months after him.

Santa Maria di Loreto

Having watched Bramante's design for St. Peter's become submerged in an accumulation of ill-conceived construction, Michelangelo was well aware that continuity of design was the exception, not the rule. Bramante enjoyed the authority that derived from being Pope Julius II's architect and the first designer of the new church. Both the nature and authority of his ideas were documented in drawings, ennobled by a foundation medal, and advanced by decades of actual construction. Nonetheless, subsequent architects introduced multiple changes, most with little respect for Bramante's original intentions. It required Michelangelo's herculean efforts to undo forty years of alterations and accretions. Given all that he had done to reverse the follies of so many previous architects, Michelangelo had little confidence that future builders would respect his own efforts. He was made aware daily of the possible fate of St. Peter's, because he lived alongside one of the most egregious examples of architectural discontinuity.[14]

Every time Michelangelo stepped out his front door in Via Macel de' Corvi, he saw the incomplete church of Santa Maria di Loreto. Begun in the first decade of the sixteenth century, the church had been designed in a fairly severe, early Cinquecentesque style. The building had barely risen above the lower story, when suddenly construction was interrupted. A solid, square plinth with conservative classicizing articulation promised a centralized dome in a similarly restrained, academic style. Meanwhile, the church, open to the sky, waited more than thirty years for an architect to raise a drum and dome over its sober square base. It was a constant reminder to Michelangelo that he would not live to see the completion of St. Peter's. Finally, in the 1570s—that

is, a decade after Michelangelo's death—Jacopo del Duca (c. 1520–after 1601) completed the building with the most extravagantly bizarre dome and lantern in all Rome (see plate 40). While fascinating, the upper construction contrasts radically with the architecture below. This is a stunning, but not exceptional, case of the failure of an earlier design to determine or influence what followed. Thus, Michelangelo perpetually faced two questions with every architectural project: How much of the building could he realize in his lifetime, and how much building was required to ensure that his design would not be altered significantly?

Problems of Logistics and Engineering

Michelangelo understood that a building is far more complicated than a beautiful design made with black chalk on paper. Just as there is little relation between a drawing and actual construction, so too there is little relationship between a model and a building. Wood does not look or behave like stone. A wood column turned on a lathe is different from excavating, transporting, and erecting a stone column, which is ten times larger, a hundred times more expensive, and a thousand times heavier. It is one thing to add a diminutive wood column to a model, and quite a different undertaking to raise a stone shaft at the building site. Moreover, a wood column does not predict the stresses placed on a stone column supporting a dome. Engineering complicates design.

We admire Michelangelo as a brilliant designer, but each and every day he confronted problems of logistics and engineering. To construct the drum of the dome, Michelangelo faced and solved problems that Antonio da Sangallo never confronted in making his wooden model.

How much travertine was needed to construct the sixteen buttresses and thirty-two columns encircling the drum of the dome; who would make and then deliver the template drawings to the quarrymen at the Tivoli quarries; how many stone carvers should be employed; how much roughing out should take place in the quarries; who could be trusted to oversee both the quarrying and transport operations;

how many carters would be needed to cart the material from Tivoli to St. Peter's; was there any way to speed up the delivery operation; how much would it cost; how much should Michelangelo worry about the cost; how much would the pope worry about the cost; how soon could the travertine begin arriving; did one need to anticipate the possibility of thieves and bandits along the Via Tiburtina; where would the stone be stored once it arrived at St. Peter's; should a shed be constructed to protect the stone and shelter the stone carvers; how much finishing could be done before the stone was lifted into place; what equipment and skilled labor was available to turn more than two hundred column drums; where would the turners work and what tools would they need; should the existing small forge be expanded in order to take care of the constant need for sharpened and well-tempered tools; could one count on the day laborers to safely move the column drums to the staging area; could the drums be rolled or should carts be used; were the hoists functioning smoothly; were the hoists and ropes strong enough to lift a column drum; was there enough rope, and was it good rope; how much material could be transported to the upper levels of construction using the helical ramps inside the piers; how many mules and handlers should be retained for the work; how much animal shit would be deposited there, and should someone be hired to clean the slippery ramps daily or weekly, and should straw be laid down to ensure good footing; where would the donkeys be stabled, and who would care for them and provide their feed; would the braying of the donkeys or the foul cursing of the drivers disrupt services being held in the semicompleted church; who could talk to the priests about the disruptions; what sort of scaffolding must be constructed at the level of the barrel vault; would it provide enough room for the hoists as well as the workers who had to maneuver the column drums into position; who could deliver enough wood to construct the scaffold; who was skilled enough to design and build it; how much time would be required to dismantle and move the scaffold in order to shift the work to a different section of the fifty-foot-high tambour; once a column drum was raised, was there room and a secure platform on which to rest another drum before moving the first into final position; how

much carving would happen after the lift; how much damage would be incurred at any one of a hundred different points in the maneuvering of the immensely heavy column drums; should the individual drums be pinned to one another, or could one rely on their weight alone to ensure stability; should one think ahead to the dome—the thousands if not hundreds of thousands of bricks that would be required, not to mention another immense quantity of travertine blocks; should more kilns be built on-site to save time and money; was there enough room and wood to fire the kilns; how much mortar would be required, and how long should it be slaked; would the Acqua Damasiana spring provide enough water for the work, or should additional water carriers be hired to haul water from the Tiber; would the canons of St. Peter's object to the smell of burning wood, to the smell of burning stone to make lime, to the smell of the donkeys, to the smell and behavior of the laborers; would they—as they constantly did—just object?

And the questions continued. How many overseers would be required to coordinate these operations; who would be hired as overall *soprastante*; who would be hired to direct the many *capomaestri* in charge of the individual work crews; were there enough laborers, working long enough hours, at a good enough wage; who among the workers had the specialized skills required to construct a double-shell dome; were there enough individuals willing to work at the dangerous height of the tambour and then over the void of the rising, curving dome; how many could be counted on for the long term; what sort of pay scale would ensure some sort of labor stability; how could anyone control the constant embezzlement of funds; even worse, how was one to prevent the purchase of substandard materials—an endemic problem that had been going on for decades; who among the *fabbrica* officials could be relied on to stem the tide of corruption and graft; should the supervising architect worry about finances at all; should the supervising architect concern himself with the day-to-day laborers; how would Michelangelo, as supervising architect, know what his overseers were doing and whether they were proceeding according to his wishes and designs; how would the supervising architect bridge the

gap between design and construction—between hands-on attention to every detail and trusting to one's appointed representatives; should Michelangelo worry about the concerns of the current pope: money and time; who would be in charge of infractions, disagreements, and disruptive behavior at the work site; should wine be provided—as many expected—and if so, should wine be provided to the workers at the highest construction levels; who would stay on-site through the night to prevent theft; would the unpredictable weather cooperate; would the *fabbrica* officials cooperate; how many lives would be lost; would another foreman get fired, move away, or get himself murdered; would Michelangelo's friends in the *fabbrica* live long enough; would the pope live long enough; would Michelangelo live long enough? Could he, as architect of God's church, fulfill God's expectations?

These prolonged sentences are longer than the rhetorical opening of Vasari's life of Michelangelo. Vasari was celebrating a genius; I am suggesting the day-to-day concerns of a fallible mortal in charge of St. Peter's: God's architect.

Art and Building beyond the Grave

Michelangelo was a hands-on architect who concerned himself with every detail of design and construction.[15] Today we would consider him a micromanaging, type-A personality. Working at San Lorenzo in Florence between 1515 and 1534, for example, Michelangelo quarried a mountain of marble, including blocks of a size and quantity unequaled since Roman times, from Apuan Alpine quarries that even today are virtually inaccessible, with a transport system of sleds, carts, and oxen that had to be organized and staffed, with equipment that was assembled and borrowed and sometimes defective. He worked against weather that often was uncooperative and roundly cursed, with men who were handpicked but required training and constant supervision. He selected and inspected all his materials; arranged for rope, tackle, and boats; haggled with carters and shippers about fees; and made drawings for even the tiniest, seemingly most insignificant detail, before turning the paper over to make calculations, count bushels of

grain, draft a letter, and compose poetry. Michelangelo was not only a creative genius but a savvy businessman, skilled engineer, versatile building contractor, and successful entrepreneur—a person who shuttled constantly between the mundane and sublime.

In Rome, Michelangelo was the same hands-on architect, but he learned to make adjustments: to the scale of St. Peter's, to the number of his simultaneous commitments, and to his advanced age. He had learned that translating design into structure required constant decisions, innumerable adjustments, and frequent intervention. In any building as large and complicated as St. Peter's, engineering problems would arise, adjustments had to be made, design changes accommodated. He was wary about disclosing his intentions, and distinctly uncomfortable with the notion of a fixed design or model. Thus, it should not be surprising that only meager evidence exists for many of the projects that Michelangelo undertook in his eighties.

Not a single contract (between artist and patron) exists for any of Michelangelo's Roman architectural projects—not for the Campidoglio, San Giovanni dei Fiorentini, Santa Maria degli Angeli, the Porta Pia, the Sforza Chapel . . . not even for a project as large as St. Peter's. Contracts, like finished drawings and models, were a traditional means of guaranteeing a design, and the patron's only insurance against the notorious noncompliance of artists. We should understand this absence of material evidence as testimony of Michelangelo's unique position in late Renaissance Rome—a position that, in subsequent centuries, leads to Gianlorenzo Bernini and Francesco Borromini, and then to Christopher Wren, Robert Adam, Thomas Jefferson, Henry Hobson Richardson, and Frank Lloyd Wright. Michelangelo helped give birth to the modern architect.

One of the most remarkable aspects of Michelangelo's late career is the authority he wielded in his lifetime—and then from beyond the grave. If an architect inherited an unfinished project "touched" in any fashion by Michelangelo, there was widespread acceptance that it remained Michelangelo's. Subsequent architects were circumscribed by "Michelangelo"—as defined by persons who professed to have knowledge of the master, of his design, of his "intentions." Michelangelo's

design decisions, whether actualized or merely purported, achieved unquestioned authoritative status.[16] If changes *were* introduced, they were done by affirming respect for Michelangelo's intentions, as Carlo Maderno did when he extended the nave and built the facade of St. Peter's.[17] If there was not enough information, in the form of drawn designs, models, or contracts—which was almost always the case—then the next best claim was to have knowledge based on a personal relationship, as Michelangelo's one-time assistant, pupil, or friend. The closer your proximity to the master, the more you could allege to know his intentions and the more certain your claim to have inherited something of his authority. Fame by association; authority by proximity.

In almost every case, the best evidence we have is not the hard evidence offered by contracts, drawings, and models but rather that from the personal relationships Michelangelo cultivated with his circle of collaborators—from accommodating patrons to trusted site supervisors. Michelangelo's architecture depended on such personal relationships. Over his seventeen-year tenure as papal architect, five popes, three friends in the *fabbrica* office, and four invaluable site supervisors (*soprastanti*) were instrumental in assisting the realization of the half dozen projects for which Michelangelo was the responsible architect. Supremely valuable, since Michelangelo worked with them on a daily basis, were the successive overseers at St. Peter's: Jacopo Meleghino (until his death in 1549), Sebastiano Malenotti (c. 1550–57), Cesare Bettini (1560–63), and Pier Luigi Gaeta (1563–). In addition, several of these *soprastanti* also managed day-to-day operations at Michelangelo's other Roman projects.

Equally important to Michelangelo's professional and personal well-being were the individuals who remained close to the master in his final years, first among them, Tommaso de' Cavalieri. Cavalieri, a teen when he met Michelangelo, was now an important Roman citizen and a deputy of the *fabbrica* that oversaw the Campidoglio. Their friendship matured—mellowing from its initial passionate intensity—and continued for more than thirty years. It is touching that Cavalieri was at Michelangelo's side in death, and suitable that the younger man's name is commemorated in the entrance vestibule of the

Palazzo dei Conservatori, on the Campidoglio, since he helped realize the project.

In his waning years, Michelangelo also grew close to a handful of younger artists, especially Marcello Venusti, Daniele da Volterra, and Tiberio Calcagni. These friends were important not only in offering the aging artist companionship but also did much to realize his incomplete projects and, by extension, to expand the notion of his authorship. An essential aspect of Michelangelo's later career was the steady increase of demands made upon him. As he grew older, everyone, it seemed, wanted something "from his hand" (*di sua mano*). With the great architectural projects of St. Peter's, the Farnese Palace, the Campidoglio, the Porta Pia, and Santa Maria degli Angeli, Michelangelo had less time—and perhaps less inclination—to paint and carve the unique, single-author works that had characterized his early career and helped to establish his reputation. Now he increasingly satisfied requests by furnishing drawings that his circle of collaborative artists used to produce work that was considered "by Michelangelo" because it was based on his idea or design.

In the 1540s, Marcello Venusti (1512–1579) painted two large altarpieces for Rome's Santa Maria della Pace and San Giovanni in Laterano from designs furnished by Michelangelo. In addition, Venusti executed a number of smaller pictures from Michelangelo's drawings, including three that were presented to Vittoria Colonna: a *Crucifixion* (see plate 8), *Pietà* (see plates 41 and 42), and *Christ and the Woman of Samaria*.[18] These paintings proved wildly popular. The sheer number of replicas attests to the fame of Michelangelo's conceptions, the widespread desire for examples of his art, and the central importance of Venusti in satisfying a rapidly growing demand. Venusti was a talented artist who successfully translated the master's designs into paint, but far more than an agent for increasing Michelangelo's artistic production, the younger artist sparked the master's creativity. Michelangelo was drawn to the highly polished, enamel-like manner of Venusti's work—a "stylish style," in the words of John Shearman, that greatly appealed to sixteenth-century taste.[19] Michelangelo *elected* to collaborate with Venusti. The two grew close, and

Michelangelo stood as godfather to Venusti's first child, another boy named Michelangelo.

Daniele da Volterra (1509–1566) was already an established artist when he became a friend, and willing collaborator, of Michelangelo in the 1540s. Daniele's artistic stature certainly exceeds that of Marcello Venusti; however, as with Venusti, Daniele's friendship was as important to Michelangelo as his professional abilities—although that is Michelangelo's perspective, not history's. Daniele was intimate with Michelangelo, moved into his house, and created an affecting portrait bust of the artist. Their most celebrated collaboration was the equestrian monument Catherine de' Medici commissioned to honor her late husband, King Henry II of France. Catherine (1519–1569) was the daughter of Lorenzo de' Medici, the duke of Urbino, whom Michelangelo had immortalized in the Medici Chapel. With a tone at once beseeching and imperious, as befitted a queen, Catherine wrote to Michelangelo in November 1559:

> I have resolved to erect, in the court of my palace, an equestrian statue in bronze of my Lord of such proportions as may suit that place. And as I am aware in common with all the world how excellent a Master you are in art, above all others of this age, whilst you have been attached to my family as is clearly shown by the statues on the monuments to my relatives [the Medici Chapel], I beseech you to accept this undertaking. I am aware that you might to another plead your great age, but I believe that you will not make this apology to me, or at all events that you will make the design and employ the best Masters to be found, to cast and chase it.
>
> No one, I assure you, in the whole world, could do me a greater favour or one for which I should be more grateful.
>
> I write to my cousin Robert [Strozzi] at this time, and I say no more, leaving it to him to explain on my part, therefore without more, and praying God to preserve you in happiness. Catherine.[20]

Roberto Strozzi had been the recipient of Michelangelo's two marble slaves or captives, originally intended for the tomb of Julius II and now in the Louvre. He was a prominent member of the Florentine

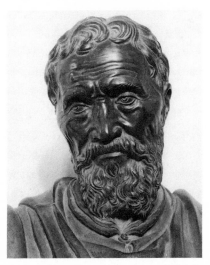

Daniele da Volterra, *Bronze Portrait Bust of Michelangelo*,
detail, 1565, Bargello Museum, Florence

community in Rome and was among those who attended Catherine's
court in France. Persuaded by her person, her position, and his long
attachment to her family, Michelangelo agreed to make a design and
provide oversight, but he turned over the actual execution of the
bronze equestrian to Daniele, one of "the best Masters." By providing
a design (see plate 43), Michelangelo satisfied the expectations of the
patron who wanted *his* work, since the concept of authorship resided
in the invention rather than in the manual execution. In a sense,
Catherine is the supplicating client, Michelangelo is the patron of
Daniele, and Daniele is the artistic extension of Michelangelo (as
were Jacopo da Pontormo, Sebastiano del Piombo, and Marcello Ve-
nusti previously).[21]

Almost a year later, and with little evidence of progress on the proj-
ect, Catherine again wrote to Michelangelo. She appealed to his long
association with her family and resorted to overt flattery:

> I entreat you by the affection you have always shown to my family, to
> our Florence, and lastly to art, that you will use all diligence and assidu-
> ity, so far as your years permit, in pushing forward this noble work, and

making it a living likeness of my lord, as well as worthy of your own unrivalled genius. It is true that this will add nothing to the fame you now enjoy; yet it will at least augment your reputation for most acceptable and affectionate devotion toward myself and my ancestors, and prolong through centuries the memory of my lawful and sole love; for the which I shall be eager and liberal to reward you.[22]

A similar language of extreme deference was employed by the queen's agent, Bartolomeo del Bene, and by Roberto Strozzi himself, when each of them addressed Michelangelo regarding the commission. Strozzi affirmed to Michelangelo that "all depended on him" and begged him, "as much as I can," to see it carried out (*io vi supplico quanto posso*).[23] And in a subsequent letter, Strozzi wrote: "I offer and recommend myself to you, and I pray to God that you are well."[24] What is notable in the entreaties of Catherine and her agents is a reversal of the traditional artist-patron relationship; the work of securing the commission fell to the patron. Fifty years earlier, it would have been the artist addressing the patron rather than vice versa.

The equestrian statue proved challenging. Daniele was a slow worker and already had multiple obligations, not the least of which was spending increasing amounts of time with the ailing Michelangelo. During the master's final illness, Daniele regularly corresponded with Lionardo Buonarroti, in Florence, and after Michelangelo's death, he lived and worked in the Via Macel de' Corvi house until his own death, in 1566. The equestrian monument was only partially realized (the horse without a rider was shipped to France in 1622 and was destroyed during the French Revolution), nonetheless, it mantains a firm place in the oeuvre of Michelangelo.

Another amanuensis, Tiberio Calcagni (1532–1565), also helped carry forward several of Michelangelo's projects. From the early 1550s, Calcagni was assisting Michelangelo as both a draftsman and a sculptor. It was Calcagni who rescued and repaired the Florentine *Pietà* (see plate 31), which is certainly his best-known but not his only contribution to Michelangelo's life and oeuvre. In social station and affection, Calcagni ranks somewhere between Tommaso de' Cavalieri and the

artist's beloved Urbino. Although he never lived with the master, Calcagni quickly became a central figure in Michelangelo's final years, proving to be one of the artist's most valued assistants and most trusted companions. Calcagni's relationship with Michelangelo was both professional and personal. He was deeply inserted in the master's affections and closely involved in his late artistic projects. These included a number of architectural commissions but also sculpture, for he was accomplished in both arts, as his grave memorial attests: "Tiberio Calcagni, Florentine . . . would strive with utmost zeal toward outstanding excellence in sculpture and architecture."[25]

According to Vasari, Calcagni assisted Michelangelo with the bust of *Brutus* (see plate 44) and the Florentine *Pietà*. Vasari's testimony has done little to bolster Calcagni's reputation, since he and many scholars blame the younger artist for supposed faults in these sculptures. Rather, we should recognize that Michelangelo not only "loved Calcagni," he also chose to collaborate with the artist on multiple projects.[26] Of his many contributions, Calcagni proved most valuable in assisting with the master's late architectural commissions.

Calcagni drafted presentation drawings from Michelangelo's designs, since the elderly man—well into his eighties—no longer had the steady hand and patience required to make finished architectural drawings. In addition, Calcagni traveled to Florence to represent Michelangelo and present the designs for the new Florentine church in Rome, San Giovanni dei Fiorentini (see plate 45), to Cosimo de' Medici. Calcagni was Michelangelo's collaborator, right-hand man, and on-site supervisor for a number of additional architectural projects, including the Sforza Chapel in Santa Maria Maggiore and the Porta Pia. Throughout Michelangelo's final decade, Calcagni served him in multiple capacities.

We can trace an additional, wider circle of persons who were not as personally close to the master but who, with his encouragement and extended authority, helped to carry forward his many obligations. At the Campidoglio, documents record the invaluable and ubiquitous presence of Benedetto Schela, who also served as *capomaestro* at the Farnese Palace and Santa Maria degli Angeli, alongside Antonio and

Jacopo del Duca, and Jacopo Rocchetti. A later generation of the Schela family, Francesco, also worked as *capomaestro* at the Campidoglio, as did Giacomo della Porta and Jacopo del Duca. In the 1570s, after Michelangelo's death, Meo Bassi worked alongside Francesco Schela. Bassi was the grandson of Bernardino Basso, a *capomaestro* who had worked closely with Michelangelo for forty years in both Florence and Rome.[27] It is a constantly overlapping group of interrelated individuals—the relatives, friends, and neighbors (*parenti, amici, e vicini*) who made up the backbone of Michelangelo's workforce. The fact that these names are familiar only to specialists is testament to Michelangelo's success in appointing deputies who followed his design intentions, although the traditional evidence of drawings, models, and contracts remains frustratingly scarce. The results, nonetheless, are attributed to Michelangelo—not to Benedetto Schela or Meo Bassi.

When Jacopo del Duca (c. 1520–after 1601) worked on Michelangelo's projects—and there were many—the respect shown for precedent guaranteed that the project would carry Michelangelo's name, even if Jacopo and associates did the majority of the work. When it came to St. Peter's, every designer was constrained by Michelangelo, because here his authority waxed greatest. Therefore, for example, Jacopo del Duca could never have introduced a weirdly extravagant dome for St. Peter's, as he was free to do at Santa Maria di Loreto (see plate 40). Rather, when Giacomo della Porta built a beautiful dome for St. Peter's—he was completing Michelangelo's church. Ask anyone: Did Michelangelo or Giacomo della Porta design the dome of St. Peter's?

Drum and Dome of St. Peter's

Michelangelo lived long enough to complete the fifty-foot-high drum (tambour) of St. Peter's—up to the level of and including the crowning cornice. The attic would follow, then the dome. The drum, however, provided the key structural and aesthetic element, as it set the parameters for the dome that rose above it. First and foremost, the drum established the scale, proportions, and fundamental engineering of the dome's double-shell construction. The drum was the foundation, and

as in any building foundation, it plays a critical role in what rises above it. The dome logically followed from the drum.

While Michelangelo did not live to oversee the construction of the dome, his extant drawings offer evidence that the dome is his design. It is true that Michelangelo considered many alternatives: semicircular (Pantheon-like), catenary (its curve with the profile of a slack hanging chain), and stilted (a steeply tapering profile).[28] As is revealed in two much-discussed drawings, one in the Musée d'Art et d'Histoire in Lille (see plate 46) and the other in the Teylers Museum in Haarlem (see plate 47), Michelangelo experimented with various designs, even on these two sheets. On the less finished, more exploratory drawing in Lille, Michelangelo began by sketching a semicircular, Pantheon-shaped dome. However, he continued drawing until he had sketched no fewer than a dozen different potential dome profiles on this single sheet. The related drawing in Haarlem appears to offer a more developed and therefore a more "definitive" indication of Michelangelo's intentions. The alternative profiles are fewer, numbering eight, and suggest a double-shell construction with semicircular inner and a stilted exterior profile. Ultimately, however, no matter how attractive these drawings, they cannot be construed as definitive evidence. They are design drawings that fall far short of defining Michelangelo's final intentions or guiding construction. Many decisions had yet to be made.

The domes of the Pantheon and the cathedral of Florence were Michelangelo's inspirations and most important models. Particularly in the Lille drawing, it appears that Michelangelo imagined raising a semicircular dome, like that of the Pantheon, but envisioned placing it on a tall drum, thereby thrusting the simple geometry of the Roman precedent high into the sky. Technically, however, Michelangelo was building a radically different structure. He did not have at his disposal the versatility of Roman concrete—a technology that would not again be available to builders until the nineteenth century. Therefore, the Pantheon was mostly irrelevant as a model for how to build a double-shell dome on a high, vertical drum. Moreover, a semicircular dome would never support the weight of the crowning lantern that Michelangelo drew on both the Lille and Haarlem sheets.

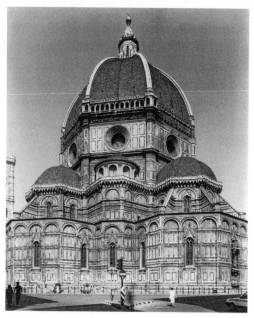

Cathedral of Santa Maria del Fiore, Florence

The majestic cathedral of Florence was another inspiration—both aesthetically and structurally. Almost immediately after taking over as architect of St. Peter's, Michelangelo requested a friend in Florence to send him the height of the cathedral dome, built more than one hundred years previously by Filippo Brunelleschi.[29] A few years later, he again requested precise measurements, because he wanted "to know which is larger [in diameter], the dome of St. Peter's or that in Florence."[30] Having received the dome's interior and exterior dimensions, Michelangelo next asked—if it was not too much bother—for the height and width of the Florentine bell tower, an interesting request, given that St. Peter's does not have a freestanding campanile.[31] Particularly relevant was his adoption of Brunelleschi's innovative double-shell dome construction—something Michelangelo carried with him in memory. Thus, Brunelleschi's dome offered a more informative structural model than the Pantheon, yet neither offered much in the way of solutions to the legion of everyday problems.

Michelangelo faced a radical unknown: how to build a dome as large as that of the Pantheon but nearly three times higher. He knew the final outcome was not predictable, and it could never be guaranteed by a drawing or even by an expensive wooden model. He would proceed one step at a time, solving problems as they arose, anticipating as much as possible, but always prepared to make adjustments and ready to bridge the yawning gap between intention and execution, ideal design and actual construction.

The dome of St. Peter's is convex in every part, as if it were a well-inflated dirigible pushing outward against its restraining skeleton (see plate 48). There are sixteen vertical ribs. From any vantage point, just eight ribs are visible. The number eight, symbolically, suggests the Resurrection, and a dome is a metaphor of heaven. Thus, the dome is both a beautiful structure and significant in meaning.

Each of those mighty ribs springs from tall impost blocks supported by a pair of columns: thirty-two columns in sixteen pairs. The paired columns are reiterated in corresponding but smaller pairs surrounding the lantern: thirty-two lantern columns in sixteen pairs—each pair surmounted by a curving volute and a candelabrum. Thus, as the dome rises, the form and number of the architectural elements are consistently repeated, even as they diminish in proportion and vary in decoration. The same is true inside the church. Each of the paired columns on the exterior drum has a corresponding set of paired pilasters on the interior: thirty-two pilasters in sixteen pairs.

Perhaps number symbolism underlies the multiples of two, four, eight, and sixteen, but more important is the visual effect of order, continuity, and rhythm, as well as the correspondence between interior and exterior decoration. Paired columns and paired pilasters serve as the consistent, unifying scheme, both inside and outside the basilica. Of all these elements, the paired columns on the drum's exterior are the most important, since they are the solid, earthly supports to the heavenly dome.

Each pair of columns sits on a shared plinth and rises to support an individual piece of broken entablature that encircles the base of the dome. While the columns appear to be free-standing monoliths, they are, in fact, three-quarter round, attached to rectangular piers that are arranged perpendicular to the circle of the dome. The piers are the visible part of sixteen massive buttresses that counteract the weight and outward thrust of the dome (see plates 49 and 50). They serve the same purpose as flying buttresses in a Gothic cathedral, but they are visually integrated into the unified structure of the dome. In order to counteract similar thrust, Brunelleschi encircled the base of the Florentine cathedral with an invisible chain of wooden beams and iron links. For the same purpose, Michelangelo created a wheel of immense and visible stone buttresses. Michelangelo always preferred stone.

Despite their enormous bulk, the buttresses are not conspicuous. One perceives the extent of their projection only when one regards the dome in profile. The overlap of the tightly spaced buttresses prevents the eye from dwelling on the prodigious mass of any single buttress. In addition, the engaged columns adorning the front face of each pier distract from their immensity.

The columns add weight and volume to the buttresses, but they have an equally important visual purpose. Thus, we see columns rather than buttresses; they direct us vertically to the pronounced entablature and then horizontally, encouraging us to follow the vigorous cornice lines of the entablature and attic. The psychological weight of so much stone is further lightened by the fact that each pair of columns alternates with a colossal window opening. Altogether, one is little aware that the drum, given its elegant symmetry and classical beauty, is a massive concentration of stone.

Columns in Pairs

As seen in Greek and Roman construction, columns defy gravity, making a heavy building appear light. Paired columns, however, were not a standard part of those ancient building traditions.[32] The ancients tended to space single columns, whether freestanding or engaged, at

regular intervals. The idea of pairing or bundling columns was largely a late-antique/early-Christian innovation, when columns were employed as much for decorative as structural purposes. At St. Peter's, Michelangelo employed paired columns as simultaneous structural and aesthetic elements.

We see an early example of Michelangelo's experimentation with paired columns in his designs for the facade of San Lorenzo and in the wooden model for the same project. In the extant San Lorenzo model, there are six pairs of columns, each standing on a shared plinth and supporting a section of broken entablature. Michelangelo subsequently used paired pilasters as flanking elements to the central niches of the Medici Chapel tombs. But the most important elaboration of this idea came in the vestibule of the Laurentian Library, where the paired columns sink into wall recesses and appear to be supported on paired volutes. Thus, Michelangelo's architectural ideas that germinated in Florence reached maturity in Rome—not only at St. Peter's but also in designs for San Giovanni dei Fiorentini and the Sforza Chapel. In the Florentine examples paired columns (or pilasters) were more decorative than structural. In his mature Roman architecture, Michelangelo employed paired columns not only as an attractive ornamental device but for important structural purposes.

In Rome, Michelangelo would have seen examples of paired columns in the cloisters of many early Christian churches, such as San Giovanni in Laterano, Santi Quattro Coronati, and San Lorenzo fuori le Mura. However, cloister columns tend to be smallish colonnettes, the pairs set at right angles to the cloister ambulatory. Thus, in appearance, scale, and function, they are as much decorative as structural, more delightful than substantial.

In addition, Michelangelo certainly knew examples of late-antique mausoleums in Rome, such as Santa Costanza and the two rotundas alongside Old St. Peter's (his Rome *Pietà* was originally located in one of the two, Santa Petronilla). At Santa Costanza, for example, the central vault was supported on twelve piers surrounded by an annular barrel vault. Each of the piers is composed of paired columns that share a single base and entablature block turned at a right angle to the

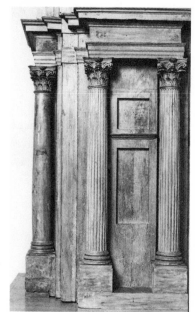

RIGHT. Wooden model of facade of
San Lorenzo, Florence, detail, c.
1516–17, Casa Buonarroti,
Florence

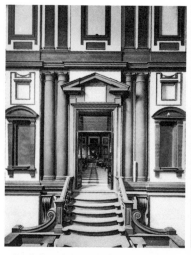

Michelangelo, Vestibule of Laurentian
Library, San Lorenzo, Florence

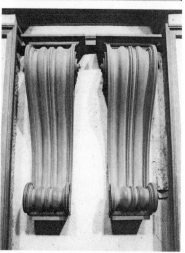

Pair of volutes, Vestibule of Laurentian
Library, San Lorenzo, Florence

Paired columns, detail, Cloister of San Giovanni in Laterano, Rome

ambulatory. This is precisely what Michelangelo designed for the drum of St. Peter's. However, in a stroke of genius, Michelangelo moved the paired columns to the exterior of the building, where they serve as both aesthetic elements and structural components supporting the dome. Thus, while late-antique buildings may have provided Michelangelo with ideas, his use of paired columns is highly original, especially when we consider that St. Peter's is a significantly larger structure.

One may identify possible sources for Michelangelo's ideas, but in every case, he developed his own original forms.[33] Michelangelo's introduction of broken and redundant pediments, so-called kneeling windows (as seen in the Medici Palace in Florence), and the giant order, with pilasters rising in successive stories (as in the Palazzo dei Conservatori), are widely acknowledged, yet little attention is paid to his similarly innovative use of paired columns. In fact, it was not until Michelangelo's use of the paired column motif that it became widespread—so widespread that we tend to overlook its originality.

Often, Michelangelo's innovations in architecture and architectural ornament were so quickly adopted that we fail to recognize their origins. In some ways Michelangelo is like Shakespeare. Both were prolific inventors who introduced so many new forms and motifs, words and phrases, that we take them for granted. Their respective

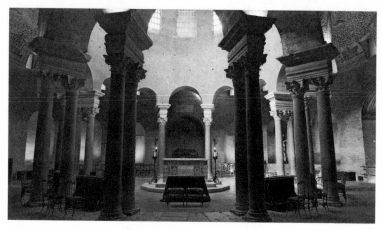
Santa Costanza, interior, Rome

innovations in architectural and spoken vocabulary were so quickly
absorbed and so widely disseminated that we hardly recognize a time
before they existed.

Rising Higher

Above the imposing drum of St. Peter's sits a comparatively under-
stated attic (see plate 51). While modest, this attic is crucial in visually
distinguishing the heavy, earthbound drum from the heaven-bound
dome. The attic is the dome's launching pad. A multilayered vertical
plinth with secondary entablature rises above each pair of columns,
and those sixteen plinths, in turn, support an additional cornice from
which ascend the curving ribs of the dome. While much less emphatic
than the attic's lower cornice, this upper cornice is an entablature with
its own important part to play, as this is the final demarcation before
all vertical lines begin to curve inward. The horizontal foundation now
releases the sixteen vertical ribs, which accomplish the hard work of
supporting the dome and the aesthetic task of carrying our eye heav-
enward. Like giant whale bones, the tapering, serrated ribs rise majesti-
cally, converging beneath the lantern.

Against the sky, the dome attracts the eye like a buoy on a boundless
blue sea. Birds are drawn to it: cawing gulls in the morning, silent

swifts in the evening. At night the dome is more beacon than buoy—a light in a vast ocean of darkness. It is seen from everywhere in Rome. The vertical rise is so majestic that only the substantial attic, emphatic cornices, and monumental lantern are able to counteract the upward surge. The dome both contains and concentrates vertical forces. It is a mountain rising above the sacred ground of the Mons Vaticanus.

The mass and weight of the drum are relieved by the large, yet comparatively light and floating dome, which is punctuated by windows and surmounted by a truly imposing lantern—dark by day, luminous at night. The ring of colossal windows in the drum is echoed in the dome, in three ascending, diminishing ranks. Those in the first row are dark eyes with emphatic architectural eyebrows; the second, winking eyelets with thin eyelashes; the third and smallest, brightly lit ship portals sailing in the darkness. The windows, in their varied design and diminishing size, assist in carrying our eye upward, even while encouraging us to circle the dome in ever-tighter horizontal bands. This is a building that inverts the architecture of Dante's hell; rather than a descent to a netherworld, the dome ascends in progressively diminishing circles that lead us to heaven. The lantern that crowns the dome continues this ascent while also shedding light into the church below (see plate 52).

As the principal source of interior light, the lantern can appear ethereal, but it is actually a massive structure. It is a necessary structural element, for its compressive weight holds the ribs in place and under tension. Crowning the lantern are sixteen thinner ribs rising precipitously to support a gilt orb and cross. In all essential features and overall design, the lantern reflects and reiterates, in miniature, the drum and dome below.

Michelangelo did not live to build the lantern, but it is entirely consistent with the drum that he did build and with the beautiful design on his drawing in the Teylers Museum, Haarlem. Again, the lantern is evidence of the effectiveness of Michelangelo's strategy: to build enough to ensure the continuation of his design.

As Michelangelo visited the St. Peter's work site throughout the winter of 1562–63, he watched the drum—some fifty vertical feet of stone construction—nearing completion. He already was planning the next phase of work: the beginning of the dome. For a while the stonemasons would be laying horizontal courses of stone, but shortly the brick masons would take over, and the curvature would begin. Michelangelo knew he would not live to see this phase of the building construction. However, the drum alone was a majestic sight. It pleased him to know that a number of artists had drawn and even made engravings of the unfinished church and truncated drum, thereby tacitly acknowledging the majesty of the construction (see plates 53 and 54).

More than the great crossing vaults that had stood for so long as the only evidence of the building's progress, the completed drum promised a finished dome and church. What Michelangelo accomplished in his lifetime was enough that Rome, the pope, and God could believe in New St. Peter's.

Is It Michelangelo's Design?

Were Michelangelo's intentions realized at St. Peter's? From what we know, Michelangelo constantly changed his mind and made adjustments, in sculpture as well as architecture—not because he was secretive, but because he was experienced. He had already confronted so many problems, and he knew he would face infinitely more complex ones when it came time to begin the dome's construction.

Michelangelo was almost certainly the first of the many St. Peter's architects to consider seriously the engineering problems attendant to the dome's construction. Bramante created a beautiful design for St. Peter's, and he constructed the piers that, after being greatly enlarged by Michelangelo, supported the dome.

But Bramante did not adequately account for the difference between a paper design and stone construction; he did not fully consider what happens when one scales up from a drawing to a model and from a model to an actual building. Cracks began to appear in Bramante's

piers almost immediately, but since they were not yet supporting a dome, no one expressed the necessary concern.

After Bramante, not one of the successive architects paid much attention to the engineering faults of the unfinished structure. Rather, each new architect developed his own design and presented a beautiful drawing to his pope. No one dared to point out the engineering deficiencies of the building, and there were many—so many. Every single architect after Bramante had a plan—Giuliano da Sangallo, Raphael, Baldassare Peruzzi, Antonio da Sangallo—but not one of them confronted the most important problem: how to raise a dome with the diameter of the Pantheon 250 feet in the air. Just as the Florentines were willing to wait more than one hundred years for someone to solve the problem of creating a dome for their ambitiously large cathedral, so the Roman authorities never demanded that Bramante or his successors communicate how a dome could be successfully built for New St. Peter's. In Florence the answer came from Filippo Brunelleschi; in Rome, Michelangelo.

Michelangelo's genius as St. Peter's architect was to turn his attention first to structure and then to translate structure into aesthetics. That is why the piers and drum so dominated his attention and his design. In the final building, the much admired crossing piers and the less celebrated drum are necessary structural elements but also aesthetic highlights. Without them, the dome would have failed.

Of course, changes were later introduced to Michelangelo's design. Chronologically, Michelangelo was in charge of just about 12 percent of the building's long history. Actually, it is more stunning to state this in the opposite manner: given that Michelangelo did not control some 88 percent of the building's history, it is astonishing that he accomplished as much as he did and that we give him credit for the church. We consider St. Peter's to be his building—not Bramante's, even less Raphael's, and certainly not Giuliano or Antonio da Sangallo's. Giacomo della Porta and Carlo Maderno may have completed the church, but no one credits them as its author.

Some post-Michelangelo changes may even have been for the better—for example, the decorated attic introduced by Pirro Ligorio; the

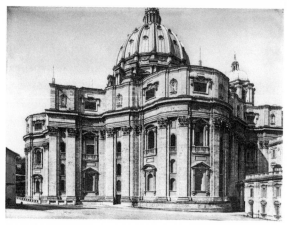

St. Peter's Basilica, exterior, with Pirro Ligorio's attic, Vatican City, Rome

sheathing of the church's interior in marble; and the lengthening of the nave, by Carlo Maderno.

One might legitimately argue that Ligorio's design improved the unadorned attic initially constructed by Michelangelo. Ligorio's attic provides a strong horizontal band that wraps around and unifies the entire structure and, at the same time, creates greater continuity with Michelangelo's giant order below.[34] Similarly, Michelangelo might have appreciated the marble sheathing on the interior of St. Peter's, since it ameliorates the raw, barnlike space that one sees in many large Italian churches, such as San Biagio in Montepulciano, Santa Maria della Consolazione in Todi, and San Petronio in Bologna. Perhaps only the extended nave of St. Peter's would have met with Michelangelo's determined opposition. It undermines the perfect and satisfying geometry of Bramante's original plan, and it disrupts the view of the church and dome from the piazza. On the other hand, the nave makes the church grander and more functional. And Maderno believed he was merely extending Michelangelo's design, not contradicting it.

None of the changes compromise the fact and perception that this is Michelangelo's building. It was less important for Michelangelo to build a specific design than to protect the integrity of the church. It was God's church and he was God's architect.

GOD'S ARCHITECT

Prior to St. Peter's, Rome was a city of medieval bell towers. To the Englishman Magister Gregorius, who visited Rome at the beginning of the thirteenth century, it was "a city in which so many towers rise that they seem like stalks of grain."[1] Except for the columns of Trajan and Marcus Aurelius and a few mammoth ruins, bell towers were the most visible signposts for the local citizen and the medieval pilgrim. They were tall, square, and brick: visual and aural markers.

St. Peter's transformed a city of bell towers into a city of domes. In the fifteenth and early sixteenth centuries, a number of smallish domes were constructed around the city: Santa Maria della Pace, Sant'Eligio degli Orefici, Sant'Anna dei Palafrenieri, Bramante's Tempietto, and the Chigi Chapel in Santa Maria del Popolo. A somewhat larger dome was built over the crossing of Santa Maria del Popolo, but its squat exterior profile is still lower and less impressive than the church's medieval bell tower.

St. Peter's became the first highly visible dome in a city of bell towers. Located on the rising ground of the Mons Vaticanus, the dome spawned a multitude of imitations. When one looks over the current cityscape, the medieval bell towers are mostly obscured by the thicket of modern buildings, above which rise dozens of tall, mostly Baroque

domes. Like bulbous mushrooms, they have sprouted across the city. Over them all—and without comparison—soars the magnificent dome of St. Peter's. As the Russian writer Nikolai Gogol described it in *Rome*: "The majestic cupola of St. Peter's seems to get bigger the further away from it one gets, until it remains completely alone on the whole arc of the horizon, even when the city itself has disappeared."[2]

Never to See Florence Again?

When Michelangelo took over St. Peter's, he never imagined it as an obligation without end, nor as the reason he never again would see his native Florence. It took some years for him to recognize those sad realities.

When Michelangelo turned eighty-five in 1560, he had not visited Florence in more than twenty-five years, nor had he met his nephew's wife or their only male child, the sole heir of the Buonarroti bloodline. At Michelangelo's request, Lionardo visited Rome in April 1561.[3] It was the first time they had seen one another in five years; Lionardo had just turned forty and Michelangelo was eighty-six. Conscious that he was nearing the end of life, Michelangelo hoped Lionardo might return for a subsequent visit with his young son, Buonarroto, who was nearly eight years old.[4] Michelangelo began sending "two kisses" to little "Buonarotino."[5] After the birth of Lionardo's second son, in July 1562, Michelangelo asked whether the whole family, including his niece, Francesca, could visit Rome the following Lent.[6] Unfortunately, death arrived before the visit took place.

In the last three years of his life, Michelangelo wrote to Lionardo infrequently—there are just a dozen letters—and with ever greater brevity. On one, he merely signed his name to a letter written for him, advising Lionardo, "Don't be surprised if I don't write to you myself, because I'm an old man, as you know, and I cannot endure the fatigue of writing."[7] His affection for his nephew was undiminished, but age visibly unsteadied his hand. Increasingly, he relied on others to keep Lionardo informed, and in this task Michelangelo was well served.

The sculptor Tiberio Calcagni continued to loyally assist Michelangelo. Calcagni, who felt privileged to work for "this saintly man," genially referred to the aged artist as "il Vechio" or "Vechio nostro." Calcagni enjoyed speaking with him as they rode together to St. Peter's. He marveled at Michelangelo's robust health at age eighty-six, writing to Lionardo: "God be praised, he is extremely well for his age."[8]

Lionardo also received regular news of his uncle's health from Lorenzo Mariottini, who served as the artist's companion and personal secretary in his final years. Mariottini, a relative of Sebastiano Malenotti, is a mostly faceless but also selfless person: "I remain vigilant," he reassured Lionardo, "to make certain that nothing happens, either at his house or in his life."[9] He reminded Lionardo to write often and promised always to respond.[10]

One of Michelangelo's favorite evening walks was up the hill behind his house to Monte Cavallo. This was Colonna territory and the site of many happy hours spent with Vittoria Colonna and friends, now all dead or dispersed. There, on a late Saturday afternoon in March 1562, Mariottini encountered Michelangelo in company with some persons unknown to him; therefore, as he wrote to Lionardo, he did not extend his usual greeting, "God grant you a good evening." Rather, Mariottini assured Lionardo that he would see Michelangelo in church: "I will speak with him tomorrow morning at the Minerva," referring to the Dominican church of Santa Maria sopra Minerva. Like Calcagni, Mariottini was impressed by the artist's continued vigor: "It is enough that he is, for his age, extremely well."[11] The day before, the artist had turned eighty-seven.

Michelangelo could walk comfortably to Santa Maria sopra Minerva in about fifteen minutes. He may have gone every day, or at least frequently, since a month later, Mariottini again expected to see him at Mass "tomorrow morning," a Saturday.[12] When it became oppressively hot in the summer of 1562, Mariottini reminded Lionardo to send his usual shipment of white wine, "if it pleases God that we should live."[13] Once, Mariottini asked Lionardo to "send me some of that good Chianti wine when no one is looking," adding, "under the table" (*soto a la tavola*).[14] Michelangelo may have complained that he

no longer had friends with whom to share the wine, but clearly Mariottini took pleasure in the superior Tuscan vintage. Mariottini is the last in the long line of persons—Lionardo Sellaio, Giovanfrancesco Fattucci, Bartolommeo Angelini, Luigi del Riccio, Urbino, Sebastiano Malenotti, and finally Tiberio Calcagni and Daniele da Volterra—who acted as Michelangelo's personal assistants and generously offered him those things most cherished but rarely possessed by the elderly: time and companionship.

Once, in a drawn-out correspondence with Lionardo regarding the purchase of a new house, Michelangelo expressed some of his most tender feelings on the subject of his desire to return to Florence: "I wrote you in my last letter about a house, because, if I am able to free myself from my obligations before death, I would like to know that I have a nest just for myself and my brood [in Florence]."[15] The phrases used, *un nido* and *mia brigata*, suggest a profound desire to be reunited with his home and family—to return, as he admitted, to a "nest" and his second childhood (*rinbambito*). In March 1560, many persons assumed that Michelangelo would soon return to Florence. Benvenuto Cellini thought so: "In the last few days I have heard that you are certainly returning to Florence, which the whole city greatly desires, and especially our glorious Duke."[16] As we have seen, Cellini was one of several ambassadors enlisted by Cosimo de' Medici, the duke of Florence, in a sustained effort to lure the artist back to Florence. Cosimo was determined, but one might rightly ask: Why was the powerful prince of Tuscany so eager and deferential toward Michelangelo?

Michelangelo began his career in the bosom of the Medici. More than a half dozen members of that illustrious family had supported him and provided him with unprecedented opportunity. Michelangelo grew up in the household of Lorenzo "il Magnifico" and in the company of two Medici princes, the cousins Giovanni and Giulio de' Medici, who subsequently were elected popes (Leo X and Clement VII) and employed him over more than two decades. Even the current queen of France, Catherine de' Medici, continued to beseech him for a large and expensive equestrian monument. And, of course, he now served the current pope (Pius IV), yet another Medici. It was only

natural that Cosimo de' Medici would wish to add Michelangelo to his glittering entourage of artists, writers, and poets. An artist of Michelangelo's stature would certainly add luster to Cosimo's court.

In the last decade of Michelangelo's life, Cosimo made repeated overtures, even promising the artist a sinecure without obligation. The artist was sorely tempted, yet to every entreaty Michelangelo responded by declaring his "need to put my affairs in order."[17] By "his affairs," he increasingly meant St. Peter's. The full weight of the artist's obligation is sensed in a letter he wrote to Lionardo in 1557, a letter that he asked his nephew to read aloud to Cosimo:

> When he came to see me here in Rome about two years ago Messer Lionardo [Marinozzi], the agent of the Duke of Florence, told me that His Lordship would be greatly pleased if I were to return to Florence and he made me many offers on his behalf. I replied to him that I begged His Lordship to concede me enough time to enable me to leave the fabric of St. Peter's at such a stage that it could not be changed in accordance with some other design which I have not authorized. I have since continued with the said fabric, not having heard anything to the contrary, but it is not yet at the said stage. . . . I think it will be necessary for me to stay here for at least a year. For the love of Christ and of St. Peter I beg the Duke to concede me this length of time.[18]

In his personal life, Michelangelo was a persistent pessimist, yet when it came to his professional work, he was a perennial but unrealistic optimist. Michelangelo imagined one more year in Rome and then a happy return to his homeland. When he begged the duke to grant him time to complete his work, the artist indicated that he was not just building a church, he was working on behalf of Christ and Saint Peter. Seven years later, he died in Rome never having returned to Florence.

"I was put there by God"

Michelangelo's correspondence with Vasari and Cosimo is in striking contrast to his generally abbreviated, businesslike missives of these

years, and especially those mostly laconic letters directed to Lionardo about family matters and property investments. In one notable instance, however, powerful emotions spilled over in a candid and revealing letter to his nephew:

> Lionardo—I would rather die than be in disfavour with the Duke. In all my affairs I have always endeavoured to be true to my word, and if I have delayed in coming to Florence as I promised, I always had this proviso in mind, that I should not leave here until I had brought the fabric of St. Peter's to a stage at which my design could not be spoilt or altered nor an occasion given to thieves and robbers to return there and to thieve and to rob as they are wont, and as they are waiting to do. I have always been, and am, thus diligent, because many people believe, as I do myself, that *I was put there by God.*[19]

Esservi stato messo da Dio: it was an extraordinary admission to Lionardo, an extraordinary statement altogether. A more usual refrain followed: "Because I am an old man and have no-one to leave in my place, I have not wished to abandon it, and also because I serve for the love of God, in Whom is all my hope." Michelangelo wrote with such candor, in part, because Lionardo had been enlisted in the campaign to bring him home:

> Lionardo—In your last letter, as in others, you urge me to return to Florence, but I tell you that those who are neither within sight nor hearing of me do not know what my life here is like. So there's no need to tell me differently. I'm doing my best in the circumstances in which I find myself.
>
> As regards the exceeding courtesy, consideration and kindness of the Duke, I'm so overcome that I do not know what to say. I need Messer Giorgio Vasari to help me.[20]

Years earlier, in the summer of 1557, Michelangelo had been on the verge of taking up Vasari's kind offer to accompany the artist on the journey from Rome to Florence. But after nearly a quarter of a century in Rome, Florence may have become a foreign country to him. Thus,

despite the sustained assault on his emotions, Michelangelo resisted the temptation to return home.

It is astonishing—even something of a miracle—that Michelangelo succeeded in shaping Christianity's greatest church under such circumstances and at such an advanced age. He had expressed his belief that he was God's instrument shortly after returning from Monteluco, where his sense of divine purpose had been nourished during the weeks he spent in the woods, "attending to my devotions."[21] Given the importance of Saint Francis in Michelangelo's life, it is likely that the artist's stay in the Franciscan hermitage inspired thoughts of that saint and his mission to rebuild the church—metaphorically as well as literally, as Francis did at San Damiano in Assisi.[22] For Franciscans, the spiritual mission to "repair Christ's house" and the physical building of churches were related; this was a message and a mission that Michelangelo imbibed deeply.

Michelangelo's promise "not to fail St. Peter's nor to fail myself," expressed in a letter to Lionardo, was further encouraged by his friend Ludovico Beccadelli.[23] Although fully aware of the incomplete state of St. Peter's, back in 1556, addressing Michelangelo, Beccadelli had described the building as, "that magnificent temple . . . immortal creation of Your Lordship's divine virtue."[24] Beccadelli clearly realized, as did Michelangelo, that St. Peter's—whatever its physical condition—gave compass to the artist's life and endowed it with spiritual purpose. Aware of Michelangelo's sense of exile, Beccadelli wrote of his own diaspora: "As regards matters of the flesh, I am in exile; but with regards to the spirit, I thank God for having called me to his service."[25] While both friends felt themselves to be exiles, they nonetheless heeded God's call to service: "I serve for the love of God," Michelangelo wrote, "in Whom is all my hope."[26] Michelangelo declared more than once that he worked "for the love of God"; to abandon St. Peter's, he felt, "would be the cause of great ruin, a great shame and a great sin" (*sare' causa d'una gran ruina, d'una gran vergognia e d'un gran pechato*).[27] These were the reasons he repeatedly invoked to justify his perpetually delayed return to Florence, to well-deserved acclamation, to family and *nido*, and to a peaceful death.

While Michelangelo hoped that his devotion to St. Peter's would guarantee his personal salvation, he also worked for the greater glory of the Church—as he said, for "God and St. Peter." Michelangelo was indeed a servant, but to a higher purpose. Thus, he prayed that God would "help and advise me."[28] Giorgio Vasari ultimately came to understand better Michelangelo's final mission, and in the expanded, 1568 edition of the *Lives of the Most Excellent Painters, Sculptors and Architects*, he too linked God, Michelangelo, and St. Peter's when he wrote: "God, who looks after good men, favoured Michelangelo during his lifetime and never ceased to protect both him and St. Peter's."[29] This was a significant revision of tone and emphasis from Vasari's 1550 life of the artist, in which St. Peter's is barely mentioned.

Aside from the spiritual and salvific significance of St. Peter's, there still remained the practical matter of getting the church built. In letter after letter—to his nephew, to Giorgio Vasari, and to Cosimo de' Medici—the artist reiterated his commitment not to leave Rome, "until I had brought the fabric of St. Peter's to a stage at which my design could not be spoilt or altered."[30] He never again wavered from this resolve, which was as important to saving his soul as it was instrumental in shaping the future of the building. He expressed a similar sentiment even before Spoleto, writing to Vasari that he was committed "to work here on the fabric of St. Peter's until it had reached a stage at which it could not be altered."[31] Having heard this repeatedly from Michelangelo himself, Vasari, in the expanded 1568 edition of the *Lives*, paraphrased the artist's letters, writing that Michelangelo "continued working on various parts of St. Peter's, with the object of making it impossible to change what was done." Vasari continues by noting that, "for seventeen years, Michelangelo had devoted himself entirely to settling the essential features of the building."[32]

In the same manner that he addressed the figure in drawings and sculpture, Michelangelo concentrated on the building's torso, its anatomical center and structure; the rest was appendage. Thus, it mattered little that subsequent architects—most notably Giacomo della Porta and Carlo Maderno—deviated from Michelangelo's designs, since he had already fixed the principal form of the building's core: plan, space,

proportions. As Vasari clearly recognized, Michelangelo "settled and established the form of the building."[33]

Although Michelangelo's goal was to define the plan and essential features of St. Peter's, the slow pace of construction and the numerous setbacks meant that he could never completely free himself of the project. Thus, despite his express desire (in a letter to Cosimo de' Medici) "to return to Florence with a mind to rest there in the company of death," he never reneged on his commitment to St. Peter's.[34] The artist's beloved Dante (1265–1321), a fellow exile, may have offered some consolation. In Canto V of *Paradiso*, Dante has Beatrice address the poet's concerns about unfulfilled vows, which resonated with Michelangelo's regret for his many uncompleted tasks and unfulfilled promises. Beatrice assures Dante, "You have both Testaments, the Old and New, you have the Shepherd of the Church to guide you; you need no more than this for your salvation."[35] Christ was Michelangelo's shepherd and St. Peter's his salvation. Michelangelo may have taken further comfort from Cicero's essay on old age, *De senectute*, in which the aged Cato describes the elderly landowners planting and "working at things which they know they will not live to see." Cato then quotes the poet Caecilius Statius, who wrote: "He plants trees for the use of another age."[36] The best that Michelangelo could do was plant the seeds for another age—for a future St. Peter's. And he did. He truly believed that he was "put there by God." And he never left. But what could he realistically expect to accomplish in the little time remaining to him?

1560 to Death

Well into his eighties, and after repeated disruptions in his life and work, Michelangelo fully realized he could no longer control or do everything himself. Many days he felt too feeble to appear at the work site. Moreover, the micromanagement that characterized his earlier career was not a practical means of overseeing a project as large as St. Peter's, not to mention a half dozen other architectural sites scattered across Rome. Now, almost exclusively, Michelangelo came to depend upon the small group of trusted individuals who understood his vision

and directives. Those assistants and friends, including each of the successive overseers at St. Peter's, are the unsung heroes of Michelangelo's old age.

Michelangelo had lost his most reliable overseer when Sebastiano Malenotti departed Rome in 1557. Tiberio Calcagni was so busy in various capacities that in 1560, Michelangelo hired Cesare Bettini as chief overseer at St. Peter's.[37] Cesare was the son of Piero Bettini, who was a relative of Giulio Brunelli, the second husband of Urbino's widow, Cornelia Colonelli. Thus Cesare Bettini was yet another of nearly a dozen male and female assistants, servants, and companions from the small town of Casteldurante, birthplace of Michelangelo's faithful Urbino.[38] Bettini quickly became so busy at St. Peter's that Michelangelo sought to appoint an additional overseer, Pier Luigi Gaeta, to assist him in supervising aspects of the giant construction. Michelangelo made the case for hiring Gaeta in two letters to the deputies of the St. Peter's *fabbrica*:

> Lord Deputies—As I am an old man and as I see that Cesare [Bettini] is so occupied in discharging his own office at the fabric that the men often remain without supervision, I have thought it necessary to appoint Pierluigi [Gaeta] as his colleague, whom I know to be an honest and capable person suited to work at the fabric. Also, because he is accustomed to the work and lives in my house, he can explain to me in the evening what is to be done the next day.
>
> Will Your Lordships authorize the payment of his salary, beginning the first of this month, at the same rate as that paid to Cesare; otherwise I'll pay him out of my own pocket; because, knowing the needs and requirements of the fabric I am determined that he shall be there.[39]

Whether the *fabbrica* would cooperate with Michelangelo and hire his chosen assistant was soon overshadowed by a more immediate crisis. In August 1563, Tiberio Calcagni was in the midst of writing a letter to Michelangelo's nephew when he was interrupted by his brother Vincenzio, "who tells me that just now at St. Peter's, Cesare [Bettini] the *soprastante* was stabbed three times, and if he is not yet

dead, he soon will be, for he certainly will not live. [Vincenzio] doesn't know who did it, or why; it is enough that Bettini does strange things."[40] Calcagni had good reason to suspect that "strange things" lay behind the crime, and it soon emerged that Bettini had been stabbed repeatedly when he was surprised *in flagrante delicto* with another man's wife. A week later, Calcagni again wrote to Lionardo, offering further lurid details: "I have nothing else to write except to tell you about the death of Cesare, *soprastante*, who was found by the cook of the Bishop of Forli with his wife. The man stabbed Cesare thirteen times, and his wife four times." In a marvelous understatement, Calcagni added that "the old man [Michelangelo] is much distressed."[41]

Michelangelo was certainly upset by the violent murder of his assistant, but he was even more distressed with the deputies of St. Peter's. He had recommended that Pier Luigi Gaeta be appointed to fill Bettini's vacant position, but, influenced by the continued opposition of Nanni di Baccio Bigio, the deputies decided otherwise.[42] Michelangelo was incensed and frustrated; even after fifteen years as principal architect of the building, he was not given a free hand in appointing his own supervisors. For a month, Michelangelo refused to go to St. Peter's, until the pope himself entreated him to return to work in September 1563.[43] In the meantime, the little-known Pierluigi Gaeta was finally hired and served as Michelangelo's "agiente." He was "honest and capable," and because he lodged in Michelangelo's house, Gaeta could report to Michelangelo on a daily basis, and together they could decide what needed to be done the next day. In this way, work on St. Peter's continued long after the day laborers had been dismissed. Note that it was Gaeta who knew the "needs and requirements" of the building, and it was his responsibility to explain the day-to-day progress of work to Michelangelo, not vice versa.

So Little Time, So Tired

On March 6, 1563, Michelangelo turned eighty-eight. Now he rarely arrived at the building site before the workers. Moreover, he questioned whether he should go to St. Peter's every day while he also was

responsible for building projects elsewhere in the city. Should he ride out to see and advise the workers at the Porta Pia or Santa Maria degli Angeli, or should he just cross the neighborhood and take a look at the Capitoline Hill construction? If he did decide that St. Peter's required his presence, he generally arrived well after the overseers had given daily assignments to their respective teams. Although it was contrary to his preferred means of working, Michelangelo had to trust that he had placed competent overseers in charge of the day-to-day building operations.

Since he had entered his eighties, Michelangelo less frequently remained at St. Peter's for the full day. Many laborers took little notice of him. St. Peter's was a sprawling construction site, and much of the work was fairly routine, even monotonous: a lot of squaring and finishing of travertine blocks, almost endless laying of bricks and mortar. The bricklayers and stonemasons would have little reason to speak with Michelangelo, and the master had less reason and inclination to hover over their work (in contrast to the work carried out at San Lorenzo more than forty years earlier). In fact, he rarely made the climb to the upper reaches of the building. He tended to make the rounds, speaking with his *capomaestri*, and then generally disappeared into the Vatican Palace. And then there were days when Michelangelo was slow getting out of bed. Old age weighed heavily. More and more he depended on his trusted team of overseers.

On good days Michelangelo rose with the sun, at the same time work usually began at St. Peter's. He rarely ate anything in the morning, perhaps a leftover crust of bread with some watered-down wine. He spent a few moments in prayer, usually at nearby Santissimi Apostoli. Alongside the church stood the Della Rovere Palace, a reminder of an important patron and his problematic heirs. Yet, Pope Julius II had died a half century ago! Michelangelo rarely visited the pope's tomb in San Pietro in Vincoli. He had strength only for the work that remained naggingly unfinished.

Michelangelo often found respite at Santa Maria sopra Minerva. The Dominicans were punctual about morning devotions. Opposite his sculpture of the *Risen Christ* was the monument to the sculptor

Andrea Bregno (1421–1506), its inscription celebrating him as the new Polyclitus and as STATVARIO CELEBERIMO. Bregno had died at age eighty-five; he had lived nearly as long as Michelangelo. Would Michelangelo be remembered as a "celebrated" sculptor, or would anyone ever call him a modern Polyclitus?

Visiting Santa Maria sopra Minerva humbled him, because so many of his Florentine compatriots were buried there: Popes Leo X and Clement VII, as well as Lorenzo and Roberto Pucci, both of whom had helped the artist navigate the Julius tomb affair. Michelangelo had carved the four-figure *Pietà* as his grave monument, hoping to be buried here among friends and Florentine compatriots. But the sculpture was a ruin, and now it was gone. His friend Francesco Bandini recently had persuaded the artist to allow him to remove the wrecked sculpture from his studio, at no little effort. Almost immediately thereafter, Michelangelo began work on another marble, also intended to be a *Pietà*.

A Last Sculpture

Until just a few days before his death, Michelangelo worked on the so-called Rondanini *Pietà* (see plate 55), named for the palace of the Roman family in which it long stood before being acquired by the city of Milan in 1952. There is no indication that the sculpture was intended for anyone but the artist himself. Carving had become a form of prayer, a way of bringing the artist closer to God: salvation through creation.

The subject of the sculpture is difficult to describe. We call it a *Pietà*, but it is radically different from Michelangelo's other two versions of that subject and unlike anything else he ever made.[44] Mary stands on a rock and embraces, but scarcely supports the weight of, her son. Defying both logic and gravity, the figures are suspended in a timeless moment. The semi-standing pose and unfinished character of Christ lend him greater animation than might be expected from a slumping, lifeless body. His head turns, and at least one eye appears to gaze toward his mother's hand, which rests on his shoulder. The forms fuse. Mary and Christ, once of one flesh, have become so once again.

Looking at the sculpture less poetically and less forgivingly, one sees that Michelangelo had too little stone remaining to fully form the figures. He carved and recarved, removing one idea after another, as he cut deeply into the tall, thin block. Evidence of multiple iterations is most obvious in the detached stalk of Christ's right arm. A remnant of an earlier composition, this haunting fragment attests a once larger, more muscular body. Without this ghostly truncation—a moving testimony to the artist's relentless assault on the block—the viewer might never imagine that Michelangelo made so many radical changes. He kept carving but never finished, confronted by the unavoidable paradox of representing spiritual matters in material form.

A side view of the sculpture reveals the extent of Michelangelo's excavation into the stone (see plate 56). The abstracted figures might suggest a sculpture by Constantin Brancusi or a rising flame-like form that metaphorically offers hope of resurrection. We are attuned and appreciative of such radical abstraction, but the artist surely saw the son of God and a mother's unimaginable loss.

Every blow of the hammer was a further laceration of Christ's flesh. In anguish, Michelangelo admitted a profound sense of futility in making art: "No one has full mastery before reaching the end of his art and his life."[45] But now Michelangelo *was* at the end of life and *still* he did not have full mastery.

This sculpture was even more disappointing than the broken *Pietà* he had given to his friend Francesco Bandini. Neither could be finished, and neither was suitable as a grave marker for display in a church. Having twice failed to carve a grave memorial, Michelangelo could hardly avoid wondering whether he would be forgotten soon after his death. He even wondered whether he was still Florentine, now that he had spent the majority of his life in Rome.

How distracting these reveries were; how much work time he lost thinking of things beyond this world. Michelangelo came out of Santa Maria sopra Minerva under the dreary, overcast sky of a fall day. With his already slowed steps, he passed the Medici Palace at Piazza Navona. As did many sites throughout the city, the building elicited memories of the past. Some were pleasant, some painful. At times, he re-

called his halcyon days as a youth in Lorenzo de' Medici's Florence; at other times he reflected on the Medici of today: tyrants who persecuted and exiled many of his friends. Michelangelo had no desire to be entangled in politics. Given that Cosimo had shown him great deference, there was no reason to compromise that tenuous relationship, especially since Michelangelo still longed to return home. Muddled emotions: he no longer was capable of or willing to sort them. In about an hour, or forty-five minutes—depending on the length of his morning prayers, the slowness of his gait, and other distractions—he arrived at St. Peter's. There was much to be done.

The Walk Home

At the end of the day, the walk home was even slower. Michelangelo was tired, stopped more frequently, and contemplated the end of life: "My shuffling steps, taken with so much effort, are slow in one so loaded down with years."[46]

The beginning of his route, to Ponte Sant'Angelo and down the broad central street of the Florentine quarter, retraced the steps he had taken in the morning. Inevitably, he passed the Strozzi Palace—not without thoughts for a family that had been so important to his career and the advancement of his family, especially his beloved brother Buonarroto. Why, Michelangelo occasionally wondered, was he still alive when his younger brother had already been dead for some thirty-five years? Despite the *bando* against the exiled Strozzi, Michelangelo felt deep affection for the many years he had been associated with the family.

In the evening, instead of turning into the Via del Governo Vecchio, Michelangelo preferred to walk along an alternative route, the Via dei Banchi Vecchi, because that street offered some wine shops he favored. He never drank much, but at the end of the day, he enjoyed sitting for a while among those who did. Of course, he could have ridden to St. Peter's—as he sometimes did; it all depended on how he felt. The slow, clumping rhythm of his horse actually helped relieve the pain of kidney stones. But if the weather was nice, he enjoyed the walk, especially

in the evening when there was no hurry to return to his mostly empty house. Since Urbino's death and Cornelia's return to Casteldurante, Michelangelo often had no one with whom to share a meal or conversation. There were, of course, his illiterate servant and cook, but they were generally sullen companions. Pier Luigi Gaeta and Daniele da Volterra were much better company. But these busy *capomaestri* would not return from work until well after Michelangelo had taken his modest supper. At least he could look forward to Sunday, when a friend or two would stop by for a laugh and a glass of wine. The cheap wine he was now drinking in a dank hole on Via del Pellegrino was nothing like the smooth Trebbiano sent by his nephew; in fact, this swill was pretty dreadful stuff—probably from Abruzzo. *Ma che*—

Continuing his slow walk, Michelangelo passed the palace of Cardinal Raffaelle Riario—long dead. He recalled his first days in Rome, now more than sixty years ago. Those were heady times, although disappointing, because the cardinal had failed to appreciate his *Bacchus*. On the side street along the Riario Palace, small spaces were rented to merchants and prostitutes, but Michelangelo could not imagine passing time in such fetid hovels. After all, he once strutted in the great hall of the illustrious cardinal.

Despite the numerous efforts by reform-minded popes, Rome was unable to escape its reputation as a city of sin. As one English visitor wrote, "It's abysmal / everywhere I go in Rome. There are whores / who beckon bold as brass from open doors / winking, leering, and ready to jump my bones."[47] When Michelangelo, a wizened old man, was propositioned by a leering whore, he hurried his pace, passing through the still-crowded market stalls in the Campo de' Fiori.

He enjoyed the smaller streets beyond, for here lived the craftsmen who plied their trades—woodworkers, ironmongers, barrel makers, the specialists who fashioned keys, hooks, nails, and all kinds of tools such as were needed at St. Peter's—and of course the forgers of money and clippers of coins. Michelangelo particularly liked the aromatic smells of fresh shavings and burning wood along the woodworkers' eponymous street, the Via dei Falegnami. Because they were poor, they worked late into the evening. Shortly beyond the church of the rope

Via dei Falegnami (Street of the Woodworkers), Rome

makers—Santa Caterina dei Funari—he emerged from the dense warren of streets into the wretched neighborhood at the foot of the Capitoline Hill.

This inevitably was a depressing moment, not because Michelangelo was among the destitute but because he was confronted by his mortality. The Campidoglio (see plate 57) was the first great architectural commission Pope Paul III assigned to him, back in the 1530s. While this important civic project had been dear to Paul, it was of much less concern to subsequent popes, who had little interest in funding this rival symbol to papal authority. Thus, although it was Michelangelo's longest outstanding architectural commission, the Capitoline project suffered most, from politics, inertia, entangled bureaucracy, and lack of funding. It constantly reminded him that he was just an artist, with little control over the commissions he had been asked to undertake. Moreover, and more sadly, passing by the Capitoline Hill always reminded him of Paul, the patron and friend with whom he once shared excellent Tuscan wine and succulent pears.

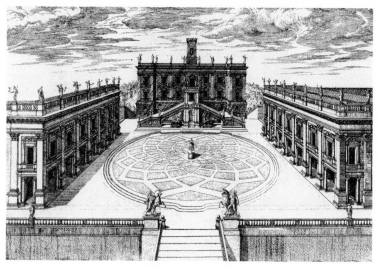

Etienne DuPérac, Engraved image of the Campidoglio, 1569.
Washington University, St. Louis

Early in Paul's pontificate, Michelangelo had positioned the ancient equestrian statue of Marcus Aurelius on the piazza at the top of the hill, at the center of what he and the pope envisioned would be the greatest urban renewal project since Roman antiquity. Michelangelo thus initiated the rebirth of Rome's magnificent center on the most important of the city's seven hills. Toward this end, he even managed to transport two monumental ancient river gods from the Quirinale to the Capitoline Hill—no easy task, given the muddy, rutted lanes winding down one hill and up the next.

All this effort amounted to little. More than thirty years later, the Capitoline was still far from complete. There was no facade on the Palazzo Senatorio. No entrance ramp (*cordonata*) led to the still-unpaved piazza. Only three of seven bays of the Palazzo dei Conservatori were under construction at the time of Michelangelo's death, and its mirror building, the Palazzo Nuovo, was not even begun until 1603.[48]

No matter which route he took in returning home from St. Peter's, Michelangelo would pass the Capitoline Hill. It was a constant reminder of the molasses-like pace of architectural construction.[49] Look-

ing up at the unimpressive buildings that crowned the hill (see plate 58), the artist had little desire to see whether there had been any progress at the construction site. He did not want to know whether Tommaso de' Cavalieri—one of the two deputies in overall charge of the project—was too busy with other duties to pay the project much attention. Long ago, he had realized the near impossibility of achieving one's vision, even if you lived a long life. He had learned to live with incomplete buildings, hoping that others would carry forward his design after his death. The Campidoglio, San Giovanni dei Fiorentini, the Sforza Chapel, Porta Pia, Santa Maria degli Angeli, and New St. Peter's—all would be left incomplete, like so many of his sculptures.

He knew better than to be discouraged. The Campidoglio was far from what he imagined, but on-site were good young architects, like Giacomo della Porta, who understood the design and would continue the work, especially if the longtime *capomaestro* Benedetto Schela remained on the project. And besides, after the long walk from St. Peter's, he was simply too tired to dwell on unfinished projects. Instead, he stepped into the nearby church of San Marco to hear vespers. Darkness was falling, and this was a neighborhood where cutthroats and toughs looked for easy marks. As the Roman satirist Juvenal had warned, "He who goes out at night goes to his death."[50] It was still true fifteen hundred years later. After all, Michelangelo lived on the edge of the Suburra, which was just the sort of poor quarter that might have inspired Juvenal's admonition.

Michelangelo had no intention of being caught by the dark, even though many of his younger assistants and housemates would stay out carousing on this Saturday night. The artist felt his years, and suddenly he found himself hobbled, walking with a bit of a limp. On arriving home, he sat in the dark entrance hall to replace his worn, muddy boots with his soft leather slippers, all the while muttering to the skeleton he had sketched on the wall. He had written some time ago to his nephew, and he felt the sentiment more frequently these days: "I am old and full of confusion."[51]

His aged housekeeper had cooked him a *zuppa di faro*, which he found in a clay pot on the hearth, still warm. It had been a long day,

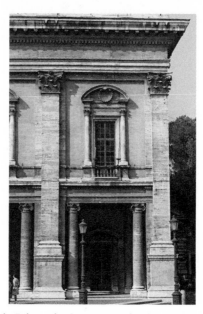

Michelangelo, Palazzo dei Conservatori, detail, Campidoglio, Rome

and tomorrow, as always, was uncertain. On an odd piece of paper he wrote, "Death is the end of a long prison."[52]

Illness and Death

As Michelangelo gradually shrinks from our view, his rasping voice remains strong though less frequently heard. At home were Pier Luigi Gaeta, the overseer of St. Peter's, finally confirmed by the *fabbrica*, and a coterie of loyal servants, mostly drawn from the ranks of the late Urbino's extended family from Casteldurante. In addition, his inner circle of friends frequented the house and looked after the artist: Tiberio Calcagni, Daniele da Volterra, Tommaso de' Cavalieri, and Lorenzo Mariottini.

In December 1562, Michelangelo fell ill with a fever, but then again, so did three-quarters of Rome.[53] He was better in early January, and he went riding to take some fresh air. Because it was still cold, Lionardo was asked to send some black cloth for a new overcoat, with the

instruction, "don't pay any attention to the cost."[54] Riding was considered good for one's health, and Michelangelo made it a regular evening habit whenever the weather permitted. Many years earlier, his friend Sebastiano del Piombo had advised riding for good health.[55]

Toward the end of January 1563, after being away from St. Peter's for many days, Michelangelo went to check on the site's progress.[56] The prospect of an imminent visit from Lionardo, even though previously suggested by Michelangelo, suddenly was too much to contemplate: "It would do nothing but add vexations to my worries for the time being."[57] The letters written by his friends painted a less gloomy picture, and one of Lionardo's letters even caused the artist to laugh aloud.[58]

One Sunday afternoon in July 1563, the artist passed a few delightful hours with Tiberio Calcagni and Pierantonio Bandini, the son of his recently deceased friend Francesco Bandini.[59] Calcagni reported the pleasant visit to Lionardo, mentioning that Michelangelo was working on a small wooden crucifix, evidently intended as a gift for his nephew.[60] Earlier in the spring, Cosimo de' Medici had given his blessing to the founding of the Accademia del Disegno, in Florence, and Michelangelo had been honored to be elected "head, father, and master of all." The election prompted Vasari to write yet another extravagant letter encouraging Michelangelo's return to Florence.[61]

Writing proved difficult, and the artist apologized for not answering letters.[62] At one point, Lionardo was misinformed that Michelangelo's housemates had been mistreating him. In a hand that is shaky but remarkably controlled, Michelangelo let Lionardo know the situation, in no uncertain terms:

Lionardo—I see from your letter that you are lending credence to certain envious rascals who, being unable to manage me or to rob me, write you a pack of lies. They are a lot of sharks [*una brigata di ghioctoni*] and you are such a fool as to lend credence to them about my affairs, as if I were an infant. Spurn them as envious, scandalmongering, low-living rascals.

As regards allowing myself to be looked after, about which you write me, and about the other thing—I tell you, as to being looked

after, I could not be better off; neither could I be more faithfully treated and looked after in every way. As regards my being robbed, which I believe you mean, I assure you I don't need to worry about the people I have in my house, whom I can rely upon. Therefore look after yourself and don't worry about my affairs, because I know how to look after myself, if I need to, and I am not an infant [*non sono un pucto*].[63]

Fiercely independent and crusty as usual, Michelangelo was still creative in turning a colorful phrase. He was old and much beholden to his loyal household, but he certainly was not senile. His friends kept a close watch on his health. Word continued to be encouraging: he was well (*sta bene*) in October, and very well (*sta benisimo*) in November and December. At the end of December, Michelangelo wrote to thank Lionardo for twelve "most excellent and delicious cheeses." Even at eighty-eight years old, the cramped hand is still remarkably clear:

I'm delighted at your well-being; the same is true of me. Having received several letters of yours recently and not having replied, I have omitted to do so, because I can't use my hand to write; therefore from now on I'll get others to write and I'll sign. I think that is all. From Rome on the 28th Day of December 1563.[64]

This was the last of more than two hundred letters that Michelangelo wrote to his nephew; indeed, it is the last letter he ever wrote. Lionardo heard nothing from Rome throughout January 1564. On Saturday, February 12, Michelangelo worked all day on his feet, carving the Rondanini *Pietà*.[65] He was just three weeks shy of turning eighty-nine. But suddenly he was struck by fever and visibly began to fail. Just two days later, Calcagni wrote to Lionardo:

I wanted to inform you that as I was going about Rome today, I heard from many persons that Michelangelo was ill. I went immediately to visit him and although it was raining he was out walking. When I saw him I said that I did not think it was a good idea to be out in such weather. "What do you want me to do? I am not well and I cannot find peace and quiet anywhere." I have never before feared for his life but

with his uncertain speech and look, I was suddenly afraid that he had little time left. However, one must not despair, for God in his grace may yet grant him a little time. . . . At least this letter is not an ambassador of bad news.[66]

Calcagni advised Lionardo to hurry to Rome. The same day, Daniele da Volterra, writing to inform Lionardo that his uncle was asking for him, repeated the request three or four times, adding, "I beg it of you." Weakly, Michelangelo signed after Daniele's name. The letter was enclosed in another from Michelangelo's new friend, the Sienese sculptor Diomede Leoni, who was somewhat less urgent in calling for Lionardo's immediate departure for Rome:

> You will learn from the enclosure how ill he is, and that he wants you to come to Rome. He was taken ill yesterday. I therefore exhort you to come at once, but do so with sufficient prudence. The roads are bad now, and you are not used to travel by post.

Leoni continued:

> I left him just now, a little after 8 P.M., in full possession of his faculties and quiet in his mind, but oppressed with a continued sleepiness. This has annoyed him so much that, between three and four this afternoon, he tried to go out riding, as his wont is every evening in good weather. The coldness of the weather and the weakness of his head and legs prevented him; so he returned to the fireside, and settled down into an easy chair, which he greatly prefers to bed.[67]

Leoni assured Lionardo that he, Tommaso de' Cavalieri, Daniele da Volterra, and Michelangelo's servant Antonio were in constant attendance upon his uncle. And so were two doctors who prescribed a fantastic array of medicines—mainly purgatives, expectorants, and various decoctions that Michelangelo took every day. Some were benign, such as the carafe of sweetened water with sage and the lozenges to suppress coughing. Others must have been less helpful, such as the crushed pearl in sugared rosewater—a special and expensive remedy prescribed to important persons, including Lorenzo de' Medici on his

deathbed.[68] The pearl concoction and daily syrups did little for the failing man. On February 17, Calcagni urged Lionardo:

This is to beg you to hasten your coming as much as possible, even though the weather be unfavourable. It is certain now that our dear Messer Michelangelo must leave us for good and all, and he ought to have the consolation of seeing you.[69]

It was too late; Michelangelo died the following evening, between four and five in the afternoon. Leoni again wrote to Lionardo:

He died without making a will, but in the attitude of a perfect Christian, this evening, about the Ave Maria. I was present, together with Messer Tommaso dei Cavalieri and Messer Daniele da Volterra, and we put everything in such order that you may rest with a tranquil mind. Yesterday, Michelangelo sent for our friend Messer Daniele, and besought him to take up his abode in the house until such time as you arrive and this he will do.[70]

No final words were recorded, but Daniele da Volterra offered a few more particulars about Michelangelo's final illness in the account he wrote a month later to Giorgio Vasari:

When he became ill, which was the Monday of carnival [February 13], he sent for me, such being his habit whenever he felt unwell, and I let Messer Federigo di Carpi [one of the doctors] know and he came at once pretending that it was by chance. When he saw me he said: "Oh Daniello it is over with me, I beseech you do not leave me." He made me write to Messer Lionardo his nephew that he might come, and he told me that I must wait for him in the house and on no account to leave. So I have acted, although I felt myself more ill than well. His illness lasted five days, on two he sat up by the fire, for three he lay in bed, he expired on Friday evening, as we may certainly believe in peace with God.[71]

Michelangelo died peacefully, in God's good graces and with the sacraments of the church that were so important to him.

EPILOGUE

St. Peter's is Michelangelo's greatest achievement. He devoted more time, effort, and expertise to this than to any other project of his career. The church, the artist declared, was his best hope for salvation and the forgiveness of his sins. He recognized the brilliance of Bramante's initial conception and corrected its engineering deficiencies, thereby reinvesting the church with exterior and interior clarity. He had the courage and vision to remove much intervening construction, which demanded enormous faith on the part of both the artist and a succession of papal patrons. In just seventeen years he corrected what had gone before and largely shaped what came afterward. Despite changes inflicted on the building during its 150-year construction history, St. Peter's is Michelangelo's creation and his masterpiece.

From the outside, the church is a compact sculptural mass; inside it is a luminous, expansive, uplifting space. The building rises from ground to lantern in one continuous sweep. The vertical ascent is so majestic that only the substantial attic and emphatic cornices counteract the upward surge. The dome both continues and concentrates these vertical forces. Although he did not live to see it built, the dome is the centerpiece and culmination of Michelangelo's compact design. Its soaring magnificence dominates the skyline of Rome in a manner that its ancient predecessor—the Pantheon—never has. Michelangelo died deeply uncertain of his accomplishment, yet he did, in fact, succeed in

bringing the building "to a stage at which my design could not be spoilt."

How many persons die before completing their life's most important work? Michelangelo was painfully aware that his final project was yet another unfinished work. But while his life's journey was ending, his greatest masterpiece was just coming into being. St. Peter's is his crowning achievement as well as the most prominent symbol of papal authority and the universal Church. While the artist is not buried there, the church is in many respects the artist's lasting memorial.

It is a general perception that Michelangelo was less prolific toward the end of his life, that there is no equivalent production to match the *Bacchus*, the Rome *Pietà*, the *David*, the *Moses*, and the Sistine Ceiling, much less the Medici Chapel, Laurentian Library, and his more than two dozen other marble sculptures, all produced in the first half of his career. I contend that we have been seduced by the myth of the young and heroic Michelangelo.

In his final eighteen years, between the ages of seventy and eighty-eight, Michelangelo installed the monumental Julius tomb; carved the *Rachel*, *Leah*, *Brutus*, and two *Pietà* sculptures; and painted two giant frescoes in the Pauline Chapel. He learned to extend himself by making drawings that artist friends, such as Marcello Venusti and Daniele da Volterra, then transformed into finished works. And as architect to a succession of five popes, he designed a half dozen building projects and acted as adviser on dozens of sculptural, architectural, and archaeological undertakings around Rome. And he built New St. Peter's. Indeed, I would argue that in his final years, Michelangelo was busier than at any time in his career. But he was a different artist—no longer a creator of single-author works that astonished the world. His prodigious creativity operated through others; therefore, he was able to transform the city of Rome, but more importantly, he transformed the professions of artist and architect.

In late life, Michelangelo was less concerned with creating the unique works that propelled his rise to fame than with finding the courage and devotion to continue tasks that he knew he would never

see to fruition. He persevered despite the loss of his closest friends, greatest patron, and his entire immediate family. By gaining the trust of patrons, influential friends, handpicked supervisors, and younger artists sensitive to his intentions, Michelangelo ensured the eventual completion of his many projects, even long after his death. His authorship is not dependent on how many bricks and travertine blocks were laid in his lifetime, but on the clarity and compelling character of his conceptions. Thus, we rightly give Michelangelo credit for the Campidoglio, the Porta Pia, Santa Maria degli Angeli, the Sforza Chapel, and, of course, New St. Peter's. His authorship and influence were much broader than the paintings, sculptures, and buildings he made or designed with his own hand. What most distinguishes Michelangelo's late life are the number of projects for which he assumed creative responsibility and the much greater number with which his name is associated. Thanks to what he accomplished in his final years, Rome once again could claim its place as *Caput Mundi.*

NOTES

Introduction

1. See Wallace 1994a.

2. *On Artists and Art Historians*, 145.

3. Orlofsky.

4. E.g., Fremantle; Acidini Luchinat 2013. In his essay "Literature and Biography," Boris Tomaševskij writes: "Thus the biography that is useful to the literary historian is not the author's curriculum vitae or the investigator's account of his life. What the literary historian really needs is the biographical legend created by the author himself. Only such a legend is a 'literary fact'" (*Authorship*, ed. Burke, 89).

5. Elliott, xi.

6. Holmes 1993, 229. Equally pertinent are Holmes's reflections on the nature and practice of biography, which is a process that "has two main elements, or closely entwined strands. The first is the gathering of factual materials, the assembling in chronological order of a man's 'journey' through the world—the actions, the words, the recorded thoughts, the places and faces through which he moved: the 'life and letters.' The second is the creation of a fictional or imaginary relationship between the biographer and his subject; not merely a 'point of view' or an 'interpretation,' but a continuous living dialogue between the two.... It is fictional, imaginary, because of course the subject cannot really, literally, talk back; but the biographer must come to act and think of his subject as if he can" (Holmes 1985, 66).

I first encountered the effective use of fiction to illuminate history in Diane Favro's brilliant book *The Urban Image of Augustan Rome*, in which an early and a final chapter are devoted to an imagined walk through the city, permitting the reader to "view" and experience the transformation of Rome during the reign of Augustus.

Chapter 1: Moses

1. For the inventory of Michelangelo's house and goods, see Gotti, 2:148–56, and for an English version, see Beck, 220–25. The property belonged to Michelangelo as part of an arrangement made in 1532 with the heirs of Pope Julius II; see Hatfield, 98–103.

2. *Ricordi*, 331. Vincenza's brother, in fact, was Jacopo Rocchetti (c. 1535–1596), who subsequently developed a close artistic relationship with Michelangelo.

3. Girardi no. 267.

4. Masi 2008.

5. A. Forcellino, 218–23.

6. *Carteggio* 4:196 (before January 25, 1545).

7. The Florentine *Pietà* is a larger block, but Michelangelo had not yet begun that sculpture.

8. Vasari/Bull, 345.

9. According to Giuliano's son, Francesco da Sangallo; see Fea.

10. Contemporaries marveled at the mountain of marble that arrived in Rome for the tomb (Condivi/Bull, 25). On the tomb, see Tolnay, *Michelangelo*, vol. 4; Frommel 1977; Echinger-Maurach; Frommel 2016.

11. Condivi/Bull, 24–25. Also related by Vasari (Vasari/Bull, 343).

12. Elam 1998, 492–93.

13. *Carteggio* 4:128–29.

14. *Carteggio* 4:106.

15. *Carteggio* 4:151; trans. Ramsden 2:27.

16. Condivi/Bull, 53.

17. *Contratti*, 52–53.

18. *Ricordi*, 304; see also *Carteggio* 4:133–34, as well as the accounting of these costs in a letter to Pope Paul III on July 20, 1542 (*Carteggio* 4:135). Excellent photographs are found in Frommel 2016.

19. Moreover, the architecture of the upper part of the tomb cost nearly double the more richly decorated lower level (Frommel 2016, 63).

20. Freud.

21. Bober and Rubinstein, 55.

22. Barolsky 1994, 5–9; Barolsky 2001.

23. Palladio at least made the trek to San Pietro in Vincoli. In his *Description of the Churches of Rome*, published in 1554, he wrote: "There is also a marble Moses below the sepulcher of Julius II, carved with wonderful skill by the consummately divine Michelangelo" (*Palladio's Rome*, 143).

Chapter 2: Friends at Seventy Matter More

1. As he stated in December 1546: "Mi son sempre ingegniato di risuscitar la casa nostra" (*Carteggio* 4:249).

2. Wallace 1994b.

3. *Ricordi*, 307–9.

4. On Michelangelo's relationship with Luigi del Riccio, see Steinmann 1932; Frommel 2007; Wallace 2014a. For the artist's relationship with the Florentine exile community, see Papini q.v.

5. *Carteggio* 4:279; trans. Ramsden 2:82.

6. *Carteggio* 4:142. As Michelangelo wrote to Luigi, "io vi mando un sacho di carte scricte" (*Carteggio* 4:141).

7. *Carteggio* 4:236. On property investments, see *Carteggio* 4:234, and Hatfield. Regarding the tomb, see *Carteggio* 4:199–200 and 201–2, based on a draft by Michelangelo (*Carteggio* 4:198).

8. *Carteggio* 4:176; trans. Ramsden 2:39.

9. E.g., *Carteggio* 4:210–11; see also *Carteggio* 4:225 and 226 (which is mostly in Del Riccio's hand).

10. "Io sono tutto vostro, come sapete" (*Carteggio indiretto* 2:28).

11. *Carteggio* 4:130–31; trans. Ramsden 2:16.

12. *Carteggio* 4:133–34.

13. *Carteggio* 4:222 and 223.

14. *Carteggio* 4:222.

15. *Carteggio* 4:223.

16. *Carteggio* 4:196.

17. *Carteggio* 4:196.

18. *Carteggio* 4:142. It was with evident regret that Michelangelo turned down such kind invitations, once apologizing to his friend and commending himself to Del Riccio's beloved nephew, Cecchino Bracci (*Carteggio* 4:164).

19. See Wallace 2005.

20. *Carteggio indiretto* 2:13, 14, 15–16.

21. *Carteggio* 4:233; trans. Ramsden 2:51.

22. See Smith, 121–26, and Wallace 2014a.

23. *Carteggio* 4:220.

24. *Carteggio* 4:144–45; trans. Ramsden 2:23.

25. Saslow no. 132.

26. *Carteggio* 4:177; trans. Ramsden 2:35.

27. *Carteggio* 4:120–21; Ciulich 1989, 64–68; a color reproduction of this sheet is found in *Michelangelo: Grafia e biografia*, cat. no. 40.

28. Saslow no. 149; see also no. 159.

29. Gouwens, 55.

30. See especially the laurel-wreathed sultry-eyed figure imagined by Jules Joseph Lefebvre, for which see Crescentini, 62. See also Østermark-Johansen, chap. 3.

31. *Carteggio* 4:102.

32. Condivi/Bull, 52; Vasari/Bull, 376.

33. *Carteggio* 4:101.

34. *Carteggio* 4:102–3; trans. Ramsden 2:4–5. On Michelangelo as a letter writer and master wordsmith, see Parker 2010.

35. "... il quale, certamente ha crucifixe nella memoria mia quante altre picture viddi mai" (*Carteggio* 4:104).

36. "Io l'ho ben visto al lume et col vetro et col specchio, et non viddi mai la più finita cosa" (*Carteggio* 4:104).

37. *Carteggio* 4:101.

38. *Carteggio* 4:169.

39. See Cambon; Prodan.

40. Nims no. 159.

41. Nims no. 159.

42. Nims no. 164.

43. Nims no. 237; Gilbert, *Complete Poems* no. 237.

44. Nims no. 240.

45. Saslow no. 241.

46. Nims no. 166.

47. Modersohn-Becker, 237.

48. Michelangelo described the book to his nephew as, "un Librecto in carta pecora, che la mi donò" (*Carteggio* 4:361). A Vatican Library manuscript (Cod. Vaticano Latino 11539), containing 103 neatly written poems, has been identified as the book given to Michelangelo; see Vecce; Scarpati 2004; Scarpati 2011; Brundin 2005; and Brundin 2008, esp. chap. 3. On the importance of the two friends exchanging gifts, see Nagel 1996 and Nagel 2000, esp. chap. 6.

49. *Carteggio* 4:361.

50. The poems intended for publication have been identified by Carl Frey; see Frey no. CIX, pp. 112–207, recently edited, with commentary, for which see *Rime e lettere di Michel-*

angelo Buonarroti, and translated as an intact collection by Sydney Alexander (Alexander nos. 113–210, pp. 141–239). For a reconstruction of the collection, see Corsaro; Fedi. For some of the editorial manipulation, see Saslow 2013, and for the essentially inchoate state of the unfinished project, see Campeggiani 2015.

51. In a letter of Benedetto della Croce to Pier Luigi Farnese: "Hora che è morto Luigi del Riccio, che governava tutte le sue cose, li pare essere impaniato di sorte che non sa che si fare se non disperarsi" (Steinmann 1932, 28).

52. Cavalieri's marriage contract with Lavinia della Valle was signed in December 1544. He was active in civic government from 1539. In 1546, he served as *consigliere*, that is, as a member of the city council/senate, and he was probably also a member of the Società dei Raccomandati del Santissimo Salvatore di Sancta Sanctorum, an exclusive society to which the Cavalieri family belonged. My thanks to Maria Ruvoldt for this information.

53. *Carteggio* 4:233; Saslow no. 171.

54. The first printed but much bowdlerized selection of Michelangelo's poetry was published by the artist's grandnephew, Michelangelo the Younger, in 1623. For this history, see Saslow, 53–61.

55. "Io son vechio, et la morte m'ha tolti i pensieri della giovanezza" (*Carteggio* 4:258; trans. Ramsden 2:72). Further, Michelangelo wrote: "I go on as usual, bearing with patience the failings of old age" (*Carteggio* 4:344; trans. Ramsden 2:120). In the course of a single letter, written when he was sixty-seven years old, Michelangelo first reports that he is "vecchio" and then later in the same missive he is "molto vecchio" (*Carteggio* 4:135–37).

56. Saslow no. 295; Wallace 2015, 8–9.

57. Saslow no. 295. Oscar Schiavone notes that *morte* appears with an insistence throughout Michelangelo's poetry, including 152 times in the *canzoniere* (Schiavone, 75). See also Clements, esp. chap. 17, 287–97: "Old Age, Approaching Death, and Renunciation"; and Masi 2015, 43–45.

58. "il Cristiano si tenga giusto solamente per la fede di Cristo" (Benedetto da Mantova, *Beneficio*, 35); "Questa immense benignità di Dio" (Benedetto da Mantova, *Beneficio*, 22). On the importance of the *Beneficio*, see Moroncini, and Ginzburg and Prosperi.

59. "questa dolcissima predestinazione" (Benedetto da Mantova, *Beneficio*, 69). See Brundin 2008; Prodan, part 2.

60. "Tutti noi, che crediamo in Iesù Cristo, siamo figliuoli di Dio, secondo che dice san Paulo" (Benedetto da Mantova, *Beneficio*, 72).

61. Benedetto da Mantova, *Beneficio*, 77.

62. MacCulloch, 233.

63. Firpo 2015, 62.

64. Reforming tendencies extended to every major city in Italy, and to every social class, from noblemen to merchants, grocers, cobblers, and weavers, "all bound together by a sense of community, who passed from hand to hand books by Luther, Melanchthon, Zwingli, Bucer, Curione's *Pasquino in estasi* and unpublished works by Juan de Valdés" (Firpo 2015, 84). On Michelangelo and his relations to the Spirituali, see Firpo 1988; M. Forcellino; Barnes; Prodan; Moroncini.

65. Firpo 2015, 166; MacCulloch, 226–33.

66. *Carteggio* 5:35–36.

67. See my essay for the exhibition catalogue of Michelangelo drawings in Budapest, "Michelangelo's Late Drawings," *Triumph of the Body: Michelangelo and Sixteenth-Century Draughtsmanship* (Budapest, 2019), 89–109.

68. *Carteggio* 4:229.

69. *Carteggio* 4:237.

70. *Carteggio* 4:276.

71. *Carteggio* 4:289; trans. Ramsden 2:86.

72. *Carteggio* 1:93–94, and *Carteggio* 1:95–96; trans., Ramsden 1:52. On Michelangelo's relations with his brothers, see Wallace 2016.

73. *Carteggio* 4:290.

74. *Carteggio* 4:289; Ramsden 2:86.

75. *Carteggio* 4:290; trans. Ramsden 2:87; see also *Carteggio* 4:291, 292.

76. *Carteggio* 4:290.

77. Saslow no. 151. On the famous sonnet, see Panofsky, chap. 7; Blunt, chap. 5; Summers 1981, esp. chap. 14; Mendelsohn; Agoston; Wallace 2008.

78. *Carteggio* 4:257–58; trans. Gilbert, *Complete Poems* 285.

79. *Carteggio* 4:257–58; trans. Gilbert, *Complete Poems* 285.

80. *Carteggio* 4:265–66; trans. Ramsden 2:75.

81. *Carteggio* 4:265–66; trans. Ramsden 2:75.

82. *Carteggio* 4:265–66; trans. Ramsden 2:75.

83. *Carteggio* 4:260.

84. *Carteggio* 4:260.

85. Saslow no. 274. For an illustration of the fragmentary letter and poetic verses, see Tolnay, *Corpus*, no. 424v.

86. Saslow no. 272.

87. Saslow no. 263. On the recto of Tolnay, *Corpus*, no. 424.

Chapter 3: A Long-Lived Pope

1. Vasari/Bull, 375–76; Condivi/Bull, 51.

2. *Carteggio* 4:81.

3. Vasari/Bull, 378.

4. *Contratti* 278–80; Ramsden 2:308; Bredekamp 2008. Two earlier *motu proprii* issued by Pope Paul (1539 and 1540) offer further insight into the relationship between the pope and his artist, confirming Paul's knowledge and esteem for Michelangelo and his profession; see Schlitt.

5. *Carteggio* 4:270.

6. Grieco 1999; see also Grieco 1996. On pears, see Montanari, 37–38.

7. *Carteggio*, 4:299; trans. Ramsden 2:91.

8. Grieco 1994, 181.

9. Grieco 1994, 180–82. More generally on the topic, see the superb exhibition catalogue by Zirka Filipczak.

10. Grieco 1994, 166.

11. Giess.

12. On the controversy between Michelangelo and Sangallo regarding the fortifications, see Ackerman 2:116–17; Ramsden 2:Appendix 32; Cassanelli et al., 149–54; Pepper; Fiore. For Michelangelo's subsequent work on the Vatican Borgo fortifications, see Brunetti; Rebecchini 2009.

13. Rebecchini 2007, 168–69, n70.

14. On the proposal to halve the Aurelian circuit of walls, see Pepper.

15. On Bufalini's role under both Sangallo and Michelangelo, see Maier, 86–89.

16. Adams and Pepper, esp. 68–71.

17. Zanchettin 2010, 369–71.

18. His niece, Francesca, was fearful that he had forgotten her (*Carteggio* 4:248).

19. With the possible exception of the chapel of Pope Leo X in Castel Sant'Angelo, for which Michelangelo designed merely a facade.

20. Ackerman 2:87, Thoenes 1997. The model is 7.36 meters long, 6.02 meters wide, and 4.68 meters high.

21. Vasari/Bettarini 6:77. Ten years later, Michelangelo wrote that he was put in charge of the *fabbrica* by Pope Paul III, "under duress and against my will" (*Carteggio* 5:105; trans. Ramsden 2:174).

22. Millon, 93.

23. Vasari/Bull, 386.

24. *Carteggio* 4:251; trans. in Condivi/Bull, 119.

25. *Carteggio* 4:251; trans. in Condivi/Bull, 119.

26. *Carteggio* 4:251; trans. in Condivi/Bull, 119. For Michelangelo's indebtedness to Bramante, see Robertson.

27. For the *tegurio* (English, tegurium), the temporary structure built to protect the grave of Saint Peter, see Shearman 1974; Tronzo. On the ruinous state and appearance of the building, see Thoenes 1986, Thoenes 2006.

28. Condivi/Bull, 38.

Chapter 4: Architect of St. Peter's

1. On the long history of construction attended by destruction at St. Peter's, see Bredekamp 2000; for Michelangelo's part in this history, see pp. 80ff.

2. *Contratti* 264–67. Most likely the "red" column from the "Antoniana" came from the Baths of Caracalla, known since antiquity as the Thermae Antonianae (my thanks to Nathaniel Jones for this information).

3. Wallace 1994a, 45.

4. *Contratti*, 293.

5. *Carteggio* 4:274.

6. Zanchettin 2006; Zanchettin 2008; Zanchettin 2009; Zanchettin 2012.

7. *Carteggio* 4:252.

8. For the incident, see Saalman. On the nearly constant resistance of the deputies to Michelangelo during his seventeen-year tenure as architect, see Millon and Smyth 1988, 237 and n148, with references.

9. ". . . rare virtu sue non solo della pittura et scultura ma della Architectura" (Saalman, 491–92).

10. Letter from Giovanni Arberino and Antonio de' Massimi to Mons. Archinto in Bologna dated March 27, 1547 (Saalman, 491–92).

11. Wallace 1994a, 141–42.

12. Wittkower 1968.

13. *Carteggio* 4:267–68.

14. Vasari/Bull, 419; Summers 1981, esp. chap. 10. On Michelangelo's inventive architectural vocabulary, and its departure from orthodoxy, see Summers 1972; Hemsoll; Elam 2005.

15. *Carteggio* 4:267–68; trans. Wilson, 510–11.

16. Vasari/Bull, 428.

17. *Carteggio* 4:267–68; trans. Symonds 2:224.

18. One of the first letters to announce Michelangelo's death in Rome was sent by the agents of Cosimo de' Medici. Enclosed in that letter was one from Nanni di Baccio Bigio asking to be instated as architect of St. Peter's (Loh, 173).

19. For Meleghino, see Giavarina. Meleghino, for example, was "site architect" for Antonio da Sangallo (Kuntz 2003, 235).

20. *Carteggio* 4:81.

21. *Contratti*, 285

22. *Contratti*, 285.

23. *Carteggio indiretto* 2:93, 96, 97.

24. This latter project sparked a raging dispute between Urbino and his co-worker, Giovanni de' Marchesi, which had prompted Michelangelo to beg Luigi del Riccio to intervene (*Carteggio* 4:130–34, and *Ricordi*, 304).

25. *Contratti*, 276.

26. *Contratti*, 284.

27. *Contratti*, 272–73.

28. On the Pauline, see Redig de Campos; Steinberg 1975; Fehl 1971; Gilbert 1978; Wallace 1989a; Kuntz 2003; Kuntz 2005a; *Michelangelo e la Cappella Paolina*.

29. Baumgart and Biagetti, 76ff, no. 29; Pastor 12:633.

30. Baumgart and Biagetti's count of the *giornate* has been amended in the latest conservation campaign (*Michelangelo e la Cappella Paolina*, 113).

31. "In la stalla.—Uno ronzinetto piccolo di pelo castagnaccio" (Gotti 2:150).

32. Walter; Wallace 1997.

33. *Carteggio* 4:182, n3; *Carteggio* 4:183–84, n1.

34. *Carteggio* 4:186.

35. Ruvoldt.

36. *Carteggio* 4:279; trans. Ramsden 2:82. Michelangelo was doubly cautious, since some years before he had similarly been accused. In October 1512, Michelangelo learned that "it is said in Florence that I have spoken against the Medici." He had to explain to his father that "I have never said anything against them" (*Carteggio* 1:139; trans. Ramsden 1:81).

37. *Carteggio* 1:135.

38. "Tutti e savi sono timidi, perché conoscono tutti e pericoli" (quoted in Guicciardini, 118).

39. "Bisognia achordarsi col tenporale e atendere a stare sani" (*Carteggio indiretto* 1:262).

40. *Carteggio* 1:172; trans. Ramsden 1:94.

41. Quoted in Brucker, 10.

42. Minter.

43. Pastor 12:633.

44. Letter from Marco Bracci in Rome to Agnolo Niccolini in Florence: "Michelagnolo ancora che dipignere nella Gran Capella di Sixto, si levo da lavorare con gran furia e ha fatto intendere a sua S.ta se lei non vi ripara la capella se ne viene in tera certo saria gran dano per amore di quelle belle figure" (Archivio di Stato di Firenze: Mediceo del Principato 337, fol. 247; reference from the Medici Archive Project [www.medici.org], entry no. 305).

45. Pastor 12:633.

46. Pastor 12:451–53.

47. *Carteggio* 4:337; trans. Ramsden 2:113.

48. *Carteggio* 5:68

49. Tolnay, *Michelangelo* 5:22, 103; Vasari/Bull, 379–80.

50. Vasari/Bull, 384.

51. "Cristo dà le chiavi a Pietro" (Vasari/Barocchi 1:123).

52. The unusual pairing of the scenes has been explained in various ways by scholars; see Tolnay, *Michelangelo* 5:70; Steinberg 1975, 16, 44–45, 57, 62; Hibbard; Hemmer; Acidini Luchinat 2007, 345; Kuntz 2005a, 163–70; Roney.

53. Freiberg, esp. 161–71.

54. Fehl 1971.

55. K. Frey 1909, 161, no. 295.

56. K. Frey 1909, 161, no. 295.

Chapter 5: A New Pope: Julius III

1. *Carteggio* 4:339; trans. Ramsden 2:118.

2. *Carteggio* 4:341; trans. Ramsden 2:119.

3. Vasari/Bull, 325. For the Italian, see Vasari/Bettarini, 6:3–4. On the rhetorical brilliance of the sentence, see Barolsky 1990, 67–68; Barolsky 1994, 139–41; Eriksen 1997, 52–78; Eriksen 2001, chap. 4, 79–109.

4. Scholars generally agree that Petrarch read Boccaccio's *Vita* and responded to its characterizations in his own autobiographical "Letter to Posterity." Thus, Petrarch—who Michelangelo greatly esteemed and emulated as a poet—serves as an important precedent and model for the artist "editing" his own life. My sincere thanks to Timothy Kircher for this information. See also Barolsky 1990.

5. Barolsky 1990; Wallace 2014b.

6. On the relationship between Vasari's and Condivi's *Lives*, see Barocchi; Wilde, chap. 1; and the books by Paul Barolsky (Barolsky 1990; Barolsky 1994), in which the relationships between art and life, literature and biography are richly explored. See also Pon; Hirst.

7. "... a rifare et acrescere la casa" (*Carteggio* 4:210), and: "... acciò che l'esser nostro non finisca qui" (*Carteggio* 4:376). On Michelangelo's brothers, see Wallace 2016.

8. "voglio aconciar le cose mia dell'anima e del corpo" (*Carteggio* 4:315; trans. Ramsden 2:102).

9. "... perché noi sià(n) pure cictadini discesi di nobilissima stirpe" (*Carteggio* 4:249), and "... perché gli è noto che noi siàno antichi cictadini fiorentini e nobili quante ogni altra casa" (*Carteggio* 4:310; trans. Ramsden 2:98). Therefore, it was imperative that Lionardo purchase "una casa onorevole," as Michelangelo reiterated time and time again; see *Carteggio* 4:248, 249, 385, 386; *Carteggio* 5:14 and *passim*.

10. *Carteggio* 2:245. On Michelangelo's belief in his noble ancestry, see Wallace 2000a; Wallace 2010a.

11. Condivi/Bull, 7.

12. For which, see Steinmann 1913, pl. 39.

13. Vasari/Bettarini 6:114.

14. Vasari/Bettarini 6:113; Vasari/Bettarini 6:119.

15. Over the course of his seventy-five-year career, Michelangelo started some thirty-seven marble sculptures but fully finished and delivered just eighteen of them—that is, less than half of the sculptures he ever began. Once he accepted the responsibilities of papal ar-

chitect, the number of incomplete works multiplied. Vasari was fully aware of the paucity of finished sculptures, "which altogether do not amount to eleven, the others, I say, and there were many of them, were all left unfinished" (Vasari/Bettarini 6:92; trans. Vasari/Bull, 404). See Schulz; Wallace 2010b.

16. Condivi/Bull, 61–62.

17. Condivi/Bull, 65.

18. Vasari/Bettarini 6:92.

19. *Contratti*, 278–80, discussed extensively by Bredekamp 2008.

20. Condivi/Bull, 62–63.

21. Condivi/Bull, 61.

22. *Carteggio* 4:343.

23. Pastor 13:49.

24. Pastor 13:146.

25. *Carteggio* 4:386. Deborah Parker is especially sensitive to nuances of meaning in the words that recur in Michelangelo's correspondence: "Michelangelo is not so much a man of few words but of key words," and *onorevole* is certainly one of them (Parker 2010, 118).

26. Pastor 13:51.

27. Vasari/Bull, 397. On the significance of seated deference, see Denker and Wallace.

28. For these various projects, see Ackerman 1961, 1964; Nova 1982; Nova 1984.

29. Condivi/Bull, 61–62.

30. A commission from June 1550; Nova 1984.

31. Vasari/Bull, 393.

32. Vasari/Bull, 399. Moreover, this exaggerated claim of intimacy appears only in the second edition of the *Lives* (1568)—that is, after Michelangelo's death.

33. Moreover, at one point Vasari admitted that he was not writing more often because he does not wish to bother Michelangelo: "Io non scrivo spesso a quella per non impeder le molte occupationi vostre" (*Carteggio* 5:156).

34. See Parker 2005; Wallace 2017. For an alternative view of the correspondence, see Bambach.

35. Never published (Vasari/Bull, 393).

36. Vasari/Bull, 398–99.

37. *Carteggio* 4:346–47.

38. *Carteggio* 4:344–45: the "cover letter" to Fattucci.

39. *Carteggio* 4:346–47.

40. Condivi/Bull, 61–62.

41. Vasari/Bull, 429.

42. On the sculpture, see Stechow; Steinberg 1968; Liebert; Shrimplin-Evangelidis; Kristof; Steinberg 1989; Arkin; Wallace 2000b; Fehl 2002; Verdon; Wasserman.

43. Quoted from Lavin, 43.

44. "Opera faticosa, rara in un sasso" (Vasari/Barocchi 1:83).

45. Vasari/Barocchi 1:123.

46. *Fatica* and its cognates is, as Deborah Parker observes, an especially important word in Michelangelo's vocabulary and self-perception (see Parker 2010).

47. Steinberg 1968.

48. ". . . serà la più bella opera di marmo che sia hoge in Roma" (*Contratti*, 5)

49. Wallace 1988.

50. Condivi/Bull, 57.

51. *Carteggio indiretto* 2:104. On the medal, see Fenichel.

52. Psalm 51; see Barolsky 1990, 47–48; Fenichel. In Fenichel's words, "Michelangelo's portrait medal is one of the artist's boldest and most public aesthetic statements of self" (Fenichel, 134).

53. Saslow no. 282.

54. Vasari/Barocchi 1:99. On Calcagni, see Wallace 2000b, 88–90.

55. Vasari/Barocchi 1:112 and 1:100: "... e riffatto non so che pezzi, ma rimase imperfetta ..."

56. The Florentine *Pietà* may still have been in Michelangelo's Roman house in Via Macel de' Corvi as late as 1561; see Wasserman, 75–76.

57. "Non ha l'abito intero prima alcun, c'a l'estremo dell'arte e della vita" (Saslow no. A35).

58. "falsi concetti" (Saslow no. 282; Nims no. 282: "mistaken notions").

59. "... l'arte e la morte non va bene insieme" (Saslow no. 283; Nims no. 283).

60. *Carteggio* 4:380–81; Saslow no. 285; Nims no. 285. On the sonnet and praise for Nim's excellent translation, see Barolsky 2000.

61. For the sheet (Cod. Vaticano Latino 3211, fol. 95), see Tolnay, *Corpus* no. 423r; Wallace 2015. Nims no. 285, translates "error carca" as "a pack of lies"; "laden with error" is my translation. My thanks to Roy Eriksen for explicating the significance of "error carca."

62. Nims no. 282. While Nims's exclamation marks perfectly convey the sentiment of the three lines, Michelangelo did not, as usual, provide such punctuation. See also Saslow no. 282: "In such slavery, and with so much boredom, and with false conceptions and a great peril to my soul, to be here sculpting divine things."

63. Petrarch sonnet 189. My thanks to Roy Eriksen for alerting me to the parallel sentiments in Petrarch's sonnet and Michelangelo's metaphor of a voyage.

64. Nims no. 283; Saslow no. 28. For the physical appearance of the sheet, see Tolnay, *Corpus* no. 423r.

65. All four versions of this line (for which, see Tolnay, *Corpus* no. 423r) are different from the one Michelangelo eventually sent to Vasari: "or ben com'era d'error carca" (Saslow no. 285). See Glauco Cambon's analysis of these variants—what he terms "Michelangelo's verbal craftsmanship" with its many "cryptical torsos of language" (Cambon, 128–36).

66. Nims no. 285, *Carteggio* 5:21–22. For an image of the neatly written sonnet and accompanying letter, see *Michelangelo: Grafia e biografia*, 70, pl. 1.

67. Compare the poem written at the bottom of the letter sent to Vasari (*Carteggio* 5:21–22, and as it appears published in Vasari's *Vita* [Vasari/Bettarini 6:94]). This latter is the version that Enzo Girardi published in his critical edition of Michelangelo's poetry in 1960, and the one that most subsequent scholars have considered definitive (Girardi no. 285). See also the earlier publication of the poem in Guasti, sonnet no. 65, and Carl Frey, no. 147 (see also Frey, pp. 486–88). Both editors, while privileging the version sent to Vasari, nonetheless, acknowledge the existence of multiple variants. Realizing the numerous alternatives in Michelangelo's poetic writing has led scholars to recognize its fundamentally open, unfinished character, thus offering a different perspective on the poetry from Girardi's neat "critical" edition. For recent discussions of Michelangelo's poetic composition, see Campeggiani 2012; Campeggiani 2015; Schiavone. For other instances of Vasari editing and rewriting Michelangelo, see Parker 2005 and Parker 2010, chap. 1.

68. For the draft verse, see Nims no. 283; Saslow no. 283 (Tolnay, *Corpus* no. 423r), versus the final line of the finished sonnet: Nims no. 285. I thank Jill Carrington for sharing her thoughts on these ambiguous lines.

69. Toward this end, see Cambon, esp. chap. 3, and Masi 2013, as well as the important books by Leonard Barkan and Oscar Schiavone who are particularly sensitive to Michelangelo's tendency to "incessant revision."

70. Nims no. 282; Saslow no. 282.

71. Nims no. 285.

72. Cellini, 352.

73. *Carteggio* 4:63, 114.

74. *Carteggio* 5:87–88.

75. *Ricordi*, 317–18.

76. *Ricordi*, 327.

77. *Carteggio* 5:24, 25, 26.

78. *Carteggio* 5:16; trans. Ramsden 2:146. On Michelangelo's persistent melancholy, see Barolsky 2007.

79. *Carteggio* 5:27; trans. Ramsden 2:149.

80. *Carteggio* 5:50; trans. Ramsden 2:159.

81. *Carteggio* 5:50; trans. Ramsden 2:159.

82. *Ricordi*, 337–38.

83. *Carteggio* 5:51–53, and n2.

84. *Carteggio* 5:51–52; trans. Ramsden 2:160.

85. *Carteggio indiretto* 2:49–50.

86. *Ricordi*, 336, 339.

87. *Carteggio* 5:54; trans. Ramsden 2:160.

88. *Carteggio indiretto* 2:51.

89. *Carteggio* 5:55–56; trans. Ramsden 2:161.

90. *Carteggio* 5:77; trans. Ramsden 2:170.

91. *Carteggio* 5:145; trans. Ramsden 2:184.

92. *Carteggio* 5:214; trans. Ramsden 2:194.

93. *Carteggio* 5:228; trans. Ramsden 2:197.

Chapter 6: Rome 1555

1. Pastor 14:1.

2. Pastor 13:334; Saalman.

3. Alexander nos. 151, 152, and note, pp. 292–93; see Michelangelo's letters to Del Riccio, *Carteggio* 4:99, 100.

4. *Carteggio* 4:348, 351, 352.

5. *Carteggio* 4:315; trans. Ramsden 2:102.

6. *Carteggio* 4:317; trans. Ramsden 2:103.

7. *Carteggio* 4:324; trans. Ramsden 2:107.

8. *Ricordi*, 373.

9. E.g. *Carteggio* 4:329.

10. Saslow no. 267.

11. *Carteggio* 5:58 and 57; trans. Ramsden 2:162; see the extended correspondence about this fabric, which clearly reveals Michelangelo's mounting consternation, *Carteggio indiretto* 2:56–57, 59, 60, 61, 62, 64, 66, 68, 70, 71.

12. *Carteggio indiretto* 2:64.

13. *Carteggio* 5:59; trans. Ramsden 2:162.

14. *Carteggio* 5:68; trans. Ramsden 2:165. Malenotti, however, informed Lionardo that Michelangelo gave away to unnamed persons more than half of this shipment (*Carteggio indiretto* 2:75).

15. *Carteggio indiretto* 2:73.

16. *Carteggio indiretto* 2:71.

17. On Paul IV, see Pastor 14:56–288; MacCulloch, 217ff.

18. Mather, 301.

19. On Beccadelli, see Alberigo.

20. Galleria degli Uffizi, Florence. Signed and dated 1552.

21. Saslow no. 288.

22. Saslow no. 300.

23. *Carteggio* 5:66–67.

24. Letter of August 20, 1554: ". . . ha liberato San Pietro dalle mani de' ladri et degl'assassini et ridotto quel che era imperfetto a perfettione" (*Carteggio* 5:19).

25. For the historical situation, see Pastor 14:138–74.

26. Pastor 14:145.

27. Pastor 14:132–33, 145.

28. "Et Dio ci aiuti, che qua si vede cose crudeli" (*Carteggio indiretto* 2:81).

29. *Carteggio indiretto* 2:83.

30. *Carteggio indiretto* 2:84.

31. *Carteggio* 5:76; trans. Ramsden, 2:169. Michelangelo records having been away from Rome "per cinque sectimane," and "a Spuleti u[n] meso e cinque dì" (*Ricordi*, 320).

32. As expressed in comments found in the dialogues of Francisco de Hollanda, for which see Folliero-Metz, 77. Vasari also suggests Michelangelo's lack of interest in landscape when he wrote: "Michelangelo concentrated his energies on achieving absolute perfection in what he could do best, so there are no landscapes to be seen in these scenes [Pauline Chapel], nor any trees, buildings, or other embellishments and variations; for he never spent time on such things" (Vasari/Bull, 384).

33. Macdonald, 76–81; the following discussion was adumbrated in my Josephine Waters Bennett lecture (Wallace 2015).

34. *Carteggio* 5:74. There is little written evidence from the Spoleto trip; however, Michelangelo wrote a letter (lost) to Antonio Barberini reporting that he was staying in Spoleto (see *Carteggio indiretto* 2:74). There is also an undated record of medicine prescribed by "Beato Cherubino da Spoleti" for the artist's kidney stones, which likely dates from this time (*Ricordi*, 373, no. 316).

35. Did such musing about Lippi prompt the extremely curious comment by Vasari that Michelangelo "has always sung his praises" (*e Michelagnolo l'ha non pur celebrato sempre*)—a comment that appears only in the second edition of Vasari's *Lives* (Vasari/Bettarini 3:338)?

36. My emphasis: ". . . ché mi fu mandato un huomo a posta ache io mi dovessi ritornare in Roma" (*Carteggio* 5:74–75; trans. Ramsden 2:168–69).

37. ". . . io son ritornato men che mezo a Roma" (*Carteggio* 5:76; trans. Ramsden 2:169).

38. Pastor 14:162.

39. *Carteggio indiretto* 2:85–86.

40. A paraphrase from *Carteggio indiretto* 2:90.

41. *Carteggio indiretto* 2:90–91.

42. *Carteggio indiretto* 2:91.

43. *Carteggio indiretto* 2:92.

44. *Carteggio* 5:81; *Carteggio indiretto* 2:85, 87, 91.

45. *Carteggio* 5:81; trans. Ramsden 2:170.

46. *Carteggio* 5:82.

47. *Carteggio* 5:19.

48. Nims no. 285.

49. *Carteggio* 5:21; trans. Gilbert, 301.

50. *Contratti*, 293; see also Baldrati, 15, n7.

51. Francia; Baldrati, 27–28.

52. Pastor 13:370.

53. *Ricordi*, 340; *Carteggio indiretto* 2:56.

54. *Carteggio* 5:223. On Cornelia's relationship with Michelangelo, see Stott; Wallace 2010a, 308–10.

55. *Carteggio* 5:160–61.

56. *Carteggio* 5:86.

57. *Carteggio* 5:87–88; trans. Ramsden 2:172.

58. *Carteggio* 5:91.

59. *Carteggio indiretto* 2:121–22.

60. Dated March 1557 (*Carteggio* 5:89–90).

61. Baldrati, 56 and n35.

62. Wallace 1994a, 143.

63. Baldrati, 30, 33, 40, 56, 72.

64. January 30, 1557 (*Carteggio indiretto* 2:92).

65. *Carteggio* 5:112–14, 116–18. Millon and Smyth 1976, and Brodini (pp. 115–26) offer lucid analyses of what went wrong.

66. *Carteggio* 5:112–14; trans. Ramsden 2:178.

67. "La memoria e'l cervello son iti aspectarmi altrove" (*Carteggio* 5:118; trans. Ramsden 2:180–81).

68. Saslow A16.

69. *Ricordi*, 340–42, 339, 343.

70. Saslow no. A8.

Chapter 7: Architect of Rome

1. On these projects, see Ackerman 1: chaps. 6–11.

2. See Macdougall; Schwager; Maurer 2006.

3. See Satzinger 2005; Satzinger 2009; Ruschi.

4. Vienna, Kunsthistorisches Museum, inv. 3544.

5. On Pio da Carpi, see Capanni.

6. *Carteggio* 5:230; Vasari/Bettarini 6:109.

7. *Carteggio* 5:123. Despite Michelangelo's disinclination to theoretical musing and the laconic nature of his remark (in a letter that may never have been sent), this statement is often taken as constituting Michelangelo's "theory of architecture"; see, for example, Ackerman 1:1–10; Summers 1972.

8. Ackerman 2:18–19; Maurer 1999/2000.

9. "Basta che, quello che io ò promesso, lo farò a ogni modo, e farò la più bella opera che sia mai facta in Italia, se Dio me n'aiuta" (*Carteggio* 2:83).

10. *Carteggio* 1:209, 213, 280.

11. Ackerman 1954, 9. Michelangelo pursued a similarly open process also in drawing and sculpting; see for example, Wallace 2009; Barkan; Keizer.

12. E.g. Zanchettin 2006. On the Strozzi Palace, see Goldthwaite; for the Escorial, see Wilkinson.

13. *Carteggio* 5:84–85; trans. Ramsden 2:171.

14. On the issue of architectural continuity over generations, see Burns; Trachtenberg.

15. Wallace 1994a.

16. See Burns; Trachtenberg. Howard Burns and Marvin Trachtenberg discuss how initial design decisions restricted the choices of a project's subsequent designers.

17. See Kuntz 2005b, and Bartolozzi.

18. See Capelli; Wallace 2003; Agosti and Leone.

19. Shearman 1967, 19.

20. *Carteggio* 5:185; trans. Wilson, 534.

21. On Michelangelo's collaboration with Daniele, see Boström; Treves; Romani; Hansen, chap. 3.

22. *Carteggio* 5:236; trans. Symonds 2:256–57.

23. *Carteggio* 5:234–35. For Del Bene's letter, see *Carteggio* 5:237.

24. *Carteggio* 5:243.

25. Calcagni is buried in San Giovanni Decollato, Rome; see Wallace 2000b, 91.

26. Vasari/Barocchi 1:112.

27. Bedon, 210; Wallace 1989b.

28. See especially Tolnay, *Corpus* nos. 595, 596. On the dome and discussions of Michelangelo's "intentions," see Wittkower 1964; Ackerman 1: chap. 8; Argan and Contardi, 322–35; Bellini; Baldrati.

29. *Carteggio* 4:271–72.

30. *Carteggio indiretto* 2:71–72.

31. *Carteggio indiretto* 2:73. See McPhee.

32. One finds paired columns in the so-called Baroque facades found mostly in the Eastern Roman Empire, such as the library of Celsus at Ephesus or the Market Gate at Miletus, and in the stage fronts of theater buildings. A pairing against the main axis is more common, such as at the Temple of Vesta and the Forum Transitorium in Rome, where we see a column plus a pilaster with just a short span between. My thanks to Nathaniel Jones for these and other observations.

33. Michelangelo was certainly familiar with Giuliano da Sangallo's designs for the facade of San Lorenzo in Florence and with Donato Bramante's Palazzo Caprini in Rome, both of which employ the motif of paired columns, albeit as decorative rather than as structural elements. In the courtyard of the Farnese Palace, Antonio da Sangallo employed two engaged columns to articulate the massive corner piers; however, they are at right angles to one another and are separated by a reentrant pier. We find a bundling of a column and a pier in other palace courtyards (e.g., Urbino), loggias (Piazza della Signoria, Florence), and at church crossings, but rarely just two columns together as a single, independent architectural unit.

There are some large-scale examples in Norman architecture, such as those that encircle the apse of the cathedral of Cefalù in Sicily. But Michelangelo never went to Sicily, and it is unlikely that he was familiar with any significant example of Norman architecture. My thanks to Caroline Bruzelius for this and other suggestions.

Paired columns are found on the Roman arch at Pola, which would not have been known

to Michelangelo, but the motif was used on the gate of the Venetian Arsenal, which Michelangelo may well have seen. My thanks to Howard Burns for alerting me to these examples of paired columns.

34. Millon and Smyth 1969; Millon and Smyth 1988.

Chapter 8: God's Architect

1. Quoted from Augias, 206–7.

2. Quoted from Augias, 25.

3. *Carteggio* 5:246.

4. *Carteggio indiretto* 2:112, 115, 121.

5. *Carteggio indiretto* 2:113, 123: "Fate careze al puto, che ò speranza che lo meniate qua presto."

6. *Carteggio indiretto* 2:126, 130, 132, 135, 141–42, 143, 145.

7. *Carteggio* 5:291; trans. Ramsden 2:205.

8. *Carteggio indiretto* 2:107, 108.

9. *Carteggio indiretto* 2:138.

10. *Carteggio indiretto* 2:125.

11. *Carteggio indiretto* 2:115.

12. *Carteggio indiretto* 2:117.

13. *Carteggio indiretto* 2:130 and 122.

14. *Carteggio indiretto* 2:125.

15. *Carteggio* 5:146.

16. *Carteggio* 5:208.

17. *Carteggio* 5:83.

18. *Carteggio* 5:84–85; trans. Ramsden 2:171.

19. *Carteggio* 5:110; trans. Ramsden 2:177 (my emphasis).

20. *Carteggio* 5:115; trans. Ramsden 2:180.

21. *Carteggio* 5:74.

22. My thanks to Erin Sutherland Minter for this suggestion.

23. *Carteggio* 5:109.

24. "... quel magnifico tempio di San Pietro, segno immortale della divina virtù di Vostra Signoria" (*Carteggio* 5:67).

25. *Carteggio* 5:89. Beccadelli sent this letter to Spoleto believing that Michelangelo was still there "in exile."

26. *Carteggio* 5:110; trans. Ramsden 2:177. See the nearly identical sentiment expressed in a letter to Lionardo dated December 2, 1558 (*Carteggio* 5:145).

27. *Carteggio* 5:35. The sentiment was reiterated to Cosimo de' Medici in May 1557: "... io non potevo ancora lasciare la fabrica di Santo Pietro senza gran danno suo e senza grandissima mia vergognia ..." (*Carteggio* 5:102); as well as to Vasari: "... che abandonandola ora, non sarebe altro che con grandissima vergognia ..." (*Carteggio* 5:105). See also Barolsky 1990, 48–52.

28. "Prego Dio che m'aiuti e consigli" (*Carteggio* 5:109).

29. Vasari/Bettarini 6:106; trans. Vasari/Bull, 416.

30. *Carteggio* 5:110; trans. Ramsden 2:177.

31. *Carteggio* 5:35; trans. Ramsden 2:155.

32. Vasari/Bettarini 6:90, 106.

33. "...il fermamento e stabilimento di quella fabbrica" (Vasari/Bettarini 6:101; trans. Vasari/Bull, 409).

34. "...tornarmi a Firenze con animo di riposarmi co la morte" (*Carteggio* 5:103).

35. Dante Alighieri, 42 (*Paradiso* 5:76–78).

36. Cicero, 222 (*De senectute*, VII.24). If Michelangelo had not read Cicero himself, he was probably familiar with the work. In his *Dialogues*, Michelangelo's close friend, Donato Giannotti, describes Michelangelo wondering whether he could not learn Latin in his seventies, given that Cato the Censor had learned Greek in his eighties, a story which is related in Cicero's *De senectute*, immediately after Cato describes the pleasure of farming in old age.

37. K. Frey 1916, 42–44; *Carteggio* 5:272.

38. To follow the intricacies of these relations, see *Carteggio* 5:275–76, *Carteggio indiretto* 2:110–11, and *passim*.

39. *Carteggio* 5:272; trans. Ramsden 2:202–3; see also *Carteggio* 5:321.

40. *Carteggio indiretto* 2:157–58.

41. *Carteggio indiretto* 2:159. Lorenzo Mariottini also wrote to Lionardo about the incident, maintaining that Cesare received eighteen knife wounds and confirming that Michelangelo's servant, Antonio, proclaimed his master to be very upset about the incident (*Carteggio indiretto* 2:160).

42. *Carteggio indiretto* 2:161; see also Wittkower 1968; Ciulich 1983.

43. *Carteggio indiretto* 2:163.

44. See Paoletti; Rovetta.

45. Saslow no. A35.

46. Saslow no. 272.

47. Quoted from Bell, 81.

48. Payments for the execution of a brick pavement for the piazza, in a herringbone pattern, were made between 1563 and 1564, evidently one of the final aspects of the project witnessed by Michelangelo but still not complete at his death (Bedon, 124).

49. On the Capitoline commission and its condition during Michelangelo's lifetime, see Ackerman 1: chap. 6; Thies; Argan and Contardi, 252–64; Bedon, esp. chaps. 2–6. As Caroline Bruzelius notes, "immense scale might be viewed as a predictor of conspicuous incompletion and for significant changes in design" (Bruzelius, 114). The observation pertains to nearly every one of Michelangelo's Roman architectural projects.

50. Quoted from Augias, 98.

51. *Carteggio* 5:115.

52. Saslow no. A1.

53. *Carteggio indiretto* 2:136, 137.

54. *Carteggio indiretto* 2:138, 139, 140.

55. *Carteggio* 3:420.

56. *Carteggio indiretto* 2:139.

57. *Carteggio* 5:297; trans. Ramsden 2:205.

58. *Carteggio indiretto* 2:143.

59. d. 1562. *Carteggio indiretto* 2:155.

60. *Carteggio indiretto* 2:154; see also 126, 128, 130, 132, 135.

61. *Carteggio* 5:298–302.

62. *Carteggio* 5:307.

63. *Carteggio* 5:309–10; trans. Ramsden 2:207.

64. *Carteggio* 5:311; trans. Ramsden 2:208.

65. *Carteggio indiretto* 2:198.
66. *Carteggio indiretto* 2:169.
67. *Carteggio indiretto* 2:172–73; trans. Symonds 2:318–19.
68. *Ricordi*, 373–74.
69. *Carteggio indiretto* 2:174; trans. Symonds 2:319–20.
70. Quoted from Symonds 2:320.
71. Daniele da Volterra to Vasari, March 17, 1564; trans. Wilson, 556.

WORKS CITED

Acidini Luchinat, Cristina. *Michelangelo Pittore* (Milan, 2007).

——. "Genesi immaginaria della *Pala Nerli* di Filippino Lippi," in *Synergies in Visual Culture / Bildkulturen im Dialog. Festschrift für Gerhard Wolf*, ed. Manuela de Giorgi, Annette Hoffmann, and Nicola Suther (Munich, 2013), 593–600.

Ackerman, James S. *The Architecture of Michelangelo*, 2 vols., rev. ed. (London, 1961, 1964).

——. "Architectural Practice in the Italian Renaissance," *Journal of the Society of Architectural Historians* 13 (1954):3–11; repr.: James S. Ackerman. *Distance Points: Essays in Theory and Renaissance Art and Architecture* (Cambridge, MA, and London, 1991), 361–84.

Adams, Nicholas, and Simon Pepper. "The Fortification Drawings," in *The Architectural Drawings of Antonio da Sangallo and His Circle*, vol. 1, ed. Nicholas Adams and Christoph L. Frommel (New York, 1994), 61–74.

Agosti, Barbara, and Giorgio Leone (eds.). *Intorno a Marcello Venusti* (Catanzaro, 2016).

Agoston, Laura Camille. "Sonnet, Sculpture, Death: The Mediums of Michelangelo's Self-Imaging," *Art History* 20 (1997):534–55.

Alberigo, Giuseppe. "Beccadelli, Ludovico," in *Dizionario Biografico degli Italiani*, vol. 7 (1970), 407–13.

Alexander, Sydney. *The Complete Poetry of Michelangelo* (Athens, OH, 1991).

Argan, Giulio Carlo, and Bruno Contardi. *Michelangelo architetto* (Milan, 1990).

Arkin, Moshe. "'One of the Marys . . .': An Interdisciplinary Analysis of Michelangelo's Florentine *Pietà*," *Art Bulletin* 79 (1997):493–517.

Augias, Corrado. *The Secrets of Rome: Love and Death in the Eternal City*, trans. A. Lawrence Jenkins (Milan, 2007).

Authorship: From Plato to Postmodernism, ed. Seán Burke (Edinburgh, 1995, repr. 2006).

Baldrati, Barbara. *La Cupola di San Pietro: Il metodo costruttivo e il cantiere* (Rome, 2014).

Bambach, Carmen. "Letters from Michelangelo," *Apollo* 177 (April 2013):58–67.

Barkan, Leonard. *Michelangelo: A Life on Paper* (Princeton, NJ, 2010).

Barnes, Bernadine. "The Understanding of a Woman: Vittoria Colonna and Michelangelo's *Christ and the Samaritan Woman*," *Renaissance Studies* 27 (2013):633–53.

Barocchi, Paola. *Michelangelo tra le due redazioni delle Vite Vasariane (1550–1568)* (Lecce, 1968).

Barolsky, Paul. *Michelangelo's Nose: A Myth and Its Maker* (University Park, PA, 1990).

——. *The Faun in the Garden: Michelangelo and the Poetic Origins of Italian Renaissance Art* (University Park, PA, 1994).

——. "Michelangelo's Self-Mockery," *Arion* 7 (2000):167–75.

——. "Michelangelo and the Image of the Artist as Prince," in *Basilike Eikon: Renaissance Representations of the Prince*, ed. Roy Eriksen and Magne Malmanger (Rome, 2001), 30–35.

——. "Michelangelo's Misery: A Fictive Autobiography," *Source: Notes in the History of Art* 27, no. 1 (2007):22–24.

Bartolozzi, Anna. "Il completamento del nuovo San Pietro sotto il Pontificato di Paolo V. Disegni e dibabattiti 1605–1613," *Römisches Jahrbuch der Bibliotheca Hertziana* 39 (2009/2010):281–328.

Baumgart, Fritz, and Biagio Biagetti. *Gli affreschi di Michelangelo, L. Sabbatini e F. Zuccari nella cappella Paolina in Vaticana* (Città del Vaticana, 1934).

Beck, James. *Three Worlds of Michelangelo* (New York and London, 1999).

Bedon, Anna. *Il Campidoglio: Storia di un monumento civile nella Roma papale* (Milan, 2008).

Bell, Rudolf M. *Street Life in Renaissance Rome: A Brief History with Documents* (Boston and New York, 2013).

Bellini, Federico. *La Basilica di San Pietro da Michelangelo a Della Porta*, 2 vols. (Rome, 2011).

Benedetto da Mantova. *Il Beneficio di Cristo con le version del secolo XVI*, ed. Salvatore Caponetto (Florence, 1972).

Blunt, Anthony. *Artistic Theory in Italy, 1450–1600* (London and New York, 1962).

Bober, Phyllis Pray, and Ruth Rubinstein, *Renaissance Artists and Antique Sculpture* (London, 1986).

Boström, Antonia. "Daniele da Volterra, Ruberto Strozzi and the Equestrian Monument to Henry II of France," in *The Sculpted Object, 1400–1700*, ed. Stuart Currie and Peta Motture (Aldershot, UK, 1997), 201–14.

Bredekamp, Horst. *Sankt Peter in Rom und das Prinzip der produktiven Zerstörung. Bau und Abbau von Bramante bis Bernini* (Berlin, 2000).

———. "Zwei Souveräne: Paul III. und Michelangelo. Das 'Motu proprio' vom Oktober 1549," in *Sankt Peter in Rom 1506–2006*, ed. George Satzinger and Sebastian Schütze (Munich, 2008), 147–57.

Brodini, Alessandro. *Michelangelo a San Pietro. Progetto, cantiere e funzione delle cupole minori* (Rome, 2009).

Brucker, Gene. "The Structure of Patrician Society in Renaissance Florence," *Colloquium* 1 (1964):2–11.

Brundin, Abigail (ed. and trans.). *Sonnets for Michelangelo* (Chicago and London, 2005).

———. *Vittoria Colonna and the Spiritual Poetics of the Italian Reformation* (Aldershot, UK, 2008).

Brunetti, Oronzo. "Michelangelo e le fortificazioni del borgo," in *Michelangelo: Architetto a Roma* (Milan, 2009), 118–23.

Bruzelius, Caroline. "Project and Process in Medieval Construction," in *Ex Quadris Lapidibus. La pierre et sa mise en oeuvre dans l'art médiéval. Mélanges d'Histoire de l'art offerts à Élaine Vergnolle*, ed. Yves Gallett (Turnhout, Belgium, 2011), 113–24.

Burns, Howard. "Building Against Time: Renaissance Strategies to Secure Large Churches Against Changes to their Design," in *L'église dans l'architecture de la Renaissance*, ed. Jean Guillaume (Paris, 1995), 107–31.

Cambon, Glauco. *Michelangelo's Poetry: Fury of Form* (Princeton, NJ, 1985).

Campeggiani, Ida. *Le varianti nella poesia di Michelangelo. Scrivere per via di porre* (Lucca, 2012).

———. "Dalle varianti al 'Canzoniere' (e ritorno) sulla silloge del 1546," *L'Ellisse: Studi storici di letteratura italiana* 10, no. 2 (2015):51–68.

Capanni, Fabrizio. *Rodolfo Pio da Carpi (1500–1564): Diplomatico, cardinale, collezionista* (Forli, 2001).

Capelli, Simona. "Marcello Venusti: Un valtellinese pittore a Roma," *Studi di storia dell'arte* 12 (2001):17–48.

Il Carteggio di Michelangelo, ed. Paola Barocchi and Renzo Ristori, 5 vols. (Florence, 1965–83).

Il Carteggio indiretto di Michelangelo, ed. Paola Barocchi, Kathleen Bramanti, and Renzo Ristori, 2 vols. (Florence, 1988 and 1995).

Cassanelli, Luciana, et al. *Le mura di Rome: L'architettura militare nella storia urbana* (Rome, 1974).

Cellini, Benvenuto. *Autobiography*, trans. George Bull (Harmondsworth, UK, 1956).

Cicero, Marcus Tullius. "On Old Age," in *Selected Works*, trans. Michael Grant (Harmondsworth UK, 1971).

Ciulich, Lucilla Bardeschi. "Nuovi documenti su Michelangelo architetto maggiore di San Pietro," *Rinascimento* 23 (1983):173–86.

———. *Costanza ed evoluzione nella scrittura di Michelangelo* (Florence, 1989).

Clements, Robert J. *The Poetry of Michelangelo* (New York, 1964).

Condivi, Ascanio. *Michelangelo: Life, Letters, and Poetry*, trans. George Bull (Oxford and New York, 1987).

I Contratti di Michelangelo, ed. Lucilla Bardeschi Ciulich (Florence, 2005).

Corsaro, Antonio. "Intorno alle *Rime* di Michelangelo Buonarroti. La silloge del 1546," *Giornale storico della letteratura Italiana* 612 (2008):536–69.

Crescentini, Claudio. *La Memoria e il volto: Vittoria Colonna and Michelangelo in rare incisioni e stampe* (Rome, 2014).

Dante Alighieri. *Paradiso*, trans. Allen Mandelbaum (Berkeley, CA, 1982).

Denker, Eric, and William E. Wallace, "Michelangelo and Seats of Power," *Artibus et Historiae* 72 (2015):199–210.

Echinger-Maurach, Claudia. *Studien zu Michelangelos Juliusgrabmal*, 2 vols. (Hildesheim, 1991).

Elam, Caroline. "'Ché ultima mano!': Tiberio Calcagni's Marginal Annotations to Condivi's *Life of Michelangelo*," *Renaissance Quarterly* 51 (1998):475–97.

———. "'Tuscan dispositions': Michelangelo's Florentine Architectural Vocabulary and Its Reception," *Renaissance Studies* 19 (2005):46–82.

Elliott, John H. *History in the Making* (New Haven, CT, and London, 2012).

Eriksen, Roy. "Desire and Design: Vasari, Michelangelo and the Birth of Baroque," in *Contexts of Baroque: Theatre, Metamorphosis, and Design*, ed. Roy Eriksen (Oslo, 1997), 52–78.

———. *The Building in the Text: Alberti to Shakespeare and Milton* (University Park, PA, 2001).

Favro, Diane. *The Urban Image of Augustan Rome* (Cambridge and New York, 1996).

Fea, Carlo. *Miscellanea filologica critica e antiquaria*, vol. 1 (Rome, 1790), 329–30.

Fedi, Roberto. "Il canzoniere (1546) di Michelangelo Buonarroti," in *La memoria della poesia* (Rome and Salerno, 1990), 264–305.

Fehl, Philipp. "Michelangelo's 'Crucifixion of St. Peter': Notes on the Identification of the Locale of the Action," *Art Bulletin* 53 (1971):326–43.

———. "Michelangelo's Tomb in Rome: Observations on the *Pietà* in Florence and the *Rondanini Pietà*," *Artibus et Historiae* 45 (2002):9–27.

Fenichel, Emily A. "Penance and Proselytizing in Michelangelo's Portrait Medal," *Artibus et Historiae* 73 (2016):125–38.

Filipczak, Zirka Z. *Hot Dry Men/ Cold Wet Women: The Theory of Humors in Western European Art 1575–1700* (New York, 1997).

Fiore, Francesco P. "Rilievo topografico e architettura a grande scala nei disegni di Antonio da Sangallo il Giovane per le fortificazioni di Roma al tempo di Paolo III," in *Il disegno di architettura*, ed. Paolo Carpeggiani and Luigi Patetta (Milan, 1989), 175–80.

Firpo, Massimo. "Vittoria Colonna, Giovanni Morone e gli 'spirituali,'" *Rivista di storia e letteratura religiosa* 24 (1988):211–61.

———. *Juan de Valdés and the Italian Reformation*, trans. Richard Bates (Surrey, UK, and Burlington, VT, 2015).

Folliero-Metz, Grazia Dolores (ed.). *Francisco de Hollanda. Diálogos em Roma (1538) (Conversations on Art with Michelangelo Buonarroti)* (Heidelberg, 1998).

Forcellino, Antonio. *Michelangelo: A Tormented Life*, trans. Allan Cameron (Cambridge, 2010).

Forcellino, Maria. *Michelangelo, Vittoria Colonna e gli "spirituali": Religiosità e vita artistica a Roma negli anni Quaranta* (Rome, 2009).

Francia, Ennio. "Le 'Benfinite' di Michelangelo," *Strenna di romanisti* 54 (1993), 145–48.

Freiberg, Jack. *Bramante's Tempietto, the Roman Renaissance, and the Spanish Crown* (New York, 2014).

Fremantle, Richard. *Big Tom: Masaccio. Speculative History and Art History* (Fiesole, 2014).

Freud, Sigmund. "Der Moses des Michelangelo," in *Gesammelte Werke*, vol. 10 (London, 1949), 172–201.

Frey, Carl. *Die Dichtungen des Michelagniolo Buonarroti* (1897), 2nd ed. (Berlin, 1964).

Frey, Karl. "Studien zu Michelagniolo Buonarroti und zur Kunst seiner Zeit," *Jahrbuch der königlich preuszischen Kunstsammlungen* 30 (1909):103–80.

———. "Zur Baugeschichte des St. Peter," *Jahrbuch der königlich preuszischen Kunstsammlungen* 37 (Beiheft, 1916).

Frommel, Christoph L. "'Cappella Julia.' Die Grabkapelle Papst Julius II in Neu-St. Peter," *Zeitschrift für Kunstgeschichte* 40 (1977):26–62.

———. "Michelangelo und das Grabmal des Cecchino Bracci in S. Maria in Araceli," *Docta Manus: Studien zur italienischen Skulptur für Joachim Poeschke*, ed. Johannes Myssok and Jürgen Wiener (Münster, 2007), 263–77.

———. *Michelangelo's Tomb for Julius II : Genesis and Genius* (Los Angeles, 2016).

Giavarina, Adriano Ghisetti. "Meleghino, Jacopo," in *Dizionario biografico degli italiani*, vol. 73 (2009), 286–88.

Giess, Hildegard. "Castro and Nepi," in *The Architectural Drawings of Antonio da Sangallo and His Circle*, vol. 1, ed. Nicholas Adams and Christoph L. Frommel (New York, 1994), 75–80.

Gilbert, Creighton E. *Complete Poems and Selected Letters of Michelangelo*, trans. Creighton Gilbert, ed. Robert N. Linscott (New York, 1963; 3rd ed., Princeton, NJ, 1980).

———. "'The Usefulness of Comparisons Between the Parts and the Set': The Case of the Cappella Paolina," in *Actas del XXIII Congreso Internacional de Historia del Arte*, vol. 3 (Granada, 1978), 519–31.

Ginzburg, Carlo, and Adriano Prosperi. *Giochi di pazienza: Un seminario su Beneficio di Cristo* (Turin, 1975).

Girardi, Enzo Noè. *Rime. Edizione critica a cura di Enzo Noè Girardi* (Bari, 1960).

Goldthwaite, Richard. "The Building of the Strozzi Palace: The Construction Industry in Renaissance Florence," *Studies in Medieval and Renaissance History* 10 (1973):99–194.

Gotti, Aurelio. *Vita di Michelangelo Buonarroti*, 2 vols. (Florence, 1875).

Gouwens, Kenneth. "Female Virtue and the Embodiment of Beauty: Vittoria Colonna in Paolo Giovio's *Notable Men and Women*," *Renaissance Quarterly* 68 (2015):33–97.

Grieco, Allen J. "I sapori del vino: gusti e criteri di scelta fra Trecento e Cinquecento," in *Dalla Vite al Vino: Fonti e problem della vitivinicoltura italiana medievale*, ed. Jean-Louis Gaulin and Allen J. Grieco (Bologna, 1994), 165–186.

———. "Alimentation et classes sociales à la fin du Moyen Âge et à la Renaissance," in *Histoire de l'alimentation*, ed. J.-L. Flandrin and M. Montanari (Paris, 1996), 479–90.

———. "Food and Social Classes in Late Medieval and Renaissance Italy," in *Food: A Culinary History from Antiquity to the Present* (New York, 1999), 302–12.

Guasti, Cesare. *Le Rime di Michelangelo Buonarroti* (Florence, 1863).

Guicciardini, Francesco. *Ricordi* [Milan, 1975].

Hansen, Morton Steen. *In Michelangelo's Mirror: Perino del Vaga, Daniele da Volterra, Pellegrino Tibaldi* (University Park, PA, 2013).

Hatfield, Rab. *The Wealth of Michelangelo* (Rome, 2002).

Hemmer, Peter. "Michelangelos Fresken in der Cappella Paolina und das 'Donum Iustificationis,'" in *Functions and Decorations: Art and Ritual at the Vatican Palace in the Middle Ages and the Renaissance (Capellae Apostolicae Sixtinae, Collectanea Acta Monumenta, 9)*, ed. Tristan Weddington, Sible De Blaauw, and Bram Kempers (Turnhout, 2003), 129–52.

Hemsoll, David. "The Laurentian Library and Michelangelo's Architectural Method," *Journal of the Warburg and Courtauld Institutes* 66 (2003):29–62.

Hibbard, Howard. *Michelangelo* (New York and London, 1974).

Hirst, Michael. "Michelangelo and His First Biographers," *Proceedings of the British Academy. Lectures and Memoirs* 94 (1996):63–84.

Holmes, Richard. *Footsteps. Adventures of a Romantic Biographer* (New York, 1985).

———. *Dr. Johnson and Mr. Savage* (New York, 1993).

Keizer, Joost Pieter. "Michelangelo, Drawing, and the Subject of Art," *Art Bulletin* 93 (2011):304–24.

Kristof, Jane. "Michelangelo as Nicodemus: The Florence *Pietà*," *Sixteenth Century Journal* 20 (1989):163–82.

Kuntz, Margaret A. "Designed for Ceremony: The Cappella Paolina at the Vatican Palace," *Journal of the Society of Architectural Historians* 62 (2003):228–55.

———. "A Ceremonial Ensemble: Michelangelo's *Last Judgment* and the Cappella Paolina Frescoes," in *Michelangelo's Last Judgment*, ed. M. B. Hall (Cambridge and New York, 2005a), 150–82.

———. "Maderno's Building Procedures at New St. Peter's: Why the Façade First?" *Zeitschrift für Kunstgeschichte* 68 (2005b):41–60.

Lavin, Irving. "David's Sling and Michelangelo's Bow: A Sign of Freedom," in *Past-Present: Essays on Historicism in Art from Donatello to Picasso* (Berkeley, CA, 1993), 29–61.

Liebert, Robert S. "Michelangelo's Mutilation of the Florence Pietà: A Psychoanalytic Inquiry," *Art Bulletin* 59 (1977):47–54.

Loh, Maria H. *Still Lives: Death, Desire, and the Portrait of the Old Master* (Princeton, NJ, and Oxford, 2015).

MacCulloch, Diarmaid. *The Reformation: A History* (London, 2004).

Macdonald, Hugh. *Music in 1853: The Biography of a Year* (Woodbridge, Suffolk, UK, 2012).

Macdougall, Elisabeth B. "Michelangelo and the Porta Pia," *Journal of the Society of Architectural Historians* 29, no. 3 (1960):97–108.

Maier, Jessica. *Rome Measured and Imagined* (Chicago and London, 2015).

Masi, Giorgio. "'Perché non parli?' Michelangelo e il silenzio," in *Officine del Nuova. Sodalizi fra letterati, artisti ed editori nella cultura italiana fra Riforma e Controriforma*, ed. Harald Hendrix and Paolo Procaccioli (Manziana [Rome], 2008), 427–44.

———. "'Il'gran restauro': altre proposte di esegesi poetica michelangiolesca," in *Michelangelo Buonarroti: Leben, Werk und Wirkung / Michelangelo Buonarroti: Vita, Opere, Ricezione. Positionen und Perspektiven der Forschung/Approdi e prospettive della ricerca contemporanea*, ed. Grazia Dolores Folliero-Metz and Susanne Gramatzki (Frankfurt-am-Main, 2013), 235–59.

———. "Michelangelo cristiano. Senso del peccato, salvezza e fede," *L'Ellisse: Studi storici di letteratura italiana* 10, no. 2 (2015):37–50.

Mather, Frank Jewett. *A History of Italian Painting* (New York, 1923).

Maurer, Golo. "Michelangelos Projekt für den Tambour von Santa Maria del Fiore," *Römisches Jahrbuch der Bibliotheca Hertziana* 33 (1999/2000):85–100.

———. "Überlegungen zu Michelangelos Porta Pia," *Römisches Jahrbuch der Bibliotheca Hertziana* 37 (2006):125–62.

McPhee, Sarah. *Bernini and the Bell Towers: Architecture and Politics at the Vatican* (New Haven and London, 2002).

Mendelsohn, Leatrice. *Paragoni: Benedetto Varchi's "Due Lezzioni" and Cinquecento Art Theory* (Ann Arbor, MI, 1982).

Michelangelo e la Cappella Paolina: Riflessioni e contribute sull'ultimo restauro, ed. Antonio Paolucci and Silvia Danesi Squarzina (Città del Vaticana, 2016).

Michelangelo: Grafia e biografia di un genio, ed. Lucilla Bardeschi Ciulich (Milan, 2000).

Millon, Henry. "Michelangelo to Marchionni 1546–1784," in *St. Peter's in the Vatican*, ed. William Tronzo (Cambridge and New York, 2005), 93–110.

Millon, Henry, and Craig H. Smyth. "Michelangelo and St. Peter's, I: Notes on a Plan of the Attic as Originally Built on the South Hemicycle," *Burlington Magazine* 111 (1969): 484–501.

———. "Michelangelo and St. Peter's: Observations on the Interior of the Apse, a Model of the Apse Vault, and Related Drawings," *Römisches Jahrbuch für Kunstgeschichte* 16 (1976):137–206.

———. "Pirro Ligorio, Michelangelo, and St. Peter's," in *Pirro Ligorio: Artist and Antiquarian*, ed. Robert W. Gaston (Florence, 1988), 216–86.

Minter, Erin Sutherland. "Discarded Deity: The Rejection of Michelangelo's *Bacchus* and the Artist's Response," *Renaissance Studies* 28 (2014):443–58.

Modersohn-Becker, Paula. *The Letters and Journals*, eds. G. Busch and L. Van Reinken (New York, 1979).

Montanari, Massimo. *Cheese, Pears, & History: In a Proverb*, trans. Beth Archer Brombert (New York, 2010).

Moroncini, Ambra. *Michelangelo's Poetry and Iconography in the Heart of the Reformation* (London and New York, 2017).

Nagel, Alexander. "Observations on Michelangelo's Late *Pietà* Drawings and Sculptures," *Zeitschrift für Kunstgeschichte* 59 (1996):548–72.

———. *Michelangelo and the Reform of Art* (Cambridge and New York, 2000).

Nims, John Frederick. *The Complete Poems of Michelangelo* (Chicago and London, 1998).

Nova, Alessandro. "The Artistic Patronage of Julius III (1550–1555): Profane Imagery and Buildings for the De Monte Family in Rome." (PhD diss., University of London, 1982).

———. "The Chronology of the Del Monte Chapel in S. Pietro in Rome," *Art Bulletin* 66 (1984):150–54.

On Artists and Art Historians: Selected Book Reviews of John Pope-Hennessy, ed. Walter Kaiser and Michael Mallen (Florence, 1994).

Orlofsky, Michael. "Historiografiction: The Fictionalization of History in the Short Story," in *The Postmodern Short Story: Forms and Issues*, ed. F. Iftekharrudin et. al. (Westport, CT, and London, 2003), 47–62.

Østermark-Johansen, Lene. *Sweetness and Strength: The Reception of Michelangelo in Late Victorian England* (Aldershot, UK, and Brookfield, VT, 1999).

Palladio's Rome, ed. and trans. Vaughan Hart and Peter Hicks (New Haven, CT, and London, 2006).

Panofsky, Erwin. *Idea: A Concept in Art Theory* (1924), trans. J. J. Peake (New York, 1968).

Paoletti, John T. "The Rondanini *Pietà*: Ambiguity Maintained Through the Palimpsest," *Artibus et Historiae* 42 (2000):53–80.

Papini, Giovanni. *Michelangelo: His Life and His Era*, trans. Loretta Murname (New York, 1952).

Parker, Deborah. "The Role of Letters in Biographies of Michelangelo," *Renaissance Quarterly* 58 (2005):91–126.

———. *Michelangelo and the Art of Letter Writing* (New York, 2010).

Pastor, Ludwig von. *The History of the Popes*, vols. 12, 13, 14, trans. Ralph Francis Kerr. (London, 1912, 1924).

Pepper, Simon. "Planning versus Fortification: Sangallo's Project for the Defense of Rome," *Architectural Review* 159, no. 949 (1976):162–69.

Pon, Lisa. "Michelangelo's *Lives*: Sixteenth-Century Books by Vasari, Condivi, and Others," *Sixteenth Century Journal* 27 (1996):1015–37.

Prodan, Sarah Rolfe. *Michelangelo's Christian Mysticism: Spirituality, Poetry, and Art in Sixteenth-Century Italy* (Cambridge and New York, 2014).

Ramsden, E. H. (trans.). *The Letters of Michelangelo*, 2 vols. (London and Stanford, 1963).

Rebecchini, Guido. "After the Medici: The New Rome of Pope Paul III Farnese," *I Tatti Studies* 11 (2007):147–200.

———. "Michelangelo e le mura di Roma," in *Michelangelo: Architetto a Roma* (Milan, 2009), 114–17.

Redig de Campos, Dioclezio. *Affreschi della Cappella Paolina in Vaticano* (Milan, 1950).

I Ricordi di Michelangelo, ed. Lucilla Bardeschi Ciulich and Paola Barocchi (Florence, 1970).

Rime e lettere di Michelangelo Buonarroti, ed. Antonio Corsaro and Giorgio Masi (Milan, 2016).

Robertson, Charles. "Bramante, Michelangelo and the Sistine Ceiling," *Journal of the Warburg and Courtauld Institutes* 49 (1986):91–105.

Romani, Vittoria (ed.) *Daniele da Volterra: Amico di Michelangelo* (Florence, 2003).

Roney, Lara Lea. "Death in the Papal Chapel: Paul III and the Motivations for Michelangelo's Crucifixion of St. Peter in the Pauline Chapel," in *Encountering the Renaissance: Celebrating Gary M. Radke and 50 Years of the Syracuse University Graduate Program in Renaissance Art*, ed. Molly Bourne and A. Victor Coonin (Ramsey, NJ, 2016), 139–50.

Rovetta, Alessandro (ed.) *L'ultimo Michelangelo: Disegni e rime attorno alla Pietà Rondanini* (Milan, 2011).

Ruschi, Pietro. "La cappella Sforza in Santa Maria Maggiore," in *Michelangelo architetto nei disegni della Casa Buonarroti*, ed. Pietro Ruschi (Milan, 2011), 149–57.

Ruvoldt, Maria. "Michelangelo's *Slaves* and the Gift of Liberty," *Renaissance Quarterly* 65 (2012):1029–59.

Saalman, Howard. "Michelangelo at St. Peter's: The Arberino Correspondence," *Art Bulletin* 60 (1978):483–93.

Saslow, James M. *The Poetry of Michelangelo: An Annotated Translation* (New Haven, CT, and London, 1991).

———. "Sexual Variance, Textual Variants: Love and Gender in Michelangelo's Poetry," in *Michelangelo Buonarroti: Leben, Werk und Wirkung / Michelangelo Buonarroti: Vita, Opere, Ricezione. Positionen und Perspektiven der Forschung/Approdi e prospettive della ricerca contemporanea*, ed. Grazia Dolores Folliero-Metz and Susanne Gramatzki (Frankfurt-am-Main: Peter Lang, 2013), 99–117.

Satzinger, Georg. "Michelangelos Cappella Sforza," *Römisches Jahrbuch der Bibliotheca Hertziana* 35 (2005):327–414.

———. "Cappella Sforza in Santa Maria Maggiore," in *Michelangelo: Architetto a Roma*, ed. Mauro Mussolin (Milan, 2009), 214–25.

Scarpati, Claudio. "Le rime spirituali di Vittoria Colonna nel codice Vaticano donato a Michelangelo," *Aveum: rassegna di scienze storiche, linguistiche e filologiche* 78 (2004):693–717.

———. "Le rime spirituali di Michelangelo," in *L'ultimo Michelangelo: Disegni e rime attorno alla Pietà Rondanini*, ed. Alessandro Rovetta (Milan, 2011), 36–41.

Schiavone, Oscar. *Michelangelo Buonarroti. Forme del sapere tra letteratura e arte nel Rinascimento* (Florence, 2013).

Schlitt, Melinda. "'. . . viri studiosi et scientifici . . .' Pietro Antonio Cecchini, Michelangelo, and the Nobility of Sculptors in Rome," in *Gifts in Return: Essays in Honor of Charles Dempsey*, ed. Melinda Schlitt (Toronto, 2012; 233–61).

Schulz, Juergen. "Michelangelo's Unfinished Works," *Art Bulletin* 57 (1975):366–73.

Schwager, Klaus. "Die Porta Pia in Rom. Untersuchungen zu einem 'verrufenen Gebäude,'" *Münchner Jahrbuch der bildenden Kunst* 24, no. 3 (1973):33–96.

Shearman, John. *Mannerism* (Middlesex, UK, 1967).

———. "Il tiburio di Bramante," *Studi bramanteschi* (Rome, 1974) 567–73.

Shrimplin-Evangelidis, Valerie. "Michelangelo and Nicodemism: The Florentine *Pietà*," *Art Bulletin* 71 (1989):58–66.

Smith, Carl. *What's in a Name? Exploring Michelangelo's Signature* (n.p., The K Press, 2014).

Stechow, Wolfgang. "Joseph of Arimathea or Nicodemus?" in *Studien zur toskanischen Kunst: Festschrift für Ludwig Heinrich Heydenreich* (Munich, 1964), 289–302.

Steinberg, Leo. "Michelangelo's Florentine 'Pietà': The Missing Leg," *Art Bulletin* 50 (1968):343–53.

———. *Michelangelo's Last Paintings* (New York and London, 1975).

———. "Animadversions: Michelangelo's Florentine *Pietà*: The Missing Leg Twenty Years After," *Art Bulletin* 71 (1989):480–505.

Steinmann, Ernst. *Die Portraitdarstellungen des Michelangelo* (Leipzig, 1913).

———. *Michelangelo e Luigi del Riccio* (Florence, 1932).

Stott, Deborah. "'I am the same Cornelia I have always been': Reading Cornelia Collonello's Letters to Michelangelo," in *Women's Letters across Europe, 1400–1700: Form and Persuasion*, ed. Jane Couchman and Ann Crabb (Aldershot, UK, and Brookfield, VT, 2006), 79–102.

Summers, David. "Michelangelo on Architecture," *Art Bulletin* 54 (1972):146–57.

————. *Michelangelo and the Language of Art* (Princeton, NJ,1981).

Symonds, John Addington. *The Life of Michelangelo Buonarroti*, 2 vols. (London, 1893).

Thies, Harmen. *Michelangelo: Das Kapitol* (Munich, 1982).

Thoenes, Christof. "St. Peter als Ruine: zu einigen Veduten Heemskercks," *Zeitschrift für Kunstgeschichte* 49, no. 4 (1986):481–501.

————. "Il modello ligneo per San Pietro ed il progettuale di Antonio da Sangallo il Giovane," *Annali di architettura* 9 (1997):186–99.

————. "Michelangelos Sankt Peters," *Römisches Jahrbuch der Bibliotheca Hertziana* 37 (2006) [2008]:59–83.

Tolnay, Charles de. *Michelangelo*, 5 vols. (Princeton, NJ, 1943–60; repr. Princeton, 1969–71).

————. *Corpus dei disegni di Michelangelo*, 4 vols. (Novara, 1975–80).

Trachtenberg, Marvin. *Building in Time: From Giotto to Alberti and Modern Oblivion* (New Haven, CT, and London, 2010).

Treves, Letizia. "Daniele da Volterra and Michelangelo: A Collaborative Relationship," *Apollo* (August 2001):36–45.

Tronzo, William. "Il Tegurium di Bramante," in *L'architettura della basilica di San Pietro. Storia e costruzione* ed. Gianfranco Spagnesi (Rome, 1997), 161–66.

Vasari, Giorgio. *La vita di Michelangelo nelle redazioni del 1550 e del 1568*, 5 vols., ed. Paola Barocchi (Milan and Naples, 1962).

————. *Le vite de' più eccellenti pittori, scultori e architettori nelle redazioni del 1550 e 1568*, 6 vols., ed. Rosanna Bettarini (Florence, 1966–1987).

————. *Lives of the Artists*, trans. George Bull (London, 1965).

Vecce, Carlo. "Zur Dichtung Michelangelos und Vittoria Colonnas," in *Vittoria Colonna: Dichterin und Muse Michelangelos*, ed. Sylvia Ferino-Pagden (Vienna, 1997), 381–404.

Verdon, Timothy. "Michelangelo and the Body of Christ: Religious Meaning in the Florence *Pietà*," in *Michelangelo's Florence Pietà*, ed. Jack Wasserman (Princeton, NJ, 2003), 127–48.

Wallace, William E. "Il 'Noli me Tangere' di Michelangelo: Tra sacra e profane," *Arte Cristiana* 76 (1988):443–50.

————. "Narrative and Religious Expression in Michelangelo's Pauline Chapel," *Artibus et Historiae* 19 (1989a):107–21.

————. "Michelangelo at Work: Bernardino Basso, Friend, Scoundrel, and *capomaestro*," *I Tatti Studies* 3 (1989b):235–77.

————. *Michelangelo at San Lorenzo: The Genius as Entrepreneur* (Cambridge and New York, 1994a).

————. "Miscellanae Curiositae Michelangelae: A Steep Tariff, a Half-Dozen Horses, and Yards of Taffeta," *Renaissance Quarterly* 47 (1994b):330–50.

————. "Manoeuvring for Patronage: Michelangelo's Dagger," *Renaissance Studies* 11 (1997):20–26.

————. "Michel Angelus Bonarotus Patritius Florentinus," in *Innovation and Tradition: Essays on Renaissance Art and Culture*, ed. Dag T. Andersson and Roy Eriksen (Rome, 2000a), 60–74.

————. "Michelangelo, Tiberio Calcagni, and the Florentine *Pietà*," *Artibus et Historiae* 42 (2000b):81–99.

————. "Michelangelo and Marcello Venusti: A Case of Multiple Authorship," in *Reactions to the Master: Michelangelo's Effect on Art and Artists in the Sixteenth Century*, ed. Francis Ames-Lewis and Paul Joannides (Aldershot, UK, 2003), 137–56.

Wallace, William E. "Michelangelo Ha Ha," in *Reading Vasari*, ed. Anne Barriault, Andrew Ladis, Norman E. Land, and Jeryldene M. Wood (London and Athens, GA, 2005), 235–43.

———. "Non ha l'ottimo artista alcun concetto," *Rhetoric, Theatre and the Arts of Design: Essays Presented to Roy Eriksen*, ed. Clare Laparik Guest (Oslo, 2008),19–29.

———. "Michelangelo: Separating Theory and Practice," in *Imitation, Representation and Printing in the Italian Renaissance*, ed. Roy Eriksen and Magne Malmanger (Pisa and Rome, 2009), 101–17.

———. *Michelangelo: The Artist, the Man, and His Times* (Cambridge and New York, 2010a).

———. "Reversing the Rules: Michelangelo and the Patronage of Sculpture," in *Patronage of Italian Renaissance Sculpture*, ed. Kathleen W. Christian and David Drogin (Surrey, UK, and Burlington, VT, 2010b), 149–67.

———. "Michelangelo, Luigi del Riccio, and the Tomb of Cecchino Bracci," *Artibus et Historiae* 69 (2014a):97–106.

———. "Who Is the Author of Michelangelo's Life?" in *The Ashgate Research Companion to Giorgio Vasari*, ed. David Cast (Aldershot, UK, 2014b), 107–19.

———. "'Certain of Death': Michelangelo's Late Life and Art," *Renaissance Quarterly* 68, no. 1 (2015):1–32.

———. "Michelangelo's Brothers 'at my shoulders,'" in *Studies on Florence and the Italian Renaissance in Honour of F. W. Kent*, ed. Peter Howard and Cecilia Hewlett (Turnhout, Belgium, 2016), 169–80.

———. "Vasari's Fictional and Michelangelo's Real Family," *Source: Notes in the History of Art* 36, nos. 3–4 (Spring/Summer, 2017):247–55.

Walter, Ingeborg. "Michelangelo e gli Strozzi. L''Ercole', il 'Bruto' e un cavallo per Caterina de' Medici, *Bolletino d'Arte* 99, n. 24 (2014):85–98.

Wasserman, Jack. *Michelangelo's Florence Pietà* (Princeton, NJ, and Oxford, 2003).

Wilde, Johannes. *Michelangelo: Six Lectures* (Oxford, 1978).

Wilkinson, Catherine. "Building from Drawings at the Escorial," in *Les Chantiers de la Renaissance*, ed. Jean Guillaume (Paris, 1991), 263–78.

Wilson, Charles Heath. *Life and Works of Michelangelo Buonarroti* (London, 1876).

Wittkower, Rudolf. *La Cupola di San Pietro di Michelangelo: Riesame critic delle testimonianze contemporanee* (Florence, 1964).

———. "Nanni di Baccio Bigio and Michelangelo," in *Festschrift Ulrich Middeldorf* (Berlin, 1968), 248–62.

Zanchettin, Vitale. "Un disegno sconosciuto di Michelangelo per l'architrave del tamburo della Cupola di San Pietro in Vaticano," *Römisches Jahrbuch der Bibliotheca Hertziana* 37 (2006):10–55.

———. "Le verità della pietra. Michelangelo e la costruzione in travertine di San Pietro," in *Sankt Peter in Rom 1506–2006*, ed. George Satzinger and Sebastian Schütze (Munich, 2008), 159–74.

———. "Il tamburo della cupola di San Pietro in Vaticano," *Michelangelo: Architetto a Roma*, ed. Mauro Mussolin (Milan, 2009), 180–99.

———. "'Gratie che a pochi il ciel largo destina'. Le parole di Michelangelo negli atti ufficiali della Fabbrica di San Pietro," in *Some Degree of Happiness: Studi di storia dell'architettura in onore di Howard Burns*, ed. Maria Beltrami and Caroline Elam (Pisa, 2010), 363–81.

———. "Michelangelo e il disegno per la costruzione in pietra: ragioni e metodi nella rappresentazione in proiezione ortogonale," in *Michelangelo e il linguaggio dei disegni d'architettura*, ed. Golo Mauer and Alessandro Nova (Venice, 2012), 100–117.

INDEX

Michelangelo's assignment to design, 58–59, 65–70, 117; Michelangelo's assistants and, 91–94; Michelangelo's biographies and, 117; Michelangelo's commitment to, 2, 4–5, 183, 219–22; Michelangelo's death and, 89; as Michelangelo's greatest achievement, 239–40; Michelangelo's return to original design of, 71–74, 77, 84, 190, 239; paired columns and, 49–51, 206–10, *208–10*, 256nn32–33, Plates 49–51; Paul's funerary monument and, 110; pay rates and, 174; reuse of columns for, 78, 173; rope and, 80–81, 180; Sangallo's model for, 69–74, 84, 188–89, Plate 16; *setta sangallesca* and, 75–76; standard measures and, 82–84; transept vaults and, 174, 180–83; travertine stone and, 79, 81, 178; water and, 76–78, 81; work site organization of, 77–79, 81, 173–74

St. Peter's Basilica (Old), 73–74, 78, 135–36

Strozzi, Roberto, 29, 98–100, 198, 200

Strozzi family, 98–101, 103, 160, 229

Strozzi Palace (Florence), 187–88

Strozzi Palace (Rome), 98–101, 187–89

Strozzi Villa (Lunghezza), 31, 43

Tempietto (Bramante), 108, Plate 26

terribilità, 13, 21

Tiber River, 8, 81

Titian, 56, 161

Tivoli, 79

Topolino. *See* Fancelli, Domenico di Giovanni

Trajan's Column, 9–10

travertine stone, 79, 81, 178

Trebbiano wino. *See* wine

Twelve Apostles (Michelangelo), 12

Urbano, Pietro. *See* Michelangelo's friends and personal assistants

Urbino. *See* Michelangelo's friends and personal assistants

Varchi, Benedetto, 52–55

Vasari, Giorgio: campaign to get Michelangelo to return to Florence and, 170, 235; *Crucifixion of Peter* and, 108; Florentine *Pietà* and, 133–34, 142; fresco painting and, 106; *Giunto è già'l corso della vita mia*, 143–47; Gonzaga and, 35; *Lives* and, 6, 113–17; Michelangelo's death and, 238; Monastery of Monteluco and, 165, 168; Paul III and Michelangelo, 57–58; relationship with Michelangelo and, 121–24; St. Peter's Basilica (New) and, 71, 182–83, 222; Urbino's death and, 151–52

Vatican City: Belvedere Courtyard and, 129; bureaucracy of, 110–11, 163, 186; Pauline Chapel and, 3; St. Peter's and, 1. *See also* Pauline Chapel

Venetians, 80

Venusti, Marcello, 197–99, 240

Vermigli, Peter, 47

Vigenère, Blaise de, 133

Vignola, Giacomo, 92, 124–25

Villa Giulia, 18, 120, 124–25, Plate 30

Vincenza (Michelangelo's household servant), 8, 57

Volterra, Daniele da. *See* Michelangelo's friends and personal assistants

wine, 59–60, 158, 217–18, 230. *See also* food (Tuscan specialties)

Zuccone (Donatello), 19

PHOTO CREDITS

Note: Pl. (color plates); p. (page number for black-and-white figures)

Adam Eastland Art & Architecture / Alamy Stock Photo, p. 26
Åke E:son Lindman, Lindman Photography, Bromma, Sweden, Pl. 21
Album / Alamy Stock Photo, Pl. 55
Alinari, p. 208
Angelo Hornak / Alamy Stock Photo, Pl. 48, 49, 51
De Agostini Picture Library / G. Nimatallah/Bridgeman Images, Pl. 1, 31
De Agostini Picture Library, licensed by Alinari, Florence, p. 127
Elio Lombardo / Alamy Stock Photo, p. 23
Getty Research Institute, Los Angeles (Cat. No. 2991–261), Pl. 28
Instituto Centrale per il Catalogo e la Documentazione, Rome, p. 17, 20
Isabella Stewart Gardner Museum, Boston, Pl. 41
John A. Pinto Collection, Princeton University, Department of Art and Archaeology, p. 234
Kim Petersen / Alamy Stock Photo. Pl. 52
Kunsthistorisches Museum, KHM-Museumsverband, Vienna, Pl. 38
Livio Pestilli, Rome, Pl. 22, 23
Louvre, Paris, France Mondadori Portfolio / Electa / Sergio Anelli / Bridgeman Images,
 Pl. 24
Louvre, Paris, France/Bridgeman Images, Pl. 25
M Ramírez / Alamy Stock Photo, Pl. 50
Metropolitan Museum of Art, NY, p. 77
Pitts Theology Library, Candler School of Theology, Emory University, p. 159, 185
Private Collection Alinari / Bridgeman, p. 214
Ralph Lieberman, Williamstown, MA, Pl. 57; p. 173, 199, 204
Rijksmuseum, Amsterdam, Pl. 27, 43
Sailko / Creative Commons Wikimedia CC by 3.0, p. 96, 186
Sara Ryu, p. 209, 210
Scala / Art Resource, NY, Pl. 4, 12, 19, 26, 33, 36, 37, 56; p. 25, 128
Scala / Ministero per i Beni e le Attività culturali / Art Resource, NY, Pl. 44
Stanislav Traykov / Creative Commons Wikimedia CC by 2.5, p. 136
William Wallace, Pl. 2, 3, 5, 6, 7, 13, 14, 15, 20, 30, 34, 40; p. 17, 208, 231